FOCUS ON ART

FOCUS ON ART

Werner Spies

RIZZOLI
NEW YORK

For Monique

Published in the United States of America in 1982 by
Rizzoli International Publications, Inc.
712 Fifth Avenue / New York 10019

Title of the original German edition:
Das Auge am Tatort

LC: 81-51719
ISBN: 0-8478-0404-6

Translated by Luna Carne-Ross and John William Gabriel
Designed by Abby Goldstein
Set in type by World Composition Services, Inc., New York
Printed and bound in the United States of America

CONTENTS

A CONTINENT CALLED PICASSO

Pablo Picasso was born one hundred years ago, on October 25th, in Malaga, Spain. He died in south France on April 8th, 1973. The houses he lived in, the studios he worked in, have been emptied and his bequest distributed. Account-ants and heirs now speak in his name. *Guernica,* the *Raft of the Medusa* of the twentieth century, has found its way into the Prado. There have been more than enough facts and happenings to fill with Picasso's presence the years between death and centennial. Obviously his era has still not come to an end. We still live in his zone, exist in the climate he created: Picasso fulfilled too many of the dreams of our time to live on merely as a famous or curious image-maker. His challenge is more than artistic; what we I think find so hard to grasp is his mental and spiritual constitution, and not even his own words, written or spoken, are much help in unravelling this anthropological riddle.

Where to begin, which of the Picassos to apply the lever of explanation to, that is the problem. Picasso loved to conceal himself in his mythical labyrinth. Let us have a look at one of the clues he dropped along the way. It is a large charcoal drawing with collage, dated January 1st, 1928, and bears the title *Minotaur.* The image is quietly symmetrical, a melodious flow of line balanced by clear geometric forms. Two legs, widespread like an open compass, carry the head of a steer, its gaze directed upwards; the head divides the span measured by the legs into two equal parts. A glance at Picasso's dates suggests that an apt subtitle for this obviously autobiographical work might be *Halfway through Life.* When he executed it he was forty-six; he was to die at ninety-two.

This drawing provides a convenient outcrop from which to survey the continent of Picasso. What stretches out before the pathos-filled confession of this *Minotaur?* A successful career in the eyes of those who began applauding Picasso at about this time and kept it up for nearly thirty years. Yet Picasso himself saw it differently. His life and work of the period had none of the harmony that a Matisse moved in as if in his natural element. All Picasso could manage by contrast was a continual restaging of his own desperate unhappiness.

The most successful and celebrated artist of the century the most unhappy too? This is a contradiction only until we realize that every deformation, every wild expansion he subjected the human body to, was a kind of self-vivisection. Where his own image entered his paintings it was almost always as *Ecce Homo.* The only phase of his work in which he indulged in straightforward narration— the blue and pink periods—indulged in the ideas of isolation and melancholy as well. The color blue, psychosis of night, symbolized his own mental state. How can this so poignant sadness, in a young painter who went to Paris at twenty, be explained? In terms of the bohemian clichés that haunt all the reports of his first years at Montparnasse? The social motifs that appeared in his paintings were motifs of the day, and they are prominent also in the work of his friends, that circle of painters that formed in Barcelona and reformed later at Bateau Lavoir in Paris. Yet Picasso was the one who reshaped this motif to a private symbol of his fear of reality. His outsiders and gypsies express his own restlessness and dissatisfaction. These are images of escape from the demands of society, any society.

In giving up Spain, and more particularly Barcelona with its elegaic cult of Wagner and Schopenhauer, Picasso's move to Paris amounted to self-exile. He needed it to see himself through strangers' eyes. This indeed was to become a habitual tactic, and it has something about it almost of a phobia at being touched by the realities. Again and again he would break off all connection, to act out loneliness. The word is Hegel's, and he meant by it that the modern artist had lost the ability to seal himself off from reflection and opinion, things Hegel thought were detrimental to art. Quite apparently Picasso pulled back from history and from the time in which he lived. He did this constantly, as a look at the diverse thousands of his works shows. More than half of them are dated; yet nowhere does a date in Picasso's world correspond to a date in world history. *Guernica* is the only exception.

If in his blue and pink periods he went through a paroxysm of subjective emotion—they were in a way his *Gurre Lieder*, a peak of psychic dissonance—Picasso was to turn shortly thereafter to a pictorial language that seemed to aim at transcendental certainty. Cubism was a radical change within his oeuvre, a change that for most Picasso scholars still stands for his decisive contribution. Perhaps Cubism appeals so much to those who write about Picasso because it is so amenable to deduction, because measuring and surveying these grand techtonic paintings in which objects crystallize as out of some alchemist's concoction, satisfies their longing for a graspable, logical Picasso.

At the time, too, observers thought to discover in Cubism a new pictorial norm to replace the perspective stage set up by Giotto and Masaccio. Picasso himself was the first to repeal such high expectations. He used the new pictorial grammar only temporarily—it was a tool that allowed him to break out of the sentiment and topical tenor that had so strongly informed the early figurative phases of his work. Rapidly what had appeared a narrow directed channel overflowed into a plurality of styles.

How little Picasso was interested in becoming a twentieth-century Giotto, a pictorial legislator for his times, is shown by his panic at being imitated. One of the reasons for his turn back to a neoclassic style, to the museum, was certainly to shake off all those who had stamped Cubism a universal possession. To Cubism, that decisionist will-to-art, he opposed, one is tempted to say, the museum, the tradition of skill. And the amazing bravour of his representative painting of the early twenties was something none of his fascinated contemporaries could hope to follow. Much of what he now created looked disparate, as Picasso himself seems to have been aware. We must assume he was, at least, to correctly judge one of the most radical innovations of all—in 1912 Picasso had added to painting and drawing the technique of collage. This is what enabled him to integrate the disparities.

Collage is surely the most self-revelatory method Picasso ever used. It is a method that has too frequently been understood merely as an extension of the palette and the means of painting thanks to which reflections on the relation between reality and art arose. With Picasso, collage seems to have had a deeper meaning: it helped him to obscure a painfully felt lack of norms. Years before it was taken up by the Dadaists and raised to a medium in its own right, *papiers collé* patched over the breaks in Picasso's work and life. Collage as ideology announced that in the twentieth century art required new means, and that

twentieth-century art had no choice but to demonstrate, immediately to the senses of sight and touch, the fact of dissonance and missing standards.

Minotaur, as we said, was dated January 1st, 1928. The date marks a new birth into the already overpopulated world of Picasso's oeuvre. A new content appeared, announcing already loudly the themes and concerns that were to occupy him from then on, culminating in the "Suite Vollard", the "Minotauro-machie" and finally in *Guernica.* One frequently hears that Picasso's oeuvre had reached its full development by the end of the twenties and that what followed was mere variation and repetition. Nothing can disprove this hypothesis like *Minotaur.* Here something began that might be called the "iconographic Picasso", a period significant enough not to have to take a back seat even to Cubism. The figure of the Minotaur appeared nowhere in Picasso's work before that January 1st. How did he arrive at it? He was not to read the *Metamorphoses* of Ovid until two or three years later. At the time he created *Minotaur,* mythological references in painting were still very rare, even in Surrealism. Frazer's *The Golden Bough,* a *legenda aurea* for the art of the thirties and forties, was yet to prove fruitful, for André Masson perhaps first, a few years later.

Yet if we review the books and pictures that fell into Picasso's hands in 1927, certain clues turn up. Prehistoric and mythic art had awakened his interest. In the sketchbooks he filled during those months we find an abundance of indicators that he was looking for a way out of "studio iconography." Good examples for this are those drawings for sculptures that call to mind the monumental groups

Picasso sculpture Photo by W. Spies.

at Carnac or Stonehenge. In *Cahiers d'Art*, Picasso's house organ, many illustrations appeared between 1926 and the day he made his *Minotaur* self-portrait that must have fascinated him. Besides pictures of the steer and the acrobats from the griffon-frescoes in the coronation hall at Knossos, he found cow-headed Hathor and finally depictions of animals from the Altamira and Dordogne caves. Among these, precisely, were steers or bison with that expressive, upward poise of the head we see again in *Minotaur*. This gesture in the prehistoric drawings Picasso now—with the collage element quite literally—put on. And he made this gesture speak volumes about himself, by couching it in terms of a magic incantation—self-portrait as hunter's charm.

It is worth noting that Picasso created this incantatory image at the same time as the Surrealists were increasingly turning to ritual realms. Apparently Picasso experienced these primal images as examples of a standard incapable of improvement. And it was not only the images that must have struck him—they were accompanied by a text by his friend Jean Cassou, as essay that dealt, from its first sentence on, with the "discouraging miracles" these caves had preserved, and added, "No matter how far we go, the perfection we see in Altamira and the caves of the Dordogne we shall never be able to exceed." These words must have hit Picasso hard, for his entire life's work was a struggle with the weight of tradition, oscillating between moments of pure, self-chosen autonomy and moments in which, as if waking from a drug, he recalled his ideals.

The halfway point in life. For Picasso those were years of maturity achieved, but also of disquiet and of irritability in his personal affairs. He was reading Balzac's *Le chef d'oeuvre inconnu*, The Unknown Masterpiece. How deeply he was moved by the tragic figure of the painter in that novel, Frenhofer, is shown by the many allusions to him in his work. The labyrinth of lines that Frenhofer finally presented as the quintessence of his life's work, Picasso used in paintings and prints at a time when his Surrealist friends were counting on the revelations of automatic writing. With his *Minotaur*, an image somewhere between Ovid, bullfights and Altamira, Picasso pointed once more to the dilemma that had always concerned him—the dilemma of being anchored historically in a period yet striving to make some statement that should encompass every thinkable possibility of expression.

In a certain sense, the *Minotaur* of January 1st, 1928 has turned up here by a cast of the dice. What we can say about it, and about the new departures it signals, are not these conclusions too just as chancy, just as subject to qualification by a hundred exceptions and expansions? In making any statement about Picasso it would seem nearly meaningless to apply categories like development or cause and effect. Passing his work review, one immediately sees that everything is in flux. The notion of clear and clearly differentiated phases has come about only on account of exhibitions and books, for which selection and order is of the essence.

Yet if we look more closely, it becomes obvious that thanks to unflagging formal variation Picasso has played through almost every possible solution. It is almost like watching a computer at work. Never does a single picture stand alone, successful and definitive; each is accompanied by countless approaches. Everywhere we find close cycles of variations in which each differs from the next only in miniscule detail. The idea of an absolute, valid solution seems to have been banned from Picasso's mind. Out of infinitely fine-spun variation, modifi-

cations in form gradually arise. In some cases one almost has the feeling that from the abundance of related material Picasso gives, one could put together the storyboard for an animated film, form-in-movement.

What is it based on, the Picasso era we entered a hundred years ago? Not, surely, on the validity of any style. Picasso torpedoed every attempt to talk about his paintings, drawings, sculptures and prints in terms of a continuum. The solutions we grapple out of the magma of his oeuvre were not solutions to Picasso. Discoveries that in other hands would have been shaped to a style of the times, in his became modes of understanding reality. The abundance he offered us, or rather subjected us to, is discouraging. And we have not yet seen the end of it. Much new material turned up in his bequest, insuring that the exhibitions of his work over the past few years have again been reconnoiterings of the unknown.

In *Minotaur* Picasso projected himself into a mythic era. And the allusion to Altamira he faded into that image suggests the thought that he may here have been holding up, to his own hectic unrest, the timelessness of prehistory. Here indeed we hit on one of Picasso's besetting obsessions. It cannot be separated from the search for totality that motivated his variations of form. In conversation he would come back again and again to the feeling of having no time, of time's running short. That is why he was so miserly with it. Jaimes Sabartés, his boyhood friend and later secretary, tells in his memoirs how Picasso added, in a publication devoted to him, to the date of his birth the following handwritten note: "At eight-thirty in the evening."

This precision was crucial to him. When we look over his work and the events of his life it even seems as if behind his precise registering of time Picasso's essence were hidden. Everything points to a battle of forces between personal time and historic time. If we take, for instance, any two or three working days— which is easy enough to do since Picasso from the early twenties on dated every work to the day and sometimes even to the hour—it is obvious how aggressively he reacted to the palpable drift of time, to continuity. He shifted from one phase of work to the next at lightning speed. Again and again, in panic, he tried to barricade the flux. Within Picasso's general time we can detect an infinitely fine weave of interior times. Abrupt change, rapidity—these appear as a function of Picasso's fear of being fixed to one work or to a single moment in history. He was driven to ever-new variations—and he invested less and less time in the realization of each.

It is easy to gain an idea of the handicap that Picasso's sensitivity to time began gradually to have for his work. *Guernica*, his most monumental and complex painting, remained a case by itself. Effort and intensity depended here upon a condition that was never to be repeated—*Guernica* arose from a mission that absorbed Picasso absolutely. Yet even *Guernica* was finished in six weeks.

Picasso seems to have been conscious of his handicap. He knew the society he lived in no longer had firm commissions to bestow. The possibility cannot be excluded that the paraphrases of great works of art which after the Minotaur-period, after *Guernica* became the focus of Picasso's concern, were gestures of mourning that the age of thematically complex museum-paintings was over and gone.

We are now in the year one-hundred after Picasso's birth. When he died many

looked forward to an intermission in the Picasso play. It has not occurred. Even if Picasso does not embody all of twentieth-century art, it does seem as though no talk of it is meaningful except in his terms. It seems discussion about him is growing more voluble; more, that even those are falling under his spell who had been put off by what they considered an unreflected success-story. They hit out at Picasso as at some prime example of an arbitrary entrepreneur. We read for instance that the typical twentieth-century genius was just the opposite of Picasso, namely quiet, consistent, self-critical. Picasso certainly did look out of place in the aesthetic landscape of the sixties and seventies, where realization had given way to skeptical gesture, to the bones of a concept. The great hour of Marcel Duchamp, a strategy of less-is-more, of the isolated sign, had no word for Picasso. Yet isolation of form is clearly an attitude that dialectically is related to his own. The purist streams in the art of this century work almost like an antidote to Picasso's hard-headed refusal to be satisfied with any one achievement. He lacked character, many said, all he did was experiment meaninglessly around. Already his first show in Paris, just after the turn of the century, goaded a critic into saying that rather than a style, all Picasso offered was a selection to choose from.

His contemporaries were faced from the beginning with the question of how to handle his changeability. On the heels of the Picasso of Barcelona came Vollard's Picasso, then Gertrude Stein's, Apollinaire's, Kahnweiler's, Max Jacob's, Stravinsky's, Cocteau's, André Breton's. They all owned their own version. In the twenties, Picasso's image was up for grabs. To put him into perspective, his well-wishers spoke of his unique adaptability; it was rapidly discovered that this centrifugal genius possessed an incredible ability to integrate the most disparate things; and this ability was seen virtually to pull together the pieces of an exploding universe. Considered thus, Picasso both expressed and overcame the disorientation of modern man.

At this point Zervos came in—we are still in the twenties—with a quote from the last letter that Goethe dictated before his death: "The best genius is that which absorbs everything into itself, can appropriate anything without in the least compromising its innate basic mood, what is called character; but which rather raises and potentiates it to its true possibilities." And Carl Einstein noted: "Hence his life appears built up as from a sequence of several generations, and that is why the shadow of his work falls across several generations." Back then, over fifty years ago it was already beginning to materialize that the unheard-of acceleration which had gripped the avant-gardes profited from the low-pressure area that formed behind Picasso's speeding vehicle. In that turbulent air, art in the twentieth century contracted a positive allergy to lastingness and repetition.

To understand Picasso a conception of time was applied that from then on was to determine technology, science and consumption. No one recognized the motorics of the modern better, or reduced them more radically to their essence, than Marcel Duchamp. Was his first demand on himself not that "the look"— any recognizability of one's actions, any style—was to be avoided? But how can Picasso's strategy be characterized? A battle against familiarity, against repeating himself, against aesthetic ennui seems to have been central to it from the start. Yet with the breaks in his work Picasso was not reacting to expectations on the part of his public; on the contrary, he discontinued an activity at the very time

when consensus had reached its peak. Obviously he carried an aesthetic of self as far as it would go. Everything he did appears to mirror his own states and·moods. One might come closest to pinning his attitude down by referring it to the pleasure principle, which Freud defined as a denial of permanence. Basically, Picasso's behavior seems to reveal the man of the modern age, whom Nietzsche sketched in his "On the Use and Disadvantage of History for Life"—a behavior that consists in a mixture of denial and rehabilitation of history, in a play of subjective projection and necessary return to the museum.

HAPPINESS THROUGH INVENTORY *The encyclopédie and the significance of its illustrations*

Pursuit of happiness—or rather a systematic naming of everything that brings happiness—that is the magic incantation of the eighteenth century. In this search the contradictions of the period—contradictions that even the most abstract enthusiasm of an Ernst Cassirer or a Groethuysen cannot resolve or melt away. Happiness was everywhere—the happiness of the rich, which consisted of enjoying their privileges; the happiness of the poor, which, according to Voltaire, consisted of not missing privileges they did not have. Ability to enjoy set off against inability to suffer—this is certainly one way to keep a world in equilibrium that, according to its philosophers, ought to be ruled by the pleasure principle. Each caste, each condition had its own means—refinement or stupor— to get the best out of its earthly sojourn. But the method which broke with this particularized pursuit of happiness, which postulated the same right to information and knowledge for all, lives on in a work just over four thousand copies of which were distributed: the great *Encyclopédie* of Diderot and d'Alembert. This, the most objective, most Utopian attempt at a solution of the problem of happiness yet, is of particular interest today. The *Encyclopédie* contains what I have chosen to call happiness through inventory: happiness that consists of pursuing the articulations of the human down to their tiniest ramifications, and of putting a possessive pronoun in front of everything at mankind's disposal, everything that man had ever mastered.

The Encyclopedists lay claim to the universe by a simple trick of language, binding every object to the possessive "my" or "our." This is a trick, tried and tested throughout the history of mankind, which (since we think anthropomorphically because of it) keeps our thinking concrete even beyond the visible world. Never before had the appropriation of the world been undertaken with greater resources and greater optimism than in the *Encyclopédie* of the eighteenth century. Diderot and d'Alembert's inventory remains exemplary—first, on account of their decision to restrict themselves to the visible and the demonstrable; and secondly, because they attempted to define the visible anew. The text of the twenty-one folio volumes, in which the knowledge, artistic skill, opinions, and polemics of the period were put down from A to Z, aimed at giving the sum total of the time itself. What could be more objective than to list concepts alphabeti-

The Cork Cutter, from the Encyclopédie.

cally regardless of their importance? A summation that waives hierarchical order is not only the most practical solution for such a miscellany of knowledge and opinion, it symbolizes a new order to be ruled by stocktaking. The alphabetic sequence in the twenty-one volumes seems out of place in a social system that was still strongly anchored in absolutism—yet any reader of the *Encyclopédie* who wished to, could refer back to a fixed classification, for each term had a letter pointing to its place in the edifice of knowledge that Bacon had erected in his time.

But the most significant thing about the *Encyclopédie* was not the text—it had had many precursors in the eighteenth century, and the new ideas set forth under its 60,200 headings could be found elsewhere, in countless books and treatises. What was unique about Diderot's undertaking were the twelve volumes of plates that accompanied the twenty-one volumes of text. There, for the first time prior to the invention of photography, the world in all its abundance was rendered visible. Nowadays we can hardly imagine the effect that this work, these 3129 plates, must have had on an environment in which illustration was a rarity. These volumes are mines of information even today, containing countless references of immense value to the historians, sociologists, linguists, economists, and engineers. This unique museum gives us the prehistory of industrialization and reveals a world that was still ruled by hand.

The semantic trick the Encyclopedists used to take possession of a world split into thousands upon thousands of details, finite bits of knowledge, and jealously guarded craft secrets is immediately obvious: wherever you look man is present, the proprietor of the earth. There is no plate that does not refer to him. Everything in this work confirms the dominion of man, his omnipresence. Is there a more convincing plea for sensualism than the belief that knowledge of the world can be acquired only through our senses? In the article "Encyclopedia," Diderot chained world and man together: "If man, the thinking, contemplating being were banned from the earth, the pathetic and sublime spectacle of nature would turn into a sad, still scene. The universe would be silent. . . . Everything would be transformed into a vast void in which unseen phenomena would occur darkly and soundlessly. The presence of man makes the existence of things interesting."

Man stood looking down on the world and not only on that part of it he himself had created, that of machines and goods. With equal pride of ownership he set himself on a par with nature, preparing to domesticate the earth. Some of the plates in the *Encyclopédie* have, at first glance, an early Romantic character. Yet though we are meant to be awed by the "Pavé des Géants" at Atrim, the Irish "Giant's Causeway," we must not misuse our emotion for any fuzzy cosmological proof of the existence of God. To make sure we do not, the artist put in a group of surveyors about to measure and analyze this natural wonder. The bizarre, the exotic, the unexplainable, the mythical—everything is reduced to the *Encyclopédie*'s terms and images. One of the most fascinating examples of this is the representation of Noah's Ark, in the supplement to the illustrated volumes. This is a truly Encyclopedic ark, invented and drawn in such detail that Noah's unique feat becomes a mere packing and lading problem.

Diderot's *Encyclopédie* was, after all, an attempt to load the entire known world into books and pictures. That is the reason for the great difference between these

illustrations and the *Theatrum machinarum generale* of earlier times. For the compilers of the *Theatrum*, the machine was a wonder, part of the decor, a stage-prop. In the plates of the *Encyclopédie*, the machine has lost the almost visionary uncanniness with which the impressarios of the *Theatrum* had endowed it. It lies spread out before us, dismembered into its units, laid open—like man, who in the anatomical plates has been dissected, with comforting assurance, into his functional parts. Monsieur "homme-machine" worked like an apparatus, and the apparatus worked like the man—logical, predictable and capable of improvement.

What fascinates us so about these volumes of plates today is their epistemological character. The drawings signify the world. Diderot knew what he was about. He wanted more than to illustrate objects and things which language alone could not make clear. From the start he conceived of the text and plates as a unit. Diderot obviously cannot have guessed when he undertook the job that the process of elucidation could go so far. The visual aspect was in fact important long before the plates appeared, the crafts and industries written up in the text having been described according to sketches made on the spot. Diderot himself did much of this groundwork, and though he did not always take the trouble to base his writing on reports of artisans and on drawings, he at least tried to coordinate picture and work.

Diderot groaned under the load. What he lacked were firm concepts that signified a particular quality or quantity. Large, small, thick, thin, these are subjective notions that take on different meanings from person to person and case to case. Nor were there any proper names by which the thousands of objects and machine parts could be distinguished. Every craft had its own terminology; everywhere synonyms concealed the most disparate meanings. The plates helped correct this: proportions were rendered objectively, to scale.

The most significant part of the volumes of plates are the representations of the *arts mécaniques*, the applied arts. They reevaluated the world of objects. This statement can be made without bias, and it holds true not only from our present-day perspective, which recognizes a modern approach in this world of total objectivization. Diderot defended the *arts mécaniques* in an article entitled "Art." He showed why these *artes*, which depend on manual skill, fell into disrepute, and against the contempt for the handcrafted and the mechanical, he set the high opinion that Bacon or Colbert held of these activities.

Odd as it may sound, behind this unique collection of plates stands Colbert, stands mercantilism. For when the *Académie des Sciences* was founded in 1666, Colbert gave it the task of compiling a catalogue, with exact descriptions of all manufactures. This catalogue, destined for the king's library, was to set forth prescriptions for manufacture that would be objective as well as definitive for all time.

The *Encyclopédie* owed much to the preliminary work of the Académie des Sciences. Diderot's collaborators bribed the engravers of the Académie to obtain many plates which the Académie had commissioned over the past decades. These were simply printed as they were or clumsily retouched. The polemics this theft caused began with great noise, but the Academicans were not really interested in pressing charges. Diderot had humiliated them by saying that their work must have been slipshod, otherwise the incriminating engravings would have been published long ago.

Egoism, the official theory of mercantilism, went contrary to the beliefs of the Encyclopedists. But in Diderot's time mercantilism no longer ruled supreme, otherwise the royal censors would never have passed a work that revealed to one and all hitherto jealously guarded manufacturing secrets. Diderot saw his publication as the coup-de-grace for protectionism: "It would mean convicting oneself of robbing society, were one to lock up a useful secret."

But Diderot also had a practical aim in mind. He was convinced that a precise written and graphic definition of a trade would in fact help that trade. The sciences should concern themselves with the crafts and commerce; their intervention would improve manufactured goods that had remained unchanged for centuries. Quality, not quantity—that was the goal of the thousands of busy workers shown in the engravings. Man and object entered symbiosis in these volumes. Over three quarters of the plates dealt with manual work and the operation of workshops. The machine, in the preindustrial age, was still a tool, a clever extension of the arm. Diderot defined it thus: "The instruments and principles are like muscles that strengthen the arms." Only in a few plates, those illustrating foundries and ore and coal mines, does the labor seem impersonal. These contain a hint of what a few decades later was to irretrievably destroy the craft idyll: access to a free energy, independent of muscle power, which would squeeze out the quality product in favor of mass production.

The method used in the *Encyclopédie*'s illustrations was to depict a machine, a work process, a manufactured object, had forerunners in earlier technical books. In his tract on the art of metalworking (1640), Barba had already coupled vignette and text. But the *Encyclopédie* was the first publication to extend this method to cover complex procedures and the entire visible world.

Two descriptive possibilities offered themselves, both based on deduction from the simple to the complex: either from machine to finished product, or from finished product to machine. When the cause was simpler than the effect, the authors started with the machine, but if the result was simpler than the cause which brought it about, then they began by describing the finished product. This, by the way, is the method Diderot invariably used to describe visible phenomena. Description and the supervision of technical descriptions, sharpened Diderot's eye for the graphic image—including the fine arts.

A glance at the *Salons* in which Diderot analyzed the exhibitions of his day shows that here too he applied two distinct methods. If he succeeded, thanks to a spontaneous first apperception, in isolating an element in the picture that particularly appealed to him, he would begin by describing this immediate impression. However, if the composition was too complex to be taken in at a glance, or if its structure could only be understood by means of an exact description, then Diderot began with a systematic reading of what was represented.

Aside from aesthetic considerations, the problem was the same in the *Encyclopédie* and the *Salons*—to so precisely fix a fleeting image that one could retrieve it with a description. Diderot's intercourse with the images of the visible world refined his eye for the essential detail. In the *Salon* of 1765 he reproached Boucher: "In this whole large family you won't find a single person of any use for life's real occupations, such as learning, reading, writing, or beating hemp." This is Diderot all over, the man who always started out from what he had just

seen: *Beating hemp* and *Writing* were both activities pictured in the first volume of plates that had just appeared.

The illustrations in the *Encyclopédie* are not merely pragmatic. They give us a look into the work milieu and, in addition to technical data, a picture of work itself. The machines are shown disassembled, and human labor is likewise separated before our eyes into individual manipulations. The continuous, transitory character of these depictions is fascinating. In some cases only a hand appears—as a *pars pro toto* of the human presence—then a ballet of hands and objects, touching, joining, combining in a virtuoso pas de deux. The accompanying scenes consist of frozen movements, which lend these small genre pictures a slightly unreal air.

The vignettes provide a synthesis; weld objects, machines, and people into a whole. The rooms where work is going on are well-lighted and conform with our notion of a healthy work place. Some of them already show a touch of that passionate revolutionary soberness with which Ledoux furnished his factory designs. The well-ordered, self-enclosed world of work that arises before us in these plates opens outward in some of the vignettes: in those that show tasks being performed out of doors and where the finished product—usually a luxury product—was displayed. In these vignettes factory and sales premises intermingle; picturesque elements appear. These are illustrations that follow the principle introduced into fine art by Watteau forty years earlier, in his famous *Enseigne de Gersaint:* Gersaint's boutique, with its haggling clerk and customer and its dog scratching for fleas, lives on in the Encyclopedists' inventory.

Paris, 1967

HISTORY TURNED BACK *From David to Delacroix*

Under the motto "From David to Delacroix," borrowed from a book by Walter Friedländer of forty years ago, the French and Americans have launched a large and important exhibition the consequences of which are just beginning to be felt. Fog has descended on a clear historic vista.

No aim like Friedländer's, to define stylistically a radical shift of accents in the arts, has played much of a role in this tremendously ambitious undertaking. Nor can it be compared with the European Council exhibit, *The Age of Neoclassicism,* which was held in London in 1972. "French Painting from 1774 to 1830" is the straightforward subtitle, and it shows that no attempt has been made to fit the works into Neoclassic-Romantic coordinates, or into one or the other camp of the battle (so crucial to French tradition) between *Poussinistes* and *Rubénistes,* the linear and the painterly, or David and Ingres versus Delacroix. As a first yield of their systematic reconstruction of contemporaneous influences and realities, a team of art historians and museum people has come up with an utterly contradictory and pluralistic view of a period for which hard categories—Ancien Régime, Revolution, Empire, Restoration—buttressed by solid examples, have long been available.

Positivist art history, as practiced these past ten or fifteen years in France, seeks first of all to broaden the *patrimoine artistique*. After scouring provincial museums and church attics and chapels for Spanish paintings (one researcher stumbled on a very large and very good Zurbarán right in the center of Paris), for examples of sixteenth-century Mannerism, and for works of the School of Fontainebleau, the proponents of this method have now quite logically extended it to the recent past.

They have performed a service to French painting. The method consists, basically, of sifting through the storerooms with an unprejudiced eye, and without being intimidated by the big names. Expertise and conventional taste—aesthetics in a word—are secondary. No qualms are felt about putting hitherto unknown works before a large public, or hanging them as equals among the greats. Non-French art historians too (Jörg Garms and Margret Stuffmann are examples) have made decisive contributions which, in terms of method and lack of bias, have quickened our fascination with the blind spots in our historic knowledge, and not only that of the eighteenth century.

The period covered by this first exhibition—it is to inaugurate a whole series of such stocktakings—has been skillfully chosen, and the overtones of its marvellous title are certain to attract a wide public. A cross-section of the French eighteenth century of the breadth, say, of Watteau to Boucher, would never have had the emotional pitch that, thanks to an unprecedented series of national declines and revivals which the French still experience like some passionate present, iconology, for the first time in art history, could be read straight from ideology.

This produced a continuity between revolution and reaction unparalleled in modern times. Any other European state might well have shattered on it. But in France a capacity for mutation brought people on stage, who, like Talleyrand, were adaptive in the extreme; they blunted the dialectical edge between the Revolution and the Restoration to a mere casual transfer of power—as if that incredibly dramatic period had been a kind of especially vehement democratic two-party system.

Like Talleyrand, David too appears as a figure who forces a common denominator on a time that, studied in detail, encompassed the most violent contradictions. Even the Restoration, during which he fled to Brussels because he was physically threatened, left its mark on his work. Topical themes, Napoleonic iconography suddenly vanished behind a curtain of allegory that would have done justice to the eighteenth century of Louis XV.

David and Delacroix themselves—like the other greats, Fragonard, Ingres, Géricault—were represented in this show by only a few paintings. Over 120 artists shared the 207 catalogue numbers. Only one other Italian province has in recent years dared so to correct the view of a period; Udine, for instance, with the works of the Friuli, though that was only considered permissible because it was done in a commemorative spirit—whereas for the Paris exhibition the term revaluation would not seem too strong.

CONSEQUENCES FOR MODERN ART In Paris, not only have adjectives been exchanged or prejudices shifted; the French museum itself was to be reformed at a very neuralgic point, no doubt as part of a long-range program. What appears now as a refocussing will in the long term be seen as a reassessment that, though

it may not actually shake our premises about the modern, will immensely complicate them—and that not merely from the end of the nineteenth century on but all the way back to the late eighteenth century.

The collaboration of Robert Rosenblum of New York University (one of the best-informed experts on the early twentieth century and, predictably, one with a strong *mal du siècle* feeling about that period), in the preparation of this exhibit seemed instructive to me. In his book, *Modern Painting and the Northern Romantic Tradition: Friedrich to Rothko* (New York: Harper & Row, 1975), his search for thematic complexities in Picasso's early work started out from Cubism, then led him back to Ingres and finally to the late eighteenth century. This is an orientation that is characteristic of recent art research and aesthetic, an approach, as the art business makes ever clearer, that almost seems to be *the* creative contribution of the late sixties.

Suddenly the nonrepresentational, the reduction of painting to the free, the liberated image, have become our *mal du siècle*, completely eclipsing all debate about classification and the hierarchy of themes. What with Robert Rosenblum is an existential experience of the art of our century, a preoccupation with historical logic that leads to a fundamental change in our perception of the image, becomes in the case of his collaborators and the voluminous catalogue, open antimodernism.

History is turned back to the point when the great creative individual (David, Ingres, Delacroix) can be shown to be, if not the result, then the best possible example of a dependency on sociopolitical conditions, of a historically logical (and therefore socially tenable) deviation to genius. For the organizers it was the Academy, with its regulated competitions and apparatus of privileges, that assured the development of talent.

In their preface they lament the reduction of content, the devaluation of a codified generic system—historic painting, portrait, landscape, genre (a distinction by the way that is as meaningless to the avant-garde of our century as that between painters, draftsmen, graphic artists, and sculptors). It was obvious: the politics of art were being practiced, the exhibition had been set up as a lever to shift visual habits away from the Impressionist and subsequent periods.

Impressionism was made out to be a labyrinth of individual dead-ends; and the organizers were resolved to awaken us "to the seriousness, to the infinite ambition of artists to whom painting is not an uncommitted play with lines, a more or less loosely conceived landscape of the Ile de France." It was interesting to see how knowledge of the restrengthened Academy, the system of commissions under Louis XVI—which thanks to painters like Vien, Vincent, Gamelin, Peyron, David, Drouais, Suvée, Berthélemy and Girodet, had restored historical painting to the highest status years before the revolution and before the appearance of Napoleonic themes—was actually held up as an example to the late nineteenth century.

Against the background of these myriad complex programs, the era of the Regency and Louis XV quite naturally appears as a precursor (if one that was intercepted in time and carefully watched) of the late nineteenth century. Here as there we find a narrowed range of subject, a preference for the smaller format, a decrease in government commissions and with it a lessening of interference from above. Specialization on a few subjects led to personal idiosyncrasy; or, to use sociological terms, the laissez-faire attitude of society and those who control

it resulted in an avant-garde that was innovative, subject to personal trouvaille.

The Paris show, even if it did not openly state these problems or advocate a return to the ways of the Academy and to governmental commissions (and rejections) for our time, nevertheless brought such considerations to mind because of its obvious nostalgia. Only the Academy gives a meaningful framework to most of these 120 painters, about whom even specialists knew little until recently. In our century, the need on the part of an artist for such a framework—genre, theme, school, atelier—is considered a lack of originality—forgetting for the moment the brief personal link between Picasso and Braque in the Cubist period, the desired morphological closeness of one or another Constructivist, or the hermetic-thematic one of the Surrealists. The Romantic "no nation carries us" concept of the artist is quite at odds with that of the Academy, which easily carried even its most ordinary members.

To return to the exhibition: it could not create a simple historical view—and this was admitted with an openness that would largely account for its importance and eventual influence. It was not organized monographically, but went en bloc for the essence that hitherto had only been connected with a few names. The chance nature of the discoveries, the state of particular researches, those determined the overall impression to a large extent.

The results were some exceedingly striking symbolic confrontations: Fragonard's *Le Verrou* (The Bolt), an amorous battle over a closing lock, its push-and-pull foretelling the certain impending ecstasy which is what the picture is all about; and *Marius at Minturnae* by Jean-Germain Drouais, wherein Fragonard's rumpled clothes become divine draperies and in which the imprisoned Marius stops the Cimbri's threats to slay him with an imperious gesture. Such confrontations fascinate because of their icons of invincibility, and because of pictures like Géricault's *Wounded Cuirassier* (1814)—which introduced, even before the fall of the Empire, an imperial "man of sorrow", ushering in the end of mass heroism.

By statistical probability, as it were, an objective image of the period should have emerged. In the view of the organizers, it existed in the multiplicity, in the slow movement, in the trend; not, however, with the sudden splash with which an earlier Romantic picture was later allowed to answer a first neoclassical one. Here again, initiative is clearly credited to the institution rather than to autonomous irrational inspiration. The result was criticism of the spontaneous.

Painterly improvisation, which obstructed our view of David and his contemporaries for a long time, was put to the side; an eye that takes its painterliness in the shape of rough sketches had to relearn. The path to these artists could not be smoothed from the periphery in, because what was important to them was not the sketch, the suggestion, but the perfect finished picture with its glacé effect. Wonderful pictures, pictures below the freezing point, turn up here: David's portrait of the Lavoisier couple, to whom the glass and metal accessories lend a van Eyckian matter-of-factness; Delafontaine's *Ice-skaters;* Laneuville's portrait of Barrère de Vieuzac; Vafflard's *Young and his Daughter*, a grisaille that is an early (1804) expression of the black Romanticism that would produce the Gothic romance.

The starting point of the exhibition was not taken from any particular work. The date 1774 referred to a political watershed. With Louis XVI, a monarch

appeared under whose rule French painting would acquire a prerevolutionary character. His cultural policies are repeatedly cited as the reason why *l'ancien Régime* began to disappear from paintings long before 1789—a historical commonplace, though here reduced a little too much to French circumstances. One notices this predilection for bringing down to the national level what was probably European. Thus Cochin and Caylus are said to be more important than Winckelmann, even to those Frenchmen who studied at the Academy in Rome. The exhibition veritably drew a *cordon sanitaire* around Winckelmann.

THE USES OF HISTORY The decision of the stern, puritanical Comte d'Angiviller—appointed director of royal buildings by Louis XVI in 1774—to have themes from French history depicted, and thereby once more to upgrade historical painting, certainly influenced the tendency of a David to replace the mythological showpiece with a historically verifiable civic and ethical model. Yet between the historical reconstructions (no doubt iconographically interesting and novel at the time) of a Durameau, Brenet, Suvée, Berthélemy, and the *Oath of the Horatii* (1784–85), there remains a gulf as wide as that which separated Poussin from the French mainstream a century earlier.

The use of history, as proclaimed by d'Angiviller, was introduced with Plutarchian severity to the detriment of *l'ancien Régime*. Poses and costumes in these irritatingly moral pictures of David, Peyron, Drouais, temporarily brought an anachronism to the scene that the Revolution quickly did one better. A worship of the state, an ethical idealism are portrayed that will not find a practitioner until years later, in Robespierre; he is present at the exhibit in a portrait by Labille-Guiard, his sphinxlike smile no less mysterious than the Mona Lisa's.

The Salon of 1781 (not the one of 1775, as the catalogue has it) definitely showed the decline of genre painting. Historical painting triumphed. At the last minute David, just back from Rome, was inducted into the Academy, a necessary condition for showing in Paris the paintings that had attracted droves of Romans to his atelier during his Italian sojourn. It had taken him three tries before he had managed to get the Academy's coveted Prix de Rome.

David returned, an established Indépendant, determined to pay the institution back for the humiliation from which he was to suffer his whole life. No wonder that when the revolution started in 1789, he was at the forefront of those who began to undermine the privileges of the Academy, its most important opponent. The 1791 Salon was open to all artists, regardless of their affiliation with the Academy, which was finally abolished two years later by the Convention.

The development of art and of the theory of art—and with it the illusory shortlived view of the artist as an Indépendant and of belief in artistic equality— would no doubt be one of the most interesting problems that could be posed by an exhibition, based on the material that is now accessible. But one could immediately add: that would be *one* of the desirable exhibitions. Monographic ones should also be on the agenda, especially, and at last, one that would present the work of Jacques-Louis David, thus correcting one of the most glaring discrepancies between fame and actual knowledge. Because nothing can hide the fact that joining the names of David and Delacroix in the exhibition's title is

a matter of classification. Delacroix' *Liberty Leading the People to the Barricades* (1830), the painting that closes the show, remains for the time being the most popular, the most immediate of all.

Paris, 1975

THE NORDIC HOMER AND ROMANTICISM
"Ossian"—an exhibition at the Louvre and Kunsthalle Hamburg

The spectacular alliance between New York's Metropolitan Museum of Art and the Paris Louvre, which in addition to joint acquisition of works of art, also aims at the exchange of prestigious exhibitions (like the one this autumn of Impressionist paintings and tapestries), has found a noteworthy equivalent in Europe. The Hamburg Kunsthalle and the Louvre are jointly opening an "Ossian File." Theirs is a marriage of convenience that may have grown out of parallel considerations and experiences with exhibition politics.

As Hamburg did with the exhibit built around one painting (Manet's *Nana*), the Louvre besides its large retrospectives has also turned increasingly to a form of presentation that didactically clever and ambitious, is built around a specific theme or sets off one major painting as the principal work of the collection. Hamburg's suggestion that the partnership be inaugurated with an Ossian exhibition was accepted with delight in Paris. A detailed catalogue was compiled jointly by the two institutions. And both profit from the undertaking: Paris can juxtapose the two versions of Gerard's "Ossian" that still exist (at Hamburg and Malmaison), and surround them with a display of large-format Runge drawings. And Hamburg can show Ingres's magnificent *Ossian's Dream*, which has left the Ingres museum at Montauban only once in the past century—for Paris in 1967.

How difficult and necessary it is even today to explain the origins and to legitimize the mythology that was so crucial to early Romanticism, is shown by the reaction of the critic at *Le Monde*, who deprecatingly titled his review of the show "Crime Doesn't Pay." What he means by this is that James Macpherson's Ossian poems were nothing more than a willful mystification, a hoax for which the period fell. But it is precisely the tremendous echo they created—think of Herder, Goethe, Bonaparte, Blake—that makes them a white lie demanded by history; in effect a lie that was asked for and abetted by the thinking of the time.

VOLTAIRE'S ATTACK Macpherson expanded the fake—a fairly new phenomenon in cultural history dictated by the profit motive—into a grandiose wish fulfillment. It not only worked most successfully to broaden ideas at a time when iconography had become worn and amorphous; it also strove for plausibility of content as well as of form. Only with the rise of historicism and philology could

the work of a man who preferred recreation to the publication of old texts fall into discredit.

How correct and psychologically adept Macpherson's approach was, is shown by the fate of others: when in 1757 Bodmer published in Zürich the story of the Burgundian war from the *Song of the Nibelungs*, "Chriemhilde's Revenge and the Lament," his contemporaries passed it by without notice. It was not until de la Motte-Fouqué's *The Hero of the North* came out in the early nineteenth century that popular response to the Nibelung material was aroused. Even Voltaire, the only notable scorner and defamer of Macpherson, worked passages from oriental sources into his *Zadig* on the sly. *Zadig*, however, cannot be compared with the ambitions of the Scot Macpherson who (according to Hanna Hohl, who wrote the catalogue notes on *Ossian* in England, Germany and Denmark), created this Scottish national epic in conscious rivalry with the English and Irish.

The thought of the period was attempting to go beyond the ecumenical Christian and classical cycles of themes; it was searching for an ethnic psychology. There are echoes of this even in Voltaire, who tried to give France a national epos with his *Henriade*. Condemning mystification was clearly only secondary to Voltaire in his attack on the *Ossian* poems: he was out to get the budding Romantic movement. But it is precisely from this point of view that the question of the authenticity of the text—an incredible farrago by historical and philological standards—loses its significance. After all, it was merely one facet of a widespread, emotional revival of national, historical themes and moods. Macpherson's *Ossian* poetry was fully consonant with the cult of retrospection, with for example the studies of Gothic and Icelandic literature that were being conducted at the time at Oxford.

CLASSICISM AS ANTAGONIST The organizers of the exhibit kept pragmatically to their theme. They documented *Ossian* to the degree that he could be documented from the iconography of the time. Two exceptions, to be discussed later, give an idea of the organizers' methodological self-discipline.

A thematic limit had to be set, or else chaos would reign. The bracket chosen was Ossianism as the basic pattern of ethnic psychoanalysis, which immediately set it off against neo-classicism—though stylistically Ossianism occasionally came to terms with the latter quite nicely. This is particularly true for those of the Ossian portrayals which, instead of rendering what is new in Macpherson's poems—the interdependence of action and human emotions projected into nature—concentrate on the plot alone. This exhibition demonstrated the extent to which the songs of the "Nordic Homer" were absorbed into the iconography of the period.

Because nearly everything available for the exhibition was commissioned art, it lacks the spontaneity of early Romanticism. This is true of John Runciman's cycle for the Penicuik House (frescoes, destroyed by fire in 1899, sketches still extant); of Josef Anton Koch's drawings, which may contain the most detailed analysis of the technical framework of Ossianic poetry. It is also true of Runge's sample drawings, rejected by his publisher; of François Gérard's "*Ossian evoque les fantômes au son de la harpe sur les bords du Lora*" (in Hamburg's Kunsthalle, another version at Malmaison Castle, and an aquarelle following its design by

Isabey); of Girodet's hommage to Napoleon; and finally of Ingres' *Le Songe d'Ossian,* which, when it came back into his possession, Ingres substantially reworked, until it had become a private image.

In the series of illustrations we are mostly faced with fairly literal transcriptions of a program that remain in the high genre of nineteenth-century historical painting. Runge was the first, at the beginning of the century, to succeed in transposing these scenes prototypically. The quotes in the catalogue from Runge's posthumous writings are most revealing; many of them go far beyond simple descriptions of scenes, concerning themselves more with the cosmic relationships presented by the text than with pure narrative. Compared to Koch's drawings, Runge's give a much tenser and closer-knit interaction between nature and figure. The instructions that Runge got to create linear silhouettes in Flaxman's style, helped him. The landscapist Koch remained much more conventional, using the landscape rather as window dressing, keeping his figures closer to Raphaelite models.

Neither Koch's drawings, nor most of the other works with Ossian themes shown here, provided original patterns worth following. The work of Angelica Kauffmann and Runciman, Koch and Couder, conforms to canons that, precisely on account of their semantic openness reach a degree of "situationlessness" (Hegel) that precludes individuality of any kind. What is missing here is the compelling image, a visualization of a mood like that of the excerpts from "Songs of Selma" that Goethe (in his own translation) introduced into the second book of Werther. It was not the scenic *Ossian* that stirred Werther and Lotte, but its mood of lyrical longing.

Goethe made brilliant use of the substance of Ossian: the lamented past in Ossian's songs, which themselves reflect the songs of earlier singers; a sadness which always vanishes in the lament of a previous lament, and is presented as the hero's fate—Werther lives, experimentally, the past he is planning for himself. Jean Paul, in *Vorschule der Ästhetik,* put this type of inverted transcendence in a nutshell: "And only in the past does he find future and eternity." Image-makers had, one would have thought, a choice of only two roads: either to cut down the complicated plot structure of the songs to one or a few basic situations that would focus the new material in a lucid allegory; or to present the essence of that which Macpherson's syncretism of history and imagination had made his contemporaries sensitive—the projection of states of mind into landscape painting.

OSSIAN AND NAPOLEON The first possibility obviously implies, instead of an illustration of the plot, the use of what one might in iconographically negative terms call "missing images." The opening essay by Werner Hofmann, *"Der Traum Ossians und der Vernunft"* (dream is here synonymous with sleep, as in Goya's *Sueno*), takes on its full meaning only when one reads it against the background of the basic problem the exhibition raised: Ossian could not give rise to a new, iconographically all-embracing system, but at most to a splendid motif which, as Hofmann shows, literally leads to Picasso's *Blind Guitar Player* in 1903. This has had numerous precedents—in Giotto, in Dürer, in the various portrayals of Job.

Ossian with his harp and the phantoms are first encountered in 1872, in the work of Runciman. Significantly, that theme seems to be missing in Koch. Gerard demonstrably was the first to attempt it on canvas. Isabey's watecolor, a replica of Gerard's painting which decorated Napoleon's copy of Macpherson's writings, states the contrast between presence and sheer absence with most force. Here the main motif becomes a kind of cave allegory; and Ossian's singing a battle with oblivion, to rescue a vanishing ideal. The river Lora becomes the Lethe. The other great painting in the show, Girodet's *Apotheosis of the French Heroes* (of Malmaison), attempts to bridge the time gap. Generals recently dead are greeted by Ossian and admitted to his Olympus. Tragedy however is missing from this allusion-rich apotheosis, which was influenced by Rubens' *Maria de Medici* cycle. Here the Ossian material stands in for classical mythology, an exchange that Napoleonic iconography evidently tolerated only once.

I said at the outset that the exhibition kept strictly to its theme. Two drawings by Friedrich, and Carus' memorial to Goethe, hint at the interweavings of Ossianism and at Ossian's great influence—which appear less in the shape of an Ossian iconography than in a reinterpretation of the scenic and a subjective setting of themes. Such capriciousness in the face of the norm can also be found in Blake, who, by the way, believed in Ossian's authenticity all his life, though he never illustrated the poems. Blake's *Urizen* plays against the background of English biblical translations as much as Macpherson's texts do against that of the Irish legends or the alliterative verse of *Beowulf*, in which the unknown uninhabited land, the wolf-infested crags and storm-beaten cliffs—Ossian's decor—were already sketched.

Even a parallel in modern literature could be claimed—recollection upon recollection, rolling on in silent monologue, projected against a vacation-spot landscape, recited by a bedridden Ossian: Beckett's *Malone Dies.*

Henry Fuseli came close thematically on occasion, when he showed a Nordic Thor battling the Midgard serpent—subjects he got to know through Mallet's *Northern Antiquities.* He is even said to have studied the Icelandic language. His affinity with C. D. Friedrich—thought and emotion projected on nature—was well known to his contemporaries. In "Various Feelings on Viewing Monk by the Sea" by Friedrich, there are two mentions of Ossian: in Kleist's hymnlike introduction and in the dialogue that Brentano and Achim von Arnim originally wrote for the newspaper *Berliner Abendblätter*. (It should also be noted, as a footnote to *Ossian Today*, that Max Ernst translated this text into French for the first time in 1972, and provided it with illustrations, among them one of Ossian.)

Interesting questions come up just when the *Ossian* file must be closed, in the great parallels it suggests in the history of ideas. It will no doubt be fascinating for visitors to the exhibition in Hamburg to compare two major works: Ingres' *Ossian's Dream*, iconographically the clearest and most universal presentation of the theme, and Friedrich's *Shattered Hope* (1821), the most tremendous abstract vision ever of an Ossian-like abandonment to a glacial past. The ice age of the soul—it is there, formally, in both paintings, in Ingres' apparitions that appear, drained of the last drop of blood, to the prostrate singer, and in the uninhabitable worldscape of Friedrich.

Paris, 1974

LONELINESS AND NOTHINGNESS *"German painting in the Romantic era"*

Heinrich Heine who by his own confession was fond of noting the slightest circumstance that hinted at a sympathy of the French for Germany, once, on the Boulevard des Italiens met Victor Cousin, the philosopher and minister, lost in admiration for "the still, devout heads of saints by Overbeck." And Cousin spoke, Heine added, "with delight about the excellence of German art and science, about our kind heart and deep thought, about our sense of justice and humanity."

As far as the nineteenth century is concerned, a German now living in Paris knows that he may belong himself to the nation of composers, of thinkers and, to a lesser extent, of poets. In the French manuals and art surveys that ought to include material on German painters of the nineteenth century, one finds precious little and that mainly critical. Louis Réau opined in 1937 that Philipp Otto Runge was a provincial Jacques-Louis David. If one forgets the pejorative, this kind of opinion could be accepted and might even lead to a profound appraisal of Runge.

Yet that was obviously not the intent of Réau's words, coming from a man who saw Paris as "the capital of the nineteenth century." Like no one else, Runge (as Jörg Träger shows in his excellent book on the artist), from a provincial situation which he consciously maintained, was aiming at something basic, a new point of departure. And this became, with Blake, with John Martin, with Friedrich, the great and fascinating antithesis to David's academic Caesarism. I have already referred to *Modern Painting and the Northern Romantic Tradition* by Robert Rosenblum, which argues for a developmental history of modern art that parallels the French development centering in Paris. Rosenblum, precisely because he has an hypothesis to defend, builds for the first time a solid frame around the confusing, only apparently subjective approaches that appeared, on the periphery of Parisian painting, in England, Germany, Scandinavia, and the United States.

FROM CARSTENS TO MENZEL Henri Focillon did not go much beyond Réau in his statements about the Germans. Instead of giving definitions, he added a few more stereotypes to the list, whose effect was all the more powerful since Focillon, by his treatment of nineteenth-century art (1927), almost singlehandedly managed to make French superiority the norm. His condescention ("Schwind, whose heavy brushwork benevolently pats the observer on the shoulder") was not exactly designed to make of German painting anything more than a rural, unworldly, unsophisticated folk art. As far as Focillon was concerned, Friedrich too was one of the minor masters who "are embalmed in their provincial virginity," as Michel Laclotte, director of the painting collection at the Louvre, quoted with apologetic amazement.

Such misunderstandings can be multiplied at will; they carry no more weight than those on the German side. All in all, they are unedifying relics of a history of ideas primarily intended to polish national images. In France, the fact that a man like Marcel Brion tried to counter these belittling circumlocutions—which

arose less out of contempt than out of ignorance—had little effect; it was simply assumed that a specialist and friend of all things German was expressing his credo with a love of paradox, *quia absurdum*.

Such careless judgements no longer work, as was obvious from the response to the exhibition at the Orangerie, *German Painting in the Romantic Era*. They could survive only as long as the paintings themselves were not known. English painting between Gainsborough and the Pre-Raphaelites, which had vegetated in similar embarrassing obscurity in France, was acclaimed after a comprehensive survey at the Petit Palais a few years ago. Obviously the French, whom Caesar had already characterized as *rerum novarum cupidi*, as inquisitive, are open to visual impressions. Concerning German painters, one can now read, in French newspapers and magazines, sentences like: "The age-old barrier of the Rhine has finally given way." A barrier, it must be said, that was largely the creation of Mme de Stael, who vengefully held up the intellectual, immaterial thrones of the German poets and philosophers against the material, expansive prestige of the Empire.

More than two hundred and fifty pictures and drawings were collected, representing the period ranging from the "Romantic classicism" of Asmus Jakob Carstens to the display of sensitive moments of Naturalism (Baudelaire would have called it Romanticism because it was modern) of Adolf Menzel. Such a survey had been on the Louvre's list for some time. But since the French collections could contribute nothing to the theme, the Louvre had to depend on the good will of German and Soviet museums. And the French found these institutions singularly and generously cooperative. To be sure, not all wishes were fulfilled. It is easy to enumerate all the paintings by Friedrich, by Runge, by Koch, by Menzel, that one would also have liked to see. The absence of Friedrich's *Monk by the Sea* (Berlin, Charlottenburg Castle) was most regrettable. Is there a picture that better expresses Baudelaire's dictum about beauty, that collision of the eternal and the transitory?

The French organizers would have liked more works by the Nazarenes. It suits their policy to arouse new discussion about historical painting and thus the *art philosophique* of the Lyons school. Caspar David Friedrich was splendidly represented: thirty-eight paintings and drawings were assembled, among them *Meadow at Greifswald* (Hamburg), *Arctic Scene* (Hamburg), *Mountain Landscape with Rainbow* (Essen), *The Large Enclosure near Dresden* (Dresden), *Mist* (Vienna), *Moonrise at Sea* (Berlin), and *The Wanderer on the Sea of Mist* (Hamburg). These included four works that were not shown at the Hamburg retrospective exhibition (the superb *Morning Mist in the Mountains* from Rudolfstadt, in which the trees swim up as eerily out of the haze as the soldiers do later in Raffet's *Night Revue*, in which the Bonaparte cult received its posthumous, mythic amplification).

The new acquisition of the Louvre, *Raven Tree*, painted around 1822, also belongs to this category—a not particularly captivating picture that nevertheless works because of its theme. The subject would be taken up again by Millet more than forty years later, and can then be traced from Van Gogh to Mondrian. There was also a drawing—"Owl at Grave"—which had been thought lost and was donated to the Louvre a couple of years ago. This is the drawing Friedrich gave to the sculptor and medallion-maker David d'Angers when he visited

Dresden. Runge's portrait of Johann Philipp Peterson, recently identified by Jörg Träger in a private collection in Sweden, was on public show for the first time here. The works donated by museums in East Berlin, Dresden, Leipzig, and other distant collections should attract not only the French. Such a wide-ranging and varied presentation of this period has never before been attempted. (For the Exhibition of the Century in Berlin, in 1906, called "German Art from the Period 1775—1875" no such exact frame of reference was staked out.)

If under these circumstances a German newspaper could pointedly lament, as one did a few days ago, the absence of Carl Spitzweg, one can only say that teutonic soulfullness of the domestic variety just does not belong to the period that was covered at the Orangerie. The organizers brilliantly allowed the exhibit to more or less end with the year 1848, the spring "of yet another German dance of death." Menzel's *Aufbahrung des Märzgefallenen (The Lying-in-State of the March Dead*, Hamburg),—not at the show but reproduced in the catalogue— closes an era in a manner as abrupt and "plebian" as Delacroix's *Freedom Leads the People to the Barricades* (1830) had done an earlier one. Spitzweg, who was not to develop his delightful gutter Romanticism until 1851, after some time in Paris under the influence of Delacroix, is to be shown with other German artists of the second half of the century—Leibl and the Realists—in a further Parisian exhibit about two years from now.

Werner Hofmann (Hamburg), who has raised the standards of West German museum work far above the norm; Juri Kusnezoff (Leningrad), Michel Laclotte (Paris), and Hansjoachim Neidhardt (Dresden) have orgnized the show. They succeeded in avoiding the sterile animosities of the two Germanys' cultural policies, to put together an event thankfully free of *querelles allemandes*. They also jointly presented a catalogue that showed a surprising and convincing consensus as to scholarly achievement, method of execution, and the discussion of the themes and styles of Romantic art.

How did Paris take the exhibition? There is no point in hiding the fact that the French organizers awaited the reaction with a certain trepidation. They weren't at all sure of their case—they couldn't really be. Just imagine two hundred and fifty works, of which at most one or two had perhaps penetrated the visual subconscious of most visitors (Friedrich's *Eismeer* and—thanks to a record jacket of Pollini's interpretation of Schubert's *Wanderer Fantasy*—also his *Wanderer über dem Nebelmeer*). But the press response was positive all along the line. *Le Monde* began dithyrambically: "The exhibit invites us to discover a continent, an unknown archipelago." *Le Petit Journal*, the house organ of the French museums, had already anticipated that this show would reveal one of the greatest moments in European art to the Parisian public. As of now some two thousand people visit the Orangerie every day.

THE MARVELLOUS DRAFTSMEN In a certain sense, the great demands made on the public by so many totally unknown paintings could easily have led to the perpetuation of stereotypes. Yet opinions were arrived at, emotions were expressed with an unbelievable frankness, and that made this "voyage of discovery" one of the most astonishing of recent times. For instance, André Fermigier wrote in *Le Monde:* "While Courbet in Pavalas cried out in the face of his surging joy of life and his will to tame it, the *Wanderer on the Sea of Mist,*

this German Oedipus, seems to tell us that at the end of even the most heroic effort one can expect to face nothing but loneliness and the void."

One more thing should be added: in this Parisian autumn everything seems to have come together in this exhibit to supply the imponderables that support an eye predisposed to fascination rather than to archivism. In his introduction to the catalogue, Michel Laclotte offered the visitor a number of visual aids that struck one with the force of epiphanies. He not only pointed to the connection between a group of young artists who belong to the present Paris-School (Gäfgen, Theimer, Szafran), and the "marvellous draftsmen" of German Romanticism (Cornelius, Fohr, Olivier, Wilhelm von Schadow, Karl Friedrich Schinkel). With his reference to Eric Rohmer's film, *The Marquise of O* (after Kleist), and to Stanley Kubrick's *Barry Lyndon*, he put his finger on the intellectual fascination of the moment: the translation of the cinematic into lingering, reluctantly moving tableaux. It is this very transposition of nearly all action into panorama that the viewer finds in those paintings. A lethargic passion, a knowledge of the geology of the mind, is there before him, and would be discovered within. Just as pictorial categories are overcome in Runge's art, Rohmer and Kubrick's blends of image and silence transport viewer into actor—the actor himself being, as with Friedrich, hardly more than a figure seen from behind who experiences his own fate in projection.

"As there is a 'German requiem,' so is there a German landscape, whose creator and most gifted interpreter is Friedrich." Thus wrote a critic, and this judgment seems to crystallize the general reaction. Friedrich is quite obviously the center, and radiating out from him are all these images that carry within them the undertow of stillness: those of Carus, Kersting, Dahl, Öhme. There is the brilliance of the morning light in Runge's *Ruhe auf der Flucht* that plays in counterpoint with night; there is Ludwig Richter's masterfully graded *Morgen in Palestrina* (Dresden). One might, of course, have left it at that—an exhibition void of discord, a fascination like the staging "In the Light of Vermeer"—shown here ten years ago.

It is crystal clear that the public accepts these paintings, accepts Romanticism as landscape art. Add to this the drawings and add the other great discovery that created a furor here—the Menzel of the sketches, of the *Room with a Balcony*. At that painting the visitor grabs, finding in it a comforting caesura. What he sees approaches Impressionism and thus, again, extemporized art history.

But in Paris the aim was not simply a cultural-political one. The exhibit's aim was to present the era in all its pluralism, as one that resists categorization. Just last year the French had explored a similarly limited time span in all its facets in the show *French Painting from 1774 to 1830*. The variety of French art during that period had more rational grounds than in neighboring Germany. Stylistic changes seconded the changing regimes: l'ancien Régime, Revolution, Empire, and Restoration, brought about different breaks than those experienced by the practically unregulated art scene on the other side of the Rhine.

The influence of the early Raphael and the Quattrocentists, Dürer and the German primitives, on Overbeck, Cornelius, and Pforr, a changeover to historical and later religious themes, which Goethe chided as "new German religious-patriotic art"—these developments had certain parallels in France even before the "Brotherhood of St. Luke" united to stage the first secession in art history in

1808. In 1774 the puritanical Comte d'Angiviller put history (with consciously Plutarchian examples) back at the top of the curriculum at the Academy. What is even more astounding is that painting under l'ancien Régime anticipated the civic trend and the ethic of the Revolution with something approaching clairvoyance.

A FLIGHT OUT OF TIME The realities had soon emptied historical painting of every historical trait. Not until the Restoration was there a reason for France to return to its national history. In the meantime French art passed through a phase of active Romanticism. At first it reflected the present, increasingly heightened by a mythology of Bonaparte, of the redeemer, the superman. And then, after Waterloo, the *Empereur* lived on in a truly Romantic aura as Prometheus, as a tragic failure.

It was in the orbit of Napoleon, and of his military campaigns and expeditions, that Romanticism found its proper place—in exoticism, which, though distant, at least was focussed. It was Romanticism that, unlike that of the Germans, projected itself into real space, into far and fabulous possessions. Yet in France too one finds all the characteristics of a Catholic-national revival that turned back to the Gothic Middle Ages. Thus we can apply to French Romanticism what according to Heine, made the German variety so *triste:* "The political condition of Germany was particularly favorable to the medieval Christian mood. Sorrow draws us nearer to God, the saying has it, and in truth the sorrow was never greater in Germany . . . and indeed, against Napoleon no one could help except God."

Heine saw immobility and reaction in Germany and, as he did not know Friedrich, Runge or Carus (the greatest could bloom in total isolation in that endlessly divided country), he saw only the Nazarenes, whose engravings were being hawked on the boulevards of Paris. The retreat of the Nazarenes into history—their both religious and aesthetic reincarnation in a charismatic era—was one of Utopias of the early nineteenth century, opposing to the imperial absolutism of the French, their Empire, their Academy and its certainties, the fervor of a Christian Golden Age. This flight out of time—against a backdrop of German impotence and lack of historic possibilities—led them, at least at first (as long as they had not yet preempted all official positions in Germany and imposed a crippling academicism) to remarkable reflections on a free setting of artistic goals.

The regression to which they thus voluntarily succumbed belongs indeed to the riddles of the period. Compared to Friedrich and Runge, the Nazarenes remained a vexation as painters. Fortunately their thoroughly honest pretensions were demonized and perverted a generation later by the Pre-Raphaelites. Something of this later complication—it will call into question the naive coloristic compilations in which the Nazarenes sought their salvation—turns up in the drawings. In them certain tensions appear that one seeks in vain in the paintings and the large frescoes: they bring a fanaticism of detail that leads from reconstruction to destruction of the subject.

Paris, 1976

IN THE BEGINNING WAS COURBET *Realism as a setting for freedom*

One can read about it anywhere: Gustave Courbet was not a pleasant man. Infinitely inconsiderate, rejecting all civil and artistic authority—the eventful biography of the curmudgeon bristles with affront. To deal with Courbet today is to stand before a riddle, since such enmity between artist and society can no longer be experienced first hand. When we encounter the paintings from which most Salon visitors averted their eyes in horror, we may muse about the transitoriness of scandal. The art that one era saw as an unbearable affront to its taste, that aroused violent reactions, seemed to the next generation a captivating, sensuous feast of color and tone.

Only a few of his contemporaries voiced such praise. But one of them was (almost) Delacroix who, although he found some aspects of the work unacceptable and coarse, nevertheless welcomed the innovator. Baudelaire, who half counted as a friend, could basically do nothing with these unenigmatic, straightforward pictures. He did not write about Courbet until 1855, when he mentioned the astonishing debut, but described him nevertheless as a man who, because he narrowmindedly indulged in cynicism, destroyed talent.

The generation that saw the liberation from the norm initiated by Courbet come to fruition in Impressionism, was of quite a different opinion: Meier-Graefe thought, for instance, that the colors in Courbet at times appeared in such subtle doses that one could think the painter had applied them with his lips. The sensory trickery that was ready for any distortion of concrete forms had brushed aside the lamentations of a Théophile Gautier or Meissonier.

Cézanne had already gone considerably beyond the judgment of the painter Decamps about the "clever" Courbet who hid a great many finesses under the cloak of coarse brushwork; according to Cézanne, behind the qualities that had frightened contemporaries lurked quite simply the power of genius. He no longer needed to worry about the catchword "Realist" with Courbet, whose subjects had lost their ability to shock. Like Manet before him, Cézanne grasped the true greatness of Courbet's example: an autonomy of painterly means which made any discussion of the rules of Salon painting as well as of Baudelaire's literary concept of "supranaturalism" irrelevant. For Baudelaire, Courbet's work was "positive", by which he meant an affirmative renunciation of the enigmatic.

AGAINST THE CLAIM OF THE PERIOD Courbet belonged to those through whom annoyance was funneled into society, and into Parisian society in particular. There is no doubt that he personified regional rebellion against the centralism of the capital, against its dictatorial arbitration of taste. As late as ten years before his death he was still writing, full of pride, to Victor Frond about his unalterable independence, for which he credited his origins in the mountains of the Doubs and the Jura. He would not be one of those who sacrificed their freedom and specific otherness to Paris.

The political role that Courbet played all his life fits with this feeling of resentment toward the city. In his painting, he grimly rejected the motifs of the "capital of the nineteenth century," as Walter Benjamin called it. Even the

socialism he professed (actually more of an anarchism that was first beholden to Fourier and then to Proudhon) remained an ethic of freedom that ignored, as Marx had already ironically accused Proudhon of doing, the revolutionary potential of industrialization and the pauperism that accompanied it.

Like Proudhon, Courbet was primarily an advocate of the individuality that he saw in the republican particularism of the provinces. In the dictatorship of the masses, in a one-class society he saw a kind of refurbished ancient Régime. Proudhon had after all compared the results of that type of "compact democracy" with the old absolutism and its rigid laws about the indivisibility of state power. Those who would press Courbet, beyond this belief of his, into their special political services, misunderstand the man. That is why no one who has tried it, among them Louis Aragon in his "L'Example de Courbet" (1952), convinces when they attempt to sharpen an iconography that challenges the hypocrisy of its time into a belligerent proletarian statement.

Courbet's oeuvre has nothing to do with socialist realism. The few paintings that are repeatedly called upon to prove that it has—the *Stone Breakers* (formerly at Dresden) or the *Grain Sifters* (Nantes)—cannot make one forget the man-eating glance of the *Young Ladies on the Banks of the Seine* or the Sapphic embrace of the *Sleepers* (both Petit Palais, Paris). The interpretations—moralizing interpretations—for which Proudhon reached, overlooked the fact that Courbet was in thrall of Eros, Dream, Trance. And the later forest scenes, deer hunts, mountain caves, icy snowscapes and the so very symbolic surges of the sea, all hint, behind a realistic veil, at an obsession.

Is there a more powerful program-painting of this revolt against the demands of the period than the huge *Funeral at Ornans* (1849–50)? In it the inhabitants of Ornans (Courbet's hometown), ceremoniously assembled, attain a dignity that seems to have been practised before the statuesque liturgy of David's *Coronation of Napoleon*. It is an image of darkness, to which one can apply Theophile Sivestre's remark that in Courbet's landscapes one could find a blackened Arcadia of coal barges. When the picture was shown at the Salon in Paris, it raised a hue and cry for the simple reason that in this, his first oversized canvas, Courbet had appropriated the dimension of historical painting. Surely the primary challenge of this painting lay in its very size, a sacrosanct format that always promised a specific dignity of subject. In Parisian eyes it had no subject— apparently a genre painting, apparently the mere record of some ritual of some remote tribe, its self-assured levelling of high and low soon made this painting one of the "pillar of Hercules of Realism" (Paul Mantz, 1851). The hallucinatory enlargement, the visual threat which he achieved by simply blowing up a genre motif, belong to Courbet's most effective strategies.

The sweeping, splendid retrospective at the Paris Grand Palais commemorating the centennial of the artist's death provided the first opportunity in decades for a comprehensive survey of the oeuvre. If we take a look at the stations of the work, we notice that Courbet was repeatedly determined to try the sensitivity of the public and of government institutions. The unremitting way in which this artist tested the tolerance of his period cannot be overlooked. Take the large-format *Bathers* (1853), for instance, the scandal of the 1853 Salon. What insolence to present to lovers of pretty-bottomed nudes a cellulitic backside and allowing it, moreover, to sketch in the direction of the companion playfully

loitering on the ground a movement that seems more an inadvertance than a gesture.

Courbet's friends tried to bend this cult of the ugly to fit their ideology. Here they saw a caustic commentary on the bourgeoisie, well-fleshed and degenerating in luxury. Proudhon wrote: "Thus they [the bourgeoisie] stand before us, no different than the bigotry, the egoism, and the cookery they produce." And Delacroix, who from the beginning found beautiful passages in Courbet's pictures, was repelled by this loathsome introduction of the vulgar. Manet's *Déjeuner sur l'herbe* has its roots here.

In talking about the *Bathers* and its display of a "realistic" motif, can one call it a picture that entirely carries its meaning within itself? That seems doubtful. The outré gesture does not fit the claims of reality. Courbet has catapulted art-historical gestures into the ridiculousness of contemporary mores, trivialized the rejecting motion of the *noli me tangere*, the awe felt at the gesture of annunciation.

Courbet, the Realist, not only depicted but disguised knowledge. He himself said in 1855, in what has become known as his Realist manifesto: "I simply wanted to extract from the entire body of tradition, the rational and independent concepts appropriate to my own individuality." That becomes quite clear in the many self-portraits that punctuate his work like a continuous commentary. This loudmouth who was a past master at self-advertisement, rehearsed one costume-piece after another in changing disguise. His *Bonjour Monsieur Courbet* is an unparalleled piece of self-aggrandizement. A few of his shocked observers noted Courbet's intolerable craving to keep himself talked about; Théophile Gautier, one of those not favorably inclined toward him, thought Courbet beat his drum to remind an inattentive public that he was still around. His friends, however, justified him. For instance, in Champfleury's roman à clef *The Adventures of Mademoiselle Manette*, which appeared shortly before Courbet started *The Studio*, the painter says: "There is no more arrogant but also no weaker being than I."

Even the early self-portraits—the arrogant one, that recalls the glow of Giorgone, with the small black dog (1844), and the one with the pipe (1849)—announce a self-assurance that was to push Courbet to *divide et impera* like no other painter of the century. Was he not about the first to recognize and use the compelling laconism of slogans? In 1855 the thirty-six-year-old artist put the word *Réalisme* over the entrance of the shed he had erected, as the first secessionist, on the periphery of the World's Fair. He readily accepted his friend Champfleury's phrase, which allowed him to set himself off from all others and to face Delacroix and Ingres (to whom several rooms were given at the fair) as "third man."

What conception was masked by the "*Réalisme*" that Courbet acted out to his contemporaries? What program, based on Courbet's work, that can be set in contradistinction to Neoclassicism and Romanticism? The artist himself provided an answer in 1861: "An epoch can only be reflected by its own artists, that is, by the artists who actually live in it. I am also of the opinion that painting is essentially a concrete art and that it can only present visible and tangible objects." This statement remains quite open; it addresses life as a whole, and the advocacy of the present it contains is not aimed at class struggle. In this lies one

of the crucial questons that the work poses. To what extent can one range it with the aggressive political commitment of his friends Proudhon and Champfleury?

ENCODED MESSAGES One thing is clear: only in a few cases did Courbet approach themes that make a sociocritical statement. His work contains precious little that was topical. Compare Courbet to one of the program painters of the period, François Bonhomme, whose preoccupation with contemporary themes, his industrial scenes, can be dated to a realistically identifiable moment. Courbet's Realism had nothing to do with an accusing verism. On this point he lagged behind Daumier and even behind Millet, with whom he is so often compared. No wonder that Proudhon was finally forced to find a new formula to explain Courbet, and spoke of a "critical idealism," of a "critical art." In his posthumous *Of the Principle of Art and Its Social Purposes* Proudhon tried to compensate for the sociotheoretical shortcomings of Courbet's iconography— because Proudhon examined the content, not the revolutionary conception of the art-historical motif—through an inner monologue of the figures; this was something he had to add for Courbet, who he said was incapable of philosophical deductions.

Some years ago the Louvre's head curator, Germain Bazin, could still say: "This lack of an intellectual element marks Courbet's entire oeuvre, and explains the extraordinary meagerness of the drawing, the lack of any composition. His greatest paintings are nothing but individual complexes superimposed on or juxtaposed to one another." Such statements surely go back to Proudhon's claim that Courbet's work needed interpretation, that only an intellectually critical observer knew how to spiritually ennoble these naive representations of the facts of an era. Courbet himself was all too prone to present himself as a man beholden to no one, who had found his way without any academic training. He labeled himself a student of nature. Yet a glance at the very earliest pictures, *Portrait of his Father* (1840?), *Portrait of Paul Ansout* (1842), *Portrait of Juliette Courbet* (1844), shows that he had a stunning control of his means—his teacher in Besançon had been a pupil, albeit an unimportant one, of David. And very soon the technique of David's pupil was enhanced by a familiarity with Venetian and Dutch painting, with a resulting tone, a luminosity that allow the materiality to dissolve into color values. The current Paris exhibition tried to step in here, attempted to define the Realism in Courbet's work in a new way. Behind the factual representation in these pictures a coded message was to appear, a Courbet who would fit better into our new image of the nineteenth century.

THE ENIGMA REMAINS *The Studio* (1854–55), which Courbet himself called an "allégorie réelle," was conspicuously at the center of the exhibit. New material was added to an already thick file. Hélène Toussaint contributed many new, and at first baffling insights on this frequently studied and interpreted painting. They came from a letter of Courbet to Champfleury, recently published in its entirety for the first time: the notes referring to the figures in the left half— "the Jew," "the priest," "the republican," "the gravedigger," "Hercules," "the hunter," "the reaper,"—are no longer understood as indicating that Courbet simply surrounded himself with the figures of his *theatrum mundi*, with the types of his era who, as he wrote, stimulated his thought and provoked his action as a

painter. Mme Toussaint, with the help of contemporary portraits or descriptions, has turned the stereotyped representatives of society on the left side of the painting who balance the group of intimate friends on the right, into well defined figures. The Jew has become Achille Fould, one of the coup d'état's financiers; the priest the ultramundane journalist Veuillot; the hunter Garibaldi; the poacher Napoleon III. Other figures such as Hercules, the reaper, or the working woman now stand in for Turkey, Poland, and Greece respectively.

Such interpretations have something seductive, something satisfying about them; they give the painting, whose obviously nonsymbolic display has always irritated one, a new kind of plausibility, fill a desire for information. But how could such a detailed identification have remained unknown until now? It seems hardly possible with a man like Courbet, who was by nature outspoken. Was no one really made privy to the secret because, as Hélène Toussaint believes, the uncoded message would have created too much turmoil? Couldn't Courbet have revealed the secret at the end of the Second Empire, or at least during his Swiss exile? Somehow this interpretation is not convincing, perhaps because it tries too explicitly to remove the mystery of this picture. In support of the new thesis, Courbet is supposed to have had ties to Freemasonry, whose code of secrecy is stretched to cover *The Studio*. One does not see that this spelling out, this putative interpretation of a simple rebus, really has much to add to what Werner Hofmann noted about this painting in his book *Earthly Paradise*. The isolation of these people in an unfinished room, this melancholy unconnected group that mimes the old separation of the elect and the damned, does not sink to the level of moralizing judgment. It seems as if this work were less concerned with hitting back at certain representatives of society or at the realities of the century than with expressing, in as unique a way as the pictures of Rembrandt—who mattered to Courbet more than any other painter—Realism as the acute pain of temporality.

Paris, 1977

GUSTAVE DORÉ AND THE GRAPHIC DELUGE

"While I was drawing the interior of an Alpine hut, a cow licked away my artistic creations." This amusing and prophetic sentence appears under a lithograph of the *Unpleasantness of a Pleasant Journey* series, published in Paris in 1851, just about the time his voice was due to change, by the the prodigy Gustave Doré. It would make a good motto for a Doré exhibition—a future one, that is, for the selection from Doré's work now being shown at the Bibliothèque Nationale is sadly wide of the mark, and the subject remains one about whose possibilities the critic can only dream.

Doré ought to be the point of departure for an overview that would not rest content with displaying his books open at more or less haphazard places, with a

The Devil Approaching Earth, Woodcut by Gustav Doré.

few sketches and photos thrown in by way of background to the psychodrama, while his huge, ambitious canvases remain rolled up in storage. The addition of a few drawings by Victor Hugo, from which Doré profited as from much else, and, to document his own influence in turn, scattered references to Bresdin, Redon, the illustrators of Jules Verne, yes, even the Palais Idéal of the Facteur Cheval—all this bears witness to the rampant naivete that spins out ever more quickly improvised exhibitions the more fashionable the nineteenth century becomes.

Ever since the barriers between that epoch and the secessions and avant-garde reactions to it began gingerly to be raised, everything seems capable of association with everything else. With Doré, whose oeuvre runs to some hundred thousand items, the sky is the limit. One can "discover" George Grosz in his early drawings for *Journal pour rire*, Klee in "The Sea Battle at Sevastopol is Lost" (from *La Sainte-Russie*), the houses of Feininger's Dilapidated Cubist period in a plate for Balzac's *Droll Tales*. But neither origins (in the art-historical sense) nor Doré's influence ought to be the main themes of an exhibition of his work.

What matters is to place Doré in his time. "I am going to illustrate everything," the thirty-year-old announced, thus declaring himself to be a child of a century that devoted itself to compendia and complete editions (though Balzac could still go bankrupt publishing inexpensive classics). Only against this overabundance could the individual stand out in relief, could Baudelaire, the Symbolists, Manet, Redon prefer a mood, a delicate affinity, to "all the wonders of the world at our feet." Doré made his debut with lithographic cycles like *Folies gauloises* (Paris, 1852) and *La Ménagerie parisienne* (Paris, 1854). The second of these showed, if not Daumier's critical eye for his contemporaries, at least a thematic realism which was to remain the exception in Doré's work. There followed the first of that seemingly endless series of books of wood engravings, *Histoire pittoresque, dramatique et caricaturale de la Sainte-Russie* (Paris, 1854), which Farner has called the first historical pastiche ever.

THE INDUSTRIALIZED ROMANTIC Any discussion of Doré presupposes familiarity with his media. A notion of what could be achieved in facsimile wood-engraving and mezzotint or halftone engraving, two completely different techniques, will go far towards helping solve the "Doré Case."

Balzac's *Droll Tales, Gargantua and Pantagruel* by Rabelais—in these two books the facsimile wood-engraving still dominates. In this technique, pen-and-ink drawings were transferred by the engraver to the end-grain of a wood block with total fidelity, down to crosshatched shadows. With Pannemaker and Pisan, Doré had superb craftsmen at his disposal. Wood engraving came into increasing use at that time since the blocks could be printed simultaneously with the text, making for economy and large printing runs. The facsimile engraving was flexible enough that such different artists as Bewick, Gigoux, Gavarni, Johannot, Grandville, Vernet, Raffet, Daumier and Menzel (who also had his engraving and printing done in Paris) could adapt it well to their personal style.

The popular halftone engraving is another story altogether. It arose in the 1840's and had soon become the true medium of the time. Like the technique that eventually superseded it, autotype, the strength of the halftone engraving,

as the name suggests, lay in its ability to reproduce shades of grey, and it was used on a grand scale to make inexpensive prints of oil paintings and watercolors. Patterns of tiny lines, worked into the wood block with ingenious rollers, scrapers and burins, evoked cascades of light and shadow. Since what they reproduced were unbroken, graduated tones in the original, these prints were not facsimiles in the sense the line-prints were; in them original and reproduction diverged strongly.

Doré's first "plate-book," his illustrations to *The Eternal Jew* by Pierre Dupont (Paris, 1856), must be seen against this background. Here the visual expectations of a public grown used to "documentary" halftones in such periodicals as *Le Magasin pittoresque*, *L'Illustration* and *L'Ouvrier*, were fulfilled. The Doré stream flowed into the woodcut ocean; the stereotyped mass-Doré was born: Konrad Farmer speaks of him, borrowing a *trouvaille* from Mr. Pinkus, a Doré collector at Zürich, as an "industrialized Romantic." Behind Doré's rapidly increasing production Farner, a Marxist, sees capitalist mechanisms at work—the need, in short, stimulated by demand, to constantly offer something new. Did Doré sell out his genius to capitalism? Was he a victim?

This interpretation, tempting as it sounds, does seem a bit simplistic. There is really no evidence that Doré's production grew in proportion to his fame, or that he worked faster to keep up with it. By the time he was thirty, he had already finished forty thousand drawings. More of what he had done was in the works, that is, being engraved and printed. The question remains why Doré turned so exclusively to halftone engraving, and, as time went on, kept 136 different xylographers busy. Surely not to shorten production time: halftones involved more labor than facsimile cuts. One suspects that it was an aesthetic decision, and not only to accommodate his style to the general taste which, after all, had been partly conditioned by Doré himself. He wanted to get away from drawing and illustration. Actually, he thought of himself—and the English agreed with him—as a painter. The gigantomania he gave way to in his studio, with results the critics dismissed out of hand as potboilers, was the tragic motive for his production of wood engravings, which in the end might just as well have been engravings of paintings.

Here lies the clue to the "Doré Case," especially for the Germans, ever since Paul Westheim, in the name of an Expressionist generation, exorcised the wood engraving with the gospel of the "true woodcut." In 1917 Hartlaub had passed his verdict in the *Zeitschrift für bildende Kunst:* "Out of an enormous oeuvre in all branches of art, only a series of vignettes finally remained. And no, these do not suffice for immortality." A typical pronouncement for a period that demoted the great tormenting names, because one no longer knew what to do with them, to minor masters. Menzel was "saved" by a few passages that could be linked to Impressionism, and Böcklin by one or the other early work. Doré survived as what, since the 1850s, he had not wanted to be—a draftsman who ranked with Daumier and Grandville.

Let us go back to the opening sentence, to the cow that licked off his artistic creations. This cow is doubtless the medium of the age, the halftone wood engraving. Doré provided his engravers a pattern of painterly effects, drawing on the block outlines and areas of light and shade with India ink or watercolors. By the 1860s, his drawings were being transferred onto the wood by a photographic

process. The engravers knew exactly how a cloud, a rock, a root, sunlight and waves must be translated into the terms of their craft. Here arose the stereotyped look that mars so many of Doré's plates, which in a certain sense remained external to him, backdrops by a strange hand for an artist called Doré.

In order to carry out his gigantic, encyclopedic program of illustration, he had to rely on an army of workers—a division of labor in which, following the example of Diderot's *Encyclopédie,* all the artistic work (his lithographs, paintings and sculptures excepted) was delegated to others. That is why the terms original and collaboration can no longer be applied to Doré's engravings. A collective achievement made possible the dissemination of an oeuvre that as such was literally destroyed, for the wood engraver's work is done when he has obliterated the original.

The novelty of this oeuvre, and its immeasurable success, are rooted in the medium. One might add that, in Doré's most spectacular prints, the medium goes its own way. He did so many prints that owe their effect to set configurations of strokes and hatches and dots, and that effect was precisely the one that the original (a wash drawing) could not achieve—*the effect of reproduction.* Doré's scores required performance. The paradox is, that in a halftone engraving the very quality we admire as the unmistakable Doré atmosphere is at bottom only a stereotype, an anonymously filled void.

Doré's pictorial language, as eloquent and as generally understandable as his figure of Christ, which all creeds could accept, is repeatedly praised as a "culmination of wood-engraving art" (thus Farner). Yet only the circumstance that we have lost sight of the nineteenth-century illustrated books of popular science, allows us to experience Doré's illustrations of Chateaubriand's *Atala,* of the Bible, of Tennyson's *Idylls of the King* (steel engravings) or of *The Ancient Mariner* by Coleridge, as unmatched technical wonders, and to equate them with the art of Doré.

ILLUSTRATOR IN CINEMASCOPE A glance at the natural scientific publications of the time, particularly such fine ones as *Le Magasin pittoresque,* forces one to a revised opinion (to illustrate which would require a further department in the exhibition). The technical standard of the Doré prints, their richly nuanced transitions from light to dark, the artistry in suggesting different materials, textures, juxtapositions of damp and dry, can also be found elsewhere. One can imagine sections from Doré's engravings accompanying an essay on botany or history in the journals, just as the descriptive exoticism in *Atala* and other of his books might as well stem from the scientific literature. However—and here economic considerations come into play—Doré was not limited to the small screen. He preferred his effects in cinemascope.

Yet the illustrator of the nineteenth century who, in terms of medium and working method, was a product of his time like no other, eluded it completely in his choice of subjects. Doré added almost nothing to iconography. The elements of the era—the mechanical contrivance, the object, the *physiologies*—are absent from his work. Typically, the Balzac book he chose to illustrate was *Droll Tales,* one of the few in which Balzac dealt with historic material.

This displacement in time is particularly striking in Doré because the similarity of technique between his illustrations and the plates in natural science and

technical publications suggests a tie that substantively is not there. The wood engraver who illustrated an essay entitled "Cloud Formation before a Storm" from a scientist's sketch, could just as well have let his meteorological configuration, transferred to a Doré engraving, darken the sky over Dante's *Inferno*.

Europe was engulfed by a deluge of engravings. It swept everything in its path—novels, myths, cosmogonies, the life of insects, war atrocities, reconstructions of prehistoric birds, vaccination trials, table manners, dairies, methods of execution in far-off lands, trilobites, troglodytes, stalagmites and stalactites, M. Pasteur at work in his laboratory. There was no limit to detail in execution, nothing to indicate a personal artistic touch at the one extreme or pedantic industry at the other. Toward the end of the 1860s and in the 1870s another point of reference appeared: photography and its reproduction by autotype. Visual expectations demanded both. In the popular journals endless debates went on about printing techniques, the editors piously asserting that a wood engraving after a photograph could easily compete with an autotype. They forced the medium; soon wood engravings became so petrified that the limiting case was reached—line-patterns so fine as hardly to take ink descended, like a fly-screen, between reality and its representation. Autotype would do away with this last barrier.

On the other hand, the conflict between the two media, wood engraving and autotype, allowed for a further suspenseful *quid pro quo*, at the expense of the actual document. For a time the perfected wood engraving "after a photograph" satisfied the demand. But only autotype could bring the spectator, the doubting Thomas, proof of reality itself. One work of Doré's profited from this short moment of indecision in which an adequate printing technique was still not available for photographs: this was *London, Pilgrimage*, printed in that city in 1872. This elaborate portrayal of London could pass for reportage because at the time reproduction by wood engraving was the common medium for both drawing and photography, and thus kept the barrier open between them.

Doré worked in part from photographs, as did many artists of the time, but his goal was neither image nor draftsmanship but the effect of duplication. In his medium the hand of the artist traced, so to speak, the action of photographic chemicals. For a few short years, drawing and photography found a point of convergence in his work.

Doré's death in 1883 and the demise of wood engraving are not far apart. Both profited from one another; the obscurity of both today seems in retrospect one of the prerequisites for a coming art, an art that at first so generously left iconography, the panoramic view, the wide screen in a word, to photography, once its most bitter rival for the same handmaiden, wood engraving.

Paris, 1974

MAYBE I APPEARED TOO SOON *The late work of Cézanne*

"*Cézanne—The Late Work,*" shown in New York in 1978, created a furor in the United States. First of all, it was a miracle of cooperation, bringing together over 120 oil paintings and watercolors, most of which are still in private hands and many of which were on public show for the first time. Perhaps this was partly a result of the exhibition's theme. There was much that by contrast to the "finished," fully articulated works looked sketchy, what in its dramatic mixture of *non finito,* a process of self-insight repeatedly interrupted, could not have been considered museum art at all until Cézanne's example had been absorbed by the avant-garde ideal of *réalisation,* for which the failure, the torso were marks of authenticity.

A much-needed history lesson can be learned from the series of late portraits, still lifes, views of Mont Sainte-Victoire, the Bibemus quarry and the studio pictures, those matchless groups of bathers shimmering in a blue haze. In spite of all the upgrading the nineteenth century, thanks to sociologists and historians of ideas, has since undergone, Cézanne's work cannot be fit into any general historic view. It possesses almost the quality of an autistic *act.*

The isolated position of Cézanne's bears out those who have always recognized in the master of Aix one of the few pioneers of their own vision. During the gloom of his final years Cézanne himself was well aware of his otherness, of the changes that led him to rebel against the scientific determinism of the age—and against his erstwhile friend Zola. Perhaps nothing is more indicative of his falling out with that century of grand fulfillments, great institutions, and messianic belief in progress, than his break with Emile Zola, his boyhood friend who sneered at his skepticism and at the difficulties he had in realizing his ideas. Toward the end of his life, misanthropically estranged even from his native Provence, Cézanne wrote to the younger painter Joachim Gasquet: "Maybe I appeared on the scene too early. I was more the painter of your generation than mine."

The New York exhibition has limited itself to the last eleven years, thus illustrating for the first time the favorite chapter of Cézanne literature, which always puts the "problematic" Cézanne, the late work, center stage. The year 1895 is taken as the outside date. Roger Fry fifty years ago, Meyer Schapiro twenty-five years ago—to name two representatives of Anglo-American Cézanne studies—also saw this as the watershed. The fundamental statements of such art historians as Fritz Burger (*Cézanne and Hodler*), Fritz Novotny (*Cézanne and the End of Scientific Perspective*) and Kurt Badt (*The Artof Cézanne*) still seem not to have passed the language barrier, as can be gathered from the elaborately detailed contributions to the catalogue by Theodore Reff, Lawrence Gowing, and George Heard Hamilton.

ROADS TO CUBISM Roger Fry saw the incredible intensification of color as a mark of the late style. In terms of paint handling it was characterized as much by sketchy application as by the tormented impasto in some of the heavily overpainted portraits and landscapes. Chromatic limitation, pervasive blue

shadows, a psychological penetration in the portraits reminiscent of the late Rembrandt, the dispensing with detail—these are some of the phrases one catches at in an attempt to describe the change. The authors of the catalogue have adopted these and other categories in order to set off, against the remainder of the oeuvre, the oils and watercolors here assembled. Nevertheless opinions—is there a late style or not—diverge. Novotny denied the existence of a break, and Badt set the dividing point on which this exhibition and catalogue are based, ten years earlier: "The technique hardly changed after about 1885; it merely grew freer and richer".

As long ago as World War I, Daniel-Henry Kahnweiler spoke of the late Cézanne, of his "mighty struggle with the object." In his seminal book *The Rise of Cubism*, Kahnweiler recognized in Cézanne the point of departure for the

Paul Cézanne, *Pyramid of Skulls*. 1898-1900.

work of Derain, Picasso and Braque. It is common knowledge that Cézanne's late paintings, shown at the turn of the century at the Salon d'Automne in Paris, pointed Braque and Picasso to an art that, thanks to its conceptual liberty vis-a-vis the object, took the pejorative edge off such terms as distortion.

Only in the light of Cézanne's achievement was it possible to christen the young Cubist movement with a word of abuse borrowed from mathematics (cubic) rather than from psychology (expressionist). While it was not the task of this exhibit to pursue the continuing influence of "Cézannism" in the twentieth century, it should be mentioned that of all the essays and studies in the book that appeared in conjunction with the show, the one dealing with the relationship between Cézanne and the young Parisian artists of the early 1900s is by far the most fascinating, and startling.

William S. Rubin has contributed an essay that reveals the results of new research and advances hypotheses that are bound rapidly to confuse the admittedly somewhat codified history of the origins of Cubism. The importance of Picasso's *Demoiselles d'Avignon* for the genesis of Cubist formal language, though it is not entirely denied, is sharply limited. Sacrosanct categories of Cubist studies fall victim to Mr. Rubin's acumen: "We shall be forced to conclude that the *earliest* form of Cubism was less a 'joint creation' of Picasso and Braque than an invention of Braque alone extrapolated from possibilities proposed by Cézanne."

LIBERATION FROM THE HEIRS Rubin starts from the premise that the *Demoiselles d'Avignon* was not nearly so important for the creation of the Cubist vocabulary as the pictures Braque painted a year later in Estaque on the Mediterranean—with nostalgia for Cézanne, in a Cézannesque landscape. Here for the first time the "passage" technique so characteristic of Cézanne—a smooth interpenetration of the picture planes—appears in Braque's work. Derain, whose hitherto unknown, Cézannesque *Bathers* recently turned up in a private collection in Switzerland, is likewise accorded a totally new standing in this revision of Cubist history . Yet however persuasive these trains of thought are, however much they emphasize and upgrade Braque's role, one thing ought not to be overlooked—without the planful act of desperation that was *Demoiselles d'Avignon*, where the escape from civilization of a Gauguin can be felt more strongly than a Cézannesque cultivation of doubt, Braque's regulating influence on Picasso, and with it the birth of Cubism, could never have come about.

The challenge embodied in these late pictures of Cézanne's was not merely morphological. When you think about the term *réalisation* that figured so often in the letters and statements of his final years, and try to imagine what Cézanne's endless struggle to create in parallel to nature must have meant in terms of freedom *and* loneliness, what Derain later said about the *Demoiselles d'Avignon* becomes fully comprehensible: that some day Picasso would string himself up behind that painting. Cézanne consciously and tenaciously worked in a way that separated him from any group, that evaded every kind of social control—and therefore that eschewed every social reward. Seen in this light, his final works stand not only for a change that is graspable in stylistic terms, but for a change that permits us, from the later oils and watercolors, to predict and anticipate Picasso or, alternately, Klee and Kandinsky.

Prophecy has indeed been the tone of most of the writings on Cézanne. He is usually portrayed as the artist who overcame Impressionism to become one of the fathers of twentieth century art. His oeuvre is heard enigmatically to utter "No more . . . and not yet." The theorists and practitioners of Cubism in particular, which radicalized certain elements in his work, fixed the late Cézanne too immovably in a continuous process of development and led, finally, to his being considered solely in the light of his putative effects. This view was encouraged by thematic similarities; Picasso, for instance, did a Cubist paraphrase of Cézanne's portrait of Vollard, and his *Seated Woman* at the Tate immediately calls to mind Cézanne's *Woman in Blue* (The Hermitage, Leningrad) with its subtle geometrization of the body and tube-like arms. Even the faces in Cézanne's portraits, frozen in what often ran to hundreds of sittings into immobility, point ahead to Cubism, which gradually eliminated the psychological aspect from portraiture altogether.

The time has come to extricate Cézanne a little from the claims of his heirs. Novotny felt the same way forty years ago when he said, irritably: "Since it is typical of Cézanne's pictorial space that the fundamentals of scientific perspective are generally adhered to, with only minor departures from the key structure, no relation can be construed between these departures and the nihilism (as regards scientific perspective) of Cubism and the subsequent modes of abstract painting."

What distinguishes Cézanne's late work, and differentiates it from preceding phases—a Romantic one that reverted to Veronese and Delacroix; an Impressionist one touched off by his encounter with Pissarro; and finally the one in which he set line and techtonics against Impressionist vagueness—this has been illustrated in an astonishing manner simply by the way in which the exhibition has been hung. Since it is virtually impossible to date Cézanne's paintings exactly (one is curious to see how far John Rewald in his forthcoming oeuvre catalogue will manage better than Venturi), the organizers have turned to a method that reveals more than any safe chronological arrangement could ever do. The oils and watercolors have been grouped by theme and hung such that serial relationships, transformation of motifs, are visible at a glance.

This thematic grouping also responds in a sense to something that Cézanne accomplished precisely within the small range of his late motifs: a dematerialization of that solid material world the nineteenth century was so confident of having mastered. Not as if the subjects he painted were indifferent to him—in a way they are less gratuitous, less expendable than even the haystacks, the poplars, or the façade of the cathedral at Rouen, which Monet bodily disassembled or relativized with the resources of his time; only in the constant variation with which vision rises above motif do Cézanne's subjects scintillate as images. These subjects had an existential significance for the artist, they were rooted in the events of his life; and their message is more symbolic than it is impressionist. Is one not reminded, by these labyrinthine forest scenes in the shadow of the Château Noir, of the opening sentence from Maeterlinck's *Pélleas and Mélisande:* "How shall I ever find my way out of this wood?"

ESCAPE FROM MATTER Confronted by the sequences that Cézanne compiled, one does not feel moved, as one does with Impressionist portrayals of the

relativeness of appearance, to speak of variations on a theme. In each version Cézanne gives us of his world there is a hint of what Emile Bernard noted about Cézanne's "vision": that it was anchored much more deeply in his mind than in his eye. Cézanne himself described his aim as being the organization of impressions, of perceptions. That is why he turned against "Monet the Eye." His reaction, as we see when we trace Cézanne's development, the first phases of which were dominated by a sensual-erotic iconography, was one of disgust at the physical. In his late pictures he repressed the material world; his handling of perspective is such as to increasingly frustrate any attempt to grasp, to handle, his motifs. If one is at all so inclined, one can follow this escape from matter straight to Marcel Duchamp, beyond whose work such renunciation can go no farther. Duchamp and his disciples, however, unlike the self-lacerating Cézanne, pursue their aesthetic of negation in a state of total painlessness.

THE PLACE FOR UNSUCCESSFUL PICTURES IS THE STOVE For the first time, thanks to the systematic arrangement of the paintings and drawings, we can see that Cézanne waged his battle on a broad front. Step by step, with extreme concentration, he reviewed paradigmatically in his final years every mode of painting. They are all there—the figurative painting, which in his *Bathers* achieves the rank of true historical painting, the portrait, the landscape, and the still life. In each case the examples of the particular form are so close to one another that a seeing in situations comes about. The paintings become paintings of relationship: composition, tonality, and brushstroke represent far less isolated slices of nature than modalities of one man's intellectual independence.

One realizes—again thanks to a presentation that does not divide paintings from drawings—how much the identity between color and form so typical of Cézanne, was foreshadowed in the aquarelles. Local color recedes, even though in comparison to Impressionist work it still retains some importance in denoting a motif. In uniform gradations of hue the colors ae juxtaposed in the same sequence they have in the spectrum. Nowhere do we find a direct transferrence of sensory impression. The structuring elements of brushstroke and color gradation pervade the picture plane, as if an imagined world had been superimposed, like a translucent screen, on what Cézanne wished to give us of the real world.

Here, in the late work, the viewer comes up against so many "abandoned works," *bozzetti*, sketches, and blank patches in nineteenth-century aesthetics that he cannot avoid seeing more in Cézanne's speculations than what Novotny called "the end of scientific perspective." In order to understand the extraordinary significance of the concept of realization for Cézanne's late work, it might be helpful to turn to another of the seminal figures of the time and founders of the art of our century: Auguste Rodin. The two artists were acquainted. What we know about Rodin's studio habits, about his endless difficulties in finishing a work, about his tendency to destroy and recombine his sculptures, thereby playing off the finished parts against the unfinished, all have parallels in the hesitations of Cézanne.

Are we dealing, if not with finished then at least with concluded works in such paintings as *Entrance to Château Noir* (Pearlman Collection, New York), *Garden of Les Lauves* (Phillips Collection, Washington), and *Mont Sainte-Victoire*

(Galerie Beyeler, Basel)? To a modern sensibility the question may not even arise. Did it to Cézanne? If we accept the existence of a circumscribed late period as the exhibitors have done, then there is no reason to deny these paintings *Werkcharacter*. After all, they are not sketches for or of something, but images in which the abbreviations, simply, are starker than in others.

Let us recall Cézanne's answer to Zola's attack on his former friend in the novel *L'Oeuvre*, where Zola has Claude Lantier alias Cézanne commit suicide over the difficulties he has experienced with his *réalisations*. Cézanne is said to have commented: "How dare he say that a painter would kill himself because one of his pictures didn't come off? When a picture is a failure, you stuff it in the stove and start another." Even those paintings of the late period that do not play with the white of the canvas, that are evenly filled in, often show the same style as his sketchier compositions. This is simply because Cézanne, besides the heavily impasto, frequently overpainted oils like *Portrait of Gustave Geffroy* (Louvre) and *The Gardener Vallier* (private collection, Switzerland), created others under the influence of the airy and transparent watercolor technique.

New York, 1978

PICASSO: A CONVERSATION IN MOUGINS

Yes, Picasso exists. Behind the towering myth there is a real man, living and working—difficult as this has become to imagine. Everything about him seems elusive, even his age. Picasso and I began talking about his recent work, and I told him about a conversation I had overheard in a gallery, about three years ago, in front of paintings he had done a short time before. A voice expressed relief that even Picasso's style should show signs of wavering: "He can't draw a firm outline any more. So to conceal the fact he makes these corkscrew squiggles." Picasso laughed at this as if it were a great joke, but I could tell his machismo had been touched, the pride he has since demonstrated to the world in the three hundred and forty-seven etchings he made shortly after.

He has just entered his ninetieth year. You have to see this incredibly agile man in the flesh not to take the reports issuing from Mougins for the panegyrics of true believers. In his presence age is forgotten. The man seems to merge with his oeuvre. As I leafed through the thousands of photographs that show his drawings and paintings in chronological order, the time factor receded, then vanished, and everything focussed into a single, concentrated simultaneity. At every moment Picasso is in command of all the moments in time that lie behind him, thanks to a power to conjure up the past as if it were a set of drawers one could pull out at will. When he talks about Apollinaire, or Max Jacob, or the Barcelona of his youth, or about his first meeting with Kahnweiler, he reconstructs the period, the presence, mimetically. Yet he is not the man to live in his memoirs, quite the opposite—recall, in him, seems to be so powerful that it fairly

Picasso in Mougins, 1970. Photo by W. Spies

negates its own function. His drawings and paintings, again, are the clearest illustration of this. For forty years he has been annotating his own work, like a historian. Picasso lives and moves within himself.

Nine years ago he took this house in Mougins, halfway between Cannes and Grasse. It is a simple, roomy country house, a place to work—nothing else matters to him any more, nor did it ever. Far into the night, until two in the morning often, he paints, draws, engraves. The house is visible from the narrow road that winds along the foot of the hill towards Mougins. Its windows face south; the wide arches on the ground and first floors, the small windows above them, and the blocky loggia, all seem hewn out of the black wall of cypresses that shoots up behind the house. A sea of greyish silver trembles up the slope below it—an olive grove. Above the cypresses, far up near the crown of the hill, is a seventeenth-century hermitage called Notre-Dame-de-Vie. These words Picasso often lovingly inscribes on the paintings created in his refuge.

From the house, an overwhelming panorama of the Bay of Cannes and the red cliffs of the Estérel unfolds. Picasso takes this Mediterranean splendor, this

landscape with its heavy, sculptural accents, for granted. It has no moods, he says, just good or bad weather. And it reminds him of the countryside he grew up in, at Malaga. It is odd to think how small a part landscape plays in his work. Gertrude Stein decades ago based her interpretation of Picasso on this very Spanish indifference to nature, a mere backdrop for life.

Picasso is either a city-dweller or a coast dweller, living at land's end, and nothing in between. Before his move to Mougins he lived at a place that bore this out, in Vauvenargues, that imposing chateau with its view of Mont Sainte-Victoire. Picasso could not tolerate this super-scenery of Cézanne's for very long, but there landscape did enter his paintings tentatively. His move from Vauvenargues was more in the nature of an escape. Landscape as a subject had concerned Picasso from about 1906 to 1909, when he came to grips with Cézanne to work out a free, architectonic pictorial language, a style however that did not come to full fruition until he turned to solid objects. The freedom of Cubism had to become freedom *from* something, from the familiar object, since landscape as object was too indefinite. Liberation from the appearance of a face, a guitar, a pipe could be stated with more poignancy than liberation from a landscape; somehow Cubist fragmentation when applied to that subject never quite lost an element of verisimilitude—cliffs split like crystals, textures seen under a microscope.

From a car you have a good view of Picasso's house on the hill at first, but it disappears as you come nearer. The drive leads over the flank of the hill: the first gate is reached, and opened: the road ascends steeply through a tangle of trees and underbrush. Halfway up you cross a brook and come to a second gate. The house and its extensions are visible from the side; it looks low from here because the drive is on a level with the second floor. The rooms where Picasso works are on ground level.

As I entered the house I thought of all those doorways I had stood in front of, in Paris and Barcelona—the houses that Picasso had left for good. The circumstance that this walk through the past was about to issue in a real present, seemed to qualify my *recherche* in a strange way—it is the nearness and the remoteness of the historical, I thought, that are crystallizing now as I look at this small man, bent over an ordinary living-room table, concentrating on his drawing. He has not heard me come in. The mistral is raging outside. It has set up a metallic clatter somewhere.

Picasso was drawing the head of a bearded faun, his *bocca della verità*, with a red and a blue crayon. He was drawing on a torn scrap of cardboard he had just happened to find, a piece just large enough to fill a second's break. Then he looked up, removed his glasses, and bade me welcome—with the warmth of a man who neither accepts nor rejects. At first glance you might think that Picasso had settled into the kindly complacency of age. Not until he is seated again, concentrating on his opposite, do you realize how rash this notion was. Physically he was the Picasso one had always known. Everything about him was quick, wiry. All the familiar photographs seemed to pass over his face, fading in and out in rapid succession: that of the seven-year-old boy with his sister Lola, the portraits by Man Ray, then those by Brassaï and Duncan and Quinn. Only the eyes were constants—the black irises that almost obliterate the whites, instruments that perceive and project an image seemingly in a single action.

The room was stuffed with paintings, sculptures, books, objects. Tables, couches, chairs, radiators, music stand were engulfed by an encyclopedic chaos which his friends have always said Picasso had organized down to the last detail. Organization? Michel Foucault, at the beginning of his *Les mots et les choses*, quotes an excerpt that Borges once made from a Chinese encyclopedia, a classification that turns Western conceptions of order on their head. This book divides animals into the following species: a) those which belong to the Emperor; b) mummified animals; c) tame animals; d) guinea pigs; e) mermaids; f) legendary beasts; g) wild dogs; h) animals included in the above categories; k) animals that do crazy things; l) etcetera; m) those that have just broken the milk pitcher; and n) those that from a distance look like flies.

Scattered around the room were photographs, a book by Claude Simon, an English cartoon: this Picasso pulled out with a laugh to show me. A gang had kidnapped him, and its boss was saying to a visiting tough: "We don't have to fake any more Picassos, we stole the real thing." Opposite the windows paintings had been stacked, and wire sculptures from 1928 and 1929 hung on the wall. On the stacks of paintings a few pictures from his Barcelona period had been placed such that one could see them without obstruction. One of these was *View of the Rooftops of Barcelona*, dating from 1903, a dusky blue scene Picasso painted from the window of his atelier on Calle Riera San Joan. "All of that has disappeared. They tore down the whole quarter." It would have been hard to detect any sentimentality in this statement. Next to his own painting stood two by Matisse, one of them the radically simple portrait of *Marguerite* done in 1906-7, at the time Picasso was working on his *Demoiselles d'Avignon*. Picasso does not hang his paintings, which reminded me of what he once said to Roland Penrose on the subject: "If you want to kill a painting there is no better way than to hang it up nicely on a nail. When it's cocked at an angle you see it much better."

What I came here to talk with Picasso about is a catalogue of his sculptures I am preparing for publication. He loves this kind of book because rather than a selection it will illustrate everything, major and minor, without distinction. He immediately asked me whether I planned to include the tiny heads and figures he had torn out of paper: "To me, everything is important. I don't distinguish between big jobs and little ones. The results are usually accidental anyway. Sometimes I start off with a match and end up with a monumental sculpture." We settled down to sift the material I had brought with me. Next to us on a low table, as it happened, was *Seated Woman*, his first known sculpture. The historical side of art seems to interest Picasso very little, the critical aspect, the facts, very much. Biography, anecdote, all that sort of thing he finds simply irrelevant. He pointed out to me the mistakes and inaccuracies the books about him perpetuate, saying, "That's all right, though. Leave the stories in. Good for human interest. Invent some more and let on I told them to you. They'll believe you." This shows the distinction Picasso makes between a vital personal oeuvre and a public image that has long become sacrosanct.

He wanted to know exactly what it was I liked about certain sculptures, quizzing me on the assemblages he made during the late twenties: "What did I make this out of? And this one?" Even in the case of his first sculpture, *Seated Woman*, his memory proved extremely accurate. Its date has always been

disputed; Picasso was sure he had made it in Barcelona, but was not certain in what year. I called his attention to the striking similarity it bears to *Pierreuses au bar*, a painting done in Barcelona in 1902, in which a facetted modelling reminiscent of sculpture occurs for the first time. He confirmed the simultaneity. Suddenly he recalled it all exactly, and began telling me how he modelled thousands of nativity figures as a boy, how he had always been interested in everything that involved working with the hands. By way of illustration he began sketching an invention he made shortly after his arrival in Paris: "Back then I smoked a pipe. My friends used to mix good pipe tobacco with cheap stuff. That wasn't for me, so I built myself this pipe with a twin head. I put cheap tobacco in one hole and more expensive tobacco in the other."

Picasso is even more attached to his sculptures than to his paintings. He has kept nearly all of them. They are there in a spacious, well-lighted room on the ground floor of the house—a treasure that up to a few years ago was one of the best kept artistic secrets of the century. It was not until the Paris retrospective of 1966 that Picasso agreed to part with his sculptures for a while. Next to the castings stand the originals, made of real objects with plaster-of-paris additions. They reveal clearly the methods Picasso used to put together his large assemblages—unlike the bronze castings of them, in which the joints between the various materials and the objects have been obscured.

The Cubist constructions, the sculptures in iron, the monumental heads of the Boisgeloup period, the toys he made for his children, all were on view. And there was *Woman with Baby Carriage*, and *Baboon with Young*, *Goat*, and the sketch for his huge steel sculpture for Chicago Civic Center, and the plaster model for the *Man with Lamb* that stands in the piazza at Vallauris. This last sculpture had been dismantled at the midriff; head, chest and hands holding the lamb stood on the floor next to the legs and lower body. Around it were countless ceramics and sheet-metal sculptures. Along the end walls of the room Picasso had set up plaster casts of the Michelangelo *Slaves* in the Louvre. He had brought them from Grimaldi Palace at Antibes, to which he had lent his cycle of Mediterranean paintings. Picasso's tactile responsiveness to volumes, techniques, objects was overwhelmingly evident in this room. His sculptural oeuvre is incomparable in terms of imaginative force and paradoxical combination of textures and shapes. Picasso needs the trigger, the stimulus of real objects and forms; Michelangelo's *Slaves* stand for the contrary working principle. As Picasso once said to Brassaï, he could not understand how anyone could be stimulated by a shapeless block of marble. Some of the sculptures are painted, and Picasso said, "I'd like to paint others, too—the baby carriage, the goat, the baboon." That is a wish he has often voiced.

The musical instruments, so conspicuous in the paintings and constructions of Picasso's Cubist period, have often been put down to his indifference towards his subjects, explained away as studio iconography. Some observers have even seen them as indicating an interest in music. Picasso, however, will not be lured: "Music has never interested me." I ventured to describe my theory of the "anthropomorphic instrument" to him, saying that I thought the curved body of a mandolin or guitar might well stand for the female body. This joining of two meanings in one form came at a time when Picasso was paring down his objects to rigorously simple suggestions, and he had accomodated, to my mind, the

meaning "female body" in the form of a musical instrument. Picasso liked the idea.

Even though he is not inclined to theorize about his art, Picasso does drop hints that aid interpretation. What he said to me about his famous *Glass of Absinthe* of 1914 was particularly enlightening. In this painting Picasso had mounted, on a Cubistically modelled form, a real absinthe strainer that holds an imitation lump of sugar. "What interested me was the relationship between the strainer and the form, the way they collided with each other." Here we have a fundamental definition of his realism. When I told him that one critic had seen the *Glass of Absinthe* as a face, wearing a spoon-with-sugar-lump cap, he protested vehemently: "I never intended that." The glass retains its primary meaning for him, and this seems crucial for his self-understanding as an artist, for his nominalism, for the primacy, if you will, of the physical manifestation. The actual thing itself, the subject of each painting, is a given quantity for him to the extent that it allows him to subject what is general in that form to ever greater ramification. Against the background of this realism—of the view that there is no reality that is absolute, and fixed fo all time—Picasso conducts his expansion of reality. That is why he does not like his works to be thought of as stylistic paraphrases, but as a continuation of the demiurgic process. His saying, "One must invent new inventions" seems to illustrate this. With reference to his art and his view of reality, it means that an object can pass through all stages between appearance and disappearance; but that its pictorial form remains bound to a precise reality no matter how open—in both senses of the word—it is to interpretation. Seeing the absinthe glass as a head disturbs Picasso because he had created a definite object, not an open form allowing of various designation, which would jeapordize the reality principle on which his art is based. And Picasso insists on this principle—even when he pushes the distortion of a prototype to the point of grotesque complexity, the basic, immutable elements of that prototype remain recognizable.

This spacious room also harbors the metal assemblages that Picasso constructed together with Julio Gonzalez. I mentioned that at the home of Gonzalez's daughter I had looked into an unpublished manuscript, entitled *Picasso et les cathédrales*, in which Gonzalez discussed their collaboration. Picasso's interest was immediately aroused. "I'd really like to read that," he said. It was Gonzalez who introduced Picasso to the metalworking techniques he would later return to again and again. The notion that Gonzalez influenced Picasso's style, however, does not seem tenable, and there is nothing in the manuscript to support it. Picasso had already worked out his key formal principles before his collaboration with Gonzalez. His assemblages look like a list of Don'ts for the skilled metalworker: the individual parts retain their individuality, the joints between them are rough—technical perfection of any kind has been purposefully avoided. The beauty of these pieces indeed lies in their parody of the craft, in their wilful amateurism. Picasso: "Working on these sculptures we used to laugh till our sides split. On this head I suddenly had the idea of using colanders. So I said to Gonzalez: 'Go out and buy me two colanders'." The humor and poetry of associations like this are very much Picasso's. Though Gonzalez became aware of the artistic possibilities of his craft during the collaboration, leading him to make metal sculptures himself, he always retained his penchant for technical accuracy.

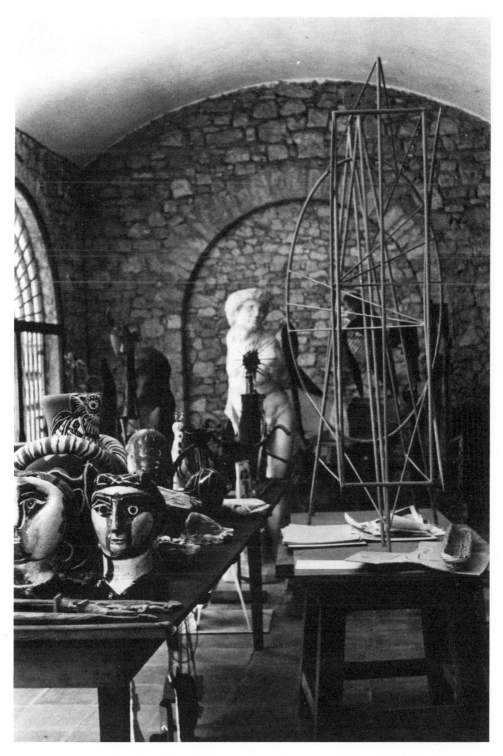

Picasso's sculpture studio. Photo by W. Spies.

Picasso: "Gonzalez asked me whether he could make objects like these himself. I encouraged him of course."

The subject of sculpture fascinates Picasso. I asked him whether he seriously contemplated, during the twenties, building the monumental sculptures for the Croisette in Cannes for which he had made sketches. Their amorphous, melting shapes could hardly have been realized, I commented. Picasso disagreed: "You can do anything." In support of this dictum he cited Gaudi, then his own work, the plaster-of-paris sculptures he made in Boisgeloup, some of which are indeed monumental. Large-scale sculpture seems to fascinate him more the older he gets. He showed me a photograph of the Chicago piece, a head twenty meters high. People climbed up on it during a demonstration once: "I like that," said Picasso, "at least it's being used for something." During the past few years Picasso has repeatedly made drawings available for monumental sculptures, for "street art." The late sheet-metal sculptures would be obvious candidates for the purpose, since they can be enlarged at any time, and Picasso could leave the execution to others.

This is something he cannot afford to do, however, in the case of those of his earlier sculptures that have not yet been cast in bronze, such as the large figure with vase that stood in front of the Spanish Republic pavillion at the 1937 Paris World's Fair. The figure, a cement casting, welcomed the visitors who had come to see *Guernica;* its hand and the vase were later broken off. Another piece destroyed during the war, the largest Picasso ever executed, awaits reassembly as well: "When I'm gone, nobody will be able to put it together." He points to the tray before him: "It's like giving tea, butter and jam to somebody who just arrived on earth without knowing what they were for. What would he do? Maybe he'd wash his feet in the tea, smear the jam on his head, and want red or blue butter instead of yellow." Isn't this new arrival Picasso is talking about none other than Picasso himself?

Mougins, 1971

THE NINETY-YEAR CENTURY *Picasso ignores his birthday—A visit to Mougins*

He'll be ninety years old on Monday. There is nothing to report but that he, Pablo Picasso, is well and that unimpeded by the burdens of age, he is working. The sadness and impotence that grip everyone at the thought of his mortality are foreign to Picasso: he himself does not brood about the wall toward which he is going. He has a job to finish, and as long as he hasn't emptied his Danaid's barrel of creativity, he seems invulnerable. Sentimentality or self-pity are not for him. The powerful work of the past two or three years rather shows—to probe its psychological content—self-mockery, autobiographical *désastres*, into which a sensual tenderness intrudes now and again.

Work is mentioned in every third sentence, but not art or painting. Shortly before his birthday he told me, smiling: "Parents should thrash their children when they start scrawling on the wall. Otherwise it could happen that they never stop." Work as constant temptation, without objective, without differentiating between masterpiece and sketchy pencil stroke: "Even today I don't know where a work will lead me. I start in a corner of the sheet, it turns into a little dog or something, and the drawing leaps ahead from page to page, from canvas to canvas."

The room in which Picasso likes to spend the afternoons after his siesta is as packed as during my first visit, but the masses seem different, as if the mounds of objects had been shifted by an underground tremor. The white dove is still there in its cage. The passageway to the adjoining room, where Picasso takes the papers and objects he wants to store with special care, is barricaded this time. At the crest of the wave of objects floats again, an early, midnight-blue view of the roofs of Barcelona, and a Matisse. Hardly anything is visible in Picasso's house— everything obscures everything else.

Thousands of drawings are buried any which way in hundreds of files. He used to paint here, but there's no room for that any longer. "I don't even have an atelier any more. I think I'll soon have to have a new one built." This is a well-known complaint. He would stuff the new one as fast as the studios he filled and locked before.

As we go through the house, the narrow white corridor that is an indispensable passage suddenly catches his attention. To the horror of his secretary, he starts planning: "We'll put shelves up here. Then I'll have room for my books." We enter the small, clean, neat room in which the secretary works. Picasso covets these few square feet, whose neatness nags at him, too. He starts rummaging around the table, discovers a tiny bit of orange-colored crayon, holds it up to me, "What nice practical things they make nowadays," and puts it into his pocket. As long as the afternoons are still warm, he works on a large flower-covered balcony upstairs, from which there is a splendid view of the shore line. His wife Jacqueline has a tiny room next to it, and the adjoining bathroom has often served for test printings of plates or linoleum cuts. Below, a few hundred meters from the sea, the highway to Cannes goes by. Picasso loves the flashing colors and movement: "In Basel I once watched the streetcars from my hotel room. I stayed at the window until it had shut down for the night. Since somebody told me that it would start again early in the morning, I didn't bother to go to bed, but stayed up for those few hours."

The gate that leads to Picasso's property in Mougins is opened less and less frequently for visitors. Occasionally it opens for Picasso himself when he goes to the dentist in Cannes, even less often to pick up a friend at the airport, and very rarely for a little excursion. A few weeks ago the access road to his house was blocked by a contractor who was building some apartment houses nearby. Picasso tells the story, still full of indignation long after the calamitous event. "Did you see the mess they made? Wait, I've got some photos." He looks for them but can't find them. What annoys him most of all is the argument used by the other side: "They claimed that I don't go out any more. That isn't true at all. Besides, friends come around. And just the idea of being locked in is intolerable."

Now, in mid-October, the gate remains closed to guests: the countdown to Picasso's ninetieth birthday has begun, it is ten days until October 25. As he has done every year, Picasso has disappeared on an imaginary trip, and is inaccessible, even to his closest friends. The telephone rings, but no one answers it. Picasso ignores his birthdays, the only milestones of his age, with ritualistic persistence. During my last visit to Mougins he said, in part amused, in part complaining: "They're preparing for my hundredth birthday." Picasso seems not to want to disappoint them, like Goya, who enjoyed remarking that Titian lived to be ninety-nine. "Everyone is interested in my birthday," Picasso continues, "except me. Yesterday I got a letter from a high government official about it. But why should I receive an official just because it's my birthday? I have my work; nobody else can do it for me."

Nevertheless Picasso has not lost touch with the world. Friends, politics, social events, even the miscellany on the last page of the newspaper all turn up in his conversation. "Did you see that film about the Surrealists, about Breton and Max Ernst, on television? It was really good." Otherwise he complains about television, saying it makes people stupid. News, political programs he likes to watch, and of course the wrestling matches, his armchair bullfights. If someone neglects to tell him about a match, he is very annoyed. Fights are serious things to him, not to be taken lightly. They remind him of the sideshows in Barcelona from which he took his first motifs.

He begins to study his world in the morning, in bed. "I often work late at night. Sometimes they wake me at eleven in the morning with tea and bread." In bed he reads the papers, looks through the mass of mail that the postman drags up, scans catalogues and prints, reads in French, in Spanish. He stopped answering letters years ago, and makes no exception. Poetry has a preeminent place in his reading, especially that of his friends Guillaume Apollinaire, Max Jacob, and Paul Eluard. He quotes them. Occasionally he sings one of the songs for which Apollinaire or Jacob wrote the texts. Or he hums a few bars from *Petrushka* in recollection of the days with Diaghilev and Stravinsky. Again and again he comes back to Apollinaire: "Do you remember *Le Poète assassiné?* The memorial that they wanted to put up in Croniamantal? Not even a statue. Just a cement-lined hole in the ground, filled with earth. That's what I'd like."

He gives himself the conversation without reserve. No irony; whatever he does, he does with passion. No words are more idiotic than the statement put into Picasso's mouth by Giovanni Papini in an imaginary interview in the fifties about his being a cynical intellectual clown; few things incensed Picasso as much as that characterization. His gestures are so powerful, so vital to his utterance, that that is perhaps why nearly all the printed, smoothly constructed conversation with him seem synthetic. Leaps of disjointed thought prevail. Picasso always underlines his words visually. The innumerable objects, papers, photos strewn around him serve, like masks or props, to elucidate his words.

The visual occasionally takes over the role of oral. "Those who write about me do not command the words that I invent when I paint." It is almost as if the many thousands of objects and sketches that he has made and that peer out everywhere, were relics of the spoken, a materialized speech, elements of a Picasso dictionary, words become things. Everywhere there are signs of his tactile language. When he talks his fingers touch everything, want to track down the

resistance and the transformability of the objects around him. The aluminum caps of the mineral water bottles that he opens at meals immediately turn, in his hands, into tiny figures come to life.

Everything has importance for Picasso, and that is why he passionately hoards works, objects, thousands of presents and souvenirs from all over the world. His entire life surrounds him: his clothes, papers, relics, packed away in crates, filling entire houses. He has kept his sculptures, with very few exceptions. When I bring him the catalogue of his sculptures, which I put together with his help, he studies it long, seriously, with surprise. He sums up his excitement in one great sentence: "This is like discovering an unknown civilization." It's as if the man who set out to learn fear shuddered, first, at his own loneliness.

Mougins, 1971

THE PAINTER OF THE CENTURY IS DEAD
Pablo Picasso 1881–1973

Picasso is dead. Could our times ever produce another? Can you imagine someone else, at some future date, once more so radically usurping his field for decades on end? He was a cult figure no one could depose. Sociologically this man was a discouraging collection of superlatives in genius, fame, physical presence, luck. His name can stand alongside those few who brand an era for good or evil. He could have guided this century's art, which he made possible, in any direction he chose. Only a lack of frivolity prevented him from playing the seducer, a role offered him from a thousand sides. After Cubism, after the brilliance of the early twenties, he could easily have reinstated academic perfection as the norm. Instead he allowed, almost charitably, both possibilities to coexist in his work: a great classicism which in skill rivals Dürer, Titian, Ingres, and a distortion that has no precursor.

Picasso in another profession? It is interesting to imagine what might have become of him. He himself once said probably a small-time crook. From the narrow road that leads from the Cannes freeway exit to Grasse, you could see, far into the night, the light at the top of the hill where Picasso, *urbi et orbi*, was at work on his faun's heads, his studio scenes, his erotic puppet plays. In the last decade, painting and drawing had increasingly become a trick to tilt the hourglass, to make each grain of sand fall singly into time past. With his crayons, paints, pictures, crammed houses, with his mania not to throw anything away, he wove himself a cocoon, built himself an iron lung.

This diminutive athlete, on whose left cheek a black age spot blossomed as a third, Cyclopian eye, right up to the end confronted death with the only truth, that of work. Eager friends had been gathered around this Volpone for decades; most of them Picasso left behind. The sea in which the nonagenarian swam was finally very lonely: he was the last survivor of his own deluge—*Götterdämmerung?*

The myth is too vast, too uncanny to be exorcised by even the most grandiose of funerals. This is not the mere death of an artist, a Cézanne, a Matisse, this is the beginning of the laborious death of an era. The myth will continue to grow at first—Flying Dutchman, Eternal Picasso. For many, however, his death will remove an oppressive nightmare: even small talents will breathe easier again. Quite predictably, once the mourning period is over, there will be all sorts of attempts to qualify Picasso's fame, his deeds, to downgrade some aspects of his work. But nobody will be able to eradicate this man's conquests. In fact, no one can guarantee that Picasso won't land again after a hundred days, to spoil the reactionary victors' celebrations.

What exactly is this fame of Picasso's? It is not the richness of his work that discomfited the general mind, but rather the feeling that he attempted too much. And it all came so quickly, in abbreviation as it were: instead of Dürer's rabbits, he pulled a woman's head, with noses, eyes, mouths turned in all directions, out of a top hat. That at least is how the world sees it. The incomprehensibility (impudence to some, genius to others, necessity to all) that everyone keeps trying to explain is something the century cannot escape. The sheer size of his oeuvre shows that Picasso's distortions were not a problem of depictability but an autonomous, willed act of creation.

At a conservative estimate, Picasso left around ten thousand pictures, the majority of them drawings; two thousand prints, of which approximately one hundred and fifty thousand are in circulation; some seven hundred sculptures; and a lot of ceramics, a few poems and plays—but, aside from a few reliable statements noted by Daniel-Henry Kahnweiler or Brassaï, no formal theory of art, no doctrine, no instructions for use.

His life, which corresponds physically to the scope of his oeuvre, began on October 25, 1881, in Malaga. The uncanny precociousness evidenced by the hundreds, no thousands of drawings and pictures in the Picasso museum at Barcelona, guaranteed that Picasso could matter as a painter even in the nineteenth century. In his large canvas, *Knowledge and Brotherly Love*, which got an honorable mention at the national art exhibition of 1897 in Madrid, the despairing, sentimental themes of the coming midnight-blue Barcelona pictures were still set off by hope. The treatment shows academic balance in form and content, and a direct connection between suffering and helping.

As in the young Goya, religious themes appeared in Picasso's work, too. But they were quickly secularized, reduced to their psychological substance. What remained were the manifestations of urban misery—Barcelona with its prostitutes and pimps, drunkards and cripples, the blind and the hungry. Picasso did not concern himself with the seamy side of life for aesthetic reasons alone. Granted, this disillusioned world drew the Spaniard more strongly than the canon of goodness and beauty. Picasso depicted the marginal with a fascination that borders on neurosis. After his trip to Paris in 1900, ringing in the Picasso century, this melancholia gradually diminished. A few works turn up in which the withered, limping, blind, maimed shapes are still recognizably images of human suffering, but in most disfiguration, injury, invalidism have already become pretexts. Physical abnormalities allowed Picasso to arrive at totally new interrelationships of form. In this early phase Picasso needed the natural, anatomically possible malformity in order to create the pictorial distortions that interested him

Daniel-Henry Kahnweiler. Lithograph by Picasso.

for their own sake. Not until a few years later would he free himself from logically explainable deformity to treat the human body as an inventory of forms and structures to be drawn on at will. In the Cubist period he would interpolate every theme, figurative and otherwise, in this way.

The two or three years before *Demoiselles d'Avignon*, with which Picasso constructed a kind of flying machine, the modern, show a withdrawal from the narrative, the psychological. The gestures and expressions of his figures became free of judgment; and objective painting attained to the necessary degree of indifference needed to provide the basis of Cubism. Maurice Raynal wrote in 1921 about Picasso's library, in which Sherlock Holmes and Buffalo Bill stood side by side with Diderot, Rousseau, Verlaine, Rimbaud, Mallarmé: "It is remarkable that there was not a single psychological or naturalistic novel among his books." This is an important piece of information when one remembers that the Impressionists were saturated with such literature. When we compare Picasso's iconographic reduction with Kandinsky's attempt to create a nonobjective world, a great difference becomes apparent: while Picasso transformed academic tradition so radically that only structural reminders were left, Kandinsky distilled the amorphous landscape painting of the nineteenth century so strongly that nothing but its lyrical mood remained.

The break that Picasso made was more universal—with Cubism he created a pictorial language that not only superseded one historic strain but reinterpreted the amorphous as well as the geometric, figure as well as object. Kandinsky's achievement appears by comparison limited. It was less revolutionary than we long wished to assume, simply because it continued the natural inclination of landscape painting, which has always preferred suggestion to outright statement. Picasso almost never concerned himself with landscape. He was always out for lucidity of form. The possibilities of landscape painting as an incredibly flexible source for an art that rejects normal representation never attracted him. Nature was always too informal for him, contained too little of its own codex against which an artist could objectively measure his intervention. Realizing that a work of art exists only against the background of a world that it either depicts or modifies, Picasso turned, with Cubism, to a primary, even banal concreteness. Instead of a nonrepresentational art, he invented an antirepresentational one, a virtual, lucid antiworld.

The possible, that tie to objective existence, also separates him from Surrealism, to which he remained immune, a few echoes notwithstanding. In the mid-twenties, when the Paris Surrealists reacted against the neoclassicism that was on the rise everywhere after World War I, even Picasso changed his Cubist, geometric style. For the first time movement appeared in his work. In the famous program-painting, *The Dance*, Picasso introduced movement-inducing abstract shapes: wavy lines, circles, breaks, turns, curves. Yet quite as important as this conceptual suggestion of dynamics (which is in strong contrast to the empiricism of movement of the Futurists) is the new brand of distortion heralded in this painting. What in the early Cubist works was geometric has become organic and plastic. The term metamorphosis, often used to describe the new technique, is not quite correct since actually the content remains strictly identical to itself. The essence of this distortion only becomes comprehensible in all its implications

when one realizes that behind the change the semantic message (head, breast, legs) remains untouched.

It has quite often been said that Picasso had concocted his world of shapes by the thirties at the latest, and had not added anything of consequence since. Steady development however, except during a few short preCubist and Cubist years, has never been his forte. All criteria of artisic judgment that are calibrated on rational, step-by-step development fail in his case. Picasso, refusing to acknowledge chronological and spatial division, has always and solely referred back to himself. He has tolerated no period-making, no personal history: only talent. Every experiment, every mania that came into his head was realized. This is where he differs from most artists of this century who, although they are agnostics as far as a binding canon goes, stretch their inventions, with a rationally efficient thrift, to cover a life.

Paris, 1973

THE REVOLUTION OF FORMS *Georges Braque*

In 1973, the tenth anniversary of Georges Braque's death was commemorated in Paris by a number of group shows that recapitulated Cubism and Futurism. The Braque retrospective at the Orangerie of the Tuileries, however, stood out, even for an old hand, as a learning experience. After the chaotic kaleidoscope of the Cubist shows, the sight of one of the true pioneers of the movement seemed like a return to its substance.

The Cubist exhibition at the Musée d'Art Moderne de la Ville de Paris consisted of a fairly arbitrary assemblage of works that, in one way or another, made use of the Cubist formal approach. Once more the followers, who since 1910 had fed on the morphology of Braque's and Picasso's pictures, benefited from the literal meaning of the term Cubism—surely one of the most nominalistic christenings in the history of modern art. One begins to wonder whether the countless "Cubist" transformations of banal motifs would ever have taken place without this superficial tag. Louis Vauxcelles's epithet, polemical in intent and the result of a shallow view, in fact describes only one, early aspect of Braque's and Picasso's work.

If Apollinaire, or Raynal or Kahnweiler, who were the first to recognize the conceptual approach of these paintings, could have imposed their terms, twentieth-century art might well have taken a different course. This was borne out by the 1971 exhibition of Cubist art at the Metropolitan Museum of Art in New York. In spite of the fact that the catalogue, edited by Douglas Cooper, dismissed Cubism as a period idiom and tied it to the four "major Cubists" Picasso, Braque, Gris and Léger, the exhibition itself clearly demonstrated the continuity of this intellectual, crystalline style (as opposed, say, to the mystical

abstraction of a Kandinsky). Cubist withdrawal from the object per se to the idea of the object, certainly had much stronger consequences than the work of such literally minded Cubists as Metzinger and Gleizes, La Fresnaye, Lipchitz, Marchan, or Férat or Kubista or Gutfreund—"minor Cubist painters," according to the New York catalogue. In this context Delaunay and Boccioni, Malevich and Mondrian appeared more truly "Cubist" than the orthodox, literal interpretation of the work might suggest.

Picasso and/or Braque, the Masaccio-Masolino dilemma of the twentieth century, has lost none of its fascinating difficulty. Art historians, having once put down the encounter between Spaniard and Frenchman to the workings of natural law, continue to see it as a meeting of extremes that kept each other in check. That however solves no puzzles. How could an individualist like Picasso, who had no bent for groups either before Braque or after, lock himself into artistic monogamy for years? One thing is clear—the commitment was mutual. Braque was much more than a mere associate. The obligations Picasso assumed towards him were too central—the invention of *papier collé*, the turn away from figurative painting and toward still life and landscape, these obviously were on Braque's account. And we are dealing here not with trivia but with fundamentals.

The encounter between Braque and Picasso ought to be viewed, I think, at least in its first stages, as a collision between two antithetical approaches to art rather than as a meeting of two complementary minds. Braque, before Picasso, can be described with one observation: the room of Fauvist paintings at the Paris exhibition shows Braque in the thrall of a group style. Soon after, the two greatest proponents of that style, Matisse and Braque, would liberate themselves from it. If Picasso's development cannot be described so succinctly, it is because he did not come out of such an obviously modern context. The paintings of the blue and pink periods, done during the first years of this, are the final great pictures of the last century. His development—a sort of phylogeny of the artistic practices of the time—led from Academicism through a Gauguinesque Symbolism, then via Toulouse-Lautrec and Impressionism to Cézanne. Little by little he reduced the thematic content of his work, a reduction that became, indeed, the precondition of Cubism.

Les Demoiselles d'Avignon, which almost everyone today sees as Picasso's great leap forward, is certainly a revealing painting. Yet actually it remained the exception in his work, a painting he thought of more as a challenge to further development than an end in itself. Other, equally complex figurative compositions, had he painted them, would no doubt have exploded the formal stringency of Cubism. It is hard to imagine that a realist like Picasso could have brought the same incredible compression of forces to such tableaux that he achieved in the simple, concrete still lifes of objects and musical instruments, and in single figures.

It was this very restriction to matter-of-fact, easily recognizable objects whose meaning stayed within the confines of the everyday, of studio iconography, if you will, that gave the formal revolution its power. For in these images, with whose content every viewer was intimately familiar, the conflict between significance and the signified thing ushered in by *Les Demoiselles d'Avignon*, was nearly non-existent. None of the other pictures, neither Picasso's nor Braque's, created between 1907 and 1914 during their association, faced the

viewer with such difficulties of interpretation as *Les Demoiselles d'Avignon*. In fact they did not require interpreting so much as deciphering. In the new approach to appearances these paintings heralded, priority was given to identifying what was depicted, to recognizing, in an objective difficulty of apprehension, a subjective necessity and opportunity. The existence of the visible world, its substance, remained unaltered. A new semiotics of the known came into being.

When Braque and Picasso met, *Les Demoiselles d'Avignon* had already been painted. It is tempting to explain the circumstance that this painting was now put aside, as a result of the new friendship. Braque, at any rate, now began to apply the facetting of form that characterizes certain passages of that painting to landscape subjects. Measured against *Les Demoiselles d'Avignon*, this at first glance appears to be a regression on Braque's part, as indeed so much in his early Cubist landscapes seems based on Cézanne. Of course no landscape could match the shock content of Picasso's figures: Expressionist motifs and a staggering of volumes interpretable as physical distortion become, in landscape and still life, techtonic. Witness the first Cubist landscapes that Braque returned with from Estaque.

There has been a tendency to credit much in Cubism to Braque's temperament, especially the logical consistency with which he proceeded from one plateau to the next, the manner, almost teleological, in which he coupled the phases of his work. He himself once said, "Luckily I was slow on the uptake." By comparison Picasso was vehement, restless; yet one should not lose sight of the fact that Picasso as well, judging by the blue and pink periods, was quite capable of continuous development. His quicker, experimental approach might well have suggested certain shortcuts to Braque. Braque made some 120 Cubist paintings between 1907 and 1914; Picasso's numbered in the thousands.

The much-touted unanimity of Picasso and Braque, those partners in painting (Picasso once described his confrère as "the woman who loved me most") naturally had its rocky moments, as the big exhibition makes clear. Their differences as painters are perhaps best described in terms of Analytic and Synthetic Cubism. Even in the analytic phase, in which the dissociation of pictorial elements was very marked, Picasso generally tied things together with his "primal lines." Braque by contrast tended to structure his work—see *Violon et palette* of 1909–10 in the Guggenheim—by juxtaposing richly contrasting single forms. *Piano et mandore* (1909–10, also Guggenheim) shows an apposition of single forms in a large format that would have been unthinkable for Picasso, who, as we see in his *Nude* of 1910 for instance, set up a far more dynamic interplay of forces. A picture so concrete and clear, so distinct in its units as *Port en Normandie* (1909, Art Institute, Chicago) would no longer have been possible for Picasso at that time. Perhaps here, again, we see Braque turning his inability to build an image of opposing forces, like Picasso, to a skillful evocation of tension between diverse objects.

The road from early to Analytic and Synthetic Cubism is one of systematic, step-by-step lessening of imitation. Objects were pared down to their essentials, divested of accidental appearance—no longer definitely located in space by the laws of perspective, their strong local colors given in general illumination from a localized light source. Painters attempted to give a coded representation of the

object, fully grasped ontologically and cleansed of all subsidiary characteristics. A theory of the apperception of existence began to be formulated. In 1912 facsimiles turned up in the works of Picasso and Braque; then, in the latter's *Fruit Dish and Glass,* an actual bit of wallpaper—the first *papier collé.* These citations from reality helped make the compositions more legible again.

At the onset of World War I Braque was inducted into the army, bringing his collaboration with Picasso to an end. If war had not intervened their symbiosis may have continued. Yet by 1914 Picasso was already doing work that no longer showed any sign of a common approach. His linearity, always absent in Braque, became more pronounced, until the conclusions that each drew from Cubism radically diverged. They still moved in parallel thematically, however, up to the early 1920s: Braque too used classical motifs, canephors. Yet even this connection could just as well be ascribed to the general turn to Classicism and verism we see at that period. Cubist stringency was a thing of the past—there were only more or less direct reversions to the style, and revival after revival. Braque's central theme remained the still life. Only occasionally did his fascination with the Picasso of the grand distortions reappear. *Recumbent Woman* (1930, finished 1952, Maeght Collection, Paris) and *The Duet* (1937, Musée National d'Art Moderne, Paris) were two attempts to adapt Picasso's studio paintings to his oeuvre; and strangely enough, the liberties he took with the figurative canon look much more like deformations than do Picasso's radical cuttings-up and piecings-together. They seem to cleave apprehensively to correctness.

Braque, in a word, allowed himself liberties only a Picasso could afford. He remained basically a Cubist, while Picasso kept redefining, of and for himself, the conceptual possibilities revealed by Cubism. Nowhere in Picasso's work do we gain the impression, as happens with Braque, that he is experimenting in an attempt to find a way out.

The present exhibition concentrates on the late work, a result of the organizers' aim to mount a retrospective in which the proportions were right. The sculpture, at least, was omitted. Nothing followed Braque's Cubist period that would bear showing side by side with it. The watershed was the mid-twenties, when Braque managed to create his most personal works, a series of reserved compositions, muted in color, dry as frescoes. Then came the often fatal swing to *peinture,* to color schemes spelled out within a representationalism that had lost all significance. The fuzzy conclusions that a mass of painters drew from Cubism, Braque did not escape. Whatever may be said for him, he was not able, like Matisse or Léger, to get his second wind. Not even the late *Ateliers* and *Birds,* with their simplified palette and more muted color coordination, can make one forget the fact that Georges Braque, splendid and irreplacable as he was in his great heyday, afterwards had to carry off as best he could the role of the century's greatest number two painter.

Paris, 1973

JUAN GRIS OR THE PATH THROUGH THE PRISM

It took a long time before Juan Gris was honored by a retrospective in France. Not until now has this member of the Cubist group been considered in his own right, as a great and separate nature. A few months after the Braque exhibit Gris triumphantly entered the Orangerie with one hundred and seventy paintings, drawings and prints, the largest exhibition of his work ever. Gris was the shortest-lived of the Cubists, but unlike Picasso and Braque he came to the movement with a fully developed style. He became a Cubist simply by opting for Cubism; before that he had been an illustrator.

José Victoriano Gonzales, later Juan Gris, moved from Madrid to Paris in 1906, taking a room at Bateau Lavoir, that rundown studio building of shining legend, where Picasso and Max Jacob were living. This was Juan Gris's first important decision. He moved in next door to Picasso and Braque not to become a Cubist by mimicry but—and there is evidence for this—because he recognized in their disciplined new art an approach very congenial to his own.

IMAGE WITH BROKEN MIRROR True, the illustrations he did shortly after his arrival in Paris for magazines like *L'Assiette au Beurre, Le Charivari, Le Témoin* and *Le Cri de Paris*, had nothing in common with the paintings he now began. If not these caricatures, then certainly the illustrations he did for José Santos Chocano's *Alma America* (1906)—rarely seen drawings that are sadly not on show here either—witness to a predisposition to Cubist structure. I shall come back to them later in connection with Gris's work of the twenties, which many still find problematical and some even scorn. It seemed important to mention these drawings here because they show that Gris, before abruptly turning against all commissioned work, chose to execute the few designs he did on his own in a representational style whose still-life character presages the later work. And this is true not only in the iconographical sense, but formally, in terms of composition.

The first great change, however, was the complete disappearance from his work of the *linea serpentinata* of Art Nouveau. Gris began with the Analytic Cubism of his neighbors, the split and facetted integument of things. Yet somehow the first paintings he did in Montmartre in 1911, compared to Picasso's or Braque's standard at the time, look strikingly, even purposefully regressive— Gris chose to go back to the point at which both had started, namely to Cézanne. In other words Gris did not simply adopt an available formula, which fact distinguishes him fundamentally, and intellectually, from the "minor" Cubists who took up that style because—well, for the same reasons a previous generation of lesser talents went Impressionist. That is why one finds it hard to countenance a Juan Gris exhibition to which such splendid early pictures as his still life of *Eggs* (now in Stuttgart) or his *Bottle and Glass* (at Otterlo) do not provide the overture.

The sensible interpenetration of bottle and tablecloth, of bottle and wallpaper, that fascinating liaison between three-dimensional shapes and flat background, is the clearest aim of Gris's work up till the early twenties. It led him to take up, at an early date, an "equestrian perspective," that high point of vantage that

enabled him to pull table and objects together into a whole. This viewpoint also contributed to an alienation of the subject matter itself, an alienation he pushed furthest in paintings like *Violin and Glass* (Musée National d'Art Moderne, Paris) and *Still Life with Guitar* (Gelman Collection, Mexico). In these the artist seems almost to have been suspended in midair above the motif spread out like a map below him, and to have added to his cartographer's image the knowledge of what he has seen from other points of view. Only one year after the still life *Eggs*, Gris painted such pictures as *Bottles and Knives* (Otterlo) and the fine still life of New York's Museum of Modern Art—works that achieve a rigorously controlled facetting not encountered anywhere in the paintings of Picasso and Braque. They are like the tables of the law. In them we have Gris's equivalent to the hermetic phase of Cubism.

It is instructive to compare such works to *Portuguese* by Braque (1911) and *Ma Jolie* by Picasso (1911–12). Nowhere does Gris dissociate color and line—the painting is linear, the line painterly. The lightest plane abuts the darkest, and each propels the other forward. The nearly monochrome color scale enhances this effect. Picasso's "primal lines," that graphic network that holds a pulsating painterly surface in check, ties it together and designates the subject, appears in Gris as a smooth, prismatic polish of the paint surface itself. Gris can manage without this rigging with the bits of surface lashed to it like sails. The lengths to which he was prepared to go to counter free fragmentation with one that professed to optical probability is shown by *Le Lavabo* (Paris, private collection), a painting into which he pasted not only pieces of paper but shards of mirror. The laws of optics, reflection and refraction, are demonstrated by the image itself.

The mirror, as a possible reference to a world of appearances passed through a prism, is even more significant in a way than the use of collage elements in Picasso's and Braque's work of the same period. In Spring 1912 Umberto Boccioni, in the *Technical Manifesto of Futurist Sculpture*, had demanded a modernized sculptural arsenal which would include glass, cardboard, iron, cement, hair, leather, cloth, mirrors and electric light. Almost simultaneously Picasso and Braque had begun to incorporate elements of the extant world into their paintings and drawings, replacing illusionistically rendered newspaper pages or wood grain with the real thing. With his fragments of mirror, however, Gris brought into play a brand of reality that can neither be depicted nor imitated. Gris, of course, had never been interested in painting mirror images or reflections, a *trompe l'oeil* quite common in art. His shards of mirror in their mosaic-like arrangement clearly have a conceptual meaning, the recognition of which takes us beyond the compositional intent of this program-picture. The reassembled mirror—a prism with its bases and sides spread out on one plane—is one of the tools of Gris's art, an intellectual tool rather than a practical one.

As far as we know, Gris never resorted to optical devices as aids to painting. Nor can his pictures be de-distorted by any optical subterfuge, since he demonstrated in them formal alliances that raised the extant world to a transoptical experience. He achieved this expansion not through iconographic complexity but by making an imaginative challenge to perception. For Gris, as for Picasso and Braque, recognizable everyday objects remained the iconographic measure. Our foreknowledge of the object, now intricately transcribed and

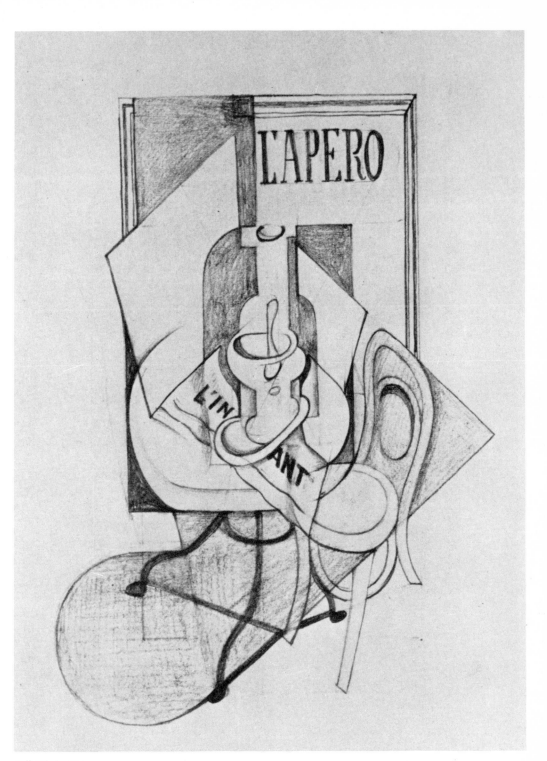

Still Life by Gris.

nonobjectively reassembled, is what enabled Cubism, building on Cézanne, to create what has been called a new hieroglyphic.

EMBLEMS OF REALITY Daniel-Henry Kahnweiler, Gris's friend and dealer to whom the Paris exhibition has been dedicated, besides referring to Neokantianism was the first to apply concepts from linguistics to Cubist painting. He recognized in it a new world, consciously altered in its symbolism out of the tension between signifier and signified. The linguistic approach has since come to strike us as more illuminating than the philosophic, or perhaps better, the historical philosophic one. Thematically, Cubism never strayed beyond the bounds of realistic art, just as Picasso, who unlike the short-lived Gris had a chance to ramify on the style, always remained a realist. As Kahnweiler pointed out, Cubism replaced symbols with emblems of actual things, casting no doubt on the stability of the visible world. Here lies the basic difference to Malevich and Mondrian, whose paintings only superficially built on Cubist morphology and whose symbolic transcendence of reality is literally worlds apart from Cubism and its linguistic brilliance.

In his writings, Gris's thought revolves continually around the question of the expressibility of things. He speaks of deductive method, the quintessence of which, for him, is that an object has to be brought into correspondence with a composition, and not the other way round. This means that Gris always began with autonomous configurations of form and color, and finished with a clear figurative suggestion. For on this point Gris tolerated no freedom, no looking inside, no reading into on the part of the observer: "When I specify pictorial relationships down to the objects they signify, I do it to prevent someone looking at the picture from doing it himself, and to keep the whole of the colored forms from suggesting a reality to him that I had not intended." This is certainly a key statement—objects are not taken apart, but those qualities of objects are fitted into an autonomous pictorial structure that are adequate to that structure. Having said this, we might infer that Gris took a spontaneous image and determined it representationally at the last moment. If that were true, the rudimentary representation would be, as it were, an emergency brake that stopped him just short of pure abstraction.

The assumption is misleading, though, since there can be no question that such pictures as *Watch and Bottle* (Jerez de la Frontera, private collection, Basel) or *Violin and Old Engraving* (Museum of Modern Art, New York) should have attained their objective significance only at the last moment. Their final meaning must have been planned in, since the range of meanings these images could encompass was limited from the outset. What we are dealing with here, as in the case of Picasso and Braque, is "studio iconography," objects like glasses and bottles, guitars and books and pipes that by virtue of their simplicity are easily identifiable and can take a deal of graphic compression or expansion without disappearing. Moreover these forms, in spite of all their differences, are so fundamentally similar as to allow them to be fit together like building blocks or printing letters. Gris's paintings and drawings of 1911 already possess the formal framework that carries within itself, as images recalled, the objects from which it derived. Each picture to follow was based on forms that even in their abstrac-

tion—to planes, cylinders, volumes, curves—could serve as frames for the objective qualities they were initially molded on.

Gris's command of means grew steadily between 1914 and 1920; significance and the signified began to rhyme in ever more complex pictorial poetry. If the frequent claim is true that Cubism was born out of protest against the hedonistic lushness of Impressionism and the seductively coiling vines of Art Nouveau, it still must be said that Cubism itself attained, with Gris at the latest, a sensuality that no Monet or Renoir can match. With such works as *Grapes* (Museum of Modern Art, New York) or the incomparable *Still Life with View of Place Ravignan* (Philadelphia) we see Gris, beyond any neoPlatonic reflection on essence and appearance (not by chance do we find the collage-quote "The True and the False" in his *The Table*), engaged in a trance-like search for beauty of a kind to be found, at that date, only in the greatest paintings of Matisse. Like a diver we sink into these pictorial depths, where each form stands separated from the next not only by outline but by an illusion as of something palpable, possessable. It is no accident that these two men felt such affinity at the time, that waves of stimulation went out from the younger, scarcely noticed Gris to Matisse. Nor is it a coincidence, one might add, that among Matisse's themes of the day was the aquarium with goldfish.

INNER WORLD AND OUTER WORLD The simplification that came to Gris's work at the onset of the twenties could be observed in Picasso and Braque as well. The stereoscopic effect was toned down, the color grew more strident. Elaborate polyphonic relationships were succeeded by generalized forms out of which the lines cut sharp, almost unbroken silhouettes. The paintings of this period have long been denied the regard they deserve. True, the *Pierrots* and the figures in general do not have the tension that distinguishes the still lifes; perhaps because it is not possible within such a complex form as the figure, which eludes objectification, to set up correspondences that use object-character only as a belated means of orientation. Compared with Picasso, the figure appeared very late in Gris's work, barring the few early portraits. Nor did it play the style-generating role with Gris that it did for Picasso.

In the paintings, drawings and book illustrations of the twenties, the angular crystalline form and translucent color underwent a change. The forms became softer and began to overlap like pieces of fabric. This is where the illustrations Gris made for *Alma America* in 1906 come in again: in place of intersecting, diverse viewpoints we find Gris using flat transpositions that recall the modelled planes of Art Nouveau. From then on, barriers between the styles began to fall. In the twenties Gris not only reverted to his early illustrations but also, occasionally, even to the colors of Art Nouveau, to its typical violets and faded greens. He took up new subjects, such as the figurative themes mentioned above, and still lifes placed before a landscape backdrop. In paintings like *View of the Bay* he again staged a magnificent confrontation between inner world (the studio) and outer world (the landscape) like that of *Still Life with View of Place Ravignan*, where the joyous color of a new and carefully ordered world stood opposed to the nebulous blue realm outside. In these still-lifes-with-landscape of the twenties, Gris brought about an intermingling of the two realms to a world of

unreality, even surreality—if one were to push that certain small white cloud only slightly further into the room, one would have purest Magritte.

Paris, 1974

WORK AND CELEBRATION *A resume of Fernand Léger's work*

After a number of very large Léger exhibitions, we now have the largest. Except for two major works, *Nus dans la forêt* (1909–10) and *Le Grand déjeuner* (1921), everything of importance has been brought together. His post-mortem production which, thanks to the generosity of his widow Nadja, flourished in the shape of tapestries, prints, and bronzes, has likewise and, luckily, been excluded. Three hundred and fifty-three Légers now hang in the Grand Palais in Paris, not far from the halls in which Francis Bacon's paintings roar in chorus.

Both are oeuvres with a commitment to representationalism, although it is a representationalism strongly tempered by its opposite: Léger's by the abstraction of Delaunay and the Constructivists, and Bacon's by action painting. Worlds more divergent than those of Léger and Bacon could not be housed under one roof. Bacon's pathetic solipsism is opposed by Léger's pathetic lack of psychology. Both work in a large format. Léger stretched his *Composition aux deux perroquets* (1935–39) to a monumental canvas thirteen feet high and fourteen wide; and one composition, *Pienture decorative*, was enlarged in 1951 by collaborators at the studio to fifty-three by twenty-eight feet for the Milan Triennale. The extent to which Léger succeeded in achieving new pictorial effects independent of image size, especially after his return from the United States (where he spent the war years), is made undeniably clear by the Paris exhibition. His last creative years can be grouped almost systemmatically around a very few themes. The sixty-four sketches and variations of two of the most important ones (after *Partie de campagne*), *Les constructeurs* (1950–51) and *La Grande parade* (1943–54) themselves fill a great hall.

There they hang, these credos of a moral-aesthetic Utopia, pictures with which Léger hoped to break away from the museum and collector's art of his time. Like no other artist of his generation, Léger asked what the lip service given to "art for the people" really meant. He carved himself a path between the hermetic compositions the Russian Constructivists dedicated to the people, and the paternalistic offerings that, cleverly endowing the masses with aesthetic literacy, superimposed a popular image on the tired bourgeois pictorial world of the academy. Thus Léger seems to be the only major modern artist to strive for a recognizable synthesis beyond both self-perpetuating aesthetic and the Dadaists' ironic wrestle with the world of objects and work. As the exhibition showed, all this took place without any attempt to sell himself short or to curry favor with anyone. The only thing that might seem calculated was Léger's enrollment in

the Communist Party in 1945, thus giving his pictures a formal guarantee that the Party only grudgingly seconded.

One really ought to consider Léger's development in retrospect, beginning at the end, with *Les Constructeurs* or *La Grande parade,* and try to define its mixture of comprehensibility and aspiration. The themes of work and celebration are comprehensible. As fas as Léger's subjects go, there is nothing to interpret. The simple, very logical tie between theme (scaffolding) and formal interest (Constructivism) is likewise comprehensible. Léger turns the themes of Lissitsky, Moholy-Nagy or, as far as color is concerned, the late Mondrian (in *Les Constructeurs*), into a situation that can be objectively experienced. We are on hand to watch the concrete blocks of Constructivism being, so to speak, toted away from the edifice by the workers. That is surely one of Léger's most ingenious and intelligent achievements: the demands made on contemporary painting, pursued unconditionally by Léger during decades of development are suddenly, with a masterly ruse, made by the pictorial reality itself. The raison d'etre of the image, clear not only to the connoisseur but to any manual laborer, is symbolized on two levels: this icon of the modern age signifies the comprehensibility of the modern working world and beyond that, by quoting analogous Constructivist forms, it proclaims the no longer superficial realism of twentieth century painting to be a necessity.

The second picture cycle too, which in 1954 led to (now the Guggenheim Museum's) *Grand parade,* also tried to keep midway between comprehensibility and complexity. As in *Les Constructeurs* and indeed most in all of Léger's work, the people are presented strictly frontally. Thus perspective effects are dispensed with from the start. Wherever space does not permit the figures to be placed next to one another, they are simply stacked vertically. Léger had already used this trick to balance the pictorial space in *Composition aux deux perroquets,* using human figures to build a pictorial continuum. In *La Grande parade,* drawing and color areas remain separate. Actually Léger always used color autonomously. Ever since his friendship with Delaunay, with whom he had occasionally shared a studio, he had used color as an independent element of composition, in opposition to Picasso's and Braque's anti-coloristic Cubism.

Color is often used for its contrasting effect. Léger got an empirical explanation for this during his stay in New York. The spotlights in Times Square impressed him: "You're standing there talking to someone and suddenly he turns blue. Then the color fades, another one comes on, and he's yellow. The color of these spotlights is free: it is in space. I'd like to do the same with my pictures." And in *La Grande parade* the color of spotlights seems to project onto the pictorial stage. Red, blue, yellow, orange, green turn up without gradations, superimpose another composition on the black-contoured drawing. Again Léger has appropriated a preclassical technique: the rejection of perspective is supplemented by the effect of medieval stained-glass windows which is to dematerialize composition. Like Mondrian, Léger's color fields create tension without modulation; they are juxtapositions of pigment.

These two pictures, which thanks to numerous variations are on view in many museums, have done more to mold our image of Léger than any of the preceding work. Those who name Léger as an antecedent of Pop Art always refer to *Les Constructeurs* and *La Grande parade.* They are right, if only in a certain sense.

The bunch of keys that Léger combined with the Mona Lisa in 1930, the signal-like use of color and a consciously naive combination of figures and objects, all bring Pop to mind. But irony and persiflage, so eminently necessary to Pop for its effects, are totally absent to Léger. Where among the Pop artists does one find a man who so uncompromisingly expressed belief in the social and moral role of art.

Another point: the artists who belong to Pop come from the outside, as it were—they make Pop. If Léger were to be counted in, you would have to say he was Pop. This is where the difference arises—a Pop artist is made, not born. Only the disinterestedness with which, thanks to Marcel Duchamp, Lichtenstein, Warhol, Rosenquist pursue their activities gives rise to their works, in which every literal statement is accompanied by a tacit negation of the factual.

Léger's own encounter with Duchamp best illustrates this difference. In conversations with Dora Vallier that appeared in 1954 in the *Cahiers d'art*, Léger recalled visiting an air show with Duchamp prior to World War I. Duchamp suddenly said: "Painting is finished; who can make anything better than a propellor like this?" Léger for his part was stimulated by the confrontation with technology. It gave him his new themes. At the same time—and this should not be overlooked—the world of objects only had a relative value for him from the very beginning: "Themes have never been lacking, in the past or now. All you have to know is how to make use of the themes, to avoid imitation, making a copy. Every thing, every image, every ornament has an absolute value in itself, independently of what it is meant to represent." By way of explanation he once wrote: "I never copied a machine. I invent machine pictures the way others invent pictures of landscapes."

At first, after breaking out of the Impressionist realm, Léger was concerned—like the Picasso of the *période nègre*—with tactile, Cézannesque pictorial space. *Les Nus dans la fôret* (1910) shows, in Léger's own words, "the battle for volume" at its height. Two years later, when he was working closely with Delaunay, he tried to conduct "a battle for color" in his *La Femme en bleu*. His work clung to this twin fascination until the end of World War I. Volume and color seemed to exclude each other, and therefore appeared alternately. The early 1920s brought, with *Les Pêcheurs, Femme et nature morte*, and *Femmes dans un intérieur*, the marvelous compositions that have, in addition to strongly hued contrasts of plane, very precise plastic modeling. These are almost exclusively pictures in which figures and objects interpenetrate, in which both are equally important to the effect of formal references—heads becoming congruent with vases and balustrades.

This is how Léger succeeded in creating a pictorial continuum in which persons and objects reciprocally complement each other. And yet his figures remain standardized; they are not vehicles of expression. Unromantic, suprain-dividual, they belong to the world of objects.

In the 1930s Léger increasingly drew back from images that reflect the hardness of the world of machines. The pictorial space opened up, grew more strongly articulated, and in place of a tactile ordering of people and objects one behind the other in a shallow space, there is depth. The clouds and free forms that float around the figures create a depth that is no longer logically palpable. This is reminiscent of pictures by Picasso and Miró of the same period. The splendid *Adam and Eve* and *Composition aux deux perroquets* (both 1935–39),

and later the series of *Plongeurs*, thus acquire an effect that borders on the irrational.

Paris, 1971

THE EIFFEL TOWER IS MY FRUIT CUP *The work of Robert Delaunay*

The circus music bounced loudly out of the summer-spruced Tuileries into the exhibition: Robert Delaunay was being honored with a retrospective in France for the first time in twenty years. The festivities in the gardens around the Orangerie, in the middle of the city on the Place de la Concorde, brought a hint of the mixture of colors that Robert and his wife Sonia wanted to bring into life. Clothes, furniture, book jackets, posters, industrial exhibits, fancy dress balls—thanks to the elaboration of a principle of simultaneity, all of these were to call forth a single pleasant emotion as their peacock splendors reached the eye at the same time.

Robert and Sonia Delaunay were among the first artists of this century to try to stage a happy ending between men and their manufacturers. Yet whatever they attempted, clothes designs, decorations, book covers, shrunk back into art. The museum, the collector, historians, for whom priorities count, have denied the things that proudly belonged to design, to environmental decoration, the right to their self-chosen name. The tiniest painted box has become an incunabulum for tendencies in Op Art or Hard-Edge.

This is due simply to the fact that Sonia and Robert Delaunay—like most designers—lacked the opportunities to have their proposals in quantity. What is missing from these designs is banalization through general use. In addition, we now know that in 1935 Robert Delaunay was telling a Russian visitor, Kliment Redko amid the clutter of paintings in his studio, that he wanted to get away from the picture to "signal art." At the time Delaunay was working in a factory in order to make an adaptable synthetic material that could be dyed for architectural purposes. He showed his visitor multicolored, standardized building blocks that could be used to shape economical, colorful streets and cities. One must not forget the readiness of both Delaunays to let their images spread out into the environment.

THE WAY OUT OF CUBISM Delaunay's development inevitably stagnated fairly early, since the arena for this readiness was missing. What he painted between 1914 and his death in 1941 of necessity revolved around the old motifs, rang changes on a narrow series of themes which themselves had already been treated in series. Only the important commission for the wall decorations for the Paris World's Fair of 1937 managed to stimulate him once again. With a crew of fifty

painters he decorated 2500 square meters of wall in the Railroad Pavilion and the Pavilion of the Air.

In these works Delaunay used his signallike simple forms—the circle, the "endless rhythms"—as stimulating symbols for movement, distance, space. These last works—in which the unity of the person, his intentions and the Utopias revealed—lead us back to the beginning. In 1902 we find Delaunay in the workshop of the decorator Ronsin. That is where his apprenticeship began, not in an artist's studio. His dissatisfaction with an art that limited itself to painting soon turned into opposition. This is probably also the reason for the difficulty of fitting Robert Delaunay into his period. In 1912, his friend Guillaume Apollinaire created a stylistic concept which was to make "the way out of Cubism" easier for him: he spoke of the orphism of the "window paintings." Color blared into Delaunay's work as if through a megaphone. That is what at first distinguished him most clearly from the Cubists.

At the time Delaunay also accused them, especially Picasso, of painting with cobwebs—that is, gray-in-gray, underground. In other ways too Delaunay, vastly self-conscious, wanted to set himself apart from the Cubists and to keep his distance. There is one phrase of his that can most easily be interpreted: "The Eiffel Tower is my fruit cup." At first that merely sounds like a pretty bon mot. Delaunay painted or drew the Eiffel Tower thirty times. He contrasted his motif with the themes of Picasso and Braque, with their "atelier iconography." For in their Cubist language they only used what could be found in their studio, things that happened to fall into their hands. One could, with Picasso, Braque, Juan Gris, speak of an iconography of the touchable.

They rendered the palpable, what can be grasped by the hand, indeed their aim was to put defined bodies on canvas whole and undiminished. They very soon left landscape behind. Suggestions of distance, the knowledge and representation of pictorial spaces that open up one behind the next, such things no longer interested them. What did concern them was to grasp the volumes of an object and to position it in a narrow, controlled, enclosed space. Against these "display cases" of the Cubists, Delaunay set his "window pictures." His windows, he would have had it, opened out on a "new reality."

Touchable world of the Cubists—untouchable world, only to be grasped by the eyes, of Delaunay—one might thus describe the point of departure, briefly, schematically. Which is not, however, to deny the young Delaunay's infinite debt to Picasso and Braque, nor the fact that he owed to them at least the suggestion that it was time to come to grips with Cézanne. This can already be seen in the 1909 self-portrait. It reveals Delaunay's with a style that was coming to an end, with Impressionism, the late phase which involved experiments with the theory of "optical mixing"—dots of pure primary colors in close proximity that merge in the eye of the spectator.

Delaunay evidently owed his most important insights to the coarsest examples of this didactic afterglow of Impressionism. In the late work of Paul Signac, in the Matisse of *Luxe, calme et volupté*, and mainly in Henri-Edmond Cross, the juxtaposition of ever larger color dots that grew into color planes eventually finished off "optical mixing." The quantity of color in the units that impinged on one another, prevented the mutual illumination of the pigments. It was not a mixing in the eye but—and here Robert Delaunay stepped in terminologically as

well—the simultaneous perception of clearly separated single colors that mattered. And it was this strong coloration with which the Fauves came to grips. True, we find this free, color-against-color treatment in the Expressionists, in Chagall as well. But the difference which Delaunay was after lay in this: he let color planes work autonomously, as planes. By virtue of his unbroken application of single, strong colors, he arrived at a simultaneity of hues that was, in the best sense, immediately comprehensible. Yet the tone of each color remained separate and unique, those of musical instruments.

The hypothesis might be advanced that the notion of simultaneous seeing of colors was first set forth in depictions of simultaneous spatial experiences. At the beginning of Delaunay's painting cycles—no doubt influenced by those of Monet—is his view of the interior of a Gothic church, Saint-Séverin in Paris. Not pictorial architecture but architecture in the round—architectural volume expressed on a plane surface—became his problem.

NEAR AND FAR SIMULTANEOUSLY The distortion of the architectural elements reminiscent of a look through a convex lens, allowing us to see the whole at once, have often been described. Yet that is not the crux of this series of pictures. Braque had already achieved a similar effect in 1908, in his *Trees in Estaque*. There too we find trees, elements of the landscape, inscribed into oval linear structure. Delaunay's Saint-Séverin pictures lead us to another question: it concerns the type of architecture that is depicted, the interior of a Gothic church. Delaunay did not—like Picasso or Braque—proceed conceptually, he did not distort a finite, graspable object that can be taken in as a whole; rather he reconstructed an actual visual experience. The Gothic space, its engaged columns carried in an unbroken rhythm from floor to ceiling, was conceived in a simultaneity of all elements as an entity; this, on reflection, may well have been the point of departure for Delaunay's search for total representation. Naturally other experiences in Gothic buildings, the tinted light in the interiors and the abstract colored patterns it throws on walls and floors, were also important for him.

A further step in the same direction were his *Eiffel Towers*. In the Paris exhibition five of the seven large canvases that have survived—those at Basel, Essen, Düsseldorf, Chicago and New York—were brought together. The Eiffel Tower, that industrial-gothic challenge thrown down by the expiring nineteenth century, now fired Delaunay's interest. Yet as with the side aisle of Saint Séverin, he was not out to capture its best or most characteristic aspect. In endlessly varied superimpositions, interlockings, distortions, Delaunay tried to present every conceivable visual and emotional experience. He wanted to portray the tower from the inside, from close up and far away simultaneously.

The theme of modernity that Delaunay set against the still lifes and studio themes of the Cubists now comes into its own. He shared it more with the poets of the period than with the painters. Not until Dada, with Picabia and Duchamp, would visual artists come to grips with the artifacts of their time, albeit only skeptically and ironically. Apollinaire and Blaise Cendrars would elaborate on Baudelaire's fascination with the city, with its confusion of detail and faceless crowds. The banal word elbowed the literary, mechanical products took their seat alongside cultural values. The Italian Futurists empathized much more unashamedly, and illustratively, than Delaunay with this key thought of the time.

Delaunay worked with contraction and symbolic forms: Eiffel Tower, biplane approaching the tower, rugby player. It seems as if he had hesitated for an instant about whether he ought to introduce a more narrative formula to catch the simultaneity, the modernity, the ubiquitousness of life. In large-format pictures like *La Ville de Paris* (1912) he tried stacking themes one on top of the other—a view of the Seine borrowed from a self-portrait of the Douanier Rousseau (whom he admired), the Eiffel Tower, a glimpse of the city. Into these motifs he blended the Three Graces. Thus he produced a picture which encompasses a maximum of themes—but which for that very reason becomes a confused conglomerate of isolated small forms.

Evidently Delaunay, in this painting, wished to take up the challenge of his friends Henry Le Fauconnier and Albert Gleizes who, in canvases like *Abundance* and *The Soccer Players*, applied Cubist splintering of form to complicated, richly narrative themes. Though Delaunay's La Ville de Paris does stand out from these ambitious demolition sites in that it gives us some idea of the images he began with, the crucial thing, simultaneity, is completely observed by the nervous, jittery structure.

La Ville de Paris is a synthesis and an end. After it, Delaunay increasingly turned away from representationalism; he searched for a means of presenting the principle of simultaneity unmixed with realistic statement, independent of the theme of modernity and speed. In the series *Windows* (begun in 1912) he succeeded. Color was set free from the object and reacted to other color in concert. The connection he established with the artists of the *Blaue Reiter* brought an important historical anchor. Delaunay had not had the enthusiastic reception in France he received from August Macke, Franz Marc, and Paul Klee. To them he was a pioneer, his poetic calculation seeming to counterbalance Kandinsky's spontaneity.

The idea of order in Delaunay fascinated Klee, and influenced him to reflect on the fundamentals of painterly thought. It is curious that Klee in 1914 should call a picture *Homage to Picasso*—and that Delaunay should take him literally. With this title Klee gave Picasso a bow that was an ironic refutation of Delaunay's claim to sole representation, while at the same time showing that formally precise, thoroughly calculated composition could be broadened with the aid of Delaunay's corrective art of color.

Paris, 1976

DRAWN WITH SCISSORS *The late work of* Henri Matisse

If any artist of our century has produced mature works that are recognizably different from what he had done before, that playfully comment on the earlier oeuvre—then that artist is Henri Matisse. Photographs from the forties and early fifties show him engaged in a rebellion against fatigue and death. We see the

artist in his villa, Le Rêve, in Vence, in the studio at the Hotel Régina in Nice, in bed, in his easychair, with his scissors. Flowers, stars, a flurry of recurring figurations grow in his hands. Every wall, up to the ceiling, is hung with these vivid cutout picture-words that would afterwards be wedded in masterly combinations to bring up memories of the South Seas, of circus life, of bathing scenes. Physical handicap and reflection about his own work led Matisse to create a suite of *papiers découpés*, to cut-out works that often reached monumental proportions.

This world of arabesques, of luminous contrasts, appears unified, orderly. Closer examination discloses the reason for this harmony. Calculation corrects enthusiasm: Matisse sets limits to his world of forms. He uses elements that do not reflect objects too exactly. He suggests moods in his compositions rather than realities.

This late activity of Matisse's was no secret. The retrospectives usually included examples from the series, *The Wild Poppies, Polynesia, The Sea*. Louis Aragon, in his two-volume Matisse novel, contributed some important personal insights. In 1978 three American museums for the first time put together a comprehensive exhibition of *papiers découpés*. The show was seen at the National Gallery in Washington, then in Detroit, and finally in St. Louis. In conjunction with it, a detailed catalogue appeared that contains all of Matisse's works that were cut out of paper and pasted. All in all, it lists some 218 items. Among them are sketches for book jackets, posters, tapestries, chasubles, glass windows, stage sets for ballets, costumes. Eventually this working with paper replaced drawing, painting, and sculpture for Matisse. It is exciting to see how Matisse gained mastery over a new medium, how he worked himself into this initially unaccustomed procedure: repetition of form, use of positive and negative shapes—the cutouts and the paper that remains—give the compositions their unity.

Matisse and his scissors and paste—a baffling turnabout. It isn't possible to speak of Matisse without mentioning Picasso—or vice versa for that matter. Picasso labeled this interdependence "North Pole–South Pole." In the forties the history of twentieth-century art could have been fitted into two gigantic, voracious monographs. And Matisse ended up using the very thing with which the revolutionary Picasso had begun: cut-out papers assembled into compositions.

It was not Picasso who found his way to this late paraphrase of the *papiers collés*, it was Matisse. The early Matisse rejected the collage and the late Picasso abstained from it. By and large this is true. Nor can the late work, of either artist, be understood without the antagonism that always prevailed between Picasso and Matisse.

Extremes often meet, however, as they did in the case of Matisse's cutouts and Picasso's sheet-metal sculptures, which he began in 1954 with the *Sylvette* heads. Picasso made small models from paper or cardboard and let an artisan fashion them in metal. How far he was able to carry the virtuosity of this technique is shown by his work in the sculpture *Chair*, for which he cut the paper model out of a large sheet of heavy paper and folded it into a plastic configuration. It is a pity that the catalogue did not follow through these interrelationships.

These days the center of preoccupation with the late Matisse has shifted. Postwar art has appropriated a great deal from his laconic cutouts. The

possibilities inherent in combinations of simple shapes, in putting together a formal alphabet in ever different ways, of keeping one's handwriting as understated as possible, all that is now standard. Color-field painting reaches back to Matisse, as much as do painters of Hard Edge, who put separate field of color side by side. Matisse's influence on Optical Art is incalculable. He plays with interferences and mutual irradiation of color, and (like Albers) perfers a psychologically based factor of uncertainty in the perception of color to quantifiable color theories.

The very first maquettes that Matisse made in this technique for the covers of the journals *Cahiers d'art* and *Verve* cannot as yet be called works in their own right. The gummed paper was simply used as an aid. One of the earlist cutouts, *Two Dancers, Red and Black* (1937–38) shows how Matisse proceeded. Only some of the elements of which the work was composed were firmly glued into place. Others were pinned on with thumb tacks. In this manner Matisse could keep changing the arrangement of the elements, a modular system that allowed him to recapitulate very quickly a variety of formal solutions.

This work had so far not been shown. Can it already be considered an independent work or does it belong to the artist's technical experiments, like the collages for the Barnes Foundation mural, of which only photographs remain. This would be a case for saying that it was given the status of "work" only in hindsight. The knowledge of the succeeding autonomous cutouts made it the cradle of Matisse's later attempts to unite color and drawing into one operation.

But we should not too readily embrace the idea of the permutability of all forms that this work seems to put before us and that reminds us of later efforts (by Jean Tinguely, Yaacov Agam) to keep images in a state of flux. Certainly Matisse was able, thanks to these mobile forms, to see a variety of solutions quickly. However, the fact must not be overlooked that he always did choose a single definitive version, which he then fixed. This mobile system presented him with a multitude of variations. In a kind of cumulative process he could then gradually isolate the ideal solution.

The original cutouts were hardly known in the beginning. They were disseminated in the book *Jazz*, published in 1947, which contained twenty images, and had soon become a book of patterns for the generation of artists to follow.

Matisse's criticism of the proofs for *Jazz* is at first surprising. After all, he did not himself determine the coloration of the papers that he used for the collages. The procedure is revealing and characteristic of the later period: the ailing, bedridden Matisse had large sheets of heavy white paper covered with unmixed gouache colors by one of his assistants.

Evidently Matisse then thought of having prints made from these models. Therefore the sheets were now colored with Linel gouaches, which were identical to printers' ink colors. The brush strokes remain visible on these colored papers, and they lend the color surfaces an alive, irregular accent, a handwriting. And this handwriting that is not his own was deliberately taken into account by Matisse and incorporated into the original cutout—the criticism of the reproductions of *Jazz* shows this.

The contradiction disappears, however, when one looks at the history of collage. It can to a large extent be defined as a procedure that uses existing,

Matisse's atelier in Ville le Rêve, 1946. Camera Photo, Venice.

found material and integrates it into the work. The available world becomes the starting point of a structural coupling. Seen thus, Matisse's taking over, even usurping a handwriting that is not his own but his assistant's is entirely in line with collage doctrine.

By taking someone else's handwriting into his work, Matisse made it his own. Basically, he was repeating what Picasso and Braque had done forty years earlier in their *papiers collés:* instead of copying the typography of a newspaper, the grain of a strip of wood, the pattern of wallpaper, they brought the things themselves into the picture or relief. For Matisse this switch to a kind of work that was in large measure dependent on other people's collaboration must at first have been strange. How distant he'd always been from any collage art can be seen by the absence of any hint of assemblage in his sculpture.

A second characteristic of his cutouts was lost in the reproductions. And this loss is probably more important, since it concerns Matisse's own action. He himself said: "I draw with scissors." When we examine the originals we see that this "drawing"refers to an exceedingly precise technique; and it expresses itself in the sheets of paper. One can feel the cutting edges—they bring an abruptness, a dissonance into this world of arabesques and fairy hues. They mitigate the decorative.

Wherever the scissors penetrate the color-drenched paper there are warps, the white ground of the base paper comes through the cuts. The hairline cracks in the paint made by the cut contour impart to the glued surfaces something of the tactile precision that is found in silverpoint drawing or drypoint etching, in which the sharp raised burrs show up in the print.

Reproduction in another medium has too much of a leveling effect. Matisse was not satisfied with juxtaposing cut-out, clearly outlined surfaces: very often one or another form is composed of a variety of elements which, pasted over each other, were fashioned into a silhouette. The paper appears relieflike. This complication of the monochrome is not only the result of a frequently drawn-out, hesitant execution in which—like modeling in clay—mass is added or removed.

Even later—in the early fifties, long after Matisse had stunningly mastered the new technique—we see how even simple silhouettes are created synthetically. In the series of *Blue Nudes* (1952) this patching of the surface out of a great many small pieces of paper loosens the monochromism—in fact it distracts from the idea of monochrome. (Incidentally, one might think that Yves Klein's fascination with the transparency of the single color goes back to Matisse. Klein's body prints too seem to be close to Matisse's blue nudes.)

In his old age, Matisse was again drawn to arabesques. However, he saves them from artsy-craftsy platitude by sensitive modeling of the field of color. He remains a painter even as a paper monteur. Basically Matisse returns, with the means of his mature style, to the genial simplification of *The Dance* and *Music.* Here is the impetus for the contrapposto of form and surface that determines the pasted pictures. In those early monumental pictures a painterly arrangement of color fields brought life to the radically simple juxtaposition of few colors.

Matisse came late to collage. The designs for *Jazz* seem to be the first that acknowledge the qualities of the new medium. It was only the comparison between original and finished print that allowed Matisse to discover the individuality of his new works. A few years later, in 1951, he raised them to

equal footing with his paintings. This was after he had done his last sculpture and his last painting, and collage had become the only means of expression of which he was still physically capable.

It sounds plausible to say that only this technique allowed the old and ailing man to be active at all. But isn't this interpretation a little too pat? If we glance back at the work of the thirties, we see a dominant painting style that totally contradicts the simplification found in the *papiers découpés*.

At the same time one realizes how the work on the Barnes Foundation murals, with their simple planes, led Matisse to a change in style. The preliminary studies for the *Pink Nude* in Baltimore, of which there are twenty-one photos, show how the use of the pieces of paper, which were changed and moved around, influenced the structure of the painting. A new orientation is announced in the drawings of the *Themes and Variations* group—a series of outline drawings from the years 1941–42.

There is a string of statements by Matisse from this period, indicating that he had been rethinking the relationship of form to color. "I am hamstrung by some convention or other that prevents me from rendering in painting the image that floats before me. My drawing and my painting split apart. My drawing suits me because it expresses what I feel. But my painting is hemmed in by new conventions: surface, through which I must fully express myself—only localized tones without shadows, without modelling, that should work on each other to suggest light, spiritual space."

A few months after this statement Matisse started the preliminary work on *Jazz*. The flat style made its appearance, even before the new medium that forced this paring down of forms and colors had become the basic method of work.

Washington, D.C., 1978

THE GRAND ICONOCLAST *On the Centenary of Mondrian's Birth*

A hundred years ago, on March 7, Pieter Cornelis Mondriaan was born in the town of Amersfoort, near Utrecht, Holland. Like another artist nine years his junior, Pablo Ruiz Picasso, he was to chop syllables off his name, a gesture of creative reduction and independence. Three years before World War I he discovered Cubism, went to Paris, and became Piet Mondrian.

The Kunstmuseum in Bern is celebrating his secular birthday with a large retrospective taken over from the Guggenheim Museum in New York. Missing from this show, as from those held in Berlin and Paris in 1968 and 1969, are two paintings in which Mondrian suddenly, like a desperate man, denied his reductive principles—*Broadway Boogie Woogie* and *Victory Boogie Woogie;* the canvas is too thickly encrusted and the collage too fragile to travel. By way of

compensation we are given two major collages, studies for *New York City I* (1941–42) which were not shown at the Guggenheim. These at least give the visitor a notion of how Mondrian, in the last years of his life, by arranging painted strips of paper on gessoed canvas much as Matisse did in his final collages, culled viable solutions from a play of variations.

The pulsating restlessness of these late works is a far cry from the equilibrium of Mondrian's classic period. Shapes proliferate, virtually swallowing up any calm that might have arisen from formal, planar, or color relationships. The results point the way to non-relational art—or anticipate, by reintroducing the Post-Impressionist color-dot as elementary constituent, those eye-blasting patterns that the adepts of Op constructed so gleefully during the fifties and sixties.

One is almost forced to conclude that with these paintings which have more than merely a symbolic relation to the city after which they were named, Mondrian reneged on his strict rejection of the concrete case. When we turn to his writings for help, writings that add up almost to an aesthetic eschatology, we find that New York, that grand nature-denying artifice, struck Mondrian as a vision of the New Jerusalem on earth: "In the metropolis beauty is expressed in more mathematical terms; that is why it is the place where the mathematical-artistic temperament of the future will develop—the place from which the New Style must emerge." In his last paintings what we see, I think, is Mondrian's struggle to overcome, to go beyond, pure abstraction. The measure of reality that reenters his images at this point recalls those works he did just prior to 1916 or 1917, years in which he was beginning relentlessly to close in on his motifs—church facades, seascapes—with the arsenal of geometry, the flags of signifying color.

A Mondrian retrospective that leads the observer quite effortlessly along the path of abstraction, making each step seem a necessary, even logically unavoidable act, is somehow confusing, inexplicable in its linearity. For support one grasps at a Picasso, at the *oeuvre* of a Kandinsky or of Léger or Klee or Max Ernst, and realizes that there, too, logical periods occur, even periods that are deducible from what went before; yet these nevertheless remain points in a random field. Again and again their work reaches back to previous modes of expression.

This dialectic is obviously missing in Mondrian. Everything points one way, towards a principle that negates reality. The Guggenheim exhibition made this absolutely clear. It transformed Frank Lloyd Wright's spiral into a convincing approximation to Plato's hell. The path led from the top down (or from the outside in). One descended past the early naturalistic landscapes, still lifes and portraits; then past the Symbolist, Cubist, and Neoplasticist works; finally, arrived in the depths, one looked back, and there were the manifold shadows stretching back along the wall . . . Visible reality, from which the young Mondrian had once taken his cue, now lay behind him, a random accident. The leap from distilling form out of real appearances to divesting real things of every limitation appearances imposed—the idealist's leap—was taken by Mondrian in the years 1917 and 1918.

That was when the *de Stijl* group formulated the conditions for a new form that would give up individualism in favor of universal harmony. Suddenly, something that had been regarded as a process of abstraction, as a reduction to

geometrical forms and few colors, acquired a totally absolute, freely placed stroke. That's where the crucial difference with the Cubists lies. Picasso, Braque, Léger, and Gris never went in for such ideological absoluteness.

Their most important means of achieving their goal was many-sidedness, the superimposition of different visual experiences in one form. The extent to which the sensuous aspect balances the theoretical one can be seen in the fact that the Cubists preferred motifs which contained the potential for visual breaking up within themselves: glasses, bottles, mirrors, musical instruments, fans, all objects that display their own many-sided aspects.

Mondrian and his friends, however, were not satisfied to leave it at that, at a rational, sense-derived qualification of the existing world—or of visual perception either, for that matter. Rather than viewing things from many different perspectives, thus both relativizing and expanding the concept of pictorial reality without cutting off from the *real* reality that sustains it, the *de Stijl* group attempted to cage in color and line, the idea of totality itself. Mondrian is revealing on this point in his definition of *Neue Gestaltung*. He begins by assuming that every form exhibits its boundaries in what he calls a tragic manner: "If bounds no longer existed, the tragic element would disappear entirely, but so would everything else that in our eyes represents the appearance of reality."

Like that of Kandinsky or Malevich, Mondrian's development, which led him to codify without real proof certain colors and certain shapes as fundamental, cannot be separated from a leap of faith. In 1909 Mondrian joined the Netherlands Theosophical Society, a group that was heir to the Calvinist belief in the creative power of the human spirit, and to an offshoot of that belief, a denial of nature. Hans Jaffé has called particular attention to the first act of Puritan pietism in the Netherlands, the smashing of sacred images, and he sees Mondrian and the *de Stijl* movement as legitimate successors to these iconoclasts. To them, as to the Mondrian of the Neoplastic period, every image, every portrayal, which by depicting one aspect of existence must exclude others, was a slur. Whether Mondrian's fundamentalist leanings were complicated, and crucially so, by a loathing for nature that approached the neurasthenic, is a question I should like to put up for debate. At all events, Mondrian is said, as he grew old, to have invariably sat with his back to the window because the sight of trees, as of the "too much" in Sartre's *Nausea*, filled him with revulsion.

Quite early in his career Mondrian began to distill the general from typical, local motifs. His studies of trees and his landscapes, at first very much *plein air*, gradually crystallized into expressive pantheistic types (a tendency, by the way, often seen in landscape painting). Formal simplification is found in such early series as the *Dunes* and *Church Façades*, done long before Mondrian encountered the Cubist "primeval line" in Paris. *Wood near Oele* (1908) shows a first tentative concentration on form and free color that is reminiscent partly of the Fauves, partly of Munch.

Mondrian had the Dutchman's eye, trained to see landscape as invariably bounded by a low-lying, almost unbroken horizon, and gradually, as his development shows, he began to invent variation after variation on the vertical-horizontal theme. In this sense the abstraction, or better reduction, to which he subjected his native countryside retained—at least until about 1911—this realistic

base. Seeing mostly horizontals all around him, Mondrian was led to play down the rare ascending diagonal by pulling it into the vertical, making it static as a plumb-line.

This is probably also the deeper reason why Mondrian broke with van Doesburg when the latter admitted the diagonal to his formal canon—diagonals, Mondrian must have thought, remembering his struggle with abstraction, diagonals are somehow suspect, because they always seem to suggest some real object or other. A number of authors have pointed out a further interesting parallel between Mondrian's work and the Dutch countryside, where what appears natural is really artificial, having been shaped by man out of a centuries-long battle with the sea. Like some engineer reclaiming a salt tide-bank, creating, as it were, artificial land, Mondrian built his spare landscapes.

Up to about 1916 the reduction-from-natural-motifs explanation fits the facts. The subjects that took Mondrian farthest are *Pier and Ocean* and *Façade;* here, the idea of composition came into play and promptly pulled both motifs together into coherent images. These two paintings, embedded as they are in Mondrian's own, personal development, are nevertheless unthinkable without Synthetic Cubism, even to the central oval that serves to isolate one section of a continuous formal rhythm that would otherwise fill the plane. Mondrian's oval differs from that of the Cubists, of course, who used the device to defray interest from the concentrated activity in the middle of their pictures and channel energy off towards the edges. This need to play off the center does not arise in such paintings as *Pier and Ocean, Church in Domburg* or *Composition in Lines*—the criss-crossing horizontals and verticals divide the picture plane regularly, fill it evenly. The oval border merely cuts a section out of this continuum; it does not so much make a coherent image out of the painting as isolate, within the painting, one truncated segment of an overall pattern.

One is tempted to remark that this oval shape has a similar effect, visually, to standing a square canvas on edge, what Mondrian was to do much later. The image seems to project itself beyond the frame. Max Bill, who has gone into this phenomenon of the tipped-up square, says that it ". . . develops around its circumference an activity that spreads in the four horizontal and vertical directions to the wall behind it." Whatever the case, this attempt of Mondrian's to construct art of vertical and horizontal lines and forms and, like the Cubists, to divorce color from contour and let it create form in its own right—this attempt at a radically new pictorial language would probably not have succeeded if it had not been for van Doesburg and above all van der Leck.

Like Cubism, the *de Stijl* movement grew out of cooperative effort. Bart van der Leck must be credited with having worked out a severely planar style in which the only colors were the three primaries and black, white and grey; and Mondrian never denied having been influenced by him. Yet though van der Leck's paintings show a great resemblance, in morphological terms, to those of Mondrian and van Doesburg, a closer look reveals them to be abstractions from nature rather than pure abstractions.

Now, this "arts and crafts" distinction might not have been worth wasting another word on, if it were not for the written memoirs of an old friend of Mondrian's, a Mr. A.P. van den Briel, that were published shortly before his death in 1971. His words have started a debate about the flesh-and-blood content

that may well lurk behind Mondrian's divine curtains. According to Mr. van den Briel, the artist once referred to his *Composition No. 2 with Black Lines* (painted 1930, now in the Stedelijk van Abbemuseum, Eindhoven) as a portrait of himself, that is of the author of the reminiscences. Now if we call in Mondrian as a witness, the only thing we may infer with justice is that the totality which a painting expresses obviously encompasses elements of the specific. In his own words, the fact that "style in art . . . logically excludes the individual appearance of things does not mean that it negates these things themselves. Style, after all, shapes the universal—the germ of all things. Therefore it lends them a form that is closer to perfection." And ". . . all true art has emphasized the universal more than is the case, at present, in nature. So it was only a matter of time until the demand was raised that the universal be represented precisely in art."

This brand of communion with the absolute, this insistence on *a priori* laws, cannot, in Mondrian's mind, have been expected to bring forth paintings that relate developmentally to any other paintings on earth. The artistic theology that Mondrian supplied gratis with his paintings—and, by the way, which we have largely neglected to read before using, since the paintings long ago slipped smoothly into that mental niche between Cubism and Constructivism—this cosmogony, utopian as it may seem to us, was for Mondrian the real and true future. Art, he wrote, points the way to a coming existence from which the Tragic (i.e. the individual) shall have disappeared. At this point Mondrian lost touch with reality, condemned himself to being a Messiah without hands. Though he accepted the attempts that van Doesburg and other architects of *de Stijl* made to adapt Neoplastic forms and colors to architectural and decorative use, he did so only grudgingly, and he never attempted anything of the kind himself.

Mondrian's own revolutionary stand sounds by comparison a bit naive: "If only our intentions are good enough it should not prove impossible to create an earthly paradise." Van Doesburg was more sensible. He was willing to let the designers loose on *de Stijl's* forms and colors, to profane the Word of Mondrian, for, as Jean Leering writes, van Doesburg ". . . didn't give a hoot about the 'sanctity' of painting." There is no shorter way to a realization of just how isolated Mondrian was within the *de Stijl* group than to read the unfinished manifesto that van Doesburg wrote in 1926 and 1927. "Painting and Sculptural Elementarism" is an attack on the dogma of the right angle. The "Elementarism" of the title, by breaking through our innate stasis, was to call forth ". . . a new flexibility of mind accompanied by a new vision." A term that better describes what van Doesburg was after, is *peinture concrète*, which he defined, in the first 1930 number of *Art concrete*, to mean liberation from both real appearances and flights of aesthetic fancy. In this regard van Doesburg's definition of abstraction differs fundamentally from, because it goes beyond, that couched by a Kandinsky, a Malevich, or a Mondrian. To him colors and shapes on canvas were just that and no more; they had no reference to anything outside, above or beyond; the appearance of a painting was all.

It took a self-sufficient aesthetic of this kind to pave the way for a complete formal interpenetration of architecture and design and art. How important van Doesburg's appearance on the scene at the same time as the Weimar Bauhaus was, is obvious from the many testimonies we have from Bauhaus artists. Nor has

the polarization betwen Mondrian and van Doesburg, as the development of non-objective art over the past thirty years shows, lost any of its poignancy. Opposed to such representatives of idealistic art à la Mondrian as Rothko, Newman and Yves Klein, stand such masters of the calculated effect as Albers, Bill, Vasarely. Mondrian himself indeed looms before us now as a great figure simply because the beliefs he preached are irrelevant to his paintings. These paintings are anything but icons for the initiate; they are fascinating sensory signs, the culmination of one great strain of twentieth-century aesthetics, an attempt to formulate a *more geometrico*.

Bern, 1972

HEADSTAND OF AN ICONOCLAST *The work of* *Kasimir Malevich*

Paris, the city that Malevich was not allowed to reach during his lifetime, is celebrating the artist's centenary with a retrospective at the Centre d'Art National et de Culture Georges Pompidou.

The organizers have mounted the most comprehensive overview of the work thus far. The museums and collections of the West have been generous in aiding an establishment that can boast not a single Malevich work of its own. Certain remarks about the presentation, however, need to be made. It seems illogical to take certain of Malevich's inventions out of chronological order and present them simply because they happen to be lithographs or woodcuts, as examples of a genuine graphic contribution.

Printmaking, for Malevich, was a way to communicate ideas and not, as is claimed in the specially constructed gallery within the exhibition, an artistic method apart from painting. Separating the graphic artist from the painter would seem desirable, at most, for the art trade. What it has resulted in here is an emphasis on the individual image that seems out of line with Malevich's own views. The extant photographs of the historic Malevich exhibitions show how strongly the artist favored a complex syntax of pictures over spotlighting the single work.

If the early years of this century produced a spirit as antithetical as Duchamp to "retinal" art, it was Kasimir Malevich. The inscriptions on his drawings, his plays on words show this as much as his attack on the Mona Lisa or the sentence: "Never will you find the smile of a seductive Psyche appearing on my square."

Another point calling for comment: the picture boards, that Malevich brought with him to Berlin in 1927 as examples of the pedagogical work done at the Institute for Artistic Culture in Leningrad, and showed in his famous room at the great Berlin Art Exhibition, can hardly be used to introduce a critical retrospective. (These visual aids, by the way, together with the major part of the works Malevich left behind with Alexander Dorner and Hugo Häring, were snapped away from the lethargic German museum people by the Stedelijk Museum in

Amsterdam in 1958). In any case, many of them have nothing to do with Malevich's teaching at all, but represent the color concepts of Michael Matiuchin as Troels Andersen pointed out in his fine 1970 study of the Berlin exhibition, and for which he considered Malevich "in no way responsible."

But every retrospective leaves room for such criticism, which is really the business of the specialist. It scarcely matters anyway in the face of the real problem, the real scandal: the fact that the Soviet Union virtually refused to participate in this homage to Malevich. One wonders just how dangerous this "nonperson" still is. Before the opening of the show there were rumours about fabulous loans from the Soviet Union, whose museums and collections harbor over one hundred pictures. But on the whole these hopes were frustrated. On balance the Soviet contribution was meager: only the *Portrait of Ivan Kliun* from the Russian Museum in Leningrad is worthy of mention. In addition to a *Flowering Tree* (1904) and a small Cubist *Railroad Station* (1913), only three late figurative pictures (1930 and 1933) made the journey.

The Soviet authorities naturally in no way countenance the real, Suprematist, abstract Malevich. Where they cooperated they did so, it would appear, simply to further what must cynically be called a banalization of the oeuvre. The return to representationalism in the last years was pushed as an essential part, in fact the entelechy, of the work—and unfortunately the Paris catalogue joined in praising what is plain intellectual disaster.

As for the representational role Malevich had to play in his final years, the distressing fact is that he himself predated these icons of artistic unfreedom. He dated them to their proper period, to the time when his own painting had hardly begun to absorb the lessons of Cubism and Futurism. It is depressing to know that *Red Cavalry*, dated 1918 by Malevich, was not painted until the last years of his life. Was he so frightened as to need an alibi, proof of a prompt and thematically sanctioned commitment to the revolution? Of course one might argue that such a "return to order" was quite in keeping with the tide of the twenties—consider Derain, de Chirico, Picabia, even Picasso. But that would be too easy to equate the situation in the Soviet Union, with the undangerous experiments, the often aimless play with possibilities, of the Paris School.

The inescapable fact is that Malevich's work ran its course in a very few years. Compared to the stunning Suprematist pictures, created between 1915 and 1919, the others carry little weight. *Peasant Woman with Pails* (1912, Museum of Modern Art, New York), *An Englishman in Moscow* (1913–14, Stedelijk Museum, Amsterdam) may have earned a solid place in the history of Cubo-Futurism, or pre-Dada collage, but the real, unexpected quantum leap of *Black Square on White* (Russian Museum, Leningrad, not exhibited) is impossible to predict from Malevich's prior development—as impossible as Marcel Duchamp's decision at about the same time to pit the entire world of objects, through random Readymades, against museum art.

Malevich too invites us to a tabula rasa. What can be found in the earlier work are relationships and reactions, reflections of Moscow's enormous fascination with Matisse, whose *The Dance* and *Music* could be seen, from 1911 on, at the home of the Moscow collector Shchukin. Malevich's own *The Bather* and *On the Boulevard*, both slightly predated, immediately took up a Matisse-like simplification of forms and colors, and show that he had come to terms with the themes

An architectural model, 1925.

and the primitivism of Natalya Goncharova. There was also a kinship apparent with Léger's *Nude in the Wood* (a kinship, not a dependence, as Alfred Barr already pointed out in the thirties). Then suddenly this entire interlock with the avant-gardes of the time disintegrated.

It is on this mystery of the reduction to a quadrant within a quadrant that the effect of the subsequent, basically much more plausible projections of surface trajectories, lines in space, depended. For there one could at least refer to the system of "primal lines" that Picasso and Braque used in their Synthetic Cubist pictures. There, to put it bluntly, Malevich's work became once more describable. His images called forth visual associations. One series of paintings he himself withdrew from circulation, presumably because their transcriptions of a spiritual realm looked too much like space travel. His *Suprematism of the Air* (1917—18) clearly reflects the fascination of the period with Icarus, with the bombastic illusion of superhuman weightlessness that such as d'Annunzio the aviator succeeded to.

Soviet cultural policymakers can have as little interest today as they did then in Malevich's concept of "Suprematism," which encompasses an anthropological bias that is basically incompatible with the practices of socialist realism. Anatoly Lunacharsky's remark of twenty-five years ago about Malevich's "apish technicism" still holds. The very thing that drove the whole Russian avant-garde to the October Revolution, that was their commitment to it, is precisely what the party dogmatists turned to ridicule in the early 1920s.

That applies particularly to the mechanistic-constructivist tendency in Malevich, Vladimir Tatlin, Alexandra Exter, and in theoreticians like Ossip Brik. They, the "ultradeformers" (Lunacharsky), were accused of betraying the essence of socialism, this essence consisting of "snatching man away from the machine, not allowing the machine to mechanize man but on the contrary making the machine part of man, automatically his basest part" (Lunacharsky). That is why the People's Commissar for Education decreed that factory, machine, Constructivism be regarded as hostile principles as long as the forces of production mankind had invented remained its masters.

Surely this could explain to a certain degree why Wassily Kandinsky's lyrical abstraction, which was theoretically based in the spiritual, the soul, was less explosive politically than Malevich's work. Kandinsky did not take part in the negative symbolization of human dependence on the production process. To understand the Malevich problem, the degree to which approaches like his still offend every socialist aesthetic, one must be aware of the fundamental difference between Kandinsky's notion of sublimation and the claim of Suprematism to possess, independently of any actual experience, something akin to universalia. This is shown by Malevich's demand for a "null point" and with it a field of operations totally freed from any tradition and any social or historical obligation. To the best of my knowledge, no one has so understood or impressively described the Suprematist attempt at ontological emancipation as Andrei B. Nakov (*Malevich Ecrits*, Paris, 1975).

Much in Malevich's theories—and thus in his work—becomes comprehensible thanks to Nakov's labor. Nakov shows, for instance, how Malevich must have arrived—probably through the writings of Piotr Uspensky, who had considerable influence on the Russian Futurists—at a brand of speculation that refuses to

accept any mechanistic, atomistic description of the visible world. It is most interesting to see Kantian principles at work even in Russia. This definition of art as an autonomous cognitive possibility is quite comparable to what Daniel-Henry Kahnweiler following Conrad Fielder said about Cubism.

These writings make it possible to define a kind of iconographic background for Malevich's *Black Square on White*, one that aims at a derealization of the world, at overcoming deceptive perception. Rejection of experience in favor of mystical insight and a refusal to countenance real or historical categories is, after all, contained in Malevich's statement: "In nonobjective Suprematism there are no longer objects, but on the other hand in real life there are no Suprematist phenomena."

It is understandable that such an emphasis on the *a priori*, despising any kind of evolution, would seem instructive to socialist aesthetics, on condition of a later (despairing) return to (harmless) representationalism. But what is the late work if not the forced, sad headstand of an iconoclast?

Paris, 1978

THE AESTHETICS OF THE BLUE OX *The Chagall exhibition at the Grand Palais in Paris*

Marc Chagall has risked measuring himself against Picasso. Three years after Picasso, France is officially honoring, for the second time, this prosperous breeder of blue cows and red lovers. Chagall is as beloved as Picasso is famous. The late Chagall has made up for modern art. He can be depended upon for sweetness, as guaranteed and unchanging as Chanel No. 5, in every new gouache, every new oil.

The wing of the Grand Palais on the Champs-Elysées that has been readied for this exhibit far outdoes in chic and perfection the rooms in which Picasso's provocative work was shown. Paris can well use these three new floors of exhibition space. Escalators take one from level to level, to lecture and projection room, to a restaurant; everywhere taped voices gently add whatever melliflousness may be lacking in Chagall's pictures; television monitors show Chagall himself, talking as only he can talk, with touching deviousness, about art—about Klee, who in the last analysis really painted nothing but tapestries all his life; about Cubism which, unlike Chagall, got bogged down in realism.

This retrospective with its 447 items was prepared by Jean Leymarie, who had also been in charge of the Picasso show. It is a belated child of the cultural policy of André Malraux, who had recognized in Chagall, adroit at commissions such as those for opera house and cathedral, a *peintre officiel* for France. Thanks to Malraux, he is to have a museum in Nice within his lifetime. One does not have an easy time of it doing justice to Chagall. To be really fair to him, one would almost completely have to ignore twenty or thirty years' work and go back to the artist's early period. The Chagallomania of recent years has all but silenced the

Chagall who had so decisively helped to form the style and mythology of the early Paris School.

The exhibition shows this with frightening clarity. Official acclaim has fertilized sweet-smelling gardens, fostered the aesthetics of the blue ox on the roof. Untiring buyers of the endless stream of Chagall lithographs have done their best to substitute for elaborate synthetic compositions of the early period, these candied icons. Chagall has become his own iconoclast. This is particularly obvious in the monumental compositions of recent years, the large-format Gobelins. Robbed of structure, their juxtaposition of Chagallian motifs is disappointing, especially because the essential element of the late period, color, has been lightened. And refinement of color, tonal, delicate, light coloration, is not Chagall's forte at all. It brings an intellectual dimension into his work that just does not go with the barbaric power of his themes. Chagall's work lives—in his great, convincing paintings of the earlier period—on the unpsychological, unjustified intrusion of color. A glance at Chagall's development may help to explain what I mean.

The earliest noticeable influence of a painter on young Chagall's work was Gauguin. Gauguin was the first—together with Van Gogh, in whom Chagall was to be interested a little—to determine the composition and coloration of his pictures emotionally. The liberties these two artists took with color and composition seemed, in the cultural milieu of the West, like the intrusion of an alogical subjectiveness not sanctioned by artistic tradition. To Chagall the problem did not present itself in the same way. Neither Gauguin nor Van Gogh (nor the painting of the Fauves and the Cubists, who strongly influenced him during his first stay in Paris) can have appeared to Chagall as revolutionary cultural facts. On the contrary, they were easily brought into consonance with the world and the images that Chagall had absorbed in Vitebsk.

In every study of Chagall reference is made to his Jewish origin, to his unique way of overcoming the Jewish ban against image-making. This is in fact a theory that sounds enticing and one that could in part explain this nonrealistic manner of depicting people and their symbols. Yet as a corrective one would have to introduce the concept of "conscious distortion:" in line with his heritage, Chagall saw himself as called upon to transpose rather than reproduce reality. This would, at least in part, explain the source of Chagall's ongoing critique of visual appearances. The account we have of his development as an artist, the fact that he is the first great artist to have come out of eastern orthodox Judaism, largely explain why Chagall, who always listened to the voice of his ancestry, should have taken a different attitude towards representation than his bourgeois, emancipated colleagues.

Chagall's youth, the pictorial factors that were current in Vitebsk, have as yet hardly been examined. That, I think, is why we have tended to identify the *how* of Chagall's portrayal, explained by his background, with *what* is portrayed. One look at the Russian illustrated broadsheets of the eighteenth and nineteenth centuries reveals the rich imagery from which Chagall took the motifs of his first, decisive works. There is no Chagall before Chagall, no development that could be said to have prepared his world of images; his oeuvre is there complete in these first folkloristic paintings of Vitebsk. Chagall was immediate master of the elements of his themes and his composition: people doing irrational things (or

supernatural ones, as Apollinaire was to say a few years later) like walking on air and playing the violin on the roof; figures that are enlarged or shrunk not because they are near or far but because they are more or less important; rooms stacked and scrambled every which way; animals in speaking roles—all of which we find in the broadsheets.

This dialogue with folk art was by no means limited to Chagall. El Lissitzky conducted it as well. His illustrations to the *Ukranian Folktales* have less reference to Chagall than to such amusing prints as "Mrs. Terentievna Mercilessly Pummels a French Soldier with Her Shoe" (Moscow 1812). The angularity and simplification that come through as stylistic willfulness in Chagall and Lissitzky are foreshadowed in this kind of popular art. Nevertheless it is not true that Chagall turned to this world of subject and form because he had seen no other. At Leon Bakst's Svanseva School at the latest, he will have had the opportunity to abandon this folk background if he wished. Experiments with intimate interior painting show that he tried and assessed the possibilities opened up by his studies in Leningrad; yet finally he opted for a style that consciously took the distortions and imprecisions of the broadsheets into account. In so doing Chagall, probably without realizing it, paralleled the attempts of the European avant-garde.

Chagall brought his large, non-famous paintings to Paris, where Cubism was in its heyday. At first Chagall was attracted by Fauvism, particularly by Matisse; yet the Cubist formal vocabulary, he soon recognized would help him tame the distortion he had appropriated from the broadsheets. Nearly all the artists of the period tried, as Gauguin had, one new principle of design or another. The compositional possibilities opened up by African art, exploited by Picasso, Matisse and Derain, hardly touched the themes of their pictures at all. Exoticism is missing from Picasso's work. It was Chagall who added that wild, tenderly poetic note.

Apollinaire discovered in Chagall not only new formal principles but also new themes, a coupling of seeming incompatibles. Chagall, for his part, gained from the geometric scaffolding of Cubism. His paintings of the period—*The Cattle Dealer* (1912), *Self-portrait with Seven Fingers* (1912–13)—have a more composed structure than his earlier works. Links to the French environment began to turn up, with such landmarks as the Eiffel Tower and the Seine and village subjects appearing in his works. The freedom of Cubism, disintegrating reality for the sake of composition, was very useful to Chagall. His distortion of the figure, his juxtaposition of incongruous themes, he soon, with an eye to the French avant-garde, began to use more consciously and more formally, offsetting his sheer joy in story telling. In place of scenes, we increasingly find compositions in which large figures dominate. One of the masterpieces of the period, *the Poet* (1911), shows the extent of Chagall's involvement with Cubism. The reduction to red and blue shapes anticipates Léger's *Contrastes de formes* (who incidentally, credited the reduction of colors in his work to a few tones to the folk art of Epinal). Chagall's best pictures seem to be those in which the individual colors and shapes remain sharply separated. The play of the facets, the angular script that fills the surface, give these paintings qualities that are missing from the later work, in which form is eschewed for the sake of luxuriant color. Their mixture of

mathematics and dream remains Chagall's great, unique achievement, one to which the Surrealists by the way were not unreceptive.

We know less about the time between 1914 and 1922, which Chagall spent in Russia. Many important works of the period have never left the Soviet Union. Four paintings have gone to Paris from Leningrad's and Moscow's art vaults, examples of Chagall's clash with the Suprematism of Malevich and El Lissitzky are unfortunately not among them. It was a clash that had tragic consequences for Chagall and surely also for Soviet revolutionary art. Chagall, Commissar of Art and Director of the Academy at Vitebsk, could not prevail against Malevich and El Lissitzky. In the theater projects of the period, few of which were carried out, Chagall linked his imagery with Constructivist motifs. On his way back to Paris, Chagall stopped over in Berlin, where, thanks to Paul Cassirer, he made his first etchings. A new high point in his work was in preparation.

From then on Chagall the artist juggled his familiar motifs. Variations on the icons with their lovers, Eiffel Towers, wall clocks, bunches of flowers, accumulate. Formally, nothing new happens—unless it be a dissolution of form that weakens the force of the popular subjects. A droll housebroken folklore displays its tricks. Here and there, Chagall strikes a coloristic chord that pleases, but only in the decorative sense. One now hears Gershwin not Stravinsky, whose *Petroushka* seemed to sound in the spiky rhythms of the early pictures. The search for color beyond color, apparently inspired by Monet, Bonnard or Greco, his laborious plumbing of the "chemistry" of coloration, has had its best results to date in the stained-glass windows. Their transparent fire best expresses a transcendence of the material. Chagall's work in other media—ceramics and marble for instance— falls far behind them. These are works that Chagall seems to feel he owes himself as an allround artist. His fascination with another ceramist and sculptor keeps him on the *qui vive.*

Paris, 1970

EXILE IN SPACE AND TIME *The work of Giorgio de Chirico in Milan*

Will the comprehensive de Chirico exhibition now on show at Palasso Reali in Milan shake the most assured aesthetic verdict of the century? I mean that passed on the great, admirable de Chirico, who in 1919 committed artistic suicide, and afterwards annulled himself dialectically? This "disguised Oedipus" (Louis Aragon), it seems, has been trying to ruin himself for fifty years.

We are faced here with an aesthetic and a human problem. The visitor finds out just how human it is in the self-portrait gallery which leads to the exhibition proper in Milan. One thing can be said—by turning his back on himself de Chirico deliberately blocked his way to fame and greatness. In his mythical-autobiographical book, *Hebdomeros* (1929), de Chirico gives a picture of the inner conflict he suffered. At the same time, this moving book bears witness to

the fact that he changed his style so radically not because of failing powers of imagination but out of powerlessness against history. Ever since, "disadvantage of history" has made itself felt in every work.

It would certainly have been easy for him to concentrate Surrealist painting on his person; what Pierre Reverdy formulated in the twenties, de Chirico had long since rendered visible: "The more distant the relationships of these realities to each other, the more powerful the image will be." Initially de Chirico had honored the advances of the Parisian Surrealists. That he was not satisfied with his easy success speaks for his independence. Take Chagall by way of comparison. Both artists were prone to what you might call artistic self-laceration. In Chagall's case, this behavior benefited his bank-account; in de Chirico's it led to an unpleasant yet somehow necessary battle with the metaphysic which he saw realized in history. The melancholia that pervades de Chirico's early pictures passes onto the viewer, who has no chance but to accept his tragic, fifty-year wandering through the maze of history.

It was surely no easy task for the organizers of the exhibiton to put together a retrospective during the master's lifetime. Dependent on de Chirico's blessing, it could only be a compromise. There is one argument to be found in favor of the exhibition: it was high time to have de Chirico's oeuvre discussed as a whole. But whether all the bombast was necessary is open to question. The de Chirico accepted thus far by the aesthetic common sense of our century, and who will no doubt continue to be accepted, remains, quantitatively speaking, too subordinate to the "de Chirico post de Chirico" of the Palazzo Reale. Perhaps Wieland Schmied, who was a consultant to Milan and will be in charge of the exhibition for the Kestner Gesellshcaft in Hannover, will succeed in loosening up the middle part and rigorously condensing the end.

The idea of unsettling our Manichaean view of de Chirico has something in its favor, for doubtless our image of him is standardized, as Schmied points out in the catalogue. The twentieth century has made failure, the spiritual and mental conflicts of artists, become material for aesthetic reflection. An aesthetic Pyrrhonism, replacing the work for which full responsibility is taken, has become a new subject for art. Duchamp and Dada have shown that the beautiful picture is at a disadvantage with respect to ideology. But whether de Chirico can be fitted into that particular scene seems questionable after this first great retrospective. To explain Giorgio de Chirico's rejection of de Chirico's painting by a conscious act of abstinence and skepticism would be to dissemble. After all, he has created—in contrast to Duchamp—a vast, structured, formally and thematically conventional body of work. If one were to stay within the sphere of doubt, de Chirico would at best be a kind of Duchamp turned on his head.

Even if the material offered does not invite a revision of judgment, it does at least force us to examine de Chirico's re-birth. The transition from the hard and crystalline, to the Romantic-Baroque phase was not all that abrupt. De Chirico tried repeatedly to return to the dream-clear precision of the early years, either by reaching back to old motifs and composition schemata, or through new themes (as in the *Ville Romane* and *Mobili nella valle* pictures). Nevertheless the work of the last fifty years is characterized by a dissolution of form. The spatial conflicts that had brought about the plunging perspectives, the diverse vanishing

points, are missing. The disorder, achieved with mathematical precision, that frustrated the viewer because he could not logically grasp the three-dimensionality in these apparently very simple pictures—this disorder was lost in the free, Baroque compositions. As inexplicably new as de Chirico's early work appears to be, it nevertheless somehow fitted into the Cubist period. Between 1914 and 1918, the articulation of the metaphysical interiors that de Chirico was painting in Ferrara became ever more clearly Cubist. Works like *Interno metafisico con piccola officia* (1917) or *La morte di uno spirito* (1915-16) come fairly close to Juan Gris's *Violin* (1916) or *Still Life with Landscape, Place Ravignan* (1915).

The break in style to which de Chirico, in 1920, consciously subjected his painting, raises questions that do not apply to him alone. The formal conventions of the modern age—Cubism, Matisse's insistent planarity, Futurism—all reached a stability of a sort at about that time. In general one can say that a reawakened awareness of art history stimulated the development of art, in an active as well as passive sense. In the active sense: Picasso returned temporarily to a strongly classically inspired art, as did Derain. Matisse harked back to Romantic models, to Delacroix's odalisques and interiors. Neue Sachlichkeit also fits a historical mode, that of the realistic genre portrait. In the passive sense, this making peace with tradition can be perceived wherever historical awareness suddenly shed doubt on the infallibility of the avant-garde (as with Duchamp, Dada).

De Chirico's development fits into this overall scheme. Behind his conversion lies a profound experience of *Italianita*. In 1919 de Chirico stood in the Galleria Borghese, looking at a Titian (perhaps *Sacred and Profane Love*?) Suddenly it dawned on him, he relates it, how much "immortality" painting can contain. This encounter brought a definitive answer to his search for the absolute. His aesthetic hermeneutics, which until then had precipitated metaphysical melancholias, keyed up to the breaking point, had arrived at their goal. De Chirico's lonely search for the absolute became a busy traffic with what, at particular times, was truth and beauty. Therein lies the great change from the first phase, which used historical elements only to temper the realities of private experience, present or past.

In the early works two "historicities" are superimposed, one absolute, aesthetically experienced and the other private. The emotional shock of these pictures comes out of this clash between the absolute (the Italian piazzas, the stopped clocks) and personal memories of his father, who had built railroads in Greece and died at an early age (locomotives, technical instruments, the travel motif). Personal allusions, known only to de Chirico, appear scattered among solid historical facts. Interminable history and personal transitoriness stand in uneasy balance.

The formal material de Chirico used has features that are less quattrocento than Mannerist. The *manichini*, the articulated dolls of his paintings, recall the *bizzarrie* of a Bracelli or the standardized treatment of volumes in Rosso's *Moses Defending Jethro's Daughters* (a relationship pointed out by Gustav Rene Hocke). It could be said that de Chirico's early pictorial world achieves Mannerist effects with the means of quattrocento painting. The search for the "veiled image of the unfathomable mystery" (Gauguin) began in the nineteenth century. In place of Baroque-academic iconography which, for all its allusive

complexity, was still legible, came pictures whose content totally escaped comprehension; or rather whose content spelled out, no longer formed a coherent whole.

No wonder that de Chirico saw in the Courbet *L'Atelier* a kindred spirit. The aesthetic of the unexpected, defined by Baudelaire, found its first sovereign formulation in de Chirico. It is not solely the immobility of the early pictures, the fall of the shadows, that contribute a superreality to the real facades and alignments; an immobility just as stark can already be found in Seurat or Henri Rousseau. The decisive factor is de Chirico's "flight out of time," in his use of stylistic means that were totally anachronistic at the turn of the century. This, perhaps, is the basis for the most surprising effect of de Chirico's works. Theirs is a style that takes, as its main stimulus, a forgotten moment in history.

This argument could be countered, of course, by saying that the Cubists and Expressionists broke the historic continuity of the art of their time by introducing non-European forms. Still the effect was different. De Chirico went back in time, he reached for an atmosphere that was present in the sub-consciousness of his educated viewers. He pulled another European period into the present. The fascination with non-European art—especially African and Oceanic sculpture— brought about a different result. For the first time European artists reacted to stylistic means contrary to their own. They tried to change the very principle of representation, while de Chirico, in his reversion to the geometries of perspective, laid bare the skeleton of post-Renaissance western painting.

De Chirico grew up in a milieu that predestined him for reflection on art-historical facts. Arnold Böcklin and Max Klinger were among the strongest impressions of his two-year stay at the Munich Academy. The nostalgia of the Italian who grew up in Greece, his exile in space and time compelled de Chirico to search for his lost historical niche. What was to become the theme of the novecento style of Italian painting in the 1920s, the rediscovery of an overwhelming past, the background of which autonomous avant-garde activity appeared as hubris, de Chirico anticipated in a fascinatingly intellectual way. Out of this realization, I think, arose de Chirico's scruples about continuing his bold synthesis of tradition and autobiography. Historical orthodoxy hampered him in pursuing his most genial discovery, the thematic collage. While others, like Max Ernst, made a creative system out of the inhibition of art toward history, this inhibition drove de Chirico to ever new, ever more tragic revisions of his own creative powers.

Milan, 1970

HALLUCINATION AND TECHNIQUE *Max Ernst at eighty*

Max Ernst's fame cannot be called popular. On the whole his work discomfits rather than pleases; from the start it has had very little to do with what we generally mean when we speak of painting. It fascinates and repels simultaneously, an ambivalent effect Max Ernst likes: "Painting happens on two different yet complementary levels. It delivers aggressiveness and uplift." As far back as 1921 Max Ernst coined his now-famous phrase, reminiscent of Nietzsche, "Beyond Painting." His first works had an influence on Paul Eluard, André Breton and Louis Aragon that must be reckoned among the most fruitful of the century.

Max Ernst was the first major artist without academic training. While still a student of philosophy and psychology at Bonn, before the First War, he began to be interested in marginal fields of aesthetics. Psychopathological art, a phenomenon that ten years later was to receive a carefully objective review in Hans Prinzhorn's *Painting of the Mentally Ill*, he saw as a positive, hitherto untapped source of subjects and compositions. Even here, at its roots, Max Ernst's approach to Dada differed from that of his colleagues in Zürich or Berlin.

No other artist who might belong to Dada or Surrealism created, to vary the Wagnerian term, such a total work of art demolishment as Max Ernst. As William S. Rubin, chief curator of the Museum of Modern Art in New York, was the first succinctly to state: "In the extraordinary variety of his styles and techniques he is to Dada and Surrealism what Picasso is to twentieth-century art as a whole" (*Dada and Surrealist Art*, New York, 1968).

The mention of these two great names in one sentence invites us to examine what separates them. Everyone has a mental picture of Picasso's world—images in which something, some recognizably real thing, is distorted. But what does a painting by Max Ernst look like? It is an image composed of elements both active and passive, realities cut up and reassembled with a skeptic eye, giving rise to a visionary realm that oscillates between the larger-than-life and the smaller-than-life, caught in continuous change. Picasso, in everything he does, remains a realist; his subjects connect with the actual. With Max Ernst even the subjects are questioned. He never alters reality by means of stylistic wilfullness, distortion or heightened expressiveness. His works are points of convergence in which the subject encounters technical procedures that render the distance between the thing represented and its representation as a distance between traditional and newly invented technique. What is revolutionary about Max Ernst's innovations is that he has worked out ways to depict visionary or ironic themes which demonstrate this new content on the level of technique itself.

The spontaneity of the oeuvre, its alternations in tone with the banal always acting as a brake on the sublime, expressing doubt and awe in one, tend to make the critic hesitant to subject it to analysis. Reading through the books and essays that deal with him, one is struck by the authors' muteness in the face of his work, or rather by their inability to find their own words. Nearly all of them approach Ernst by emulation, that is, they translate the man and his work into poetic terms. The alogical, poetic, skeptical qualities in Max Ernst are not so much

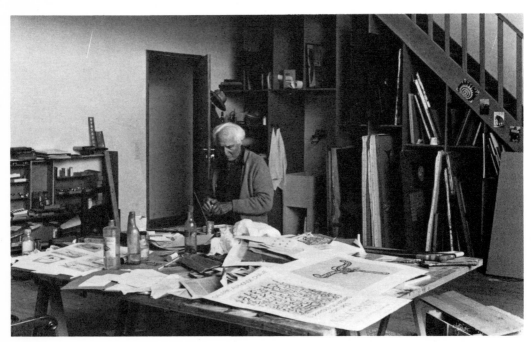

Max Ernst in his studio in Seillans, France. Photo by W. Spies.

revealed and interpreted as structures, as imitated on another level. This is what makes the secondary literature about him seem so oddly partial, without distance.

Max Ernst himself is no great help. He reveals information about his techniques, his themes, his studio secrets, only very sparingly. Not because he intends to mystify, but because he wants to avoid rational questioning, what he calls "explaining to death." What matters in discussing his work is to find the median, to find out how far analysis can be pushed without banalizing the oeuvre. Caution, at any rate, does not preclude that an explanation that sticks to the limits of understanding set so frantically by the oeuvre itself, will render Max Ernst's pictorial world more comprehensible.

Max Ernst himself refuses to adopt a retrospective attitude. What he is doing now is more important than what he has done, which explains for instance, why an entire group of works, the wall-paintings he executed in 1923 in Eluard's home at Eaubonne, should have been forgotten. These pictures were rediscovered only three years ago, and without any aid on Ernst's part. He had never even mentioned them in conversation. Curiously enough this cycle, Pompeian in its mélange of grotesques, supraportes and central images, also suffered a Pompeian fate. And another curious fact is this: Max Ernst apparently painted this cycle after reading Freud's "Madness and Dreams" in W. Jensen's *Gradiva*, an essay in which Freud discusses buried memory and its release on the basis of a novella which is set in modern Pompeii. Max Ernst reacted to the unearthing of this fascinating series of works almost like Rumpelstiltskin, as though he wanted to keep their memory to himself. One is reminded of Duchamp's readymade, *With Hidden Noise*, the roll of twine in which Walter Arensberg concealed an object unknown to the artist. And lovers of secrets may rejoice in the news that Max Ernst has named a second house in which paintings of his have supposedly been plastered over.

These past few years, Max Ernst has been spending most of his time in the south of France, in Seillans, a small village nestled in the mountains near Grasse. He lives there in seclusion, reading, working, dependent for communication with the outer world on a manual telephone service that sometimes takes hours to get a number. A life without any sort of liturgy, dedicated to being alone or with a few friends, or guests who have managed to get this far. This is a man who, despite his bent toward introversion, lavishes matchless kindness and attention on others.

Max Ernst left the Rhineland, his native Brühl, Bonn, and Cologne just about fifty years ago. Paris became the great corrective of his Germanness. There is no other example of such perfect integration of German character into French. But this had nothing to do with his being an emigrant; life and work simply fell in with each other. The real emigration began in 1941. To Max Ernst it meant expulsion from both Germany and France at once. The ten-year-long stay in the United States added a perfect English to his German-French bilingualism. Today he chooses his reading matter from a trilingual library: Carroll, Poe, Blake, Jarry, Rimbaud, Beckett, Novalis, Heine, Arnim, Grabbe, and, in addition, whatever contemporary German literature he sends for. In the evening he seems to prefer Hölderlin and can long linger over "Bread and Wine."

The painter in him is never visible. He hides whatever is connected with the métier. One senses a certain reluctance in him to actually practice the profession

toward which he was always full of diffidence. Sometimes a blank canvas will stand in his studio for days, for weeks, untouched. No signs of battle here, no blood-smeared painter's smock—just the cool operating room of Dr. Ernst. That drunkenness on turpentine that Duchamp so caustically accused his contemporaries of indulging in, is totally absent here. And automatism, a state of obsession with subject and technique verging on the hallucinogenic, likewise exists only in the Max Ernst literature. Everywhere only paintings, drawings, collages in which the shock of ecstasy is communicated clearly, without loss of rational control. In the work as with the man, skepticism finally prevails. Only by dint of constant self-monitoring could the spontaneity of which Max Ernst has such a large share be turned to stylistic uniqueness.

His work exemplifies at one extreme artistic freedom, at the other a manner of study in artistic determinism. The latter seems especially significant in that it proves that no one can deliberately put himself out of bounds by performing an artistic, or non-artistic, act. A comparison with Duchamp may make this clear— Duchamp believed that by demonstrating his indifference to art, he could reject history and even the ontology that compells humankind, in ever new ways, to artistic expression.

Duchamp's readymades have long since lost their intended meaning. Thrown like boulders into the wheels of art, they disrupted its operations only temporarily, and have since been transformed into fullblown, functioning, stylistically classified parts of the machine. Max Ernst set up the equation non-art = art in 1919, the provocativeness of which, far surpassing Duchamp's act of indifference, lay in its very denial of a boundary between art and anti-art. While Duchamp wished to prevent his readymades being judged aesthetically, attempting to circumvent such judgement, Ernst staged his provocation within the existing cultural and aesthetic mores. That the collages and assemblages which Max Ernst exhibited in 1920 at the Café Winter in Cologne were based on formal principles, that they actually resembled paintings and sculptures, must have angered the public all the more. If Duchamp reacted against art, Max Ernst reacted against taste—against the habits and attitudes that regulate our need for art. Where Duchamp attempted to negate, Max Ernst affirmed. In so doing he retained the greater freedom—he manipulated more than he was manipulated.

Any essay on Max Ernst must deal with the half-automatic methods he introduced into art, with collage and frottage and the methods he derived from them. Collage led him to a number of techniques that allowed him, in spite of his skepticism about things artistic, to build up an oeuvre beyond what had existed up to then, an approach that by coupling incongruent elements forces them into an unheard-of unity. And it is this new unity that sets logical limits to the interpretation of the separate elements of which it is built. We may dissect them out, but the functioning of the organism eludes us. Likewise, any attempt to illuminate these recalcitrant images solely by means of psychoanalytic method must fail. Ernst went beyond free association of poetic images. His response to Freud had two stages: the painter-constructor of the Dada phase, it seems, was more strongly influenced by *Jokes and their Relation to the Unconscious*, and the Surrealist Max Ernst by *The Interpretation of Dreams*. What Freud wrote about the technique of jokes might well serve as an outline to analyze the Dadaist collages and image-word combinations. The Freud of *The Interpretation of*

Dreams seems closer to the Surrealist phase of the oeuvre, because in "dream work" conceptual thought gives way to sensory impressions. The latent content that Freud read into the distorting transcription of dreams did not interest Max Ernst. To him it was precisely the evocative distortion of the manifest content, to an analyst simply a transitional stage toward rational explanation, that was the imaginative (again, not analytic) stimulus. That is why he adopted Freud's "dream displacements" as poetic values in themselves. He resorted to antinomy, and coupled realities that, logically, do not tolerate proximity.

Since Ernst uses only pseudo-psychoanalytic effects in his work, it would clearly lead nowhere to apply the methods of this science to his iconography. An interpretation must be sought by other means. I think we must start at the beginning, with Max Ernst's materials. He chose and still chooses his images from the storehouse of the visible world, treating everything as material of equal value. Distinctions between aesthetic and non-aesthetic, valuable and trivial, play no part in the selection. Nevertheless he assumes the viewer will be aware of the "cultural dissonance" in his pictures; as he has demonstrated ever since 1919, the clash between everyday realities and intellectual or cultural assets is an endlessly provocative one. And it is quite fascinating to watch him finding a style in which the active element balances the passive. This active-passive contrast can be found in all his works—collages, frottages, oil paintings and sculptures. Chance and logic intermingle. The fissure that runs through each work is a general characteristic of his style.

Piled up in his studio are illustrated books, scraps of wallpaper, raw materials of all kinds and description that Max Ernst weaves into his images. When one leafs through the nineteenth-century folios illustrated with wood engravings of the type he has always preferred for his collages, one's assumptions about his procedure are shaken. These are not spectacular images with a good many surreal qualities of their own. Ernst will often pick the commonplace, everyday illustration and turn it into a baffling statement, bringing different layers of meaning together on a single pictorial level. Looking at the finished collage, we are forced to rid ourselves of the habit, acquired by looking at paintings, of seeing pictures as entities. The contemplation of paintings has predisposed us to seeing all the motifs of an image as a sum total, simultaneously, which prevents us from perceiving the distinct parts from which a collage is built up, from breaking down the incomprehensible but coherent image into comprehensible units. The conflict between the overall image and the constantly interfering interpretation of its units, gives rise to the strange mood that pervades our encounter with Max Ernst's work—elements that are comprehensible in detail turn ambivalent on the level of the composition.

This ambivalence is disturbing. In order to escape it, our mind attempts to analyze each detail and to fashion the image, as it were synthetically, from this knowledge. Yet the image is not simply the sum of its details—it is like a force field in constant flux, irreducible and disquieting. The image as a whole resists logical solution. This may seem to contradict what I said at the outset, that Max Ernst's oeuvre has been all too glibly classified as irrational and hermetic. What I think is needed is to push to the limits of understanding, to study, in the works themselves, the workings of human logic and the recurring formal principles and structures it gives rise to. And where logic can go no farther, there the image

begins. Analysis and its opposite, the sudden shift from thinking to seeing, are what make these images so exciting.

Entire cycles of works—the frottages of *Histoire Naturelle*, the collage-novels *La Femme 100 têtes, Rêve d'une petite fille qui voulut entrer au Carmel, Une semaine de bonté*—obviously play cat and mouse with logic. Stylistically they do not fit nearly as well as other of Max Ernst's works the stereotypical notion of a Surrealism à la Dali. Indeed their effects are much stronger. They hold a beautiful balance between the real and the possible. By shoring up his visions with elements of the logical, of the real, Max Ernst brings the antinomy of Surrealism into full play.

Dada, deformation of the human figure, metamorphosis, Surrealism, cosmic landscapes; frottage, hallucinatory images, then crystalline ones that hark back to the sculpture of the years after the First World War; then paintings, finally, in which color and texture almost seem to become self-sufficient—this succession of styles, experiments and self-refutations is both impressive and confounding.

If before the last war interest in Max Ernst was mainly concentrated on the iconographer, the creator of enigmatic pictorial worlds, since then another aspect of his oeuvre has taken precedence, namely the paint textures that Max Ernst has come to see not only as means of representation but as image content per se. This has led many authors to conclude that his work must have been influenced by Informal or Action Painting. Unjustifiably, since Informal Painting owes Max Ernst a great deal. Dubuffet and Fautrier would be unthinkable without his example. Already in the 1920s Max Ernst was using allover patterns in his paintings, and working on built-up, low-relief plaster grounds. Nor has he himself ever ascribed a non-objective meaning to his work. He has always been very much against the brand of purism that holds that paint structures, color fields or color relationships are beyond interpretation. To use his own words: "Every picture reveals to us certain aspects of the painter's inner world. Your orthodox *Tachiste* would not dare to be inspired by Leonardo's famous wall. Total refusal to live like a *Tachiste*."

Paris, 1971

GETTING RID OF OEDIPUS *Max Ernst's collages: contradiction as a way of knowing*

Collage is central to the work of Max Ernst. Collages reappear throughout his oeuvre, which in fact took its inception from that technique. At the time he worked it out, in 1919, it enabled him to largely delegate the task of painting and drawing to the other people whose pictures he quoted. As a glance at his earlier work shows, work in which Ernst nibbled without real appetite at the various avant-garde "solutions" of the day, his debut as a painter had something almost self-destructive about it. One might even conclude that his slapdash mastery of the art of painting was *meant* to fail.

In support of this assertion, let me cite a revealing document. In the senior-class newspaper *Aus dem Leben an unserer Penne* (Life at the Old School) which Max Ernst illustrated in 1910, he depicted himself, complete with hat and flowing mane, mounted on a truncated column—a self-portrait as an artist, the only one he was ever to do. Beneath the capital of the column appears the inscription "Max Maria," and below that a legend borrowed from Wilhelm Busch: "A young man full of hope / Can easily with painting cope." The young man's torso tapers to a columnar shape and is stuck, at the thighs, into the column proper. In his left hand he holds a huge palette, exactly as long as he is tall. With a housepainter's brush he smears the palette, on which an excess of paint (and Art) have already congealed into "limp" stalagmites and stalactites.

Indeed the palette itself already has that deformed, "liver-like" limpness of shape which Dali was later so highly to praise. The young artist who looks out at us from this drawing is bored, not impassioned. The memorial-like column into which his body merges, by the way, foreshadows that column in the group portrait *Au rendez-vous des amis* (1922, Wallraf-Richartz Museum, Cologne) on which de Chirico is mounted as a monument to himself. And another by the way—de Chirico's figure is the only one besides that of Raffael in this painting so rife with gestures, to be represented without hands—to illustrate, I think, the poignant formula of a "handless Raffael."

The experience of the young Max Ernst led, from our vantage point in the present, as a matter of course, to that so constructive "total work of art (destruction)" known as Dada. This is what the *truly* destructive phase of Max Ernst's career had prepared him for. Let the paradox be stated: his early period was destructive, not his contribution to Cologne Dada. For as unplanned and stylistically uneven as his early paintings appear, paintings created with an eye to the Cologne *Sonderbund* exhibition, to Macke and to the *Sturm* artists, they recognizably bear the stamp of collage, a new universe of stylistically definable contradiction.

The unity of Max Ernst's work in collage is striking. Every collage recognizably belongs to his world and to no other. Yet over against this formal "clarity" stands the disquiet engendered in the viewer by images that continually escape him. They are images that lie, so to speak, on the tip of the eye's tongue. How else can one describe the effect these collages have on us? A suggestion of reality, as of something seen, somewhere, a long time ago, rises in the mind, takes shape and yet, as soon as we try to define it, vanishes. Again and again the collages recede, safeguarding the inner logic of their origin by ever new enigma, from our grasp. We can only approach a definition or an explanation, and that is what is so terribly irritating: material that in its original, isolated state was clear, a mirror of existing things, is so changed by a flick of the wrist that the new configuration fairly negates the former existence of its constitutents.

Max Ernst has not set out systematically to create *un autre monde* opposed to one which is recognizable and depictable, but to offer a world that, thanks to a frequent use of "open textures," is open-ended on principle. Looked at from this point of view, the conflicts and contradictions he prefers to straightforward statements are not merely operational, in the sense that they allow objects to be integrated into works which are dependent materially upon them. His "exploration of a new, incomparably broader field of experience"—Max Ernst's own

words—includes contradiction as one path to fresh insight. This coincides with Ludwig Wittgenstein's intention "to change the attitude to contradiction and to proof through freedom from contradiction." Wittgenstein argued for a theory of mathematics that would develop contradiction as a means to knowledge, even create contradictions in order to show "that all in this world is uncertain." The role of play and paradox is Wittgenstein's theories had its literary forerunners in the work of Lichtenberg, Swift, and the Lewis Carroll of *Symbolic Logic* or "What the Tortoise said to Achilles."

One could also add to this list, of course, Alfred Jarry, who was another of Max Ernst's favorite authors. The science that one of his characters, Dr. Faustroll, invented, Pataphysics, consists precisely in the study of the laws that govern exceptions from the rule: "Pataphysics describes a universe that one can see, and that one perhaps even must see in place of the traditional universe."

Here we have one yield of Max Ernst's collage universe—the replacement of questions and problems of representation in art by a questioning of the very evidence of representation. In this light, too, Max Ernst's contribution to art is very much of the scientific age, indeed it cannot be seen clearly except against the background of modern scientific inquiry. Rather than the stereotyped Freudian explanations that do little, after all, but stretch the elements of Max Ernst's iconography to fit a handful of rather shallow categories, what we could use would be an approach which, like the philosophy of Charles S. Pierce or Wittgenstein, or more lately Jürgen Habermas, focusses not on the fixed object of perception but on the modality of perception itself, as a dynamic process.

On the one side then, we have the man of possibilities, Max Ernst; across the gulf the man of realities, Picasso. A good motto for Max Ernst's work might be taken from Habermas, who once wrote: "Epistomology, sabotaged, takes its revenge by leaving an unsolved problem, which now must be worked out with the aid of an ironically refurbished ontology of the actual." Everywhere in Max Ernst's work this strain arises between an apprehension of existing things and these things themselves, as we immediately experience them. Into statements about the circumstances in which an image of reality may complicate our grasp of reality, he interjects slices of the real that conform absolutely to our visual expectations and to everyday experience. The obvious and the trite collide with demonstrations of the ambiguity of appearances. Vision is continually confounded by running up against its own limits.

Here an example is in order by way of clarification. It is a collage of paramount importance in the oeuvre, the one that Max Ernst selected for the cover of the publication that *Cahiers d'Art* devoted to him in 1937, the first book about Max Ernst ever. The collage had been made in 1931 for *A l'intérieur de la vue. 8 poèmes visibles*, and had been reprinted in the Spring of 1933, as the sole example of his work in that medium, in *Le Surréalisme au Service de la Révolution*, where it bore the title *Oedipe*.

Knowledge of the material on which this collage was based is indeed, in this case, instrumental, in the sense that the degree and kind of manipulation Max Ernst subjected it to allows us to draw conclusions about technical and thematic constants in his work. What I mean by this is that to break down the collage methodically is not, as the solution of a rebus would be, to interpret it. We can

Der Wunderhirte (The Miraculous Shepard) published by Hans Prinzhorn in 1922.

Boy Extracting a Thorn, wood carving.

hold to this premise, I think, even though the question as to context appears in many different guises.

How interesting the context of a collage is, also varies considerably from case to case. Here, in the genesis of *Oedipe*, we have a case whose complexity would be hard to match. And this is true not only of the relationship of the image to the original material, to pictures of comparable iconography, it also holds for the key position of this collage in the oeuvre as a whole. In *Oedipe* so many diverse and contradictory images overlap that it would seem out of the question to attempt to reconstruct the causal sequence out of which the final image may have gradually crystallized.

Let us begin, nevertheless, with a piece that shows a certain morphological kinship, *Der Wunderhirte* (The Miraculous Shepherd) published by Hans Prinzhorn in his *Die Bildnerei der Geisteskranken* in 1922. Here are the rigid silhouette, the figure seated in mid-air, bearing an animal on its chest like *Oedipe* holds a lion's head in his hands, the strongly exaggerated legs and feet. And conceivably Max Ernst could have been struck, leafing through an issue of *Magasin Pittoresque*, by the form-inductive possibilities of a wood engraving after *Boy Extracting a Thorn*. He might have *seen into* the white, unshaded areas, in his sense of the word, the contours of *The Miraculous Shepherd*.

Yet merely to see a formal analogy of this kind is not enough to motivate a work of such complexity. The title *Oedipe* points to the family of motifs we now have to

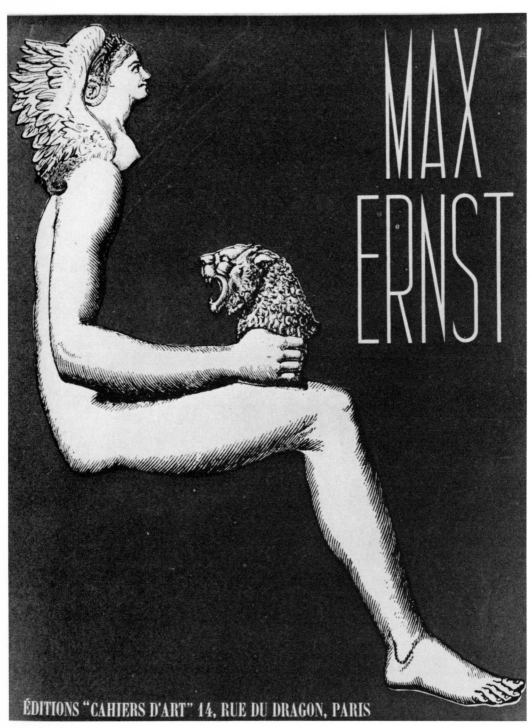

Oedipe, by Max Ernst, 1931.

turn to for further clues. And the big clue (now the analyst finds himself goaded, after all, to interpretation) is surely to be found in the shepherd-foot motif—sent into exile with pierced feet, Oedipus (literally Lame-of-Foot) was taken in by a kindly shepherd. A reference, ironically pointed, to his injury might be seen in the use of the sculpture of the boy pulling out a thorn. Thorn-extracting and solving the Sphinx's riddle are equated in almost comic disproportion.

Bringing in Ingres's *Oedipus and the Sphinx* (1806, The Louvre) and Gustave Moreau's picture of the same title (1864, Metropolitan Museum of Art, New York) not only gives us an additional iconographic framework, it reveals the patterns on which Max Ernst based his collage. In the Ingres painting, of which by the way a mirror-image turned up in 1863 that shows the figure facing right, as in the collage (Walters Art Gallery, Baltimore), we have its formal prototype in the answering Oedipus. Like the *Boy Extracting a Thorn* Oedipus is given in profile; his weight-bearing leg corresponds to the stone block in that sculpture, while his left foot rests on another, smaller rock. Max Ernst has pulled the seat out from under *Boy Extracting a Thorn*. If we cover Oedipus's weight-bearing leg in the Ingres painting, we have a silhouette that, like that of the collage, "floats." But now Ernst gives his Oedipus a Sphinx's head, and one which, together with the breast jutting straight from the throat, recalls the sphinx in Moreau's picture. There as in the collage the Sphinx looks upward.

SITTING ON DOSTOYEVSKY'S KNEE If we trace the motif of a figure seated in profile through the rest of the oeuvre, we discover an evident parallel in the painting *Au rendez-vous des amis* (1922, Wallraf-Richartz Museum, Cologne). Here Crevel is floating, like *Oedipe* in the collage, in space. Moreover Max Ernst himself, shown sitting on the knee of Dostoyevsky who in turn is likewise seated in empty space, reappears in the profile of *Oedipe*. This "unsupported sitting" was already prefigured in one of the sketches for the collage. It came about because in drawing from one of the engravings (which by the way he was to use seven years later for a collage in *La femme 100 têtes*), Ernst left out the seated figure that supported the two hovering ones.

What I should like to conclude from this is that the *Oedipe* which Max Ernst put on the cover of the *Cahiers* book in 1937, is a veiled self-portrait. This of course requires clarification. First of all the Freudian component of the image, Max Ernst's tense relationship to his father, is at most of anecdotal interest. Let us stick to the basic situation—Oedipus answering the Sphinx's question. In *Notes pour une biographie* Max Ernst describes his first walk in the woods as a boy: "Outside and inside at the same time. Free and imprisoned. Who will solve the riddle? My father Philipp? The Monk of Heisterbach? Or little Max himself?"

The confrontation between Oedipus and the Sphinx is set as a dramatic dialogue. A wood provides its background, just as it did for Heine's meeting of the Sphinx. In the preface to the third edition of his *Book of Songs* we find Herma entering an "old fairytale wood" outside a castle: "There at the gate lay a sphinx / Hermaphrodite dread and desire / A lion in body and paws / Breasts and head of a woman." The subject here is the battle of the sexes. The dread seductiveness of Eva-Pandora, of the Loreley—one can follow this fascination through any number of Max Ernst's images, culminating in the magnificent

drawing-photograph of 1925, where the world is deluged by mysterious temptations.

One is tempted to speak of a twofold fascination by the eye in Max Ernst's work, by its passive and its active functions. The first of these, the eye as the gateway to experience, or the eye blinded, seeing in night and dream, "inner sight", has already been alluded to. Over against the receiving eye we have the eye that gazes or stares, an instrument of domination. In this category of active vision belongs the Sphinx, as does the Leonardesque mirage in which nearness and distance blend to an ineffable apparition; the spellbinding glance of Medusa belongs here as much as the dangerous "velvet eye" of the octopus—and thus the desperate gestures of the figures in the collages as they try to ward off the evil eye. One might even detect, in the collage that uses Lautréamont's octopus, the eyes of Melmoth, the restless wanderer of Charles Robert Maturin's novel, those eyes into which "no one dared to look, for whoever met their glance but once could never again forget it!" Lautréamont's Maldoror is, after all, a reincarnation of Melmoth, a figure in which Milton's Satan and Byron's marked men live on.

There is another sphinx in A l'intérieur de la vue. 8 poèmes visibles, the book for which the collage under discussion was made. Her face is strewn with numbers and dots, a comparative nomenclature of moles. This type of thing was common on postcards of the day under titles like "The Secrets of Signs Revealed," with lists giving an erotic "concordance" between facial blemishes and those on parts of the body normally hidden. So solving this sphinx's riddle, at least, is reduced to a striptease.

The genesis of the Oedipe collage, has revealed that Max Ernst embodied the confrontation between Oedipus and Sphinx in a single figure. Now if we take opposition of the sexes to be the root of Ingres's and Moreau's paintings, it follows that Max Ernst has created a synthesis, and androgyne. Yet I believe this synthesis must be seen in a less literal sense, in the sense of a pulling together of question and answer into one figure, that may be said to stand as a symbol for the oeuvre—and that needs no decoding simply because a question to be answered is not there. The "known sense, the meaning" which is a condition of the invention of the riddle, is missing. Between Oedipus and the Sphinx there can be no exchange of roles like that Sancho Panza saw in a question-answer inversion, when he said he reckoned he'd rather hear the answer first and then the riddle.

My interpretation of the collage based on its contexts, has hopefully shed some light on Max Ernst's working procedures and the levels of allusion in the image. Further parallels, such as with his self-portrait in Au rendez-vous des amis, indicated the significance of the collage as a personal allegory. The joining of question and answer in one indissoluble figure which can be interpreted as a self-portrait, is demonstrated, in a certain sense, by the collage itself, which after all first became known under the title Oedipe—even with no knowledge of the contexts out of which it was developed, the viewer can take the coupling of a sphinx-like figure with the title Oedipus to be a rhetorical form that, like an oxymoron, reconciles opposites.

THERE IS NO RIDDLE A favorite textbook example of oxymoron is "icy flame," a phrase Rimbaud used in his Saison en Enfer. He wrote of his search for "arctic

flowers," an image, by the way, he was later to retract in his own copy of the poem with the note, "elles n'existent pas." Finally, we find this figure again in Max Ernst's *Bone Flowers* and *Snow Flowers*. Here the question of reality or unreality does not arise, either in scientific or metaphysical terms.

Max Ernst's collage—an allegory of the "ontology of the actual"—poses no riddle to which any logical solution can be found. Its androgynous being is a fascinating illustration of Wittgenstein's deduction, "To an answer that cannot be put into words you cannot put the question. There is no *riddle*." The Oedipus-Sphinx collage, a kind of Siamese question-and-answer twin, works in the same way as this wonderful philosophic aphorism—an image that frustrates any attempt on our part to escape into a hermetic or religious explanation.

Individual and universe, the conditionedness of self-knowledge and the limits of knowledge of the world, are both tied to language. This too can be illustrated by a phrase of Wittgenstein's: "The limits of my language signify the limits of my world." Language is here equated with the cognitive faculty: language, and not theoretical reason as with Kant, sets the bounds of possible experience. André Breton's reply to his own question about the possibility of making an unambiguous statement, must also be understood in these terms.

The *peu de réalité* (limited reality) cannot be overcome, however, by postulating some exogenous principle, some mystic speechlessness, but only by an act of speech. Language itself—and here lies an interesting parallel to Kant, whose philosophy Max Ernst went into quite deeply as a student in Bonn—becomes the transcendental condition of what the world might be. Hence Breton's proclamation that the mediocrity of the modern world could be overcome by assassinating language, making way for a new semantic order. Communication of a message was to be replaced by a passionate re-experiencing of an immanence that positivism, realism, utile application have rendered trivial.

In terms of Max Ernst's collages what this means is that his art is not an art of fantasy, it does not attempt to create a fantastic world. Out of utilitarian, comprehensible elements (the original illustrations) he makes combinations that in their use of the actual may be surreal, but are not transreal. If one leafs through the collage-novels with this in mind, one sees that nowhere in them are things that do not actually exist presented as impossibilities. Those titans who have happened into the laundry room, that giant in a restaurant, are not apparitions: nobody stares at them agape. Surrealism in this context would mean exhausting a linguistically or pictorially possible, recognizable set of combinations. And the word "recognizable" means that the conditions on which their effect is based are described in the collages themselves, again and again—an effect, in the case of Max Ernst, that depends on constants which the viewer better recognizes the more acquainted he becomes with the work.

To put it simply: repetition and recognition of similarities give these collages their comprehensibility.

Paris, 1974

ARAGON—YES, BUT WHICH ONE?
Metamorphoses of an eighty-year life

Louis Aragon lives in the Faubourg Saint-Germain, in a Louis Quinze house owned by the French state. By all appearances he is happy, satisfied, and entrenched in mementoes and memorabilia. Thus speaks the indefatigable causeur of the Rue de Varenne: "Can you imagine, not long ago Chirac used to keep coming over every morning, to chat with the concierge. He had his eye on my apartment. Pompidou, however, had made arrangements in his will. Nobody can put me out of here."

At the bottom of the staircase that leads up to Aragon's studio under the roof, squats a flesh-colored plaster cast of Carpeaux's *Young Fisherman*, who, with an amazed grin, presses a large shell to his ear. An advertisement for the grand talker upstairs? Aragon always manages to take your breath away. There is no stopping him. His memories are too strong and too many, and he lives in them. Ever since the death of his Russian wife, Elsa Triolet—and here I am passing on malicious Paris gossip—Aragon has reverted to his cult of the rare and unusual. Overnight, they say, he started sleepwalking again, living the life of a *paysan de Paris*. His fluttering cape is often spotted at ungodly hours in Saint-Germain-des-Prés. Nor has his biographer, Pierre Daix, omitted to comment on his reawakened craving for life—the sartorial snobbery so frustrated by Elsa, he says, now revels in the eccentricities of Saint-Laurent.

ELSA OMNIPRESENT The morning of my visit he was dressed gray-in-gray, from white hair to gray patent leather shoes. Around his neck dangled a gold watch on a gold chain. He was just taking leave, in the salon next door, from a man from French television, who had told him what risks he had taken with his programs, and flattered him that he had had his first true poetic experience during the Résistance, when a copy of Aragon's *Le Crève-Coeur* had fallen into his hands. Aragon led him graciously out, saying, "Cher ami, I simply can't be untrue to myself. With the dead you can do what you will. Not with the living."

The visitor stepped toward what he thought was the apartment door. Watching for just this movement is one of Aragon's favorite games: "Mon Dieu, not that door! Everyone makes that mistake. Just look where you were going!" Everything revealed up to now by the bright autumn sun suddenly concentrated to an almost somber density: one door of the room glazed, with a suggestion of further rooms beyond, filled with pictures, books, objects, furniture; the other door muffled, covered with quilted fabric; beyond that mirrors, and beyond them a photograph of Elsa, black-and-white, covering the entire wall. Draped with curtains, her image awaits the visitor like a shrine.

Everything Aragon has surrounded himself with lives from contrasts, incompatibilities. Every corner of his apartment is occupied by memories. Books, paintings and drawings by the hundreds, by Picasso, Max Ernst, Matisse, Masson, Magritte, Duchamp, Man Ray—and now and then a Russian artist who, Aragon says, was constantly persecuted. And Elsa's austere, judging gaze—it meets you wherever you look, from photographs, from drawings by Matisse. Is she Aragon's *belle dame sans merci*? Behind every line he has written since he

Louis Aragon, Paris, 1978. Photo by W. Spies

met her, her presence ticks inexorably. It was she who took him to the Soviet Union for the first time. And there is no doubt that his turn to a style aiming at agitation and change owed much to Soviet writing.

Mayakovsky—not so much his work as his effect on the masses—must have struck Aragon like a revelation. *Hourra l'Oural* of 1934 showed how deep it went. In the meantime he talks about this period as if it were some exotic realm he had discovered, and his fascination with the visual is all-apparent: "It is simply beyond our comprehension, that fantastic life, that fantastic poverty. The development of the Urals, that was Russia's version of America's 'go west'. The mayor of a small town brought us a chicken as a gift once. Nobody had eaten chicken in that place for years." The gourmet of strange situations gets the better of the realist in Aragon: "Incredible, the poverty of those people in the GUM department store in Moscow, beleaguering the goods in the locked showcases. Things that for them were unattainable, that they'd never seen before. You could only buy them with foreign currency." Typical of Aragon's talk are his paratactic constructions, his juxtapositions, like collages. Between one sentence and the next the grotesque, sarcastic, startling pop up.

His talk recalls the early experiments, the Aragon who was one of the master designers of contemporary sensibility. His was an ability to be at one with the world, to celebrate in a radically new way the simultaneity and equivalency of all emotions called forth by people—and even more by things. He replaced a psychological with an objective view of the world, encircling the plainest, most obvious things with a halo of confusing strangeness. His work had an ambiguity that he would not attain later, in the novels he wrote with a schoolmaster's brio. Not until the *nouveau roman* was the Surrealist rejection of the uninterrupted story line taken up again—at a time when Aragon himself, still half numb, was trying to shake off his belief in the "scientific" writer's omniscience.

Among Walter Benjamin's letters there is one, dated May 31, 1935, which is quoted by everyone hoping for profane enlightenment from Surrealism: "At its beginning stands Aragon—the *Paysan de Paris*, of which I could never read more than two or three pages at night in bed, because my heart started pounding so violently that I had to put the book aside." There is probably no other book, by Aragon or any other Surrealist writer, that could set off such a torrent of emotion in a prospective follower. From this book, its montage technique, its themes, the extremely enervating mixture of chance, banal, overlooked facts, nearly all the elements of today's poetics of contradiction have been lifted; without which no conscious aesthetic position seems imaginable any more. As everybody knows Breton and Aragon and their circle, encouraged by Valery and Apollinaire, declared the crisis of the novel and of storytelling itself to be a historically, even an anthropologically unique situation.

One would have expected that Aragon, who so irresistibly evoked this infinitely fragile moment in time, would in old age focus on this ecstatic phase of his life. And yet he reacted to my first question with a coldness, a suspiciousness that at first seemed unnatural: "It was a book like any other. There is no basic difference between *Paysan de Paris* and the later ones. It contradicted its time just as did the other books, written in the course of the years."

Aragon cannot admit to anything like a break in his work. "Nostalgia for *Le Paysan de Paris?* No question of that. I don't know such feelings. Life for me is the here and now. I don't play with lost Edens. The only thing I accept is the opposite of nostalgia, continuous stocktaking." And he adds with a certain smugness: "No one can hurt me any more. I'm used to it. At Breton's funeral leaflets were distributed at the cemetery saying: 'A double scandal—Breton is dead and Aragon lives on'. Do I regret anything? No, for that I'm not naive enough."

The sharpness with which these sentences were uttered is a defense against personal vulnerability and—as anyone knows who has even superficially followed a voluminous production that in the course of six decades has often slipped into barbarism and doggerel—against a criticism that is constantly provoked by his frighteningly prompt embrace of convictions and linguistic regulations. "I don't understand retrospective sentimentalities. Recently, shortly before I went vacationing in Toulon, Cohn-Bendit phoned me. Believe me, if anyone was consumed by nostalgia and complained about the times, it wasn't me."

Aragon is forever building new pedestals for his chameleon selves. A one-event person like Cohn-Bendit, who lives off the interest of an unrepeatable investment, does not fit into his historical picture. Sentimentality would undermine his

higher ambition—to act out the continuity and indivisibility of the writer, the poet, and the man Louis Aragon.

Let us take a look at *Paysan de Paris* with this in mind. What the exegetes would uncover in this startingly associative work that rings all the then-known changes on citation and montage, namely a revelation rising like a rainbow from the corpse of the past—that has no real bearing on the book. There was no distance in time between Aragon and his material; his perspective was a spiritual one that set itself to snap the unbreakable storyline and down the hierarchy of tellable things. It was not the aura of the antiquated that appealed to him (on this point, emphasized in conversation, he disagrees with Benjamin's and Adorno's interpretation of Surrealism), but rather something his contemporaries had overlooked. As he put it, "When I wrote *Paysan de Paris,* the world I described, the demi-monde of the arcades and the park on the hills of Chaumont, was a most banal thing. No serious literature would use such places to evoke an aesthetic thrill. I wrote the book in straight present tense. Basically I wrote it from nature. The description is that of a reality which I registered before it disappeared—with topographical exactness."

Aragon turned eighty on October 3, 1977. Which of his many personae can be taken as representative, if any? The incomparable angry young man of the early twenties, who could slip on, like a T-shirt, those words from *Aden, Arabie* by Paul Nizan: "I was twenty—I defy anyone to say that that's the finest time of life"; or the Aragon who, in his friendship with André Breton received and passed on his strongest impulses? Or the true-believing communist who took the Moscow trials and the de- and re-Stalinizations in stride with amazing casuistry?

THE DESIRE TO SEDUCE Can Aragon the communist be explained—as Pierre Daix, one of his most knowledgeable biographers contends—through the psychological generalization that, continually in search of a family, he first found the Surrealists and then the Mother Party? The story of the illegitimate child who for years lived in his petit bourgeois family as his own mother's brother is just the kind of thing Freudians relish. Aragon refuses to countenance this version because he sees it curtailing his Dadaist-Surrealist self-determination. And freedom of will is very important to him. This is one of the few points that still get his hackles up, even today, long after he has pulled every possible register of thought and argument. "This psychologizing of my childhood exists in the mind of poor Pierre Daix, and nowhere else." And he adds, "I was not an unhappy child. I saw through the game and knew that my guardian (a cynical Voltairean he was), whom my sister-mother and I met in the Bois de Boulogne on Thursdays when there was no school—was my father. I played along with them. It fit in very well with my early suspicions about myth and mystification. Not for nothing did I read Dickens, and a little later *Fantomas,* so enthusiastically. I was personally living a dime novel."

How irritated he was! There he sat, legs thrown over the armrest of his chair, performing for hours on end. In rhythm with his speech, he'd sit up, then sink back again, laughing at his bon mots. Sometimes I could only listen with half an ear, remembered comments about him running through my mind—Breton's "Aragon really has read everything," or George Limbour's remarks about

Aragon's diabolic memory. His stories go into the greatest detail, then suddenly he veers off to something else. And yet everything he talked about that day seemed to turn on sacrilege. He recalled the years before Elsa, proffered details that were meant to show him in the role that with every fiber of his sensuality and his seducable intelligence he plays so well—that of the libertine. Wherever he could, he pinned down dates in his early life by some excess. This was the Aragon of the first writings, who steadily rejected the factual report and cared less about a coherent story than about details in closeup. And all this he conveyed through the magnifying glass of his eloquence.

Frightening to think of all the metamorphoses of this man who, like Malraux and Sartre, became one of the institutions of the land. What in this maze of statements and partisanships, cannot be found of the categorical opinions, verdicts and doctrines that the past six decades had produced? Among the letters and manuscripts that by his instructions, are to remain locked away during his lifetime, is this sentence, jotted down in the early twenties: "The desire to seduce has corrupted me. It grips me anew hour by hour. I've got to discover my limitations. Everything drives me to new adventures."

That may be the cause of the paralyzing frustration felt by anyone who, trying to see Aragon whole, is unable to suppress the evidence that shows him throwing his genius with almost masochistic relish under the wheels of socialist realism. Even his selfcriticism he stylizes by turning his youthful fascination with Lautréamont upside down. "I was a strangely unadapted being. Excesses of formulation enraptured me. And like all my friends, I loved things that ended badly and were monstrous."

Impossible to overlook, the writings that worship Stalinism or proclaim the sinister Lysenko the Galileo of our day. Aragon's jump from subjectivity to political speechifying leaves one appalled at the limits of intellectual competence. In this hero's life there is evidently no dilemma, nothing comparable to Sartre's ethics. Abstract belief in the revolution—and this is coincident, a priori, with the hopes of Surrealism—with Aragon is not leavened by doubt or at least despair, quite unlike Sartre and the others who always related the possibility of a changed world to the constant of human existential misery.

THE PARTY FOLLOWER OF ZDANOV It would be lying to concoct some high sounding name for this life that has touched on everything in life that is praiseworthy and abhorrent. The breathtaking individualism of the early books, *Anicet ou le Panorama, Le Paysan de Paris,* or *Traité du Style,* brilliantly balanced between Dadaist revolt and Surrealist epiphany of the profane, made way for partisanship of Andrei Zdanov—and after a spell as mock-historical troubadour Aragon ended up in parochial bondage, exercising literature as force. And for this power he paid the highest price, namely acceptance of the socialist realism promulgated by Zdanov in 1934, at the First Soviet Writers' Congress in Moscow. Appropriation of the classical heritage, definition of the modern hero— all that uprooted Aragon. Nothing can hide the fact that the stylistically brilliant novels he then wrote—which with the six-volume *The Communists* made him the limner of this historic period—were written at the price of the essence of his uniqueness, that ability to radically, personally penetrate the enigma of what outwardly is wholly undramatic.

WILL THE TRUTHFUL LIAR CONFESS? The mental acrobatics and self-abasement this man of critical genius must have been prepared to undergo, can be better gathered from the smug annals of the French Communist Party than from any of the countless acts of contrition that French dissidents have performed since the Hitler-Stalin pact or, fifteen years later, the Twentieth Party Congress. Yes, Aragon did condemn, and vehemently, the Russian invasion of Prague in 1968. But the French Communist Party as a whole reacted no differently. This lip service to the cause of the Prague Spring did not interfere with a fairly prompt resumption of normal relations with Moscow, but Aragon had to pay for the "normalization" that began in June 1969, at the Moscow Conference of Communist Parties: no one was prepared to continue support for *Lettres Françaises*, of which Aragon was editor. Shorn of his influence he no longer bothers anyone when he responds to invitations from the USSR with the following condition: "Yes, I'll come, when the last Russian soldier has been withdrawn from Czechoslovakia."

If he feels a need to justify himself, nothing can be read in his face. Across from the huge image of Elsa, next to the apartment door, hangs a portrait of Byron. He has loved Byron since childhood, and he indulges himself, at public appearances, by reading from his friend Jean Ristat's *Lord B*, and with an English accent to boot. Does this reveal something which he keeps hidden in his fabrication of what he calls *mentirvrai*, his "lietruth"? Has he found in Byron, as he had before in Rimbaud—the splendid dialogue he has with Rimbaud at the beginning of *Anicet* comes to mind—a portrait that he'd like to usurp? Byron's satanism, fed by Milton—would that be a hint? But he quickly changes the subject as soon as he feels that *mentirvrai* might turn into a confession.

He declares: "The things for which I live and for which I fought have remained the same. I've been a Communist for fifty-one years. I've never regretted it, even when I violently objected to one thing or another. I hoped things could be changed." But then he adds: "In a certain sense, I've risked too big a stake."

Paris, 1977

THE WORLD IS NEVER SELF-CONTAINED

On January 4, 1976, André Masson, one of the most turbulent spirits on the Paris scene, was eighty years old. There are not many artists who succeed in totally mesmerizing those around them, like this small, fiery-headed imp.

Masson belongs to the authentic constructors of an artistic skepticism that shaped the art of our century. A little historical research and fairness can convincingly show that Masson's spontaneity and calligraphic irritability were present at the inception of even one of the most recent new movements: Action Painting. This relationship seems more evident to Americans than to Europeans. It was with good reason that the Museum of Modern Art in New York had a retrospective to celebrate his eightieth birthday. Masson's stay in the United

Painting by André Masson.

States during World War II was of surpassing importance to such American artists as Jackson Pollock, Arshile Gorky, Franz Kline.

Masson is one of those who pushed crisis, awareness of crisis into aesthetics. That is as true of his conception of painting, of what a painting ought to be, as of his choice of themes, which turn on massacres and disasters. For the Surrealists, Masson's work soon became a vanishing point of the imagination. In him they discovered not only new stylistic and iconographic tendencies but new demands on the structured self. André Breton notes, in *Le Prestige d'André Breton,* a thought that strikingly characterizes Masson's attitude toward the sum total of life: "The problem is no longer, as it once was, to know whether a picture can, for example, hold its own against a wheat field, but whether it can stand up alongside a daily paper that, opened or closed, represents a jungle."

What is typical Masson? That is the first question to come to mind. Typical is the flow of his art, his development; typical is his compulsion to react to every creative and destructive impulse at the very moment of experience. Typical too is his trust in self-endangerment, to which he constantly exposes himself. Masson has reacted to each and every inhumanitarian tendency of this century: to the First World War, to fascism, to the Algerian war. That is why Jean-Paul Sartre could write that with Masson the purpose of painting could not be separated from the purpose of being human.

Who is André Masson? First of all, he is part of Surrealism. No other artist of this persuasion contributed so much to the illustration of the journal *La Revolution Surrealiste.* His drawings and reproductions of his paintings accompanied the first texts of André Breton, Louis Aragon.

At the time Surrealist theoreticians talked constantly about automatic writing. It brought forth a flood of free-association imagery, largely unimpeded by the working process. Masson took over the concept and made automatic drawings. He did not however simply transpose Surrealist literature into graphic terms. The very elan of his drawing prevented that. Masson's case showed precisely that Surrealist painting and drawing could come out of circumstances that were not dependent on literary models.

The Surrealist element in Masson's work is often too strongly accentuated and singled out. This trait is simply one part of the artist's creative and intellectual constitution. Though Masson briefly belonged to the Surrealist movement, he refused to accept its articles of faith, and was promptly excommunicated from the fold. That Masson could not be a Surrealist in the thematic-veristic sense is also shown by the fact that Daniel-Henry Kahnweiler, who at the time would not accept Surrealism as a style, always backed Masson. In fact, he gave Masson his first one-man show in 1924, the show that brought the painter to Breton's attention.

Kahnweiler met Masson in the early 1920s. Appreciation was facilitated for the champion of Cubism by the fact that Masson in his early works was still influenced by Juan Gris. Nevertheless he subjected Cubism to a strongly rhythmic, turbulent analysis. Picasso, to whom Kahnweiler showed Masson's early pictures, recognized this immediately and said that Masson used Cubist forms but made them encompass emotions the Cubists had never thought of. Two years before the Surrealist movement had its official start, Paul Eluard wrote in 1923 about Masson's pictures: "We often see clouds on the table. We also see

glasses, hands, pipes, cards, fruit, knives, birds, fish." The structure of Masson's Cubism established a new, poetic connection between pictorial objects.

Masson's still lifes are nervous. They contain explosive material, a Baroque breakup of form. This Baroque tendency never disappeared from his work. In his writings and conversations, Masson often refers to formal principles of the Baroque, to the connection between unrestraint *and* moderation. But Masson produced more than an expressive version of Cubism. The themes he treated in his pictures were also unusual. He brought in emblems and symbols, thus expanding the question of legibility that Cubism had raised by an imaginative dimension.

Masson remained true to this interest in subject. It cannot be repeated often enough that Masson is one of the most faithful practitioners of object-related painting. Even where he seems to abandon reality and to let his pencil wander aimlessly across the paper, the interest in the iconography can still be felt. His so called automatic drawings, and the sand pictures that benefited from these forerunners of action painting, are in no way abstract. Masson always gave them an element of reality.

One of the central pictures of Masson's Surrealist period, a painting full of allusions to Heraclitus, is titled *There Is No Self-Contained World.* This phrase is the best key to this self-tortured painting, hurled onto canvas with such stupendous vehemence. It can be used to disprove the major complaint against Masson—that he is an intellectual artist. If the view is limited to Masson's themes, of course he can be called a painter who immensely increased the difficulties of reading his work with all kinds of complex citations and references, one who replaced spontaneity with erudition.

This reproach, however, has lost its point: first, because learned, allusive art has increasingly become part of the scene and has been accepted; and second, because the formal qualities in the successful works are so evident that one forgets the laborious, less than satisfying intellectual footwork of the second-rank works. The new beginnings, the conversions in André Masson's work are often at first glance incomprehensible—even intolerable. In this he resembles Picasso, who likewise frustrated any teleological view of his work. But today, beyond the clamor of countless passing notions, we perceive the unity in his work. With Masson this unity came from spontaneity, from the automatic drawing he handled so supremely well.

The splatter of his calligraphy, the tattered remnants of form flung on canvas and paper, sap all meaning from the charge that Masson is an intellectual painter. When he works, Masson—who can talk art like no other—leaves the known behind and puts the non-conceptual, the preconscious onto canvas. The reference to Nietzsche that arises so often in conversation with him, is more important than intellectual fabrication. Concepts like metamorphosis or injury, a tragic view of life, or the realization of the terror that is human destiny, bring us closer to these images.

The word that is most helpful in defining the essense of Masson's art is metamorphosis. In so many of his works the forms merge into each other, the boundaries between the crystalline, plant, and animal worlds are shattered. Masson's early works, those still close to Cubism, took from it the economical, carefully measured handling of color.

In the following period his pictorial structure became more planar and more agitated. Gradually the drawing that states the theme drowns divisions, and line totally determines the architecture of his work. The Surrealist period was quite short. Though inherent in his work from the outset, Surrealism stepped plainly into the foreground only briefly. In the *Tower of Sleep* (1938) for instance, Masson made use of Surrealist optical illusion. Such works, in which he turned to historic techniques and styles, need not detain us long. They lead to an extremely fecund period, to the works done in the Antilles and, during World War II, in the United States, works that materialize color in an astonishing way.

The dark, somber pictures Masson did in America were followed, after his return to France, by works that seem almost impressionistic. These pictures, animistic in character, seem to put the whole world in motion. They deserve a place of honor next to the Cubist and American works. The brush stroke is once more nervous, twitching, the coloration light. A calligraphy that, as before, is superimposed upon solidly anchored color surfaces, becomes dominant in the subsequent works. Masson often speaks of his debt to Far Eastern art.

These past few years Masson has abandoned the calligraphic phase in favor of works that refer back to his own beginnings. Here pictorial architectonics and easier readability come into their own once more. André Breton once called Masson a Nietzschean spirit. Reading Nietzsche did give him a foundation for his nonfinito philosophy of life, for his anthropology of becoming. When the world is unfinished, what can an artist do but, by splitting apart existing elements, himself give new variations of the possible?

Paris, 1976

SALVADOR DALI AND RADICAL DESIRE *How*
Paris staged the Spaniard's oeuvre

Say Dali and smile lasciviously and the public will flock to your door. By now one might have expected people to look at him a little more askance, this painter with his paranoic-critical method that in the meantime has grown about as shabby as Sunset Boulevard. But Dali, of course, has always been immune to criticism. When André Breton, in the thirties, called him Avidor Dollar, he picked up the anagram and wore it like an honorable doctorate.

In France Dali had to wait a long time for a museum show of the caliber now running at Centre George Pompidou (until April 14, 1980). The retrospective has been delayed by several years more, justifiably so, since during the planning stages Dali had compromised himself by making a few absolutely unqualified remarks in favor of executions under the Franco regime.

What do people find so fascinating as to make them stand for hours in line to see it? Probably not the rather rundown Dali of the past thirty or forty years, for whom the second half of this retrospective provides a Dantesque coda. The experiments with stereoscopic images that you have to stare at through optical

apparatus, such huge potboilers as *La Gare de Perpignan* (1965), and the stale if stimulating frappés of the latest pictures, compared to the amusement and shock of his earlier work, are just long drawn-out ennui.

Picasso could become a mythical figure of our times because for all the shocking harshness with which he treated reality, he retained an infinite tenderness and closeness to life. Is there anything in Dali that would show a necessity to identify, a need for warmth? Much has been made of his conception of freedom; yet when you come right down to it, Dali's vehement, paranoic assurance, qualified by nothing outside of itself, exudes tristesse. Pursuit of a pleasure principle that runs down every taboo in its path and denies even the idea of transgression—can this, appearing in such a generalized form, lead to liberation at all?

Amusing and brilliant as Dali's writings, the early ones that accompanied and commented on his paintings may be, on reading through them again one is depressed by the categorical exclusiveness with which they revolve around a very few desires which were denied to the boy and adolescent. Asocial behavior in this degree, which reduced the poetry of Surrealism very rapidly to private obsession, has been declared the rule by nobody with more fanatic assurance.

André Breton, the theoretician and perhaps even more importantly the organizer of the Surrealist movement, said the following, in conversation in 1952, long after his break with Dali: "For three or four years he was the incarnation of the Surrealist spirit, and his genius filled him with a glow that was possible only for a man who had not been involved at all in the inception of the movement with its often unpleasant episodes."

Salvador Dali was a Surrealist of the second hour. He joined the group at the end of the twenties, at a point when the internecine war among its members had awakened in Breton the hope, almost desperate, of finding some new basis for agreement. Put bluntly, there was an opening in the market and Dali hastened to fill it. This was the time of the Second Surrealist Manifesto, 1929, in which Breton had dropped almost every reference to the psychic automatism which he had praised just four years earlier as the only artistic-intellectual tactic, giving priority instead to illusionistically precise renderings of dreamlike images. At this point Dali came on the scene to give Breton what seemed almost like predestined revenge, by allowing him to confront Masson and Tanguy, who had been excommunicated from the group, with an artist who spectacularly and immediately made a public splash. Dali's painted dream-photography had nothing in common with automatic drawing, which was hermetic and based on the comprehension of amorphous configurations of line and form.

Lack of success was something Dali never had to complain of, even though his clowning and self-aggrandizement often brought him nothing more substantial than notoriety. Nevertheless during his early phase he wrote a delectable picaresque novel. His invective, his eccentric behavior and boundless narcissism soon made him the gaudy figurehead of Surrealism. More, he popularized the style like no other—not leastly in the United States, where via advertising and headlines, each crazier than the last, he spread the doctrine and eventually largely monopolized it. By the way, he left no doubt in his writings—*The Secret Life of Salvador Dali* and *Journal d'un génie*—that his aim from the start had

Salvador Dali, 1979. Photo by Jacques Faujour.

been to profit from the dynamism of the group and to collect the fame and gold for himself.

Every concept—or better every moral tenet—breaks down when one attempts to apply it to Dali's life and work. Shamelessness, polymorphic perversity, academicism, imitation of everything that in the field of Surrealist image-combination had a proven effect—why should these be held against him? There was no act to which he could not provide an encore. In voluptuous self-accusation he was the match of a Jean-Jacques Rousseau. Wasn't he one of those brilliant confessors whose favorite game is to buy others' crimes and secrets and ask absolution so to speak *en gros?*

When Breton published his First Surrealist Manifesto in 1924 he surely could not suspect that only a few years later, with Dali, the movement would absorb a figure who was to take everything he wrote there, in flights of often forced rhetoric, so literally. It was one of those remarkable conjunctions of twentieth-century art that with Dali a man appeared who, by simply acting out the frequently gratuitous and inflated written word, transformed it into terror. One could, and some have, spoken of Dali as the Surrealist word become flesh. He at least would see no sacrilege in such a statement of the circumstances.

Dali took as his springboard that key sentence in the first manifesto that defined the psychic automatism the Surrealists aimed at as "thought-dictation without any control by reason, beyond every aesthetic or ethical consideration." Yet how little the Surrealist movement was willing completely to waive moral principle, and how much Breton's and Eluard's notion of liberation continue to owe to certain norms, is shown by their legendary conflict with Dali, who seems positively to have revelled in accusing his friends of squarishness and sublimation. Obvious that he should sneer at their political and social engagement, particularly their approaches to the Clarté group, to the French communists. The long slender French bread that Dali had specially baked and that played such an important part in his actions and pictures, proved his contempt for the human condition: he himself called his loaves "anti-humanitarian," adding: "You might have guessed that Dali's bread was not intended to feed prolific families."

Surely it can be put down to Dali's sadomasochistic equipment that, already at his first meeting with his Surrealist confreres at Cadaqués, he provoked a highly embarrassing cross-examination in which his inquisitors found themselves compelled to ask him about the coprophilic tendencies apparent in such paintings as *Le je lugubre* of 1929. Dali has been called the nominalist figure of Surrealism—his individualistic approach that organized reality such that it served as a control on a system based on obsession, attempted to take Breton's statements as controlling functions. This necessarily led to his taking even the hyperboles that Breton obviously meant only rhetorically or poetically as concrete guidelines for everyday behavior.

Now again in all this we do well not to forget that Dali was anything but a pioneer Surrealist. He belonged to a younger generation; he took up many ideas that were in the air and, initially, practiced what you might call an instrumental Surrealism, a Surrealism according to recipe. Here the Paris exhibition, though it has brought together an abundance of paintings, drawings and documents, unfortunately leaves a number of important questions open. The catalogue too,

which reprints mostly well-known texts by and about Dali, leaves much to be desired. This can be accounted for only partly by the fact that many major paintings were not available—the entire collection of the Dali Museum that Reynold Morse established in Cleveland and which includes such key works as *Bread Basket* (1926), *The Ghost of Vermeer van Delft* (1934), *The First Days of Spring* (1929) and *Slave Market with Apparition of Invisible Bust of Voltaire* (1940)—all had to be done without at this, the most comprehensive Dali retrospective yet.

In about 1928 or 1929 all those elements began to appear in Dali's pictures that foregoing Surrealism had to offer: collage and the blending-in of collage elements with painstakingly painted passages to suggest either overall collage or to hide the additions behind a veil of technical skill; the verism of photographically rendered detail; and the biomorphic stretchings and compressions from which Dali's work was in future to gain much of its shock effect.

Yet none of these ingredients was so new; what was new was the impressive way they were synthesized and dramatized. His confrontation with Surrealist imagery must have liberated Dali, as we can see by comparing his early work, often so labored, with what followed. Striking that what Dali was later so strongly to identify with—an antipsychiatric love of excrement, blood and decay— appears nowhere in his pre-Surrealist phase.

This look at "Dali before Dali" shows how much effort, beyond his stupendous gift at imitating established pictorial languages, he put into creating an inimitable style and custom-tailored obsession. Up to 1928 there is nearly nothing in the oeuvre that would suggest a proto-Surrealist leaning, unless it be a recurring preference for precision-painting that pulls things into slightly oversharp focus. This brought him close to the *pittura metafisica* of de Chirico and Carrà; and, as we may glean from his writings, he was aware of Franz Roh's book *Nach-Expressionismus/Magischer Realismus*.

His fascination with the early Miró predestined him for the veristic wing of Surrealism in any case. Yet surprisingly, in addition to paintings executed with old-masterly care (*Young Girl at Window*, 1925; *Woman at Window in Figueras*, circa 1925-26) we find many, and large formats, that show him engaged with post-Cubism. Among the key works in this regard is *Reclining Woman* of 1926, which takes up the motif of biomorphic distortion that appeared in the work of Max Ernst and Picasso at about that time. Arpian metamorphoses and protuberances also find application to the human figure here. Picasso's variations on the *Anatomy* theme must have triggered Dali to infuse these structural experiments, which at first Picasso conducted in a purely formal spirit, gradually with the typical attributes of his fascination with decay, anomality, and monstrous freaks of nature.

When Dali launched his first pictures—*The Enlightened Pleasures, Adaptation of Desires, The Cruel Game, The Invisible Man*, most of them small in format— Surrealism had already colonized its new continent. Dali arrived to find the place stuck full of the flags the pioneers of Surrealist technique and iconography had planted. How did he go about staking his claim? His biography—and even today this amounts to not much more than autobiography, or sanctioned hagiography— revolves continually around the year 1929, in which we find Dali, expelled from the Royal Academy in Madrid, shunned by his own family, in a hypersensible

neurasthenic state, gripped by fits of laughter. He was saved, we are told, by Gala, Paul Eluard's wife, who was to become his inseparable companion.

Dali's psychological constitution—or better, to quote Lacan, his assumed madness—his fascination with paranoia (if a paranoia capable of development and logically fostered), these require no further discussion here. It is really secondary whether and to what extent Dali used these states only imaginatively, as storehouses of images and provocations. What is certain is that by using them he reanimated one of the central principles of Surrealist doctrine at a time when much in Surrealism had grown moribund through repetition: he reverted to that so crucial profane vision which, via de Chirico, via Max Ernst, Aragon and André Breton, had become a tradition of Surrealist inspirational technique. Dali now systematized this principle of a private revelation understandable only in terms of one's own experience, by equipping it with accents of that mental aberration which makes every sharing of experience impossible from the start.

Although the Surrealists of the first hour did seek their inspiration outside normative aesthetics and render themselves susceptible to strange images with the aid of "sleep states," self-hypnosis, and collective creation, they nevertheless remained proof against any flipping out into totally autistic worlds. The incredible integrative achievement of Breton—which is why I called him even more significant an organizer than a theoretician—cannot be emphasized enough. At a point in history when for the first time literature and art could no longer proceed on the basis of an accepted style, Breton managed to find something like a common denominator for artists' endangerment by private ideologies and private mythologies. And how clearly Surrealist art had, by the end of the twenties, arrived at a recognizable and unique stylistic and icono-graphic syntax, is shown precisely by the circumstance that an eclectic of Dali's stature who in his best work always reflected previous myth and previous method (Millet's *Angelus,* Wilhelm Tell, Vermeer van Delft, Meissonier) could shepherd Surrealism itself into its Mannerist phase.

What Dali contributed in his few great years was the absolutely new quality of an obsessive compulsion to relate everything to himself and to find for everything a lucid, if strictly self-centered, legitimation. There is surely no iconographically more consistent system than Dali's, nor one, by the same token, more exclusively understandable and interpretable only in terms of a single ego. This may fit in with Dali's assertion that he was a realist. Because in a total delusion of relation, which after all is characterized by the denial of any ambiguity of experience of the outside world, and by a closed and perfect logic that refuses to accept a metaphysic of whatever kind as necessary, what was best in Surrealism would be invalidated. The unrepeatable quality of the images of Max Ernst or de Chirico, the truly Surrealistic element that must elude any spelling out in so many words, Dali made part of an internally logical system. If the two above named artists studied Freud, it was in a sense that they were satisfied to be excited by his description of manifest dream content. The Surrealists were not concerned with penetrating, rationally, this content; they understood it as a poetic increment which analysis of the dream would only dissect and destroy. Dali by contrast used as symbols the elements he wrested from his insights into psychopathology, symbols for which he staged his own life and work as a kind of security. That is why from the outset all those elements began to accrue which he intended to

back up with his life. Thus after Freudian symbols what entered his paintings were attributes from Krafft-Ebbing's *Psychopathia sexualis*.

These are striking images and they go deep. Technique, imagination, everything conspires in the important years to produce an unforgettable compellingness. Yet very soon this quality was to be diffused in picture-puzzles, optical riddles that Dali traced on canvas with a snail's patience—he was concerned with double images, anamorphotic vision. A landscape may become a head, a horse be transformed into a woman; yet even that was not enough: the superimpositions began to pile up, fresh images to be grafted onto images already seen. These are surely the most spectacular effects Dali ever offered his public, yet the familiar paralyzing tricks on the eye are often not much more than visual gags. There where vision itself reaches its paroxysm, in *trompe l'oeil*, Surrealist vision is lost, which of course is not out to produce double images but to reveal suppressed, forbidden images for which reality can provide no model.

Paris, 1980

THE EROTIC ANATOMY LESSONS OF AN ELDER *Hans Bellmer in the Paris Centre National d'Art Contemporain, 1972*

A visit to the first French Bellmer retrospective at the Centre National d'Art Contemporain makes it seem as if pornography had long since canonized the erotic. Even the illustrations to Georges Bataille's *History of the Eye* seem to be this side of taboo. Certainly they are this side of censorship, with which the French are not exactly sparing, as publishers have discovered repeatedly these last years. Perhaps the censors realized that a work as fundamentally and, it should be added immediately, one-sidedly erotic as that of Bellmer can only be divided into showable and not showable by means of hairsplitting that borders on the ridiculous.

Censorship would boil down to scanning the work for the visual boundary of the offensive. The work of censors, consisting mainly of plucking phalli out of literature or pictures would, in Bellmer's case, undoubtedly be a matter of exercising stylistic criticism instead of sleuthing for motifs. In any case his work is panerotic, and its content would only be significant where it attained a sufficient degree of realistic representation. Among such works are the illustrations to *L'Histoire de l'oeil*, or *Portrait d'Unica avec l'oeil-sexe*, all of them minor works that in their unfortunate literalness come across not so much sensual as dreary.

The organizers of the exhibition, left alone by the censors, have instituted a type of negative censorship of their own. They have put the objectionable things in a separate, little red-painted chamber by themselves. This hurt the exhibition. It gave the impression that only in these works did Bellmer say just what he wanted, while in the others he more or less watered down his erotics to suit the

law. Let us counter this impression with the reminder that Bellmer, as his life story plainly shows, has always expressed himself without reservation.

His first work, the first version of the "doll," shows this with all possible clarity. It would not be easy to find a more scandalous "sculpture." Even today the photographs, arranged around the doll itself in a satanically black private booth, have kept their oppressive, disagreeable mustiness. In the early thirties, this sculpture announced Bellmer's claim to fun, freedom, and sadism. The boundaries have shifted so often in our time that the erotic, which stimulates by transgressing them, threatens to bring about its own end. Georges Bataille, who put together an anthropology of the erotic (*L'Erotisme*, Paris, 1957), concluded that though transgression lifts the taboo, it does not actually remove it. This was formulated out of a metaphysical view of the erotic, which in its complex analysis of the most varied taboos separates them from the unfree, instinctual (that is nonerotic) sexual behavior of animals.

Newsstand pornography has no relation to Bataille's concept, which derives from ethnological and theological knowledge. In fact, careful examination of this fascinating interpretation, which links death and Eros, could lead to the rather extreme conclusion that the sexual offender is as far away from Bataille's concept as the enlightened, perfectly calm practitioner, because involuntary negation of the boundary does away with the erotic as effectively as does hygienic completion of the act. The erotic, as Bataille defines it, offers the discontinuous individual the continuity of life that only the death of the discontinuous being can establish. Eroticism is the attempt to establish the continuity, at least for a time, of two beings based in discontinuity. That is why, for Bataille as well as for the other theoreticians and strategists of the erotic, death steps in symbolically every time. It is presupposed that for Bataille, death is not experienced in its clinically clean, enlightened package, but as the true scandal of being human. Michel Foucault, going back to the concept of Bataille's transgression, also conceives of eroticism as a means of drawing boundaries between one's own, finite being and the infinite. But unlike Bataille who, in line with his roots in Surrealism, seeks a mystical echo, Foucault starts from the premise that this experience is linked to a particular historical image of humanity, namely the Christian one. He considers it less as an ontological state of humanity than as one that has become sociohistorical. Therefore he can conclude that modern sexuality is as secularized today as any other human behavior.

The erotic world of Bellmer is very close to Bataille's definition. The idea of sin and transgression is crucial to it. Ban and taboo attract him as much as the sensual itself. Hans Bellmer has been living in France since the late 1930s. His fame has remained somewhat limited since it has been too much that of a specialist. In addition, Bellmer, unlike the few great representatives of Surrealist art, has stressed motif much more than stylistic innovation. This became obvious in the great Paris retrospective. As fascinatingly exact as Bellmer is in his drawing, he basically, like Dali, devoutly follows his academy. Even more than Dali, his effortless fine drawing finally victimized him. Only with the greatest self-control does he avoid falling into the medieval mastership he admired.

His most interesting and only attempts to throw off this top-of-the-class facility took place in the late thirties. In *Piers* we see a woman's head that seems to come straight out of Picasso's *Guernica;* in *The Girl and Her Shadow*, there is Tanguy's

world doubled by shadows; and in *Clodia—a Shameless Woman*, we are reminded of Dali. Such strong influences in the wake of the move to Paris forced Bellmer to change his style, which by nature aimed at verisimilitude, and adapt it to existing stylistic influences. In the past twenty to thirty years, Bellmer's style has grown largely schematized. No new influences have been absorbed.

Here it becomes clear that Bellmer does not fit into any avant-garde movement except in an altogether limited sense. As with Dali, the most striking effects arise where his stunning craftsmanship combines with distortions that are more a matter of content than of style. The heart of Bellmer's draftsmanship is historical: late medieval-Mannerist. It plays first in both content and style against the background of late medieval art. In a century of not only unrestrained innovation but of constant reversion, Bellmer casts his eye on Hans Baldung Grien, Albrecht Altdorfer, Matthias Grünewald, Niklaus Manuel Deutsch. *Love and Death, Woman and Death*, the vanitas theme, turn up in Bellmer with oppressive persistence. In the early drawings at the start of the thirties, the bodies are ripped open, shot through with iridescent decay. His drawing clearly tries to capture the atmosphere of Altdorfer's romantic early works *Hexen am Blocksberg*, 1506, and *Wilder Mann*, 1508. The dark-hued paper on which the white drawing almost gives the impression of a negative, creates a powerful effect. The reversal of light and dark, technically a paradox, enhances the perverse content of the portrayal.

The style becomes symbolic here. Even if Bellmer later abandoned this technique in its pure form, to draw in black on a white or lightly tinted background, he very often used white highlights for effect. In the bodies that intertwine and twist into an erotic superform, certain parts are touched with opaque white, leaving us in no doubt about where to find the erogenous zones.

At the head of this necromantic, erotic anatomy lesson stands Bellmer the puppeteer. Friends made this Bakelite world of violence more palatable to him. In 1933 he started his destructive construction, a libido substitute par excellence. A psychoanalytic interpretation of Bellmer's doll is made particularly easy by the circumstances of his childhood. Born in 1902 in Katowitz, the boy's strict and hated father terrorized him in a way reminiscent of Kafka's sufferings. Wieland Schmied, in the foreword to the 1967 Bellmer exhibition of the Kestner Gesellschaft, came to the convincing conclusion that the "doll," unlike Kafka's *Letters to My Father*, did become a real act of liberation. Indeed this self-analysis allowed Bellmer totally to break with his father. The circumstances of this liberation were captured in photos that immediately interested the Paris Surrealists, and which in 1934 and 1935 appeared in the journal *Minotaure*. The distance of time makes them seem more Expressionist than Surrealist. Particularly the photo-series "The Games of the Doll," to which Paul Eluard wrote accompanying prose poems, is like a coda to Fritz Lang's *M* (1931). In the drawings, this direct terror disappears behind a mass of allusions to mythical child murders: the death of Adonis, the Massacre of the Innocents, the ritual murders of Gilles de Rais which last was also a favorite theme of Bataille's.

To the style of the German primitives were soon added Mannerist influences. Among these anamorphoses and superimposed images that can be read in more than one way were foremost. In *Les Mille filles* (1942) a literal quote from Arcimboldo's *Herod* appears, a head that is built up of numerous female figures. Two of Bellmer's main approaches were already illustrated in "The Games of the

Doll''; overall representation and *pars pro toto*. Bellmer oscillates between the two. Explicit realism and formal symbolism stand opposed. In the latter case, Bellmer manages without literalism, and brings off his best drawings—drawings in which joints, limbs, bodies, though they do not quite merge into abstract, unrecognizable form, do acquire a tolerable independence.

Paris, 1972

THE GRAND RENUNCIATION *On the death of* Marcel Duchamp '

In Neuilly, in the small studio reached by a rickety elevator, Marcel Duchamp has died, there among the strange objects he had assembled during a long and calculated protest against art, amid the bottle racks, the urinals, the *Fresh Widow*. He had come here for a few weeks every year, in spring and autumn; usually he was to be found in New York, near Union Square, where he was at home, where, unwillingly perhaps, he had succeeded.

In the next few months every art critic and his sophomore class will once again descend on what, for lack of an oeuvre, is called Duchamp's message. The magnificent gesture of this No-sayer has long since been customized into what to many seems the most significant Yes anyone has given art in our century. With Paul Valéry, Duchamp might well have said, "To be a poet, no. *To be able* to be one."

Marcel Duchamp turned his back on the art business quite early—many think at the zenith of his triumph—to devote his life to possibilities. His renunciation has since become the cornerstone of many an aesthetic system; the negator a mythical figure; the abstinence of genius the only possible work. For decades Duchamp stuck it out, pondering how to fill the void he had substituted for an oeuvre with intentions. The most astonishing thing is that he furnished this difficult space only with such gestures and words as seemed indispensable to keep his negation alive.

Negation on a slow flame—that was Duchamp's recipe and his accomplishment: a little more heat, a touch less, and he would have been finished. After twenty years this procedure had admittedly grown a little shaky, particularly when he decided to have his Readymades turned out in series and marketed. Suddenly Duchamp retreated to the security of what had become his historic achievement, having no further gesture to add—unless one takes the contradiction in terms that editions of Readymades were, to be one more dialectical twist intended to cast doubt even on the proverbial integrity and incorruptibility of Marcel Duchamp.

With a mind that compels us to interpret its every utterance, its every motion, we eventually find it impossible to take anything at face value. To assess Duchamp, his life is as important as the "works" he left. He was the first artist to substitute life for work, to offer his person to interpretation. He is the Interpreted

Marcel Duchamp, 1967. Photo by Wolfgang Haut.

Man—every step he took was more than a step; behind every movement of the hand there must surely be, one thought, some message.

Marcel Duchamp's renunciation of painting and art is one of the most decisive, and certainly most often retold events in the art of this century—that much at least is clear. The number of those who have since adopted his stance and copied his decision to replace *objets d'art* with just objects or montages or assemblages of them, has grown too dismally large to count. Pop and the Neo-Realisms have reduced Duchamp's complex matrix of protest to superbly saleable objects. They have diluted his achievement because they understood it merely formally. Believing that his concern was with demonstrating the abstruse shapes of the abstruse things consumer society waves under our noses day in and day out, they outdo themselves in providing new objects for our meditation. For Duchamp, the form of the particular object he presented to us was secondary—what counted was the silence between one skeptical, nihilistic gesture and the next. And since over the past years even this silence and its demonstration have been aestheticized, they have virtually lost their anti-art character.

Duchamp himself could not escape the wear and tear suffered by the object in its battle against the painted, sculpted work. He was well aware of this, and as the sum of my discussion with him I can state that the immense effort on the part

of younger artists to integrate everything into art took him by surprise. When in 1913 he mounted a bicycle wheel upside down on a stool, he could not guess that this rotten egg in the face of fine art would be the favorite dish of a coming generation. He did not take into account that when art forsakes its inherited function of portrayal, any act, every imaginable object, can be heralded as art; he perhaps forgot to remember that actions can only displace, never replace art.

What Duchamp did achieve through his protest was to open up new regions to aesthetic awareness—a positive result that counterbalanced his nihilism. Yet now, in the seventies it takes almost an archaeologist to uncover what was revolutionary about Duchamp's revolutionary gesture. It can be done by thinking him back into the time against which he rebelled. In 1913, at the New York Armory Show, which brought Cubism and Futurism to American attention for the first time, Duchamp exhibited his *Nude Descending a Staircase*. It was the hit of the show. There at last was a real Futurist picture; at last Futurism, about which so much had been written, could be judged on American soil. One tends to forget that Duchamp (who could be called a Futurist only with reservations) was the only painter at the show to offer futuristic attractions. The Futurists themselves were not represented there. Duchamp undoubtedly profited from the unique opportunity; it brought him the fame without which his renunciation of art could never have been magnified into an event. If it had not been for the sudden reputation he gained through the New York show, his grand gesture would have been shrugged off. Nor should we forget that Duchamp's subsequent renunciations took place almost exclusively on the American scene, which is where he had his support—in France, he is regarded with skepticism to this day.

The hour was propitious for Duchamp's act—which alone does not explain it. It could hardly have been a pose since, aside from a very few of his contemporaries, no one in France grasped the meaning of this step. Might it have expressed, besides a deliberate anti-artistic stance, a certain insight into his own artistic capabilities? That is a question which few dare ask in public. Why not put it to Duchamp? I did, and received an answer as disarming as it was simple: Back then he had had no great chance of succeeding in Paris as a painter. Thus his decision to give up painting can be traced back to a piece of honest self-assessment. Fine, but that explains Duchamp only in part, and his revolt against art not at all. There is no resentment lurking beneath his subversive action, which was too disinterested, too disdainful, too serious for that.

Historically, Duchamp will come to be seen as the great negator. In the context of the present, he looks smaller, because he has trouble making himself noticed among the crowds of amateurs of negation. Of course Duchamp's protest was not the only authentic one. Future historians will record and compile the anti-authoritarian, anti-artistic occurrences of our century; they will find an equally strong bias against the aesthetic object in the work of Picasso for instance, or Hans Arp, or Max Ernst. Above all they will note that the protest against art could, at least for a time, make very good use of artistic means. True, Duchamp exhibited his bottle rack before Picasso began his brilliant, open-ended game with the shapes of the human form. Yet *Guernica, Crying Woman*, repudiate convention more effectively than do Duchamp's gestures—the objects he animated against art, like toys in a fairy tale, turned back into bric-a-brac overnight. What remains in an impressive struggle to elude history by ever new means, the

tragicomic attempt to stabilize once and for all a posture, a decision. Duchamp wanted to remain Duchamp, the artist who withdrew from art at the apex of his artistic renown. He did not want his No to be exalted to a conformist Yes.

Paris, 1968

THE GATES OF PARADISE AND A GLIMPSE OF BEAUTY *The complete oeuvre of Marcel Duchamp in New York—A final reconciliation with art?*

Marcel Duchamp at the Museum of Modern Art, complete—Europe is not likely ever to get such an all-encompassing view of his work, particularly since most of it is American-owned. The Arensberg Collection in Philadelphia has a monopoly on Duchamp similar to the one Amsterdam has on Malevich. Only two of Duchamp's major works, the *Large Glass* and *Etants donnés*, were absent from the show; otherwise the opportunity to study virtually his entire output was unique.

The mystery, the fascination and the annoyance that Duchamp has given rise to, have if anything increased in recent years. Ever since the great retrospective at the Tate Gallery in 1966, which concentrated on illustrating Duchamp's utopia of negation and rejection, this and other aspects of his work have begun to look like prototypes for just about everything of interest the art scene has recently had to offer.

The man who in conversation dared to say of himself that he was nothing but "a breather," posed problems and puzzles to our times that no mere knowledge of the rules can unravel. It even appears impossible to define the limits of his game, that is, to describe what Duchamp's actual work, barring its influences and emanations, comprises. Nearly every piece he made asks to be extrapolated, the idea behind it expanded to cover an entire genre, the entire oeuvre. We begin more and more to see Duchamp from the outside; and the question gets ever more tortuous as to how far we find ourselves in an aesthetic situation which, as Duchamp happened to discover especially early, is the true and general situation of us all—or how far this situation itself was Duchamp's true creation.

FEAR OF MEDIOCRITY? We are faced, anyway, with the certainty that certainty is impossible; and every category of development, statement, artistic law coalesces in the words, "There are no solutions because there are no problems." This deduction goes far beyond even the most radical redefinitions of art which, chained didactically to one avant-garde after another, have been attempted in this century. Duchamp's early progress through art invariably took place within a style—Fauvism, post-Cézanne landscape, Cubism, Futurism—each of which he very quickly brought to a point. He pulled the stops of the style he reacted to until the avant-garde instrument itself disintegrated.

That resentment and conscious irony were at work here, at least initially,

cannot be overlooked. Once, during a train trip between Paris and Rouen (a stretch Duchamp found depressing, as witnessed by his autobiographical picture *Sad Young Man in a Train* of 1911), he gave me a simple answer to the simple question that people quite justifiably have been bothering him with for the past ten or twenty years. He was surrounded, he said, by so many promising people in 1912 and 1913 that he began, as far as his own gifts were concerned, to have his scruples.

This explanation of his secret is convincingly in character: it shows us an ambitious man retiring from the scene before he sinks into mediocrity, or even rises to the level of success that Duchamp could certainly have maintained. That withdrawal is not necessarily the same thing as retreat, he might have gathered from Rimbaud, who by falling silent actually heightened the provocativeness of his work. At all events, seen from our vantage point in the present, against the background of his tremendous influence, Duchamp's decision to give up "retinal" painting naturally does not figure as the absolute negation it must have at the time.

The extent to which he anticipated his coming influence is shown by the fact that he lost no time in moving his base of operations to the United States, to an environment where every eccentricity, no matter how weird, somewhere finds its circle of admirers, and where, thanks to democratic principle, successful individualism is rewarded. Nor should we forget that *Nude Descending a Staircase* caused such a sensation at the Armory Show partly, at least, because the "real" Futurists had no paintings there. Among the static Cubist works Duchamp's picture, by reason of its subject as well as its execution, could not help but focus wonderment and scorn. So it would not seem perverse to claim that Duchamp's effect, for a while, lived off the interest of its capital.

The Readymades which he now provocatively and with studied indifference began to hold up to the painted image, were demonstrably an attempt to circumvent any judgement of style or taste. Rather than works clothed in reciprocal reference he exhibited single, solitary, naked objects which, steadfast in their refusal to be taken for *objets d'art*, simply stated *We are something other than art*—and other, it should be added, than the remainder of Duchamp's gestures, their dialectical link with them notwithstanding. These solitary gestures, their evanescence, their almost total passivity—Duchamp's famous Silence, as sibylline as the smile of the Mona Lisa, which not for nothing goaded him into ever more irritated reactions—all this has to be seen as making up an activity designed to give contours to an identity, not through repetition but through continual contradiction.

It is good to keep in mind that at no point in his career did Duchamp aim, like the Dadaists and Surrealists and their successors, at becoming an object-artist. His rejection of retinal art cannot justifiably be construed as a plea for montage or assemblage. The grand vistas of an art "beyond painting" that Max Ernst spoke of, could not tempt him. The very qualities that constitute the morphology of that brand of art—frames of reference, repetitions that eventually give rise to a personal style—are largely absent from his work. It is in this circumstance, perhaps, that we have the reason for his rarity of intention—it was the only antidote for the compulsive repetition that marks, for instance, the work of Man

Ray; it was the only way to keep his work from contracting that "look" which he feared like the Devil does holy water.

To return to the silence of Marcel Duchamp: In the window of a small gallery on Madison Avenue in New York that had once done a roaring business in multiples, stood a sign with this dictum, written by the left-Duchampian Joseph Beuys: "The silence of Marcel Duchamp is overrated." (This was said in 1964.) At the back of the gallery everything seemed ready for the movers—the furniture was piled up in the middle of the floor, and there was a sign with an address to contact if you wanted to rent the space. (Unless this too was a coded message.) Duchamp's most impassioned critic, who must surely consider his caution sociopolitically questionable, was on hand. Duchamp is bound to bother an artist who thinks that gestures can have a positive influence on sensibility.

Duchamp's indifference was not complete until this day. Beuys's statement is both naive and perfectly right, and it vindicates Duchamp's approach. Seen critically it is yet another confirmation of his influence. The imposing catalogue to the Museum of Modern Art exhibition adds much to Duchamp literature; and the plausibility of the most diverging exegeses grows. Nothing, it seems, cannot be said. And it is next to impossible, apparently, based on Duchamp's work, which is open-ended on principle, to objectively counter anything anyone chooses to say about it.

BEHIND THE GREAT WOODEN DOOR The hints that Duchamp dropped in his sketches, like Holy Writ, are open to construal. Just as Beckett, in *Waiting for Godot*, raised philological discourse to the pseudo-theological, so Duchamp has managed to get a discussion going on artistic agnosticism that is more impassioned than anything the positively intended art of the twentieth century could ever have inspired. If the viewer is irritated by his work, this is simply because he cannot countenance that such complex and formally contradictory things may just be there, as facts; and this inability leads him to do the job, himself, of transplanting what is non-artistic into artistic soil. Looked at in this way, the comment by Arturo Schwarz on the alchemical coding of the *Large Glass*°—a code apparently prefigured in *Young Man and Girl in Spring* (1911)—takes on a meaning beyond the deductions that can be drawn from it, a symbolic meaning that one is tempted to apply to all of Duchamp's activities, since it could help explain the compulsion to mystify to which the viewer feels subjected.

Here it becomes difficult to draw the line between unconscious motive and purposeful intent to conceal. His last work, *Given: 1. The Waterfall, 2. The Illuminating Gas* (1946–66), on which Duchamp worked in secret and which was made public only after his death, forces us to perform another *salto mortale*. Here the terms reduction and conceptualization are completely out of place. Duchamp offers us nothing less than a spectacle, albeit one that many have hastened to read dialectically, as a representational version of the *Large Glass*. That holds, however, for only a very few of the elements that appeared, in schematic form, in the earlier work.

°Arturo Schwarz, *The Complete Works of Marcel Duchamp*, New York, 1969, 2nd rev. ed. 1970

This new work, difficult to transport, remains in situ at the Philadelphia Museum of Art. It confronts the viewer with a large old wooden gate. Two peepholes in the door reveal an incredibly garish panorama: a woman on her back, head concealed, legs spread, a lighted gaslamp in her left hand. Behind her is a lake with a waterfall. The whole scene is bathed in intense light.

A MASTERPIECE FOR YOU AND ME Doubtless any number of iconographic patterns can be applied to this work. It is open enough to accomodate them all, particularly since Duchamp left no notes of any kind about it, except for directions for its installation. Nor can the period of its making, said by Duchamp to be twenty years, be broken down in detail. For single elements—the figure of the woman for example—preliminary studies exist that go back to 1948. It appears, though, that the crass realism of the scene may well have been inspired by one of the latest American trends, environments. Parallels with Edward Kienholz's *The State Hospital* (Moderna Museet, Stockholm) suggest themselves, or with the glamorized landscapes of Lichtenstein. Speaking of comparisons, it is grotesque to observe how those who discuss this piece, attempt to argue away any and all influence on Duchamp, as if his entire oeuvre had not developed in counterpoint to existing trends. Suddenly the ingenuous artist who discovers everything for himself is in demand and the cynical gamesman who has mesmerized his audience for over fifty years is forgotten. Suddenly, post mortem, Duchamp has made it as an artist, out to excite and please, as if all this time modesty alone had prevented him from delivering up the Beautiful Image.

Yet let us stay within the Duchampian categories, which aim at constant revocation of style, mood, expression, the aesthetic per se. In this case, again, what we must try to discover is the ambiguity of the work, avoiding any purely symbolic or allegorical interpretation. The first thing that seems unlikely is that Duchamp wanted to bid farewell to posterity with this one fine last diorama. On the other hand he may, with supreme disdain, have been toying with the highest possible praise an artist can receive, namely that given him by Apollinaire nearly sixty years ago when he said that Duchamp was destined to reconcile the people with art. The reconciliation may be discovered, if you will, in the bringing together of peepshow sex, Broadway style, with the ideal of ecological purity, a Swiss picture-postcard landscape.

In my view several important things have so far been overlooked in the interpretations of this work. Duchamp used a wooden door he had had sent over from Spain, a postcard he had brought from Switzerland, a gaslamp from Belgium, twigs from New Jersey, and bricks from his house in Greenwich Village, which had been razed. Doubtless this choice reflects the American longing to intensify existing reality to meet American needs. Forest Lawn, Malibu, Disneyland are such icons of rectified nature and culture. To explain the woman holding the lamp, critics have enlisted Diana Lucifera and advertising posters for incandescent gas-mantles. Only the most obvious and blatant parallel, with the Statue of Liberty as a fallen woman, nobody has seemed willing to state. Even the little lake in the background fits that motif. Incidentally, Duchamp had already used a picture of the Statue of Liberty once before, in 1946—she appeared, with Breton's face, on the cover of his *Young Cherry Trees Secured Against Hares.*

Thus we stand, at the end of Duchamp's career, before the notable fact that this last work, as definitive answer to a lifelong challenge to art through found objects, presents something that defies all questions: a simulation of natural beauty. The gate of paradise that blocks the general view opens to each pair of eyes individually. The "masterpiece" belongs to everybody, you and me, alone. No pushing, no crowds, no mass hysteria are allowed in front of *this* Mona Lisa. Duchamp's final ironic act is the most difficult one of all, because it includes the effect of "the beautiful".

Only the attempt at liberation it also contains leads us back to our subject, to Duchamp, and thus again to the silence which—measure of twentieth-century anthropology—has nothing but a condescending smile for the aesthetic experience. One should almost like to conclude that if, over the past fifty years, we have attempted to integrate the *Bottle Rack* and the *Fountain* into the aesthetic vista, we now face the paradoxical difficulty of keeping this posthumous, so enjoyable penny-arcade machine *out* of the realm of art. Utopia is a return to pre-Duchamp.

New York, 1974

CANONIZATION OF THE CYNIC *Centre Beaubourg in business—The Marcel Duchamp exhibiton*

At night, gliding through the glass belly of the Centre Beaubourg, the motorized stroller is overcome by one of those empty feelings which Giorgio de Chirico so magnified and fixed in images of emptiness when the century was still young: the fatigue of the infinite.

At this hour the pristine canopied bed of the arts changes into a rumpled cot. The dream of the participation of the many turns out to be a daydream; it passes, leaving dirt and spots on the carpet, cigarette butts, scraps of paper, garbage in the cracks between the bannisters. Naked tristesse slinks down the stairs that lead up to Marcel Ducamp. He is on the fifth floor, and to him has been dedicated the opening show of the new museum, to the man who for fifty years fought shy of the art circus in desperate orgies of abstinence.

Duchamp, again Duchamp. What manner of prophet is he? A cynical one to be sure, but still his canonization is making progress. One of the people responsible for this Paris exhibition has already gone so far as to say, to nearly unanimous applause, that Duchamp is much more significant in every way than "that false prophet, Picasso." Strange that a man who put culture back on calisthenics, who refused to play the stylistic game, should now be declared a pro—and the founder of a sect at that. The claim goes well with the place, which up to now has not really been a place at all.

STEP RIGHT IN, IT'S ONLY ART It has been almost two months now since the Centre Beaubourg was opened to the public. The onslaught was much greater

than predicted. Thousands and thousands of people pass daily through those parts of the building to which admission is free. This includes the ride up to the roof, which is advertised downstairs as offering a fine view of Paris. And everybody who enters the building is counted. Soon the most fabulous manipulated statistics will tell of a hunger for art that certainly does not exist, or at least cannot be measured in those terms. Within the building some areas are roped off, and cost an entrance fee—the entire Musée National d'Art Moderne, for instance, and the elaborate special exhibitions, such as that now running on Duchamp. Everything else, be it the Gerhard Richter show, a horrible overview entitled *A propos de Nice*, or a group show of Icelandic art—all these are free.

Absolute accessibility—the ideal seems almost to have been realized here. No more *public* place can be imagined. Beaubourg has staged—and sociologists and politicians of every persuasion are going to have their hands full for a long time explaining these first gigantic weeks—it has staged a confrontation between the most hermetic artistic practices of our time and an unprepared public of a size never before seen, anywhere. In this sense Beaubourg is truly a pilot project, a reconnoitering of the unknown.

Walking through the complex, which has been designed to make every visitor, even the most museum-shy, feel at home, it almost appears as if the proverbial fear of culture had flipped over into its opposite, namely indiscriminate enjoyment of a mixture of painting, sculpture, interior decoration, cafeteria, and place where the kids are persuaded to paint. Add to this aggression on the part of the public, a reaction with which, outside of totalitarian states, those who argue for an individual appropriation of art have not yet had to deal. The comments, reactions and reflexes one has a chance to observe here, amount to basic criticism of a kind that had completely disappeared from the aesthetic discussion, which after all had not been, or perhaps could not be, carried on in the public eye.

What is "Beaubourg"? And what exactly is happening here? It was André Malraux who coined the ringing phrase about the gods who had changed into sculptures when they moved from the sacred domain into the museum. Beaubourg brings about a metamorphosis of an entirely different order—it yanks art out of the museum. For obviously, the banalization of the aesthetic has never been pushed as far as it has here. Yet art for the masses can cut both ways. Nobody has yet dared to say openly what everybody whispers, namely that about fifty thousand books disappeared from the public library during the first weeks. This sad fact is bound to raise political waves—some will cry Sabotage, others Well, that's the risk of democracy. Whatever the case, the accessibility that has tempted abuse will probably have to be limited.

The Duchamp exhibition was heralded as a major event. It was, once again, to be the most comprehensive, most important ever, in spite of the Americans having already shown the complete Duchamp, most of which is in American collections, just a few years ago in Philadelphia and New York. The residue that Paris can add to his oeuvre, which consists in large measure of replicas anyway, is of no great import. And a Duchamp show without the original *Large Glass* and without his last piece, the glamorous *Etant donné . . .* , which are both at Philadelphia—it seems hardly justifiable.

In the meantime Duchamp has continued to be a posthumous inspiration. Helped by Ulf Linde, who has already given us a rather sterile copy of the *Large*

Glass, his emanations have now materialized into a sculptural version of that work's lower panel—in blue stroboscopic light Duchamp's flat, diaphanous configurations hover like the inflated homunculi of some joyfully tinkering Frankenstein. Yet even this is only part of a general trend, very apparent in this exhibition, to give priority to documents and sources that have been attributed to Duchamp in the most arbitrary way. In brief: preoccupations with the laws of optics, with perceptual psychology and problems in higher mathematics, are now being passed off as the prime motives behind Duchamp's oeuvre or non-oeuvre. Not much of a result for fifty years of continuous avoidance of "retinal art", an art not addressed to the eye.

Current exhibition design is not a great help to someone who wants to get to know Duchamp. His early period, which led from Impressionist studies in Normandy to Manet and Cézanne, and a final coming to grips with Cubism and Futurism, is, in this show, cleanly welded to what followed, as if there had never been a break—his machine subjects and above all his disgust with his "turpentine-drunk" colleagues, which he laughed off by telling himself those good little hay-theatrical jokes of his Readymades. First of all, Duchamp did take up current styles and make his variations on them. Yet in each case, we should not forget, his reaction was inhibited, it came late. Before adopting a style he would wait until, so to speak, it had gone slightly off. In this "arriving late" of Duchamp's

Duchamps's atelier in Neuilly. Photo by Wolfgang Haut.

one can perhaps find the key to his approach—it was an early marker of his indifference, his apathetic stance towards the incredible busy turmoil of the avant-gardes of the day. Formal considerations like those which dominated the work of the Cubists, Futurists and Constructivists, and which he found himself surrounded by, he put aside.

The provocativeness of Duchamp's doings lay precisely in this, that in the midst of a generally accepted avant-garde context he challenged the formal problems of 1911–12 by raising what sounded like questions of content. The diluted iconography of the Fauves, Cubists and Futurists no longer interested him. And in each of the works he subsequently produced, he posed a new problem. We have almost lost sight of it, but what Duchamp now began waging was not painting and sculpture by other, better means. His non-activity eventually amounted to one of the most complex and veiled commentaries ever given on the subject of art. And we can approach the meaning of this commentary only by relating it, beyond Duchamp, to the situation of art as a whole.

Dunchamp's attitude can be rendered visible in an exhibition to the extent that it has precipitated in objects, tangible things. That precisely is the trouble. The object-art of the past twenty years has led to the elimination, from Duchamp's works to which it owes so much, of everything requiring commentary. Pop artists and New Realists have seen to it that no Readymade in a museum can ever again amount to a sacrilege. Thanks to his own belated influence, Duchamp's renunciation of art has been falsified, and with far-reaching consequences. One of the first of these is the end of his own system—he now figures as guarantor for the ennoblement of all things, for the so popular exchange of goods between museum and department store.

Even the process of aesthetic liberation which the Centre Beaubourg has said it hopes to get underway, is based on a false, that is serious, reading of Duchamp. Again and again we are told that Apollinaire thought that, maybe, Duchamp was fated to reconcile the people with art. Yet nowhere do we find any indication that Duchamp himself shared this hope. His activities always remained within the bounds of élitist art—had that rarified boredom about them to which only the connoisseur, the professional, is susceptible. Everything revolves around the magic of apathy. What is more, Duchamp's hermetic exercises could hardly be appreciated by anyone who was not in possession of a well-developed awareness of crisis; and when we recall such figures as Rimbaud, Valéry, Hofmannsthal, we realize that Duchamp, in all this, was not alone in following a behavioral pattern of his age.

WHAT THE BOTTLE RACK MEANS Duchamp's abhorrence of activity may have been surpassed even by his abhorrence of producing anything comprehensible, in other words banal. As he himself once said, "Painting has been vulgarized, according to plan—and to the great joy of the public. Everybody nowadays has the vocabulary to talk about art. While no one would think of interrupting a conversation between two mathematicians for fear of making himself look ridiculous, it is entirely normal to hear long discussions at the dinner table about the respective merits of two artists."

Not being offered images that can be tasted and enjoyed by the eye—the famous "retinal painting"—we have to look at each of Duchamp's works objectively, or rather contemplate them in terms of a radius of interpretation the likes of which no other works of the twentieth century demand. There is no second modern oeuvre that has less of what Panofsky has called "phenomenon-sense" than that of Duchamp. That is the reason for the high demands it makes on the interpretive faculty.

Though hypotheses about the *Large Glass* multiply like rabbits, the more important aspect of the work, Dunchamp's use of Readymades and object-montages, still awaits thorough analysis. Here too, of course, speculation has run wild, and the hunt for links and connections sometimes borders on the ridiculous. Yet the careful reader of the four-volume catalogue to the present exhibition is rewarded by occasional high points of expertise, as when Jean Clair expresses his gratitude to Pontus Hulten, who had called his attention to the fact that *Objet-Dard* was not a phallic symbol but rather a casting of the female sex organ. The insight of a knowledgeable man that again confirms Duchamp's longing for the androgynous creature.

One should have liked to hear more about how the Duchamp myth was fabricated. The prerequisites, however, are still lacking. There is still no catalogue raisonné of the oeuvre. Arturo Schwarz's publication, *The Complete Works of Marcel Duchamp*, unfortunately gives neither a list of exhibitions nor (and this is unforgivable) the literature about each work or object and a chronology of their mention in print. Without such a tool, nothing meaningful can be said about the history of Duchamp's influence. The Paris catalogue too has been announced as a catalogue raisonné. Yet not even the simplest data can be found in this masterful compilation—when for instance did the *Bottle Rack*, which Duchamp acquired in 1914 at the Bazar de l'Hotel de Ville, a few steps away from the present Beaubourg, become worthy of exhibition? When did this object, which the artist casually deposited in his studio, begin to play the provocative role that every essay on twentieth-century art unequivocally assigns to it?

In order to find an event worth mentioning that places the *Bottle Rack* in the realm of readymade aesthetics, we must wait until the early thirties. Not until then did the Surrealists' interest in magical objects alienated from their context propel Duchamp's Readymades into a recognizable historic correlation. This belated circumstance made it possible to interpret the actions of the early period, which at the time remained unexplained, and thus in a sense to provide them with their artistic or anti-artistic character. It turns out, when we look at the chronology of the works, that actually Duchamp's Readymades were a long time in search of a meaning. Duchamp himself said in the 1960s: "Until fifteen years ago no one paid any attention to the Readymades. They were not seen."

What this boils down to is that much of what today is taken for Duchamp's ideology and ascribed to his eccentricity, his negating stance, was not all that clear-cut with him at first. The question arises whether the *Bicycle Wheel* (1913), or *Pharmacy* (1914) or *Bottle Rack* (1914) might not have become Readymades after the fact, whether he might not purposely have allowed his early experiments, recollections and mere diversions to be upgraded—and thus predated—by the commentators. Though he may not have endorsed the commentaries

during his lifetime, he did not reject them either. All these early things, made before his stay in America, possessed neither a conception nor a reason for being exhibited. They were not meant to challenge art on its own grounds. It can hardly be denied that Duchamp's Readymades began to lose their amorphousness only against the background of Dada and Surrealism.

MANIPULATED SKEPTICISM From a position of absolute skepticism, Duchamp stripped away all that was positive and taken for granted about artistic work. Doubt about himself certainly contributed more to this attitude than any deeplying cultural pessimism; and he gradually maneuvered himself into a position from which there was no turning back. The dialectical turnabout—a shift, that is, from a system of complex criticism of the creative to a new kind of creativity— is something Duchamp himself was not able to manage. It was not in him to rise above the ruins of Dada, to free himself of polemics.

Not until Hans Arp, Max Ernst, Karl Schwitters do we find this skepticism flipping over into a new quality. With them, no-longer-wanting-to-make-art acquired a totally different definition. From their rejection of painting they gleaned new creative possibilities; a creativity that though it took the changed historical situation into account, rapidly found that there is no stance in aesthetics—or in life—that can finally cut itself off from aesthetics—or from life. In the Readymades, Duchamp's aphoristic statements of dogma and void, possibilities of ever new impossibilities are sketched, each work blocking out a possible new horizon. Duchamp could not guess—because his skepticism was a drawing-board skepticism—that some day his work, meant to provoke, would be just as acceptable to the art establishment, to steadily expanding general receptiveness, as anything else that has careened out of the twentieth-century aesthetic orbit to smash normative ideas, taste, the needs of the imagination.

Now that Duchamp's work has received the highest institutional blessings, one's irritation tends to flow over. Why not finally challenge the claim to sole representation that is being made here? The real task of a Duchamp exhibition, and thus of Duchamp criticism, would have been to show how his interpreters have time and again manipulated him, and to determine how far his very malleability might represent the essence of Duchamp's apparent openness.

Paris, 1977

THE ONE AND ONLY AND HIS PUBLIC *The aesthetic cynicism of Francis Picabia*

Even the most docile glutton for aesthetic paradox will not be able to avoid talking about the "Picabia case": the 1976 retrospective in Paris at the Grand Palais could not be called a balanced presentation of a "normal" oeuvre, with the expected high points as well as expected gaffes.

Picabia was given a show that neatly and unemotionally put all stages of his

work side by side. Never before was this done with such thoroughness. Exhibitions have always tried to protect Picabia from Picabia, and have therefore concentrated on showing his path to Dada, with a few pictures from the early twenties (*Optophone, The Spanish Night, Plumes*) and a few examples from the "Monsters" series and the transparency group thrown in. Everyone had heard about Picabia's excesses, his mundane casino style, the commissioned kitsch for the French settlers in North Africa. They were accepted with a smile and a few words about post-Dada nonchalance, sarcasm. But here it was on view, even if the selection did not really include the most compromising stuff.

THE CHAMELEON It was quite a bouquet: bullfight scenes with a touch of Dufy; layering of motifs in which angels from Romanesque Catalonian frescoes snuggle up against pinup girls out of the fashion magazines of the early twenties; nudes raising cheers to the sun (or something); strength-through-joy physiques, painted without apparent irony. (The exegetes of the hour may now find in Picabia a guarantor for hyperrealism.) Against the background of the period, the effect was somewhat like a slice of the international collaboration style. But it all ended in 1945: we then find Picabia in the aesthetic camp of Poliakoff, Hartung, and the informal Ecole de Paris.

Quite evidently the demonstration at the Grand Palais aimed at robbing opinion and judgment of their last little bit of reasoning power. It must be realized from the onset that the provocatively "characterless" diversity paraded under the name raised questions for the viewer as no other work has, not even Marcel Duchamp's. Admittedly the comparison with Duchamp keeps cropping up. During World War I they were linked within Dada the way Picasso and Braque were within Cubism. Yet it would be a mistake to tackle Picabia with Duchamp's categories—and that is done all too eagerly these days.

If we say that Duchamp pushed art out of the realm of taste, of visual empathy—it is no longer possible to hum along with his work—then we can maintain that with the chameleonlike Picabia such fundamental decision for or against art and its practice cannot in fact be discerned. They do not matter. Compared with Picabia, Duchamp was always a moralist.

Picabia means, first of all, the presentation of everything impossible as possible. If his work were taken as a whole, of equal value, as his apologists have tried to do, then judgment must be suspended. That is, any judgment coming from outside, based on an authority other than Picabia's own. And Picabia's authority is nothing but a subjugation of generally accepted, determinable standards of conduct to private legislation. This is where we come to the sore spot of the art history of the twentieth century: the possible independence of the individual that came out of Dada. This is where we can speak of a break in continuity, and not with the Cubists or the Fauves. The area of comprehension is reduced to one-man or tiny-group art. What happened there goes far beyond Baudelaire's call for modernism in Romantic artists, a blend of the transitory and history-based stability.

Personal positions arrived at through some complex intimate process, a private kind of legitimacy, become the only criteria. An example of this is Duchamp's *Three Standard Stoppages* dating from 1914. Duchamp let three meter-long

threads fall to the floor, then fixed the resulting "curvatures" as irregularly curved gauges. Not man as the measure of all things, but Duchamp as measure of Duchamp.

We are dealing here with an operation that eventually became the symbolic form for judging a substantial part of the art of our time. To a great extent works now relate only to personal systems. They no longer speak of common experience, they translate any consideration of broader contemporary questions into a coded language of their own. The "individual mythologies" so in demand today can be deduced from this extreme interpretation of "artistic will," anchoring the causality of a work solely in the mind of its producer.

EXPLOITATION OF NIETZSCHE Francis Picabia saw himself as the first and only representative of his breed. This conclusion is the key to his intellectual history. Picabia's first wife and biographer, Gabrielle Buffet, emphasized in her writings how important the works of Max Stirner and Nietzsche were to Picabia. At a colloquium in conjunction with the Picabia exhibition in Paris, the Spanish art historian Maria Lluisa Borras managed to endow the oscillating figure of the artist with a kind of unity. She came up with the sensational information that Picabia, in his last writings—a series of letters he wrote from 1945 to his death in 1953, to Christine Boumeester and Henri Goetz—borrowed passages from Nietzsche's *Thus Spoke Zarathustra* and *The Gay Science* and from Stirner's *Der Einzige und sein Eigentum* (The Individual and His Own), and by transposing words and bringing names and concepts up to date, took care of his correspondence largely by collage.

Picabia's life and work and a part of his contradictions harmonize with his voluntaristic, private view of life. His self-assessment was elitist, and no one writing about him today ought to resort to dialectical tricks to conceal the fact that his contempt for the public was deep and his reflexes anti-democratic. He made this abundantly plain in 1913, in New York, where education is believed in: "The public! . . . From the beginning of eternity everything to do with art has been beyond their reach."

In relation to Nietzsche and Stirner, who, in different ways, were also extremely important to Giorgio de Chirico, to Max Ernst, and even to the young Picasso of bohemian Barcelona, some motivation must be found, in my view, for an oeuvre and an attitude that first try to elude social, political and historical determination and then unreservedly throw themselves into the arms of the age. Here I can only touch on the problem. In Picabia's oeuvre, where any recognizable culmination of a development or a process is erased in relentless ups and downs, there is an echo of Nietzsche's "eternal return."

MARTIAL SWANSONG What Wilhelm Dilthey noted about Nietzsche could also be applied to Picabia, and to a major chapter of the intellectual history of our time: "Nietzsche is a frightening example of what can happen to an individual mind, brooding about itself in the attempt to understand its essence. And this brooding about one's core, this continually renewed self-observation, what did it discover? Exactly that which characterizes the historic stage of today's business world, or society: 'living dangerously,' the reckless unfolding of one's own power."

His whole life long Picabia was intent on escaping the historical bond. That is

surely why he changed his masks with such baffling speed, out of fear that something just created could be given out as a description of his real, suddenly recognizable identity. That is also the reason for the incredible syncretism of the post-1918 works. Anything even remotely successful at the moment was picked up, worked in without restraint: Constructivism, the precision of Neue Sachlichkeit and of novecento painting, the biomorphic distortions of Surrealism, then a style that—as with Max Beckmann and, at the time, with Picasso—binds discordant colors with black contours.

The reasons for all this? Picabia was in no sense a naive man in search of the most interesting possibilities and dreaming of success through the right connections. He was too blatant about his takeovers for that. It is tempting to think that this kleptomaniac painting was in fact an act of criticism, and that this was his way of adding insult to injury. We must not lose sight of the fact that Picabia could well afford to escape social control. He was a wealthy, worldly, well-connected man—a man, at any rate, who was the owner of 127 cars in the course of his life. A stunning Delage, on display center stage at the Paris exhibition, is a reminder of that. There are plenty of statements in his writings that suggest that the real object of his unspeakable painterly ridicule was to defame, without favoritism, the entire cultured world including its stylish and stylistic in-groups.

Francis Picabia was born in Paris in 1879. His father, a Cuban from an old Spanish family, was envoy at the Cuban Embassy. The boy started painting early, and was a student at the Ecole des arts décoratifs. First he turned to Sisley and Pissarro. In 1906, in a huge canvas, he reduced the Impressionist and Post-Impressionist approach to a kind of academic mechanism—its title, *Effect of the Sun*, was perhaps meant in contrast to Monet's incunabulum of Impressionism, *Impression of the Rising Sun*.

If Monet's title gave a name to a movement, then we might assume, from the title of this last belligerent trumpet blast of the style, that Picabia was announcing a destiny that would henceforth be dominated by *effective* and *effect-seeking* activities. From then on Picabia got seriously involved in no style or group. Until his personal appearance at the Armory Show in 1913—he was the only European artist who could afford the trip to the United States—he toyed with Cubism, with Delaunay's Orphism, with Futurism. In some pictures he even turned to arabesques à la Matisse.

Picabia's large canvases (*Danses à la source*, 1912) made an impression in New York. He met Alfred Stieglitz, who arranged for a one-man show at his gallery, Photo-Secession, for which Picabia speedily turned out a series of large watercolors in his hotel room. After his return to Paris he began some of his most original pictures—original against the background of Futurism, Cubism and even the work of Marcel Duchamp, who was then still painting. *Udnie* and *I See Again in Memory my Dear Udnie* (1913-14) immediately preceded the machine paintings and drawings. *Automobile Pistons* is a panoply of shock absorbers and technical innards that grow like tropical vines in spaces related to those of Kandinsky's *Improvisations*. These were images in which the figurative referent had finally disappeared.

All this ended in one fell swoop. During the war Picabia started painting machines. He gave them titles—titles that are part of the image, that work within it. Picabia's exegetes have recently been able to supply information about

how individual machine pictures and their titles came to be. Documents from which Picabia borrowed technical diagrams have been dug up. His titles from the Dada period—as well as aphorisms and passages in poems—parody Latin and foreign proverbs collected and explained in the *Petit Larousse*. But such isolated examples do not suggest a method, a planned encoding of the real world, or real knowledge. Therefore such discoveries must not be overinterpreted. The underlying meaning of "une grande machine" would have to be pointed out, the idea of grandiose painting explained—an aesthetic that reacted so strongly against Salon activity could surely not restrain itself from hitting out at the Salon concept. It would have been more than amazing if Picabia had created these Dada works with a conscious code. In this connection, in *Jesus Christ Showy Adventurer* (1929), Picabia quoted an observation by Gabrielle Buffet-Picabia: "The public makes the mistake of regarding modern works as rebuses that must be solved. The work exists; the justification for its existence is that it exists."

THE MACHINE This is where the limits of interpretation lie. They were built in from the start. They are based in Picabia's ideology. They are also limits for Picabia himself. It would be a mistake to flatly take the pictures and drawings of those years as examples of an emblematic art. We are after all not dealing with works neatly finished and packaged: the background against which Duchamp and Picabia acted must not be ignored. The avant-garde of the time delivered not only new styles, new principles of representing known contents; it also raised the question of a possible iconography. Kandinsky's works were known— Duchamp had spent some time in Munich in 1912, and some of Picabia's work (*The Horses, The Henhouse*, 1912) show an affinity with the Blaue Reiter.

In a certain sense these machine representations could be considered non-objective art by other means, the means of purposeful incomprehensibility and insolubility. That is the source of the irritation evoked by Picabia's Dada pictures. He branded the common denominator of the world of that time—the machine, the invention, the technical orientation—as incomprehensible. He consecrated it as aesthetic.

Paris, 1976

HE WHO DENIES HIMSELF *The Man Ray exhibition in Rotterdam*

Man Ray, ongoing footnote to Dada and Surrealism, has now slipped into the main text. Arturo Schwartz, the Milanese panegyrist of Dada and particularly of Marcel Duchamp, gave the starting shot some months earlier, when three galleries in Milan (Schwarz, Salone Annunciata, and Milano) assembled 225 works under the title "60 anni de Liberta." The presentation was divided by technique. One gallery had drawings, Rayograms, photos, and prints; another objective works, collages, sculptures; the third the paintings and watercolors. This last, most discussable part, was shown in Schwarz's own gallery—very likely

less out of conviction than Machiavellianism. It is after all widely known that the best way to get at Man Ray is through his paintings and drawings.

For years now Man Ray has demanded, through a kind of tactical self-denial, a recognition of his entire work. A good example of this is the provocative 1969 exhibition, "Les Invendables," (The Unsaleable Ones), at the Chave Gallery in Vence. Inasmuch as Man Ray himself maliciously labeled his pictures and drawings nonsellers, he really forced the buyers to come. The exhibition was sold out in no time. Dadaist negation working in reverse, so to say: the recollection of the time when Dada was as yet unsaleable was tactically brought into play, to the profit of works that judging by their style were obviously made with sale in mind.

Now the Boymans-van-Beuningen Museum in Rotterdam is presenting a Man Ray exhibition, the first European museum to do so. In scope it can match the show at the Los Angeles County Museum of Art in 1966. One expected more from the Rotterdam retrospective than from the commercial Milan shows, especially a richer documentation for Man Ray's photographs. This expectation was disappointed. Rotterdam too gave Man Ray the opportunity to act as his own censor, as was discreetly hinted in the catalogue by Renilde Hammacher-van den Brande. She tried to relate the photographs to the remainder of the oeuvre, to take them as the starting point of a far-reaching, rich vitality. But of this there can be no question. The indirect technique, the chance effects that separate Man Ray's work from the common run of beautiful or expressive photographs, found no parallel in the painting and drawing. *The Aerographics* of 1919, to which one could point as an exception to this rule, were done before he began his career as a photographer.

Man Ray was born in 1890 in Philadelphia, had his first, slapstick-enlivened career in New York, and moved to Paris in 1921. The Dadaists prepared a memorable welcome for him. The Surrealists were interested in the photographic side of his work—and, as a look at André Breton's writings shows, exclusively in that. During World War II he returned to the United States for a few years, leading the life of an immigrant. After the war he returned to France, where he assumed a role that was already more or less historical: his photographic archives became more important to him than new work. He was no better off in this than his equally famous colleague Brassaï.

In the book *Self-Portrait* (1963), Man Ray described his life in detail—a life less of reflection than of constantly new movements and grotesque situations. He appears in it as an amusing representative of Montparnasse fauna, as a lover of "Kiki de Montparnasse," as the photographer of Paul Poiret's fashion world, of the aristocracy, and of Marcel Proust's corpse. This long text, often spontaneously wandering off into anecdote, basically restores the accents that the discontent of old age would distribute otherwise, to their rightful place. The Dada period in New York, stage-managed by Man Ray together with Duchamp and Picabia, belongs, along with the new directions the photographer Man Ray brought to that profession, definitely on the credit side of this century's art. The detailed description Man Ray gives of his laboratory chemistry, the priceless accounts of his handling of camera, negative, accidental effect, restore the value of something which was conjured away in the exhibition.

One need only leaf through the journal *La Revolution Surrealiste* to under-

stand Man Ray's unique position as discoverer of the after-image of reality. There is nothing to equal this in his painting. The search for the unreal, the fascinating, carried on by Man Ray and his Camera, fits very well with the hermeneutics of literary Surrealism: it tried to tie that definition of Surrealism closely to reality, demonstrating the intrusion of the suprareal (as often in the case of Breton, Aragon, Peret) as an imperceptible step beyond the banal.

The visitor to the Rotterdam exhibition is forced to spend much time on the painter Man Ray. Examination of the early period in New York does not lead to the discovery of a brilliant talent for painting or drawing. The influences of Cézanne and, after 1913, when the Armory show introduced the modern Europeans to New York en bloc, of Cubism, show up, in not particularly original derivations, in still lifes and landscapes. The meeting with Marcel Duchamp in 1915 doubtless brought about a great change: the half-dilettantish works, wavering between innumerable influences, gave way to a conscious stylelessness. Picasso's presence in New York during World War I helped the Dada cell there. Like Duchamp, Man Ray, who had now left idyllic Ridgefield, New Jersey, turned to found objects. Alfred Stieglitz, one of the generous American champions of modern artists, introduced Man Ray to photography; which however he was not to study as an artistic medium until his arrival in Paris several years later.

Man Ray's most interesting paintings were done in the New York period: *The Rope Dancer Accompanies Herself with her Shadows* (1916), the ten collages (1916-17) on which he later based his *Revolving Doors* (1942), and the *Aerographics*, which he did in 1919 with a spray gun and stencils. In *The Rope Dancer*, he tried for a painted mechanism à la Duchamp. Like Duchamp, he constructed a precision instrument in paint that coupled anthropomorphic reduction with exact autonomous forms. The derivation of this and other, similar works from Cubism must not be ignored: in the synthetic phase of Cubism, Picasso, Braque and Gris themselves turned increasingly toward the problems of transparency. The elements in their paintings began to slide and overlap, and the addition of *papiers colles* further emphasized this planar plasticity. Duchamp, Man Ray, Picasso—all of Dada—strengthened this trend to the mechanical.

The Readymade, that object plucked out of reality to estrange reality, became the escape-without-return from painting. But Man Ray, like Lot's wife, froze. To this day, he has attempted in his paintings arbitrarily to mix effects from Picabia, Max Ernst, Dali, de Chirico, and—in drawing—from Matisse. The superstyle that he—now as a Surrealist—sets out to produce without the least irony, is in fact a prime example of an art of literary prescriptions. It is not meant ironically; the intended stylelessness as theme of the Dadaist Man Ray disappears behind a sweaty exertion. As with the other minor Surrealist painters, he will occasionally hit on a good idea which lives on, not as a part of an oeuvre, but as chance inspiration—for instance, his monumental lips that float in the sky: *A l'heure de l'observatoire—les amoureux* (1932-1934).

In order to make the viewer forget the scant presence of the photographer, the exhibition, in addition to the paintings, drawings, and illustrations, presents Man Ray's objects and emphasizes their importance. As with Duchamp, most of whose Readymades and objects were remade in the sixties at the Galleria Schwarz and put out in multiple editions, a great many of Man Ray's lost originals have been, these past few years, profitably resuscitated in multiples. In Rotterdam they all

stand together, a conglomeration that all too often displays a manufactured lack of inventiveness. Aside from a few finds in the area of object art, which flourished everywhere in Paris in the thirties, the attempts at Duchampesque analogies accumulate. This refers less to the morphology of the works than to Duchamp's specific habit of picking up and defamiliarizing an object again and again in the course of time—in other words, of making it benefit from its own history of effect and capability of allusion. As Duchamp had delivered a shaved Mona Lisa in addition to his mustachioed one, so Man Ray gives us his nailed iron (*Cadeau*, 1921), joined in 1966 and 1967 by two other versions which—now without nails—are christened *Le Fer rouge* and *Phare de la harpe*.

The success of the Readymades and of the interpreted finds encouraged Man Ray to use this method with constantly new variations. The thirties particularly benefited from these procedures. Before the great object exhibition at Ratton one could see a legion of Surrealists, as Max Ernst reported, scouring the Paris flea market for anything exotic and odd. Object art, which has become fashionable again since the fifties, really got its start then. Neither the Dadaist object (rooted out of reality, and presented to the art establishment for discussion in the place of art), nor the Surrealist object (enigmatic, offering up its mystery as a painful, unsolvable task) is by its own definition meant for plurality or productivity. The unselective multiplication of the gesture has to result in deflecting interest from the original conceptual content to the formal aspect.

While Man Ray's first (and best) objects remained fairly simple—their striking attraction often consists of a conclusive reversal of their generally accepted meaning—they became increasingly complex in the course of a fifty-year-long practice. The transposition acquired, over time, something stereotypical. Powerful, visually compelling works like *Cadeau, New York 17, The Enigma of Isidore Ducasse,* or *Indestructible Object,* remained unmatched. The corny-gag approach, which endangers just about the entire recent output of the object-artists, has caught Man Ray too in *Mr. and Mrs. Woodman* (1970), or in *Vierge non apprivoisée* (1965). In contrast, Duchamp had, in his last stark Readymades, kept almost puritanically to the basic idea of simple unpathetic *showing.*

Man Ray seems a fragmented, nervous artist hectically committed to the order of the day—in short, an overactive representative of anti-art. As this revealing exhibition shows, his greatness remains tied to the photographic work. Man Ray not only developed this medium into a personal photographic style but, thanks to numerous technical innovations, he has unshackled it from the realism against which nineteenth-century painting reacted with stylistic revolutions. In his Rayograms he brought objects directly to light-sensitive paper without the benefit of lenses. When he did use the camera, he sought to combine chance with a calculated effect. The new definition of a photographic object owes him much: he has stretched the concept of an artistic will that makes every deviation from the rule plausible, to cover photography as well.

Rotterdam, 1971

CATHEDRAL OF COLORS *The dedication of the Rothko Chapel in Houston*

A year after Mark Rothko's death, the chapel of the Institute of Religion and Human Development, for which the artist painted fourteen monumental wall pictures, has been consecrated in Houston, Texas. Open to all faiths, the chapel stands between Houston's two universities—Rice and St. Thomas—and the spacious grounds of the Medical Center. The Institute of Religion and Human Development, founded in 1954 by a group of doctors and clergymen in cooperation with the Texas Medical Center, is located among the clinic buildings and serves as a meeting place for doctors, nurses, psychologists, and the clergy.

The building—which has been named in analogy to France's Leger and Matisse Chapels, the Rothko Chapel—was designed by Howard Barnstone and Eugene Aubry. Barnstone had given Houston two remarkable works: the Harris County Center for the Retarded and housing units for the campus of the University of St. Thomas. Various circumstances delayed the building of the chapel and changed it fundamentally in spirit. It was originally to have belonged to the Catholic University of St. Thomas, whose art department had found patrons in the French-born Houston industrialists Jean and Dominique de Menil. In 1969, St. Thomas's art-historical institute became part of the larger Rice University. The de Menils donated the murals, commissioned from Rothko a number of years earlier.

Initially Philip Johnson (who had brought the spirit of his teacher Mies van der Rohe to Houston in his pergola architecture for St. Thomas) was to have built the Rothko Chapel. But Rothko and Johnson could not agree on the architectural setting. The principle of an octagonal building with a slightly projecting apse did please Rothko, who wanted the picture series to be seen in a central space, like early mosaics. It was about the lighting that artist and architect differed. Johnson wanted daylight to flow into the building through a truncated glass pyramid, while Rothko preferred a simple cupola which would allow for direct light. The idea came from his own New York studio, which had a glass roof. Though Rothko did not live to see the chapel, as built by Barnstone, he had been closely following its development in plans and models. He had had a replica of a section of the chapel, full-scale, erected in his New York studio.

The architectural setting remains demonstratively stark. Its effect is that of a space capsule for the paintings. These hang on gray walls, in a building that has no ambition other than to display Rothko's works in a setting evocative of early Christian churches. Rothko's pictures need a neutral environment of this kind, one which does not force a particular function on them. Fortunately, no attempt has been made to turn Rothko's art into confessional art. To the viewer, these works are reagent surfaces. He has to find his answer to them without aid from any subject whatever.

One's response to Rothko in a sacred setting is much the same as in a quasi-sacred museum. The cultic origin of art is restored. Art's loss of profane function is revealed by Rothko's example in a significant manner: his paintings have proven capable of integration only into museums and now into this chapel. They will not only endure any but the imprecise site. For to discuss the Rothko

Chapel, the famous earlier commission that in a sense was its reason for coming into being, must be mentioned. In 1958 Rothko started a series of murals for The Four Seasons Restaurant in New York's Seagram Building. When he had finished the works, he refused to deliver them to the client.

Rothko had realized the discrepancy between work and setting. This allows for conclusions about Rothko's self-understanding, and it sharply draws the line between an art that no longer has at hand an adaptable iconography, and eminently commissionable Pop Art, or Op Art, which is different to its setting and usable anywhere. Perhaps more forcefully than any preceding artists, lyrical abstractionists like Rothko renounced all commissioned art, all polyvalent use of art. On the one hand they removed from their work any objective reference to reality and interpretation, on the other hand they demanded of the viewer—in place of reading and meaning—a mood adequate to the picture. Rothko himself formulated this imperative: "A picture lives by companionship, expanding and quickening in the eyes of the observer."

Rothko Chapel. Photo by W. Spies.

Questions of lighting occupied Rothko persistently. I recall an elaborate discussion about this, to him, fundamental question. The Houston paintings were ready—they hung on the walls of his large studio. Darkness was falling and it became difficult to see the pictures. But Rothko refused to put on the electric light. He sharply criticized the lighting of his paintings in Washington's Phillips Collection. It was too brutal, too constant; it did not take the picture's own light into account. The fact that Rothko showed me the Houston pictures in the late afternoon, in fading daylight, could be interpreted as meaning that basically there was no lighting problem for him, as far as daylight was concerned.

The polemic with Philip Johnson would seem to contradict this. But this could be countered by saying that Rothko instinctively preferred the proven frame of his New York milieu to an unknown architectural solution. One might add here, now that the works can be seen in Houston, that Johnson's plan would have more easily approximated the New York lighting effects under the Texas sky. The large glass cupola, installed by Barnstone at Rothko's bidding, allows so much light to stream in during certain hours that the visitor is dazzled. In compensation there is, in the evening hours, the much longer and more intensive experience of the fading of the paintings' luminance. It is tempting to give primacy to this contrasting world of experiences: midday glare which, coming from outside, darkens the dark pictures even more, and evening light that for a while balances, lightens this darkness. The fact that Rothko did not want his pictures fixed by an unchanging artificial light—by *one* optimal effect—is crucial for Rothko's self-interpretation. He himself opposed something quite different to the mystic Rothko's concept: the relativity of light, the using of the graduation between a narrowed and wide-open pupil.

This relinquishing of *one* effect, of *one* exact illumination in this ecumenical chapel might be seen as symbolic: as a renunciation of one truth, as the impossibility of favoring one light over another as *the* light. But the possibility of altering pictures through light—whereby the changing light brings about the picture's variations—seems more suited to Rothko's earlier paintings. There is nothing in the Houston panels that has the spectacular turns from light to dark and dark to light of the works done in the fifties.

In the earlier pictures, more light could, for instance, darken a blue and make a red stand out, while reduced light would brighten the blue and make the red seem opaque. The chapel pictures live on few nuances, on the variations between black and purple-reddish-violet. Such dark tones first turned up in the works of the late fifties. Rothko kept accentuating this tendency toward darkness, to the point of the Houston monochrome.

Until then—since the end of the forties, when Rothko finally dropped the graphic elements reminiscent of his early Surrealist phase—the geometric handling of the picture planes, the horizontal juxtaposition of color fields, were part of the typology of the pictures. This created tension, a tension that was maintained even in the last pictures, virtually painted only in dark tones. In the Houston series Rothko went so far as to ignore even his own fundamental condition. Only one painting, opposite the apse, holds fast to the Rothko scheme. The other pictures are painted either in one single tone or bring in a second one merely as a kind of narrow painted frame. In a few of the pictures the process can still be distinguished under overpaintings: the black which Rothko put in the

center of the picture grew ever further outward and pushed the violet out to a narrow border zone.

One first thinks of monochrome, of Yves Klein. But this is a deceptive analogy. Klein did his monochromatic pictures in pure pigment, the essence of the color. Rothko did just the opposite. An objective demonstration, independent of the visual experience, did not matter to him. He modulated his planes, gave them a fluctuating movement. We are closer here to Whistler's *Nocturnes* than to the experiments of our century, which equate forms and colors. The eye perceives a flaky application of color; but the monochromaticity that the mind tries to establish is abrogated by the calculated interdependence of the individual panels. The triptych in the apse—two dark violet panels flanking one in a lighter mauve—brings the whole back to the classic reaction of color to color, constantly varied by Rothko.

The other pictures too stand in this kind of play of relationships—a play that benefits the concentrated presentation in the octagonal central hall. Every picture can be related to each of the others. Thus a multiplicity of permutations comes about: with a minimum of means, a maximum effect is achieved. One does not look at single pictures, but at relationships between pictures, at what Josef Albers called "interaction."

Part of the ensemble of the ecumenical Rothko Chapel—unique center of ecumenical vision—is the *Broken Obelisk* by Barnett Newman. It was put up in Houston as a memorial to Martin Luther King, Jr. There was controversy connected with this memorial. A federal agency offered Houston a grant to help finance a sculpture for one of the city's public places. The de Menils were prepared to contribute the balance. They suggested bringing Newman's *Broken Obelisk* to Houston, to be dedicated to Dr. King's memory. The city turned down this overtly political gesture and the government grant lapsed. The de Menils themselves then bought the memorial and put it up across from the Rothko Chapel. Newman's pathetic sculpture, which had once stood in the plaza of the Seagram Building, and then in front of Washington's Corcoran Gallery of Art, now stands reflected in its own little pool.

Rothko's pictures were not changed by the function assigned to them in the chapel. They define, in this site, their reluctance, their inability to adapt to restaurants, movie halls, or presidential chambers. Newman's obelisk works more powerfully in their company. He played with a form that has been a part of art history since time immemorial, a form that finally experienced its sentimental, historizing interpretation in the eighteenth and nineteenth centuries. Newman's use of the obelisk—in broken form—also goes back to the nineteenth century, to cemetery sculpture. The broken, absurdly joined form symbolizes the American trauma, to which Newman's sculpture in Houston points.

Houston, 1971

ON THE PATH TO REVELATION *Abstraction and "Religious" message—The painting of Barnett Newman (1972)*

The first comprehensive Barnett Newman exhibition shown at the Museum of Modern Art in New York in 1971, has now gone on to Amsterdam, Paris, and London. The entire New York show was exported with the exception of the fourteen *Stations of the Cross,* which his widow did not want to risk sending along, and the sculpture. In Amsterdam a major work, *Who's Afraid of Red, Yellow and Blue III,* was added from the Stedelijk Museum's own collection. The extent to which the huge format can transport Newman's conception of the sublime, is shown by Max Imdahl's analysis of this picture (Stuttgart, 1971). His interpretation contributes more to an understanding of the oeuvre than the voluminous catalogue by Thomas B. Hess, who smothers this idea, so central for Newman, under a mass of anecdote and repetition.

When the subject of recent American painting comes up, people usually class Newman and Mark Rothko, together with Ad Reinhardt and Adolph Gottlieb, on one wing of Abstract Expressionism, and Willem de Kooning, Jackson Pollock, and Franz Kline on the other. Color-field painting and Action painting are opposed to each other in this classification. As far as the American scene was concerned, this twin-pronged development brought its first genuine avant-garde, a contribution understood in an anti-European sense. The intense, fruitful involvement with the European emigres—Miro, Masson, Max Ernst, Mondrian, Albers, Matta—out of which these American artists reacted, is still too distorted by isolationist propaganda in the arts for cool, objective judgment.

The exhibition catalogue again talks about Newman and American painting as if Wassily Kandinsky, Constructivism, the Bauhaus, Piet Mondrian had only existed as obstructions to the reception of American artists. Actually, their consciousness of breaking new ground came only later, and Newman's own early writing offers the best evidence of that. In 1942, in "What About Isolationist Art," he sharply castigated Americans for replacing acceptance and knowledge of historical fact with a homemade myth of unprecedentedness. He even compared this tendency to deny any and all dependency with chauvinism and fascism: "The so-called American Renaissance was a deliberate exploitation of a deep-seated desire by our artists to make a native contribution to the art of the world by a regional group of commercially minded artists who, hungry for personal success, misled a generation of artists, art students and the art public." And even more sharply: "In order to keep out the more talented foreign artists small men calling themselves artists have succeeded in imprisoning the American cultural world."

A BEGINNING WITH *TABULA RASA* Knowledge and positive assessment of a historical situation can be taken for granted on the part of the cultivated, well-informed Newman. It was at about this time that Newman came to grips with Mondrian and the process of abstraction in Neo-Plasticism. Newman stopped painting in the early 1940s. He tried to get back to a clean slate. And perhaps his

final rejection of Mondrian can be explained by Newman's almost ethical break with the immediately preceding, influential avant-garde.

Reviewing Newman's writings of the period today, one has a nagging feeling that he was attempting—even before he rid his painting of its experiments in volcanic, surreal gesture–to secure for himself a place in history, like Mondrian, by concentrating on simple morphology. Newman claimed that Mondrian's art was "founded on bad philosophy and on a faulty logic," and, more generally, that one of the mistakes artists have tended to make has been too easily to assume "that any distortion from the realistic form is an abstraction of that form."

There is no doubt that Newman's own art must be seen against this background of a purist, negatively stated case for non-objective art. Mondrian's purging of the temple was based on dissatisfaction with Cubism, which had come to geometrization through deduction. He raised geometric form, as the encompassing fundamental shape of appearances, to a religiously experienced symbol. Newman began at a different point. Unfortunately we cannot refer to his early paintings—in every book and essay about him we run up against the same blank wall: he destroyed all his early work. His paintings of 1944 and 1945, however, suggest that neither Cubism nor Constructivism challenged him. *The Blessing, Gea, Death of Euclid,* in their unsatisfying, amateurish semi-abstractions of plant forms and astronomical phenomena, point clearly to his attraction by the brand of Surrealism which, with its gestural, flowing style of drawing often (as with Masson, Matta, or the frottages of Max Ernst and Oscar Dominguez) came close to the borderline of decipherable representation. Similar results can also be found in the young Pollock and in Rothko.

PRIVATE THEOLOGY The non-objective style of Newman's painting from 1948 on (e.g., *Onement* I) still contains traces of his spontaneous anti-Constructivist beginnings. What was to characterize all of Newman's pictures, the tangible resistance that a flickering, roughly drawn line brings into the obvious, clear geometry of the image, was prefigured in a number of representational motifs. *Pagan Void* and several other, untitled works of 1946 show a dark disk on a light ground. Where light and dark meet, protuberances, irradiations arise that are reminiscent of photographs of a solar eclipse. And again and again we find those arrowlike lines that will divide the color planes in Newman's later work. Cosmic associations are obvious.

If one can go by Newman's own interpretations, these pictures, reduced to the limit, represent the first moments of Genesis, the unity of nonbeing that has not yet been split apart into a multiplicity of manifestations. As with Mondrian, a basic religious conviction seems to be Newman's starting point for abstraction— an iconographic abstraction that cannot be understood without awareness of the thrust of a religious-speculative philosophy of life.

In a certain sense both Mondrian's and Newman's abstractions were freed from this thrust by their followers. Theo van Doesburg's response to Mondrian— Doesburg abandoned the cultist limitation to primary colors and horizontal and vertical axes in favor of a purely aesthetic arrangement of concrete forms and colors—can well be compared to the answer of the Hard-Edge and Minimal

artists to Newman. In their work too the theological-cosmic substance is reduced to the actuality of the picture, to the visible materials used. The picture is the picture, a tautology that cannot be surpassed. Newman, like Mondrian, remains an exception, an artist with a private theology that does not appear in the image but that we must knowingly bring to its contemplation if its spiritual base is not to be neglected. As immediate visual phenomena, Newman's pictures remain unclear and weak.

This is where the crucial difference with Mark Rothko can be found. Rothko's mystical, twilight world of color has an immediately comprehensive meaning. He presents sensual visions, moods. His color conveys the meaning that can theoretically be presupposed. As a consequence, Rothko's work has a stronger concreteness, which is felt in the very effect on the viewer. The same can be said of another oeuvre, cited not as comparison, but as a foil—that of Josef Albers. There too the content is clear, manifest: color irradiations, the intangible, linear structure that can be conceived neither as spatial nor as planar organization. The eye is constantly deflected by visual aberration. This kind of direct statement is missing from Newman's pictures.

Certain basic elements had appeared by 1946—surfaces of thinly applied paint, almost exclusively vertical stripes that cut these surfaces, demarcation lines drawn with a ruler alternatively with lines that seem blurred by a seismographic trembling. Basically hardly anything changed in these elements from then on. The frugal variations were replaced—as with Mondrian, as with Albers—by a search for ever new formal effects. The *Stations of the Cross*, hanging side by side in one room at the New York exhibition, showed this with particular clarity.

Looking at these works, one wonders how Newman's private mythology manifests itself visually.

Newman himself was evidently convinced that his work spoke for itself, without recourse to theory, as he made clear when he called it "real and concrete." The sublime and the tragic referred to in nearly all the titles (*The Beginning, Be, Vir Heroicus Sublimis, Prometheus Bound*) are presented in images that show none of the evidence of these sentiments found in Rothko or Albers. One typical feature—the vertical line that quickly replaced the horizontal—is basic to his work. It turned up for the first time in the same year (1948) as Giacometti showed his emaciated, ragged, vertical figures in New York at the Pierre Matisse Gallery. These, and Sartre's interpretation of them in the catalogue, in which he says that Giacometti's sculptures are as indivisible as an idea, obviously influenced Newman. The series of extremely elongated formats (36 × 6 inches, 56 × 3 inches, 77 × 3½ inches, etc.) that appeared at the time suggest this; the first sculptures—like Here I (1950)—that echo Giacometti's typical treatment of material as well as the coupling of two or more filigreed figures, prove it.

The extent to which Newman's verticals might even be given an anthropomorphic meaning is an open question. The ecstatic, stripelike formats that broke with every convention—one could for the first time speak of "shaped canvases"— stand opposed to Newman's typical huge formats. These offer nothing new as such. Picasso had reintroduced the large canvas with *Guernica*.

REFERENCES TO FRIEDRICH But Newman intensifies the format in that he

puts the viewer into an exactly prescribed relationship to the picture: he demands closeness, confronts the viewer with a surface that cannot be grasped in one sweep. Thus the illusion was born of a certain boundlessness that is not thematic but is a visual experience comparable to the experience of a distant view. Max Imdahl, in his interpretation, referred to Caspar David Friedrich's *Monk by the Sea,* an image in which the confrontation between seeing and what can no longer be seen is made manifest. Man here experiences—a definition of the sublime— his limitation. This is what Newman demands of his pictures. Only a knowledge of the right behavior toward these paintings allows us to see more in Newman than a variation of color-field art. Success, however, is doubtful. In New York as well as in Amsterdam, the pictures were exhibited in a conventional way. The large canvases were hung so that the viewer was allowed a great distance from them. Nothing initiated him into the rite that goes with Newman's pictures. The discrepancy between private aesthetic revelation and routine art operations was never more pointedly illustrated.

Amsterdam, 1972

THE MYTH OF THE SOURCE *Critical notes on Henry Moore's fame*

Henry Moore, the British Council's favorite son, has come to Paris. More than two hundred of his sculptures and drawings are being shown in the Orangerie, and on the terraces surrounding that building on the Place de la Concorde, some of the sculpted epithets that have made Moore the foremost commissionee have been enthroned. A little further on, near the Carousel, the bronzes of Maillol stand, lie, hover, above the lawns. With this lightness, this sensuality at their back, the French are asked to confront Moore—an oeuvre that in Paris cannot help but annoy: for none of the superb sculptors who were active in Paris in this century ever indulged in such a megalomaniacal orgy of bronze and marble. What could, in this country, still happen after Rodin in terms of oversized commissioned sculpture remains chained to the exhibition architecture of the thirties, or lies abandoned in studios—the best example of that being Emile Antoine Bourdelle.

THE MODERN MICHELANGELO? The superlatives that have been attached to Moore's work are hard to beat: "Moore is undeniably the greatest living sculptor and one of the greatest of all time" (Alan Bowness); "Moore is in the eyes of all the dominant creative being of his time" (Kenneth Clark). For others he is simply the first real sculptor since Michelangelo. But it is not only the British— who must after all gear their cultural policy to Moore—who are beside themselves with enthusiasm. There is a postwar consensus that proclaims Moore's masses of bronze and stone to be the quintessence of sculpture. For Will Grohmann Moore was, in the early fifties, "certainly the most eminent sculptor of our time," and the Soviet point of view appeared in the seventh volume of the

General History of Art (1965): "Plastic art never had as prominent a place in England as painting or printmaking, but in the twentieth century it produced one of the greatest figures of late bourgeois art: Henry Moore."

For all the eccentricity of his forms, maneuvering a hair-thin line between representation and abstraction, we have here a "real" sculptor, one who works with bronze and marble and stone, who broods about questions of rightness of the materials—and yet who has ignored one key thing that the development of sculpture in this century has so splendidly probed—the limits of the medium.

If the ateliers of Umberto Boccioni, Picasso, Giacometti, Max Ernst, Antoine Pevsner, Hans Arp, Max Bill, Norbert Kricke, Richard Serra, Joseph Beuys, Eduardo Paolozzi were laboratories busy with collage, montage, welding, in which the paradoxes of materials were played with, then Moore's sculptural conservatory—whatever the tie that can still be felt, often painfully, with the brilliant work of the time—has one dominant notion: that of the "classical modern." The glorification of Moore is really nothing but an accolade to middling sculpture.

All one hears about Moore is dithyrambs. True, his early work provoked scandals, he was attacked. Yet a retrospective of his work cannot manage to reveal much more than a well-informed, patient maker of sculptures that, in size oscillating between knicknack and monument, desperately attempt to find some sort of originality. What accounts for the recognition given these reclining figures and constructivist abstractions, even by those who know Henri Laurens, Pevsner, Jean Arp in more than name? It may of course have something to do with the fact that sculpture in general has never attained the popularity of painting. Knowledge of plastic works is scant, and monumentalists like Giacomo Manzù, Marino Marini, yes and Moore, circumvent the need to come to grips with the incredible tactile variety of twentieth-century sculpture, oriented as it is toward "the shaping of volumes and space" (Carola Giedion-Welcker). Here we have a summarizing gigantism, a neatly polished recapitulation of what in the sculpture of the pioneers is still revolutionary *concept.*

Moore facilitates things for the general public; his work best conforms to their idea of sculpture as massive, monumental presence. He himself chose his spot on the pedestal when he stated that sculpture was more of a public art than painting. The degree to which his speculations on sheer size pays off, is shown by the incredible success of the exhibition he put on in 1972 at the Forte de Belevedere in Florence, within the aura of Michelangelo. Marble sculptures weighing up to 170 tons were transported for the occasion.

The descriptions of Henry Moore's development all point to a troublesome but fortuitous disadvantage as a necessary, positive point of departure. They speak of the English handicap, the lack of a national tradition. Every British art school he turned to as a young man they say, had a curriculum ruled by Greek Classicism. This is meant to suggest that Moore's achievement was due to natural talent, an autonomy that won out against the historical approach to which he was subjected in Leeds and at the Royal College of Art in London. Here we have all the makings of a legend of spontaneous generation, an easily marketable myth of authenticity.

But if we look more closely, we see that this image of independent development doesn't stand up. The import of the handicap has been exaggerated. The

basic decisions from which Moore's sculpture was to profit had long been made, in the works of Constantin Brancusi, Picasso, Alexander Archipenko, Arp, when Moore—a man of the middle generation—started working. And from the very first we find him thoroughly informed about the general situation of sculpture of the time. This fiction of unmediated originality, of Moore's spontaneous formal language, gave his eulogists the arguments they needed to speak of the authentic and chthonic nature of his art. From the periphery he managed to break out of his age, in himself he found the laconical—formulations like these offered escape into a timeless elementarism to a postwar generation frightened, even contaminated by history.

THE HUMAN IMAGE There is no second contemporary artist around whom questions of value, of humanism, of what no inhumanity can rob from man, have crystallized to such an extent. From that point of view, Moore's great influence in the postwar period has benefited by a discussion that battled with the absolutes—Reality, Essence, the Profound. Few observers were aware of the degree to which nearly all of his formal elements were distortions, coarsenings of the plastic language of Archipenko, Picasso, Brancusi. Much of the uncontrolled verbalizations that Moore—(and many another semi-abstract artist)—unleashed, still echoes today, as in the introductory text of the Paris catalogue, where the English critic, speaking of Moore's penetration of the compact, plastic form—a device used much earlier by Archipenko and Vantongerloo as a visual stimulus—refers to a "mystery of the hole."

A return to objective origins, to the primitive, has after all fascinated every generation of artists who, since Gauguin have tried to loosen the grip of history. There may have been no direct models in England—with the possible exception of Jacob Epstein or Henri Gaudier-Brzeska—for this kind of voluntary break with tradition and European decadence; yet, Henry Moore did find, in Roger Fry's essay on the art of black Africa, which appeared in 1920 in *The Atheneum*, the precise tones of the period: the problem of the aesthetic null point, the attempt to re-define the transcendental conditions of artistic creation.

Moore's work consequently fits in with his time, and it must be measured against what happened in sculpture since the reaction to Rodin's stunning return to Michelangelo and Impressionist splintering of form. Moore's first motifs (*Mother and Child*, 1922; *Two Heads*, 1923) were derived from two of the basic formal principles that had already appeared prior to World War I in the work of André Derain and Brancusi: blocky masses that expressively include the *nonfinito* of the late Michelangelo, and the object-like, nonrepresentational sculpture polished to perfect volume.

After that Moore found, in the imaginary museum, points of reference in the art of the Cyclades, the Sumerians, the sculpture of the Maya. The Maya gave him, with the rain-spirit Chac Mool—a reclining figure stylized to fit the sacrificial table—one of his key mythic expansions. This figure, whose "terrifying power" gripped Moore, set free that expressiveness so typical of him—and whose lack of humor is often confused with Michelangelo's *terribilità*.

BANALIZATIONS One of Moore's eulogists once said that he was too abstract for the representationalists and too representational for the abstract people. It seems

to be a good recipe for success, this compromise that Moore tenaciously held to, and in which, basically, he made use of just about every spectacular formal solution in twentieth-century sculpture. The exhibition makes this eclecticism plain. Moore reacted alertly and rapidly to the information he was able to get from shows or journals. A glance at *Cahiers d'Art*, which since 1926 was available at the London bookseller, Zwemmer's, gives an idea of Moore's encounters with the work of the period. There, for instance, we find photographs of Laurens sculptures in which the figure achieves a melodious balance of mass and space. The influence of Laurens's *Reclining Woman* of 1926 continued even to the relief *North Wind* (1928-29) on the Underground Building in London.

The offset arm of the *Reclining Woman*, which follows the body and is lengthened by a drapery; the torso itself, slightly raised to the vertical, these can be found again and again in Moore's protecting gestures. He soon added distortions as a stylistic device to his initially techtonic formal arsenal, in fact the organically flowing distortions that Picasso introduced with his *Female Figure* in 1927-28. These became the model for an entire school of plasma-like formal proliferation. And this is where Moore came in.

This organic distortion prompted him to the gelatinous thickening of motifs that quite naturally brought him close to the Surrealists. But can one seriously connect such nonsense bronzes as *Four-piece Composition* (1934)—Moore's quick reaction to Alberto Giacometti's *Model for a Piazza* of 1932—with Surrealism, and with what in spite of its automatism was an alert, intelligent formal syntax? In works like *Internal Figure* (1940) or *The Bridge* (1939-40) we see a frightening trivialization of semi-representational form.

During the war Moore made the moving and committed "Shelter" drawings, sketches from the London Underground where the populace took shelter during air-raids. The protecting gesture and wrapped figure as Moore's themes were never expressed more poignantly than in these drawings. His return to tableaux was reflected in a number of subsequent sculptures, such as *Madonna and Child*, the family groups, and some reclining figures. Here Moore managed his most compelling and assured works, achieving a balance of free form and image. But this phase soon passed, when his isolation passed after the war. His renewed fascination with Picasso (*Standing Figure* of 1950 is related to Picasso's drawings in "Une Anatomie") as well as the intellectual prestige that abstract art had come to enjoy, propelled Moore to his martial variations, inspired by the protean Picasso.

Paris, 1977

THE EYE ON THE ARENA *Josef Albers—A portrait at eighty*

There is white everywhere—an enchantment of white: white Cape Cod house; deep snow powdered by the icy wind; birdhouses, snow-bent trees. The path

between street and house has been shoveled free. The front yard is unfenced, marked by a letterbox. All this differs from its neighbors only in detail. A good, quiet residential area outside New Haven. This is where Josef Albers lives. He is waiting behind the glass-paned front door, gesturing a warning about the ice-slicked path. His face still radiates the kind of energy it had in the photos from the Bauhaus period. An impressive, powerful head. One thinks less of head than skull—of stubbornness, determination, a difficult nature. One is prepared for someone who doesn't forget the good, but who doesn't dismiss the bad easily.

Josef Albers was born on March 19, 1888 in Bottrop, Westphalia. It's been thirty-five years since he and his wife turned their backs on Nazi Germany. One of Goebbels's first official acts was to close down the Bauhaus. Albers had belonged to Weimar as a student in 1920. Before that he'd studied at the Royal Art School in Berlin, the School of Applied Arts in Essen, and the Munich Academy of Art. In 1923 he took over the preliminary course as successor to George Muche and Johannes Itten.

No one today is as critical of the Bauhaus as Albers; that is, critical with reference to the present. Albers does not believe in retrospective cheers: "You asked why my relationship with the Bauhaus is so aggressive? I was active there much longer than anyone else. I gave it more hours than the others. In spite of that it was the others who were always lauded. Moholy-Nagy claims to have introduced paper constructions. Not so. I did. And I was not a student of Klee or Kandinsky. I was a free, independent man. When Moholy, one year after leaving the Bauhaus, published his book, *The Material of Architecture*, Klee said to me in Kandinsky's studio: 'What is he doing, publishing your work?' "

The Bauhaus was a beginning for Albers, a brutally interrupted beginning. The period that followed, the thirty-five years that lie between the closing of the Bauhaus and today, were well spent by him. Thousands of students took his courses at Black Mountain College in North Carolina and at Yale University. In New Haven he taught at the School of Art's Department of Design from 1950 to 1960. He also lectured at Harvard, Princeton, the Carnegie Institute in Pittsburgh, and nearly everywhere else in the United States, as well as in Cuba, Chile, Peru, Mexico, and Germany. An entire direction in modern painting, perception-related art, which replaces theme and individualistic expression with the knowledge of optical reaction, is based on his teaching. But artists who are not part of Op Art, like Robert Rauschenberg, studied with Albers too. Rauschenberg himself has acknowledged his debt to Albers. At least one "homage to Albers" regularly appears in Rauschenberg's pictures: geometric figures reminiscent of Albers's *Structural Constellations*.

Albers is one of the great pioneers, and he is one of the few who have come out of their pioneer period with work that is now experiencing its great breakthrough. Just a few years after discovering Marcel Duchamp, who was so important to a whole generation of American Pop artists, Europe is discovering his contemporary, Josef Albers, to whom American artists constantly refer in conversation. Without him, Optical Art would hardly have taken such a well-developed, systematic turn. Albers has thought through and taken account of the forms of optical aggression. He rejected both the optical gag and the stubborn gaping at paradigmatic visual models of Gestalt psychology. His teaching of art—he calls it "visual training"—therefore is not only aimed at the artist but at

the viewer as well. Albers has educated the eye. His monumental *Interaction of Color* (New Haven, 1963), is an ideal, gripping textbook for everyone. It teaches seeing, as does another book, *Despite Straight Lines* (New Haven, 1961), which analyzes Albers's graphic constructions. The two books together offer a complete system, which ten years ago might still have been dramatically labeled a marginal visual experience.

Albers has developed a graphic system that is based on the "impossible figures" described by psychology. The system that he displays before us constantly devised alternative solutions. But one cannot opt for one, since each solution is immediately rejected. The picture suggests a solution to the viewer at lightning speed. But in the very act of perception, before the solution can reach the level of understanding, it is already cast in doubt. What is seen spatially in these works becomes, in the next instant, planar, and what looks like a solid surface you could walk on suddenly topples into the depths. Never does the eye come to rest, never can it stop the jugglery. This is where the revolutionary roots of "Optical Art" can best be grasped—revolutionary because they involve the viewer much more strongly than has any previous system of nonrepresentational art. Interpretation (or, as formulated by another Bauhaus faction, the "spiritual

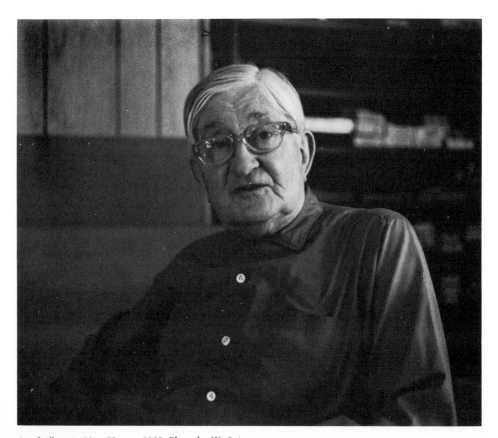

Josef Albers in New Haven, 1968. Photo by W. Spies.

in art") plays a much lesser part than the eye. The picture constructs itself in the act of seeing, on the level of perception. That level is never left, since the activation of vision is never quite abandoned in favor of an impression that can be remembered. Seeing becomes an important theme. It is not done with just one glance. It's a job we must take up again and again. And again and again the eye returns to the arena, fascinated by the aggressive power of the picture. Albers intends this heightening of vision. What he himself calls "the irrational inter-penetration of forms" is an experience of the discrepancy between physical fact and psychic effect. Because, as Albers says, a painted presentation of optical illusions is not by itself art.

Knowledge of the theory in no way harms Albers's work. In fact, it sharpens our enjoyment. At first glance the *Homage to the Square* series, those large, quadrangular works in which squares in four different colors or in nuances of a single color are imposed one over the other, are images for meditation. We think of Rothko—who spoke of Albers with great admiration—we also think of the problems dealt with by the "primary structure" artists.

But Albers is out for something different. He does not "demonstrate" an actual structure. He is after the "postretinal" effect, which he has designated "interaction of colors." This interaction comes about through the mutual illumination of the colors, in which the experience of color and form plays a part. We see how a lighter red, put over a quadrangle of darker red, becomes even lighter at the edge of the darker red, or how it becomes darker where it meets an orange lighter by several degrees. Albers has given us numerous examples of such interaction.

But the more we get involved in these phenomena, the plainer it becomes that Albers had no intention of formulating a theory of colors. When asked, he denied it, saying that because of its high mobility, color was the relative means of art. It might almost seem as if Albers were intent on taking away the viewer's confidence in his ability to see. He plunges the viewer into confusion: "Such relativity of color invites us to imagine a flat layer of opaque color as being transparent or layered, covering itself. It demands that neutral tones be read as having a tone, that a dense, heavy gray be presented as resembling gas, or blue as warm and red as cool. All that encompasses a manysidedness that even includes a loss of identity." The same deception of vision which we noted in the graphic images also interferes with a calm examination of the paintings. Once more we find ourselves thwarted. The task of determining the actual conditions of the work—its real color qualities—provokes us. Albers has introduced the dual concept of "actual fact" and "factual fact" for this dialectic. "Actual facts" are the colors as they really exist, and "factual facts" are the colors as they affect us, as they deceive us. When we can no longer ignore this doubt about our perception, then we are armed for the encounter with Albers. We are ready for active vision, for a vision continually in search of itself.

In Albers's studio—dubbed by his New York art dealer "the world's smallest"—the works pile up. Albers has finished a new series of "homages." The new color problem: red. Albers is working with more than forty hues of red—he used up to eighty of yellow. He takes the colors as they come out of the tube. At most he'll occasionally mix white and blue, as he mixed white with the red in the *Variants* of twenty years earlier. The steps between the individual

works are small, miniscule. Albers seeks nuances. That is why the *Violin Clefs,* created in the thirties, are so important. They stand in the studio right next to the newest work. Their serial nature heightens the interaction. Each work relates to other works. And the comparison is the basis for our understanding of the individual work.

Albers has expressed much that we now take for granted in looking at art. Besides the serial process, besides the kinetic effects that he has attempted to produce in his images since 1945, his working method also points to the problem of the reproductibility of a work of art. Since his works depend only on the perception of optical information, he writes the following kind of recipe on the back of the pictures: Color tone and manufacturer of paints used: "Mars violet (Lefèbre), mars violet (Bocour), ferrous violet deep (Shiva), Payne's Gray (Shiva Signature)." Anyone can copy this formula.

Albers has an answer to the unthinking fear of Optical Art. He shows that we tend not to see the optical in Optical Art just as we tend not to hear the acoustics in music. That happens when the excitement about these simple, yet never comprehensible phenomena sweeps us along.

New Haven, 1968

BUT HOW DO YOU EXPLAIN COLOR? *A visit with Josef Albers*

In *Menon,* at the second attempt to define virtue, in which Socrates gives the interdependence of form and color as an example, there is the following dialogue: "But how do you explain color, Socrates?" Socrates: "You're playing an arrogant game, Menon." This, taken out of context, is the motto for this birthday greeting to Josef Albers. This fascinating, demanding, difficult man is now eighty-five. And even after many visits one isn't really sure whether one enters a studio or a study. This too belongs to the web of ambiguity and uncertainty in which Albers entangles the viewer of his work. He himself, this maker of mazes in art, lives simply, without fuss, withdrawn, in total concentration on his work. His warmth is wonderful; the way in which he speaks about and with his pictures, presents them to the visitor as figures that have their various states of mind or moods, is full of passion. This indeed is a man who has an unequaled sensorium for colors and who, thanks to his work, has gifted this sensorium to our era.

The house in Orange, Connecticut, a few miles from New Haven, into which he moved recently, is another Cape Cod in no way distinguishable from the others in the area. Only a few pictures hang on the walls. Here and there one sees the work of one of his students. We are in a tiny studio that is reduced to minimal necessities. None of the pre-Colombian terracotta figures is visible, a collection which Albers and his wife Anni assembled from their many visits to Mexico. The sole excess comes in Albers's conversation, in his passionate and often polemical argument with the art of our century. Albers rejects everything

that has even a whiff of irony, of Duchamp, of Pop about it. Yet this is a man who lives totally in the present, whose own creative drive keeps him from retrospective preoccupations.

Albers's fame and the rapturous reception of his work in these last years have finally laid to rest the prejudicial notion that squares were all Albers painted. The electricity coursing through the variations of this seemingly simple curriculum grew too strong. It could be said that the more quadrangles Albers painted, the more that shape disappeared from consciousness and lost its primary character. A paradox: the plurality of quadrangles wipes out the quadrangle. It becomes the instrument itself. Would anyone demand of David Oistrakh that he exchange the violin for a French horn? Nor should one forget that this oeuvre, developed in logical reduction over decades, unfolds on two levels, that of color and that of drawing. Nevertheless it has unity of style. *Structural Constellations* sets forth, in a different, equally irritating way, Albers's fascination with the conflict between seeing and understanding. His entire work, from the very beginning, is a reaction against the statuelike single image. Even the earliest works, which outwardly still belong to the gloomy woodcut style of the Expressionists, overcame Expressionism. Even then Albers already saw situations, varied his theme. Everything can be one way or the other.

Albers "dares," as he is wont to say of himself, "new variants." In other words, no fixed world, no single picture will be put up, as a personal answer, as the expression of the individual, against a possible multiplicity of expressions. With this theoretical as well as practical achievement, he stands as one of the giants of our time. Every assertion is always qualified by a glance at the mass of possibilities. Albers's work illustrates such logical principles. One thinks of what Edmund Husserl said, in his *Experience and Judgment,* about the conscious perception of what exists singly: "Every previsualization takes place in a conscious, fluid variability, in the consciousness of being able to fix variables. For example, as a particular color, but as free variant for which we can just as well substitute another."

It is significant that we tend to take most of the references to interpret and describe Albers's work from logic and, since it addresses our vision, from theories of perception. The "structural constellations" turn vision and judgment upside down. They consist of simple lines drawn with a ruler. Their effect is startlingly direct. We never succeed in grasping this framework of lines. What we read as plane leaps into three dimensions, and what we recognize as representation of space tips over into representation of plane. But this change does not occur in tranquilizing sequence. It all happens simultaneously. This torments the eye. Yes, Gestalt theory does help to explain the discrepancy between perception and comprehension. But understanding this does not make us less helpless. Our eye tends to see large, comprehensive forms. Those of Alber's compositions constructed of straight lines that circumscribe a surface and thus intersect are more easily combined in the eye than those built up of lines that do not meet. And because Albers's drawings combine representation of planes and illusion of space in a single form, our solution cannot favor one or the other. Albers uses the optical illusions which appear in textbooks as monstrosities of perception, and divesting them of their didactic meaning takes them through ever-new variations. The struggle between plane and space sharply activates the viewer's attention.

One of Albers's major problems, that of aporia, surfaces here. We have an experience that runs counter to our wish to fix a form. In the space of a split second a solution is offered, but in the very act of seeing, before the solution can be grasped, it is already rejected as if it were a foreign body. And here we have the difference with the Constructivist activities of other artists. Albers doesn't care about geometry—at most one could speak of a geometric Surrealism. These works lend themselves to monumental execution as wall reliefs, as the two supra portels at the entrance to the Landesmuseum Münster in Westphalia Show. There the simultaneous two- and three-dimensional impression creates irrational sculptures for which there is no precedent. Albers again achieved the maximum with minimal material expenditure: planar sculpture and spatial sculpture jutting deeply into space occupy the viewer more deeply as illusion, as effect, than an environment constructed with the most elaborate technical tools.

It isn't uncertainty that leads Albers to repeatedly ask his friends and visitors how his work is received in the outside world. He had to wait a long time for his accomplishment to be recognized as a unique combination of theory and creativity. The genial teacher—and thus he was hailed from the start—stood in the way of the artist, out of a justified skepticism concerning pedagogic art. His great success as an artist only came in these last few years. Albers, who gave the American avant-garde (which gave it to the world) the color field its strongest stimulus, has deliberately set himself apart from the movement that more or less consciously refers back to him—Hard-Edge. Actually, the sharp line between colors remains for Albers, who always likes to couch his formulations in an amusing, pithy meld of anger and self-justification, a "defamation."

In fact, experience has convinced him that there are no lines between colors. Color, the most relative tool of art, continues to deceive. Colors continually jump the limits assigned to them, influence each other, change each other. Albers once more confronts the basic concepts of color and line, that age-old problem of aesthetics that set Florentines and Leonardo, *Poussinistes* and *Rubenistes*, Ingres and Delacroix, Picasso and Matisse, against each other. Delimited, edged color exists only where the *disegno*, the sharp drawn line is used.

Books, exhibitions—among them New York's Metropolitan Museum's first retrospective for a living artist, a consciously provocative act in exhibition politics—those are the important stations of the past five years. A few months ago the two portfolios "Formulation-Articulation" appeared; they present the life work in a fascinating way with 127 silk screen prints. Typically for Albers, this self-portrait appeared only after the homage to his teaching and learning (to him an inseparable double concept).

Interaction of Color, the other monument of his life, a teach-learn book that with exemplary humility puts practice before knowledge, was published ten years earlier, in 1963. Significantly, Albers dedicated the book to his students at Yale. That is where it came into being, out of shared learning and teaching. The text edition, published in German in 1971, brought Albers's pedagogic genius back to his native land, from which the Nazis forced him in 1933. What does Albers set against self-satisfied academic method? A kind of artistic midwifery through which the student feels that he is getting at the right questions out of his own previous knowledge—and is making himself uncertain.

From the beginning, even in the preliminary course at the Bauhaus, which

Albers reorganized in a revolutionary way and in which he established a dialogue between work and materials, we see his passionate rejection of accepted techniques. Paper, wood, silver foil, or whatever else his students used, was treated with a creative mastery that transcends the predetermined, pragmatic uses of the material. Albers freed himself from the romantic principles of the Bauhaus which Gropius published in 1919, together with the Bauhaus program. For Gropius handcraft was to be the redeemer: "Architects, painters, sculptors are craftsmen in the fine sense of the word; that is why for every student the requisite foundation for all representational work will be thorough training in the basics of handcraft in ateliers and in experimental and work places." It was never sufficiently emphasized how strongly Albers rebelled against this tradition of handcraft as the supreme value. He wanted a creative association with the working material, not one in which its productive treatment is dictated by long tradition. Even as a student Albers refused to abide by the rules. As he made the rounds of garbage dumps, with rucksack and hammer, to collect bits of broken glass and bottles, Gropius warned him: unless he concentrated entirely on wall painting, he'd have to leave the Bauhaus.

Instead of a conservatory of all sorts of technical and handcraft skills, Albers seeks the paradox, the nonexpert, the error. Even in the simple handling of material, one of the major themes of his own art crops up: the conflict between what actually is and effect. All his books and statements revolve around that and are a unique contribution to the psychological and philosophical examination of this gap in our knowledge. Albers has only analyzed color in this brilliant, important way for the past thirty years. *Homages to the Square* belongs to the last stage of his work—which, seen as a whole, is extremely rich and varied.

Albers is interested in refining our ability to react to color intervals, color interferences, in directing our eye to the relationship between colors. The principle of his teaching: color remains the most relative medium of art. Color deceives constantly and allows for innumerable interpretations. Through a trial-and-error method to which he exposes his students and himself, he tries to develop an eye sensitive to color quality and color quantity. He always puts practice before theory. This is where his book differs from all those that build up color systems or use color as a measure of moods; it contains more color psychology and visual training than system. He presents no color theory, because the effect of color cannot be inferred from concepts. In that connection he says the following: "In order to use color successfully, one must recognize that color deceives constantly." *Interaction of Color* contains a wealth of ingenious exercises that challenge everyone who takes the book in hand. Albers in no way demands correct answers as in a test: after all, what matters in the final analysis is the realization that knowlege is not possible, which leads to personal preferences and resolutions. The conclusions he has reached belong equally to the perceptual and to the moral: "To come to no decision can also count as an important answer and certainly as a positive position." The dominance of practice thus acquires deeper meaning, reinforced by Albers's own work. The sum total could, after all, be called a system.

A look at the development of art since Impressionism shows that speculation about color, as about all the tools of art, has increased constantly in independence. Yet it has remained fixed to the morphology of the work. Albers freed

color from every context, be it in representational or nonrepresentational painting. That is why he chose the "zero-form" quadrangle as his arena. He offers us hundreds of versions, and uses a variety of schemata. The pictures are in three or in four colors. The scheme itself has no formal purpose, it serves to solve different quantitative problems, to play differently sized zones off against one another. Thereby areas with different levels of color activity arise. In the narrow strips the colors come closer together, lending the image a more coloristic effect than in the broader zones.

All these are optical facts that can be described, accounted for. But there is an abyss between reason and effect. For the viewer, Albers's work belongs to a realm where questions about reasons to not detain for long. What Albers managed to achieve was to give visionary evidence by rational means.

Orange, Conn., 1973

THE AVAILABILITY OF ART *A visit with Vasarely—His triumphal March, a phenomenon of French artistic life*

Part of Victor Vasarely's doctrine is to overcome the artist; that is, to do away with the idea of the artist intent on the single work. The attitude of the master who fulfills his mission drunk on turpentine, in Duchamp's words, does not suit him. He has ideological reasons for that—and we'll come back to them—but they alone cannot explain Vasarely's aversion. He needs this curt rejection to dialectically devise its opposite. This opposite is, in Vasarely's eyes, more modern, flattering, and trustworthy. The artist Vasarely is an industrialist, a man who not only beautifies an interior, but who wants to modify society itself.

Behind the orderly, dazzling white Empire façade of his comfortable, roomy house in Annet-sur-Marne, east of Paris, everything seemingly goes like quarz-clockwork. Assistants finish pictures according to Vasarely's sketches and charts, and women cut out the "plastic unities" from which Vasarely has now begun to have his works assembled. A plastic unity (*unité plastique*) consists of two geometric forms, the smaller one contained in the larger. The units exist in fifteen different formal patterns; the two forms are in contrasting colors, and fifteen colors are available for each form. There are six different basic tone scales, each with eleven nuances. Thus the possibilities of variation are almost unlimited.

Between the entrance gate and the house there is a path of flagstones with light gravel to the right and left of it. The breaks in the flagstones seem deliberate—they form a free geometric pattern. A trifle that nevertheless is no accident in Vasarely's planned existence. The play of lines documents one of Vasarely's most important experiences, in 1936, when he lived in the southern Parisian suburb of Arceuil. On his visits to town he had to change trains at Denfert-Rochereau station, whose walls were covered with square tiles. These tiles were crisscrossed by innumerable hairline cracks. The organization of these

Victor Vasarley. Photo by Wolfgang Haut.

surfaces became a source of inspiration to Vasarely—back then sensory experiences still inspired him. The Denfert Period—a concept under which Vasarely himself groups the works he did from 1948 on—played a considerable role in his development. Starting out from the network of cracks on the tiles he arrived at a pictorial structure in which a net of lines separates color zones. Reminiscences of objects still turned up in these pleasant, decorative works. Other stages of the oeuvre also show that Vasarely derived his version of geometric abstraction from visual experience, for example his Belle-Isle Period (1947), during which he created ellipsoid shapes based on pebbles, mussels, and sea-polished fragments of glass. The "spiritual in art" still had the upper hand—Vasarely's egg shape was meant to express "the oceanic feeling." It was his Crystal Period (1948) that brought—as a result of an experience with axonometric perspective at the Abbaye de Sénanque—the first fundamentally geometric compositions.

Behind the house lies a rambling parklike garden, at the bottom of which stands a large, two-story cubic building. This is Vasarely's new atelier, or rather his new assembly line. The building is dazzling white, the park deep green. Other colors are totally absent. Color appears only in the work which has rights of exclusivity in these ascetic surroundings. The neutral environment is like a hunger pang before a meal. In this environment one can almost physically feel what Vasarely wants to express: the organization of the work creates the mood. This mood resides as much in the chromatic transitions of his large-format pictures as in the fanatical order in the house (which in turn is a symbolic form of the posture of the antiartist who equates disorder with inspiration). And most of all it comes out in Vasarely's own demeanor. He is well-groomed, distinguished, with a self-confidence that might at first glance be taken for arrogance. He cultivates his image with an unflagging pleasure in detail. One display case in the workshop is devoted to himself, shows photographs, catalogues, books. In discussion, he only reluctantly takes a risk; he does his utmost to stick to his theoretical position—even if it contradicts the work itself.

His convictions—he has repeatedly committed them to writing; the volume he published in 1965, Vasarely, is a masterpiece of self-interpretation—revolve mainly around the theme of art and artists in today's world. He coined several dicta that were taken up by a group of artists in Paris in the fifties, artists who came to be associated with the Denise René Gallery. The doctrine that has since developed around Vasarely and the gallery is one which could be asserted and accepted with such consistency—and, I am tempted to add, such naivete—only in a country that has no Bauhaus tradition. With that as a starting point, Vasarely's achievement can now be sketched. His success is not startling compared to that of Op internationally. Measured, however, against the background of the Ecole de Paris, it clearly shows that a radical change is taking place in French intellectual life. France is—or was—*the* European country that remained virtually immune to Bauhaus ideas.

Vasarely constantly refers to the Bauhaus—actually to his own student experience at the so-called Budapest Bauhaus, the Muhely. The importance of this encounter is questioned in some quarters, and particularly by Henrik Berlewy, who claims proprietary rights to mechanostructure and kinetic art. That would certainly narrow down the problem of Optical Art.

Vasarely himself could only have acquired an interpreted, second-hand

knowledge of the Bauhaus through his teacher Bortnyik in Budapest. After his visit to Weimar, Bortnyik developed his own version of the Bauhaus curriculum. A letter (yet unpublished) that he recently wrote to Vasarely contains information on this point. Bortnyik acknowledges that Vasarely quite early went beyond conventional art.

This letter is an important piece of evidence. Vasarely's vision was formed by Bortnyik's geometrical-abstract compositions. Thus it is not true that Vasarely deliberately chose a style later on that he thought would bring him success. Consequently we can believe Vasarely's dates, which are often double—one for the conception, another, often years later, for the execution. In any case, in Vasarely's work the invention is of lesser importance than the discipline, the tenacity that he brings to working out a program. That too is immediately linked to his concept of the artist concerned with a group of works, and not the individual work.

This tendency has become ever more pronounced these past years. In the latest phase his own creative activity has been largely reduced to selecting among various attempts at solutions. Cybernetics, computers, are part of his daily vocabulary. Nor is he concerned with finding the optimal, sole solution—that would, in Vasarely's eyes, be a regression to the romantic definition of the work of art as unique creation. Vasarely starts out from two premises. One is that art in our time fulfills a new function, that is, it must be communicable in the broadest possible sense; the other, that the technology of our era must have an influence on its art and design. This doctrine scorns the age-old vision of the original work. Vasarely replaces the concept of the original with the concept of the prototype. The artist creates a model that can afterwards be reproduced as often as necessary, since it can be duplicated materially; this model has no such intrinsically artistic qualities as texture, brushstroke, changes and recommendations. Vasarely dispenses with the brush and has his compositions and color ideas executed in premodeled *unités plastiques*. The *unité plastique* is the work's irreducible element; it replaces the brush stroke.

Vasarely's newest works are not very rich formally. Nevertheless he insists on programming a minimum of seven aesthetic data into even the simplest solution: these consist of color contrasts, contrasts between different plastic units, and spatial and planar density and diffuseness. Here ideas come into play that transcend the theory of the work—for in truth Vasarely has never entirely adapted himself to his theory. Artistic freedom is regained in circuitous ways. Beneath the order of his studio, which seems to sacrifice artistic unrest to algorithm, hides an uncertainty quite at odds with the scientific attitude Vasarely chooses to assume. And this is caused by the fact that, once realized, these mathematically calculated color and formal values acquire a presence of their own that demands aesthetic judgment.

We can turn Vasarely's procedure around and say that if these works were calculated, then they must be calculable. Yet that holds true only for the analysis, not the perception. Perception remains difficult. One can only recall Wölfflin's statement, in connection with ornamental art, that planar patterns of such complicated composition that their rules cannot be recognized, can have an entirely painterly effect.

This applies to Vasarely to a high degree, especially when the total oeuvre is

kept in mind. And everything tends toward a total oeuvre: the immense "imagotheque," in which over a thousand prototypes on graph paper are classified, the plan to create a Vasarely foundation near Gordes, in southern France, in which over five hundred pictures will be housed in addition to the sketches (prototypes), and finally his efforts to lift the barriers between painting-sculpture and architecture-urbanism. Vasarely would like cities to benefit from his works. They need not be colorful cities, but they must be structured ones. His New City he sees growing out of contrasts, out of rhythmic juxtapositions of differently structured zones.

So far, not much of this has come to pass. The first experiments are underway—thanks less to architects than to manufacturers of building materials. The glass factory of St. Gobain is producing colored tiles, and cement factories have been commissioned to make colored blocks. The Age of Reproducibility—as Walter Benjamin so brilliantly demonstrated–has not only altered our relationship to the work of art, but in Vasarely and in Op it has received an answer from art itself. The phenomenon that visitors to museums often spend more of their time choosing postcards than looking at the originals cannot be denied, nor should it be arrogantly dismissed.

Vasarely's answer to this is a work in which original and reproduction coincide. The thinking behind this answer, which suits Vasarely's aesthetics less than his ideology, is by no means new. The boldest anticipation of this idea can be found in a man who was hardly inclined toward simplification, Paul Valéry: "As water, gas, electric current at an imperceptible movement of the hand enter our homes from afar in order to serve us, just so will we be provided with pictures of tone sequences that will appear at the slightest movement, almost a sign, and will leave us in the same way" (*Pièces sur l'art*).

Vasarely has commissioned such a machine that will, someday, project his works into every home. In addition, he has been working for years on a color film that will show his development, his working procedures, and his oeuvre. The fact that his works can be reproduced is, in his view, a great advantage. What the work of art sacrifices in trancendental aesthetic uniqueness it wins back through its material indestructibility. It is repeatable forever.

Paris, 1967

IN THE BEGINNING WAS AGAM
A comprehensive exhibition in Paris

A title that turns up in the bibliography of the catalogue to the large Agam exhibition at the Musée National d'Art Moderne should be quoted right at the start: "In the Beginning Was Agam" (Jean-Claude Meyer, *Combat*, 7/16/71). Whoever speaks to Yaacov Agam knows that such a conviction is free from self-irony. Agam does not like it when influences on him are detected, when one assigns to him—and the morphology of the works makes that no trouble at all—

a playfully boisterous Constructivism. Today's artists are quick to jump up and defend themselves as well as their rather modest inventions. Proofs of dates promptly go into the safe—that is part of a situation where art, inspired by technology, is vulnerable to legal action, and as often as not finds itself at the door of the patent office. Op and Kinetic Art, an area that itself often and uninhibitedly claims an analogy with the natural sciences, increasingly forces artistic judgment to take account of such claims. From work to work, from artist to artist, there is at most a slight change in structure or in manner of functioning. At the same time, the search for individuality reveals the real problem of a pseudotechnical art, and this is what fundamentally destroys the analogy with natural science. The difference does not only lie in the purpose. How figurative this parallelism between art and science is meant to be, is made crystal clear in the dialogue between Agam and François Le Lionnais, printed in the catalogue. On the one hand we have the claims of an aesthetic research weighed down by technical jargon; opposed to these claims, the convictions of the mathematician who—if he has to talk about ostensibly scientific art at all—counters it with the results of mathematics and physics, to him the real avant-garde. This contradiction ought to be kept in mind when we consider Agam's electronic-technical "easel."

Yet it is precisely because of this discrepancy between technological claim and a renovated concept of concreteness that makes an unconvincing attempt to symbolize technical processes, that Agam's work—and that of other proselytes of the art-and-technology ideology of our time—has managed to exert considerable influence. Agam, as an official artist of today's Ecole de Paris, has even penetrated the Palais de l'Elysée. After the grand Forum at Leverkusen, West Germany, Agam has been allowed to fit out a grand salon for President Georges Pompidou.

There is no doubt that Agam's work is effective, as witnessed by the crowds the Paris exhibition drew—the first big Agam show anywhere. Finally his development could be studied whole, his odd mixture of precise and Dadaist-aleatory inventions could be seen in one place. Just what it is that gives the oeuvre a feeling of development becomes clear quite soon. Movement seems to be the common denominator. In his writings Agam emphasizes the ideological nature of his fluctuating works. He isn't satisfied with an abstract justification of movement (like, for example, Jesus-Rafael Soto or François Morellet). Merely to make use of the viewer's sensorial givens—perception, irritation, after-images, difficulties in adapting—is not enough of a basis for him; nor are the social implications, to which Vasarely and Julio Le Parc are wont to point. Not since Mondrian has an artist of Constructivist persuasion so uncompromisingly insisted on the transcendent conditions of his activity. Agam starts out from the Jewish ban on images: and he circumvents it in the sense that he achieves not a fixed likeness but a vision that never stabilizes. The artist keeps reaching back to this distinction between forbidden image and relativized vision. But however syncretic his intellectual-religious world is, one can assume that the proscription against making images (these are in fact never attempted in geometric art) was quickly adapted to the field of nonrepresentational form.

Kinetic Art, which engaged a whole series of artists in Paris in the fifties (the exhibition "Le Mouvement" at the Denise René Gallery in 1955 gave this tendency a programmatic form) is preempted ideologically by Agam. His self-

interpretation is doubtless of great interest—it gives his particular brand of Kinetic Art a kind of spiritual reserve account.

It is certain that Agam beat Soto, Pol Bury, or Jean Tinguely by several months with his 1953 show at the Galerie Craven, when he exhibited his *Transformable Pictures*—the reliefs that could be manipulated by the viewer. Their closeness to Tinguely's "meta-Kandinsky" or "meta-Malevich" reveals the early ironic-Dadaist aspects of such work. The viewer is supposed to interchange the elements, put them in different places in the picture.

Agam first studied at Bezalel Academy in Jerusalem with Mordecai Ardon, a former Bauhaus student. At the end of 1949, Ardon sent him to Zurich, to his own former teacher, Johannes Itten. In Zurich Agam met Siegfried Giedion and Max Bill. In 1951 he took a trip to Paris, and stayed. In Zurich as well as in Paris, he was able to extend his knowledge of the Bauhaus. *Structure I* (1952) and *8 + 1 in Movement* (1953) take over almost literally material that had been studied in the preliminary course of Joost Schmidt. These formal problems—here, variations on a few basic themes—may have come to Agam's attention in 1952. We have no proof for that, but the themes are pictured and described in the Bauhaus book published by Walter Gropius and Herbert Bayer in 1952. This book, at the time the only comprehensive study of the Bauhaus period, definitely had a widespread influence.

Movement, total registration, analysis of the visual process stand at the beginning. The transformable pictures which the viewer could remake with his own hands (at the retrospective he was asked to refrain), brought Agam to André Breton's attention. Breton, who after the war generously tried to preempt young artists and new trends for Surrealism, saw in Agam an opportunity to classify the psychological reactions of gallery goers. Evidently he remembered the "Decalcomanie" of prewar times, the semi-abstract transfer images offered by Oscar Dominguez and Max Ernst as lascivious vegetative Edens. But the allusions to Gestalt psychology contained in Agam's pictures were certainly not intended. One can indeed put together heads and little figures from the separate elements (which seem to derive from Kandinsky's late Parisian pictures), but Agam wanted the material to be left in its concrete, open state. Consequently he began to limit the active participation of the public in his work, shifting the possibility of variation to the work itself. The "tableaux polyphoniques" require that the viewer, by walking up and down before the image, set free the various overlapping "picture stories."

Agam no doubt arrived at this change of principle under the influence of Vasarely, who started to put together his depth-kinetic pictures in 1953. In these, two or three motifs, each on a sheet of glass separated by a space, were superimposed. A change in one's point of view called forth changing interferences. From then on Agam more or less standardized his works. The plane surface was replaced by a kind of vertical harmonica bellows. El Lissitzky had used something like it in 1926, in Dresden, in his *First Demonstration of Space*. The surface is split such that what is represented on it is only revealed from a certain angle. Soto's wires and strings, Carlos Cruz-Diez's *Physichromies*, are based on similar principles. In them too palpable, relieflike patterns conceal and interrupt the uniform picture surface. But whereas Soto and Cruz-Diez were after a rapid continuous disturbance of the plane, Agam worked with what might

be called a lower frequency of oscillation. With him, the frequency remains so measured that in spite of all the changes of form and color within a picture, there are nevertheless single autonomous motifs that detach themselves. His works contain up to eight separate themes. In spite of that, the composition, the pictorial vocabulary that Agam uses (he loves color inversions, strong contrasts in motifs) remain conventional. Nearly all the details of form and color are familiar from the works of the Constructivists of the first generation.

Agam's true strength and the astonishing effect of his work, lie in the transposition of form into movement. He subjects the viewer to a vortex of movement. This does not, as with other Kinetic artists, simply mean offering configurations that create perceptual uncertainty, that challenge the viewer to look and look again, though this too plays a part in Agam. The eye keeps trying to find a satisfying, total view. The illusion of total sight, of multivision, drives it on: but equally strong is the sensory satisfaction that this color-contrasting hide-and-seek game gives. In small formats, where the picture slats are closer together, there is even a kind of mirage: the image that was withdrawn from the eye is reflected in what we are now seeing. The pearly-opal tinge that seems to float across the painting recalls Renoir and Art Nouveau glass.

The exhibition is rounded out by a series of single pieces in which Agam expresses, more or less pathetically, his fascination with mobile, unpredictable effects. *Let There Be Light* belongs to the realizations that Agam classifies as "téléart." A light bulb flickers or lights up when you sing or speak less or more loudly. Or a record player with four tone arms touches a disc at four different places simultaneously. It's reminiscent of a Dadaist trouvaille that could easily have come from Duchamp or John Cage. The sculpture is superb, and the best novelty after the *Tableaux Polyphoniques.* Since 1966 Agam has been preoccupied with mobile sculpture that, consisting of single pieces, keeps displaying new variations. Here the concept of change is brought to a form that in itself postulates multiple vision. All in all, an important, impressive oeuvre that, in spite of all the metaphysical adornments, has enough sensory legitimation to warrant its popularity.

Paris, 1972

HÉLION OR THE RETURN TO THE TREE

The painter Jean Hélion spends most of his time in a little castle near Chartres, in Bigeonette. In the sheds nearby he has enough room for the large-scale canvases he has been painting these last years—colorful, tumultuous scenes that capture the streets on a scale of one to one. He is a painter who for more than thirty years has been brushing his talent against the grain.

Hélion, born in 1904, has had to listen to this reproach innumerable times. His return to representation in the thirties brought him a lot of head shakes and teasing, but also savage abuse. Since then the Hélion case has been treated as a continuation—though not as tragic in its self-destruction—of the de Chirico case.

Jean Hélion. Photo by W. Spies.

Museums and the exhibition establishment hardly bothered with the "Hélion after Hélion," who from 1939 on so obviously rebuffed the *Compositions orthogonales* (1929-30), the series of *Equilibres* (1933) in the portrait of *Emile* or in *Still Life with Umbrella*.

THE ETHICS OF VISION When a retrospective includes works from all periods without favoritism, the shock is understandable. An alliance of the incompatible is what Hélion seems to serve us with. On the one hand, there are compositions from the early thirties—before Hélion attained originality with his *Figures*—that juggle with Piet Mondrian's de Stijl—and look very contemporary. Then there are scenes of everyday Parisian street life, vegetable stands, done with a palette that the representatives of the young generation like Gilles Aillaud or Eduardo Arroyo have in the meantime already appropriated. It is obvious that Hélion, for his part, interrupted the aesthetic phylogenesis that is demanded of artists in our times. He got off the one-way street that leads from visualization to abstraction fairly quickly.

Now apparently Hélion's time has come. Jim Dine, on a stopover in Paris, visited the Hélion retrospective at the Galerie Karl Flinker. He then exhorted the French to finally pay due tribute to this great forgotten artist. Such a statement does not express a mere casual opinion, it is much more basic—a delegate of the Pop generation has let a cat out of the bag.

Hélion has meant something to the Americans before now. Among those who appreciated him even in the forties—as a representational painter—is Richard Lindner. He saw Hélion's early figurative pictures in 1944, at the exhibit at the Rosenberg Gallery in New York. Hélion had at the time returned to the United States. He'd settled there for a while in 1936; at the start of the war he went back to France, was drafted and became a prisoner of war in June 1940. In 1942 he succeeded in escaping from a labor camp in Pomerania, and managed to get back to the United States by way of Marseille. Hélion aroused interest, against the trend of the time. Balthus, Alberto Giacometti, Meyer Schapiro, Francis Ponge were among his earliest friends. This is where one can detect elective affinities. I asked Hélion about people who had given up an existing renown, as he had, in favor of new work. He didn't deliberate long before replying: "Giacometti. He turned away from Surrealism after the war."

But there can be no question of turning Jean Hélion into a prime example of a reversible conviction, as a man who changed his identity out of disgust or urge to destroy. He did not simply shrug off geometricizing abstraction, thanks to which he has a place in the history of nonrepresentational art. Nor should it be overlooked that the rigorous world of images, which, at the end of the thirties, tipped over into a kind of trivial sphere of the twentieth century, continues to appear in his work. In 1947 he painted an ambitious picture (now at the Musée National d'Art Moderne, Paris), which he titled, characteristically, *A rebours* (*Against the Grain*).

The painter stands in the middle of the composition. To his right there is an easel on which an abstract painting can be seen. This "picture within a picture" is reminiscent of the *Equilibres* of the thirties. It works like an ideogram for the female nude lying, head down, on the painter's left. Boxed in between model

and picture-within-a-picture, the painter considers. Without a doubt this is a program picture, about the relationship between artist, model, painting.

The discrepancy illustrated brings to mind Picasso's studio subjects in the etchings for *Suite Vollard*. There the reversibility of representation and abstraction is carried through in an exemplary way. As for Hélion's picture, it obviously wants to call attention to the fact that the return to figurative painting is in no way simply a negation of the preceding stage.

Again and again easels with paintings turn up in the later pictures—like in the more than twelve-foot-long triptych of the *Rue de Dragon* (1967). And reminiscences of the previous abstract style appear in these paintings. They propagate, it could be said, an "ethics of vision." Hélion's coming to grips with abstraction in the early thirties could be put under that heading. In 1932 he described his intentions in a text that strongly appealed to André Breton: "Thanks to the habit of following the curves of cast-iron balconies, sniffing dogs, the movement of women's dresses, the up-and-down of posters, and everything you get to see every day, people's eyes have become confused. And what a tangle the eyes' roots make in the brain. I am trying to build a machine that will comb the gaze."

Hélion is conscious of the controlling function his earlier paintings were meant to perform. He understands how to emphasize, in conversation, the mock naivete of such picture cycles as *The Market at Bigeonette* or his street scenes.

MONDRIAN TO THE POINT OF BIGOTRY The reason for the friendship between Hélion and Francis Ponge—the splendid Ponge, by whom anything at all, be it a pebble, a piece of soap, the smoke of a cigarette, is transmuted in his writings, epiphany-like, into an object of value—becomes self-evident. But one feels very quickly, with Hélion, how inevitably, how quickly every statement leads to an autonomy that seems so specific to the oeuvre. Like Ponge, he understands how to linger in the phenomenology of the lowly, how to proclaim the random object as the focal point of his view of the world. Once Hélion's passion for things is experienced, it becomes comprehensible that in a choice between the Neo-Plasticist vocabulary and a structural penetration of concreteness, sooner or later the latter must win.

The reflections that pushed Hélion out of the circle of the Paris group *Abstraction-Création* in the second half of the 1930s, today seem of fundamental importance. Little about that period is known. Hélion appears as the star witness. The positions and publications in the journal *Abstraction-Création-Art Non-Figuratif*, of which Hélion was a cofounder in 1931, along with Hans Arp, Albert Gleizes, Auguste Herbin, Frantisek Kupka, and the now totally forgotten Tutunian, Valmier, and Vantongerloo, have captured the climate of the period. The generic "nonrepresentational art" was assigned two different definitions of nonrepresentationalism, namely "abstraction" and "creation." Abstraction in this context meant deductive abstraction, which eliminated the representational elements from the picture step by step. Creation, on the other hand, meant a creative process that limited itself from the outset to dealing with compositional elements that had no objective significance. Repressed, displaced representationalism for the ones; absolute "concrete" nonrepresentationalism for the others. The examples that appeared in the journal belong to both trends.

No wonder that fairly soon differences between the various groups arose. The

associations with objects that inevitably turned up in most of the pictures were criticized. As Hélion tells it, there were endlessly drawn-out discussions during which, with extreme anxiety, objective echoes in the compositions were denounced. "Once Valmier brought a painting. I thought it had come off quite well. But Vantongerloo claimed that he could see a fish. It dawned on me then that we were on the wrong track. If one denied a picture the right to evoke the world, then one killed the picture. In only a few years, abstraction had grown a paunch. It revolved only around itself. Everything revolutionary was gone. I had the feeling that we were growing conservative. And suddenly it came to me that the opposite of what we claimed was also necessary."

From then on, Hélion found it impossible that every line, every brush stroke should be judged on the strength of its distance from reality and independence of the object. "Mondrian told me, every time I drew a diagonal line, that I was a naturalist. With Mondrian's emulators this purism became pure bigotry."

Nevertheless, Hélion added, in the midst of all these discussions, Mondrian remained very liberal; and even, compared to Vantongerloo or Herbin, very calm and composed. He had accepted other approaches—on condition that they preached hatred of nature. "I recall a visit to the Dali show at the Galerie Goemans on Rue de Seine. Mondrian liked his challenge to nature, his denial of the natural."

THE TECHNIQUE OF CLEAN HANDS Abstraction as ideology, around which artists of the most diverse backgrounds congregated in the early thirties, was only comprehensible, in Hélion's view, against the background of the optimism of the time. That moment of immobility between the wars, the calm before the storm, encouraged the tendency toward the abstract and—that was after all what it meant ideologically—the absolute. Mondrian's political idea, which moved on the heights of a conflictless Utopia, Hélion's thoughts, characterized the period perfectly.

The group around *Abstraction-Création-Art Non-Figuratif* was not active politically. That distinguished it from the Surrealists, who were at the time very much committed: "Our group (Hélion said) would on the one hand have liked to emphasize impact with the proletariat, but on the other hand shrank back from it. I had the feeling that there was a freedom in Surrealism that we did not have, and that I longed for. I envied Max Ernst the opportunity of playing with various levels of reality and thus of coming into stimulating contact with the world— while we had to go to the laboratory. It was also typical that no writers found their way to us. They didn't pay us any attention. In a certain sense we rejected words, we accepted only the general, the structure."

It can be felt everywhere, that fear to get one's hands dirty, thus blocking one's escape from detail to essentials. This is symbolically reflected in these painters' methods—they were "clean" techniques; and the style was strictly planar. "Maybe that was the secret. As long as you held strictly to the surface, you were safe against the figurative. But as soon as you began to use a technique that played with qualities, the world would relentlessly intrude."

Hélion's first works of the early thirties rid themselves completely of the object. But very soon works appeared in which the flatness was lost. The series of *Compositions* went back to watercolors made at the time—very light, colored

sails spanned between India ink masts. They are reminiscent of Bissier's later works. But for Hélion they were, as he says himself, sketches without absolute, intrinsic value.

LOVELY AND COLD These forms return in the paintings, though not as gesturally soft, but rather strictly subordinated to color perspective. The colors are modulated gradually from the dark to the light end of the scale. The resulting effect is similar to that of pictures like Léger's *Cardplayers* (1917). But anthropomorphic combinations quickly began to appear within these abstract compositions, giving rise to works with such titles as *Upright Figure* (1935, Albright Knox Gallery, Buffalo). The transition to a new, elementary figuration can be felt in all the pictures originating in that period—a concretizing of abstract configurations.

This gradual transition did not lead simply to the turn in the work that came through in pictures like *Emile* or *Still Life with Umbrella*. Nowhere in the preceding works did clearly outlined objects appear. At best schema, molds for object-qualities. But in a flash all this changed. A painting style in the Constructivist spirit—"lovely and cold," as Meyer Schapiro wrote in 1940, in the foreword to a catalogue—turned into an art in which particular motifs are ritually repeated. Where the *Compositions* and *Figures* of the thirties tried to bring in a phrasing of form, a glissando of colors, and to incorporate these in the total composition (Hélion: "Poussin's grouping of elements fascinates me"), this radical change in his work at first produced an aggressive isolation. Single elements precipitated out, colors confronted each other in shrill dissonance.

The things that began to turn up in the paintings now, confounded each other like strangers. Instead of composing them, Hélion formulated a distance between objects which is not unrelated to that seen in the works of Neue Sachlichkeit or of veristic Surrealism. "I decided to look the world in the face;" and, a little pathetically, he adds: "I painted a tree." That sounds odd; it brings to mind the description a starving man might give of his first solid meal. Hélion did not mention the tree by accident. It made one think of Mondrian's mania about sitting with his back to the window to avoid seeing a tree.

Hélion went from antiobject back to object. His first heads had the effect of still lifes. "I pushed the hat over the model's eyes. That was an effect I could paint. That way I didn't have to do the eyes. I started grabbing at objects. Objects are no-nonsense things. If you make a nose too long, it stops being a nose. But an umbrella that's too long is still an umbrella."

In New York, in the early forties, the themes appeared that still dominate today: show windows with mannequins, newspaper readers, people out walking, still lifes. The circumstance that a painter like Hélion exchanged an "essential" style, nonrepresentationalism, for such banal themes doubtless influenced the Pop generation. And beyond that, Hélion's work appears exemplary for the situation of today's art in general—for the possibility and necessity of artistic realization outside of apparent causality and determinism.

Paris, 1975

THE PROLIFERATING GRIMACE *The Francis Bacon Retrospective at the Grand Palais in Paris*

Jointly organized in Paris and Düsseldorf, the large Francis Bacon exhibition that has just opened at the Grand Palais will go on in March to the Kunsthalle. The catalogue lists 108 works, making this show even larger than the retrospective at the Tate Gallery in 1962. A revealing test, at this point in time, to put an artist up for discussion who had to be satisfied with the role of famous outsider for so long—because he painted figures. The representational-versus-non-representational dichotomy lost its theoretical edge years ago.

During the fifties Bacon was a much-appreciated exception, a kind of alibi figure that certain museum-people, otherwise devoted absolutely to the informal abstract run, liked to cultivate on the side. This is probably what gave him his monopoly in the field—a man who handled the oil paint of Rembrandt and Velasquez with as much matter-of-fact authority as his illustrious countryman Henry Moore did Rodin's bronze. And though seemingly intended to shock, Bacon's paintings were out for the grand effect.

And they achieve it easily. His stupendous technical skill, the allusions that finally allow the relieved viewer to get back to the Imaginary Museum, obviously satisfy more than works like, say, those of Mondrian and Albers, which exist in a kind of ongoing quarantine. Bacon has a genius for playing on the conservative bias of his viewers, on the pleasure everyone has at comparing, weighing, measuring. His is one of the few oeuvres of our time that since it encompasses so many visual associations, still seems *judgeable*.

The work of recent years shows Bacon turning for procedures to a brand of painting which his own stubborn grip on the object had in a sense paved the way for: his *Three Figures in a Room* (1964), *Three Studies for a Portrait of Lucien Freud* (1966) or his *Three Studies of a Male Back* (1960) make use of means to which Pop has accustomed us. Everyday furniture, venetian blinds, toilet bowls, bathroom mirrors in which men contemplate their own strange images in the act of shaving, flowered carpets, juxtapositions of color to describe which the word harmony would be completely out of place. The change in his style seems abrupt. Looking back, the paintings of the first period, on into the sixties, appear to be a conservatory of every conceivable painterly approach—the late Rembrandt, Velasquez, the Flemish School, Degas, or, in works like *Magdalena* (Madeline?) of 1945-46, Bonnard, and finally, in his shredding of the motif into commas of color, the results of his study of Van Gogh's *Painter on the Road to Tarascon*. In all of these, the deformation of the subject was almost invariably balanced by masterly, traditional technique. Jarring color contrasts had not yet appeared.

Bacon's personages, in their present chic Pop environment, still look grotesquely distorted, and his color range richly nuanced. Yet taking the work of recent years as a whole, a certain banalization can nevertheless be seen. The effects have grown coarser. The threatened individual of Bacon's earlier work has shrunk to a kind of Mickey Mouse doll that can be twisted into the most unlikely positions. An example of this is *Two People Lying on a Bed*, painted in 1968. It is a composition full of unintended humor, one from which existential threat

seems to have vanished. In the recent canvases Bacon's figures appear in sharp definition against smoothly brushed, uniform backgrounds. They project, complex silhouettes, into a lucid shallow space. These figures are as stark as calligraphic symbols, they melt like Dali watches; and their contours are richly articulated, vibrating with movement in suspension.

The exhibition is extremely informative and complete. Only Bacon's early years were better documented at the London show. Four paintings exhibited there, executed prior to his *Three Studies for Figures at the Base of a Crucifixion* of 1944, are missing in Paris. Thus the oeuvre starts, so to speak, at a lower level of content—the derivation of Bacon's human image from the Christian passion theme has been almost completely obscured. Recent developments in his work, which have pushed his Expressionist beginnings further and further into the background in an attempt to recast, as it were, the gore and deformity of earlier years as formal qualities in their own right, may explain why Bacon has censored his work. Involved in the selection for this show, Bacon must have had his reasons for wanting to suppress any too obvious evidence for the narrative base of his figurative distortion. His self-image as an artist, as the revealing conversations with David Sylvester show, compells him to argue away the gruesomeness, as when he says that he never intended to portray horror in his paintings.

No one who discusses his work can sidestep this apparent paradox. The spectator comes to this exhibition with images in mind that figure as prototypical examples of an expressive approach: gaping mouths, lacerated martyred bodies sewn back together any which way by an inept plastic surgeon, paint seemingly laced with blood, an impasto that evokes crusted, clotted excretions. Of course Bacon has resisted, from the beginning, any such direct interpretation of his images, every attempt to read them as separate statements. That may possibly be why he is so partial to the tryptich form and to theme and variation. Looking at Bacon's tryptiches, what first becomes apparent is that they usually—and at odds with tryptich structure, which tends to build to a climax—subdue the theme. Bacon will generally vary one and the same figure through all three parts of the composition, thus avoiding any hierarchy of importance. There is no intensification of plot, no building up of an event to its climax. Strictly speaking, the images are tautological. The emotional expressiveness of a theme (or rather a manner of presentation that suggests its expressiveness) seems almost to be cancelled out by its repetition from one panel to the next.

As for variation, it is given in terms of movement. Figures are presented in different postures and situations from work to work. The faces that one would expect to reflect the situations their bodies are in, are left in a state of fundamental deformation which throughout entire series of paintings is neither relaxed nor screwed up to a higher pitch. This is deformation *fortissimo* and of a sameness, and since there is no point of comparison by which to judge it within the oeuvre, it gradually loses its content—its very quality of being deformed. If now and then an undeformed image or even an image in the early stages of distortion were to appear, it would work as a regulative, a marker of degree. Picasso, to whose freedom Bacon obviously appeals, does use such contrasts in his work: after a period of classical adherence to the rules his subjects will suddenly slip away from every known means of portrayal. It is precisely the

stereotyped nature of Bacon's physiognomies that robs them of psychological tension.

Having standardized the mask, Bacon nowhere revises or qualifies his decision; and the grimace loses its force to finally become, psychologically speaking, an indifferent phenomenon. The lack of a situation that would explain the physical fact—that these faces have been injured—qualifies their effect on us as human beings. Clearly, Bacon has been attempting to find an emotion-free brand of distortion comparable to those deviations from the figurative canon that set in with Cézanne and Cubism. This underplaying of the expressive side of his work in the past few years may, among other things, be due to a realization that the expressive and aggressive as subjects of art have lost almost all their power to reflect reality. Injury and distortion have become stylistic devices in their own right. And too much expressiveness finally cancels itself out.

Francis Bacon was born of English parents in Dublin in 1909. Self-taught, he began painting in the thirties. Before that his travels had taken him to Berlin and France; he had settled in London in the late twenties, where he designed furniture and worked as an interior decorator. Bacon destroyed, with a few exceptions, all the pictures he painted in the thirties. We have a painting of his studio, however, done by Roy le Maistre in 1932; the works it shows appear to be derived from geometric abstraction.

The mythical creatures Bacon deployed at the base of the cross in 1944 as ancient goddesses of revenge, for the first time bring that organic distortion into play which was to dominate his work from then on. Here it is interpreted thematically. Bacon's Eumenides crouch for the spring, shrieking, their mouths studded with horrible tiny teeth. The most important influence here is Picasso's. This kind of anthropomorphic mis-shapenness appeared in Picasso's work in a series of drawings he did in the summer of 1927. He gave these studies no titles; the formal elements in them which were new to his work at the time fit into the usual Picasso themes—portraits, women on the beach, studio interiors. Only once, in 1932, did he use the expressive possibilities of these distortions to heighten an expressive subject—again, the crucifixion. Undeniably, at this point, Bacon derived his approach from Picasso. Max Ernst seems to have made an impression on him as well. The vacuum-cleaner-like neck of the middle figure, with a second neck twisted around it, can be found in *The Elephant Celebes* of 1921, which came in 1938 to the Roland Penrose collection in London.

Francis Bacon's oeuvre really began in 1945, with paintings like *Figure in a Landscape, Painting* and *Head II. Painting,* along with the Velasquez paraphrases, is one of Bacon's most impressive achievements. In it he mixed Rembrandt's crucified ox, the Surrealists' umbrella, and his very own seated, howling businessman. The faces in such early canvases were still almost amorphous, stylized to a scream. His model was reality, and the photographic material he used was still very much in evidence. Photography has been to Bacon what the study of nature is to other artists: he never works from a model directly. Nor do we find him—and this is perhaps indicative of the grand effect he aspires to—putting down his ideas in the shape of sketches or drawings. His studio is piled with books of photographs and pages torn from newspapers and magazines.

There is one photograph that haunts every publication about Bacon and that

appears again to the visitors of this exhibition, the screaming nurse from Eisenstein's *Potemkin:* pince-nez slipped, blood streaming down her face from the bullet-wound in her eye. One of the most repulsive images of cruelty ever fixed. This face looks out at us from many of Bacon's pictures, which would seem to contradict his statement, referred to above, that he did not intend to portray horror in his painting. Yet the longer one looks at the works in this exhibition, the clearer it becomes that Bacon's words were just. The painting process itself, the presentation of an extraordinary range and mastery of color, finally supplants the subjects portrayed. There is nothing to compare to it in postwar art.

Yet, paradoxically, equivalents can be found in the work of Wols, Henri Michaux and Jean Fautrier. There, too, the stuff of oil paint or gouache conceals damaged content. Bacon would thus seem more strongly attuned to the European *Informel* than had appeared at first sight. For comparison, it is enough to cite Fautrier's *Hostages.* The interpretations of Fautrier by Jean Paulhan, André Malraux and Francis Ponge would read his accumulations of impasto as human faces distorted by torture. Yet the portrayal of torture in a style that hands us the results of torture on a plate like some temptingly garnished meal, demonstrates the terrible ambivalence that threatens every attempt to depict physical pain by artistic means: terror dissolves in the image.

Paris, 1971

THE DEATH DANCE OF REMEMBRANCE
Richard Lindner and exile

Fascinating, the independence Richard Lindner's paintings have managed to achieve these last years. How little, really, they are embedded in the scenery against whose background they originated and were discussed, becomes increasingly obvious. One can still serve Lindner up in Paris as the father of Pop Art— and for the French critics he is alternately that and a cobeliever of the Hyperrealists!—but his rightful place is to be discovered outside these movements which, in the good American way, try to displace history with the moment.

Lindner is about to become a *révélation* for the French, the likes of which has not lately to be had. The number of visitors to the exhibition at the Musée National d'Art Moderne is considerable, the heatedness of the discussion about him near incomprehensible when you think that up to now, he was virtually unknown here. Lindner's prehistory in Paris consists of one small gallery show in 1965. The time for the present exhibition seems propitious: art, so willingly handed out as group offering and hung around society's neck as its unconscious longing, is being returned to the care of its individual makers.

Only three years ago Lindner would still have been lumped with Pop. In the meantime critical approaches have become more sophisticated, historically aware and thus more interesting. Lindner and Pop, as well as Lindner and Neue Sachlichkeit, these are no longer glib tautological labels; they form the coordinate

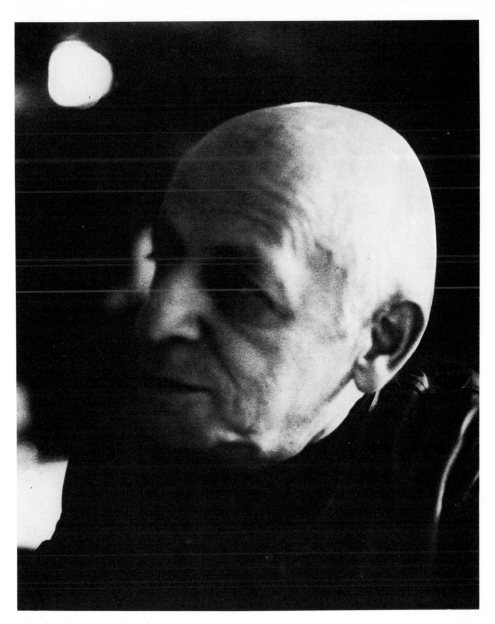

Richard Lindner, 1972. Photo by W. Spies.

system into which an oeuvre fits that is best seen against the backdrop of these two urban painting styles par excellence.

The focal point of most of Lindner's paintings, at least those of the last ten years, remains New York, even if his strong commitment to urban folklore has now abated a little. It has abated in terms of subject, that is, the palpable American trappings, but not in terms of effect, which continues to arise from contrasts. The latest pictures, *Solitaire, The Ace of Spades* (both 1973), are cases in point. One of Lindner's main motifs, the inequality of the sexes, with him indeed an all-pervading parable, leads to ever new variants of disproportion, in which the man is reduced to dominating the woman with padded shoulders and knife-edge trousers. As an additional symbol of masculine inferiority Lindner uses the card-playing motif—a game in which Venus always holds the ace.

THE COLD SEX Sex turns up in these pictures so conspicuously that it is tempting to consider it the stimulus behind them. Lindner a painter of the libido? Certainly not in the sense that Tom Wesselmann is. Lindner presents sex as the absolute limit of human relationships, as the impossibility of transgressing one's own existence. That is why introverts like Ludwig II or Marcel Proust play such a mythical role with him. In the total retreat into self, an androgynous fiction arises in which one's own self-image triumphs over every real difference.

With Lindner, sex does not become, as it does with Warhol, a product as consumable as Campbell's soups, but the most tangible symptom of the separation and existential confinement of the partners. Seen thus, Lindner's work acquires an intellectual depth and certainty that goes far beyond Pop. The content of his pictures is closer to such monomaniacal metaphors for life as Picasso's painter and model. There is a peculiar, tenacious ambiguity about these paintings. It challenges both Americans and Europeans. And both try to pass off Lindner's perspective on their own world as the exoticism of the other.

For the Europeans it is the signal-like simplifications in the pictures, the visual quotes from American city life—though here too the tendency is to overlook the fact that such simplifications in the visual decor go back to Delaunay, Léger, and Mondrian. Lindner appears as the go-between who gives each continent the message it can grasp. And here we touch the nerve center of the work and its effect: by totally waiving the artist's right to spontaneity and identification, Lindner has built an oeuvre that in every sense and quite deliberately is neither here nor there.

Since the early seventies Lindner has spent half his time in Paris, where he now has a studio. The emigrant has become a commuter between the old world and the new. Earlier he would have turned down such an option for Paris. He has too many bad memories of the city, where he spent some hard years, shadowed by French chauvinism, on his flight from Nazi Germany. What seemed to him of paramount importance after the war was New York's stimulating climate—in fact it was that that goaded the artful old European into painting in the first place.

DISTANCE TO POP New York was never the art center to Lindner that it has been in a position to claim for the past decade or so. A change of scene cannot

have been the reason for his move either, because the triple season he spent in Paris cannot be detected in the picture done on Place Furstenberg or in the Rue des Saints-Pères. Paris never had a strong attraction for him, but that has only been all the better for New York—at least initially his stay in Paris is helping him to keep fit for his favorite role, namely that of living at a distance, downplaying his sensibility into its cool opposite, indifference, and making, almost agnostically, the most of this emotion.

Lindner remains a painter in exile, a sustained and carefully nurtured exile. The move to Paris could be explained by the requirements of his work, which needs distance, or as a flight from the temptation to identify with his surroundings, that too-great intimacy with the motif, almost to the point of taking it for granted, which might be read in pictures like *East 69th Street*.

Such behavior in itself separates Lindner from all the ideology of *hic et nunc* which only the Pop scene could have produced. He lacks the sociological-biographical fit into the American milieu. That is basically why we find so few elements in his paintings that relate to those of American artists. He is unable to use the set pieces of everyday life there with frankness; he lacks both the naivete which is a condition for experiencing such short-term mythologies, and the socialist strain of the Neo-Dadaist revivals. His skepticism and his age work against him there. He uses this American environment purposefully and with fascination, but he uses it, still, against the backdrop of his European otherness; involved in a kind of ethnological research project, he plays off America against his memories, inserts slices of it like foils into images that in terms of statement, are based strongly on recollections of Europe.

For here we are dealing with a pretty unique case, that of a fifty-year-old man who started to paint and within twenty years had achieved a worldwide reputation. Earlier, before 1950, there was nothing to make you sit up and take notice. Lindner was an illustrator, a commercial artist much in demand. He does not try, in hindsight, to retouch this image. The response of his first wife is illuminating; when she found out that Lindner had begun painting, she asked, incredulous, whether he could do that too. An oeuvre, with which the query about the Lindner-before-Lindner—a schematic query very useful for exegesis of the avant-garde—leads almost exclusively back to the realm of experience, of lifestyle, and of aversions.

No matter where we try to start with Lindner, we come up against the priority of memory, in fact of memories that were preserved so strongly because they never received any kind of meaningful interpretation in real time. Experience was not transposed into images stage by stage. Hence nowhere do learning, experiencing appear linked directly and spontaneously to a work. A fifty-year-old memory may not have surfaced until it had become alien to itself. Lindner started painting the way a literary amateur goes about writing his memoirs.

America was a catalyst. A world which after the war started to believe in transcendental certainties, which posited a constant that was independent of history, nationality, or race, found its aesthetic symbol in the spontaneity of Action painting. Reading the statements of artists and spokespeople of the day leaves no doubt of that. There we find the program and the tone of American postwar aesthetics; an aesthetic that in contrast to European historicity, tried to profess a *tabula rasa*. This, to cultural policymakers inclined to play up America's

independent beginnings, and to understate the influence of the European immigration during the war, was bound to seem an indigenous achievement.

The new "world-style" at first rested on a conscious rejection of history, of the museum. This rejection also became, in a sense, a prerequisite of Pop Art which, propelled along by an expansion of the American way of living and buying, managed to insert the manufactured decor of American life into the world-style. Consumption became the area of agreement of a new humanism.

Lindner, far from countering such optimism with irony, saw his chance in the possibility of linking his own background and ties to the world of goods that now surrounded him. It was also an opportunity for the man in exile to minimize the break in his life. Against this background, he set his memories free; these, as the first pictures already show, have gained from American spontaneity a talent for syncretic structure.

The Meeting looked at the time of its inception like the absolute counterpart to American artistic tourism, which spreads its souvenirs with an even hand. But it soon became apparent that in that painting the course was being set, both thematically and formally, for future work; this holds true for the isolation by which all the figures in the pictures are affected, even those that really belong together, and it also holds true for the different human types that are grouped here as in a theater still. The formed modification gradually spread to Lindner's recollections, altering their dependency on European literary models (Wedekind, Strindberg, Brecht) and artistic models (Cubism, early Duchamp, Neue Sachlichkeit, Léger). In these pictures history became souvenir, as if recited by rote.

The accessories of the figures began to change, the most striking indicator of a metamorphosis of Lindner's style. It is like a history of customs, for everything in these pictures opposes nature. There are no landscapes, no nudes; even the dogs that turn up are trained to pose. Pumped-up flesh makes the disguises and fetishes swell. A smooth, cosmetic deathlessness reigns here.

UNEXPECTED VISUAL PLEASURES The exhibition—from which a dozen important pictures, among them *Leopard Lily* and *Pillow*, in the Ludwig collection, are missing—gives a better insight into the artist's working procedure than any other ever dedicated to Lindner. An entire room is devoted to the sketches and preliminary drawings. Broad-liberal lines position persons and objects, try out the effects of different color contrasts. Here one can also observe Lindner's reaction to a new idea, a motif picked up outside. Very quickly the discovery is translated into a gesture and added to the existing inventory of forms.

Between these sketches and the final paintings lie the gouaches and the large drawings in colored pencil, in which Lindner achieves a perfection that carries away even those visitors who had given up in front of some of the other pictures. Here Lindner offers a visual enjoyment that recalls that of the drawings of Juan Gris or Fernand Léger. The eye so willingly follows the deviations from the natural and the plausible that it overlooks the disproportion between content and dazzling portrayal.

Lindner goes against mass production and repeatability out of sheer love of craft. Fascination with the standardized, however important it may have become

to him, is barely mirrored in his style. Lindner, suspended between two worlds, scours the American asphalt for the elements that fit his private passions. Nuremberg toyshops, Bavarian Baroque, literary and political myths, are all projected into an environment that only recognizes the efficiency of the moment, the best performance of a product, a body, an idea.

Whatever the positive fascination he derives from the self-suggested fiction of a world perpetually in the present, Lindner's statement nonetheless basically points to anesthesia, a dance of death.

Paris, 1974.

THE MACHINERY OF DISCOMFORT *Richard Lindner's search for Proust*

Fragile, unsentimental, and caustic in self-defense, Richard Lindner has fashioned an imaginary world in which he himself disappears as if into a padded box. We owe to him the creation of upholstered furies, hormone-enhanced sex, the mechanization of humans and the intelligent animation of their objects. Man and woman dramatize a virtually unendurable otherness in nearly every picture—Lindner's Wedekindian snarl had disappeared only once, at the beginning, in an androgynous fiction. His cynicism has led him more recently to add dogs to people and their kinky environs. "I've concluded that canine society has much in common with human society. Dogs are afraid of losing their job, and consequently do all they can to give their masters the best possible service."

Lindner came up in the world with Pop. Elements from it are not lacking in his pictures, but the origin of his work leads us to different zones, points us to an intellectual preoccupation that, though it shares the fascination with consumption and cliches of the young Americans in a kind of nostalgia for the present, totally redefines it through his own suspicion of spontaneity. The work's statement was barely noticed, finalized as it was by the inexact contemporary style. We now have the chance to see Lindner differently and to recognize in him a singular representative of a syncretic European-American approach.

Only against this twin backdrop do Lindner's pictures acquire their uniqueness. The reciprocal foil is quite fascinating: for the Americans, he is European, and for Europe American. It would be too much to call his recent decision to spend his summers in Paris a return to Europe. Lindner would reject such an interpretation, dear though it be to the art politicians, who love to play off one scene against the other. No, his move was meant more to refresh an important contrast, namely a tie with the past which American thirst for reality and innovation would excorise. "I juggle with the past," he says, "I paint postcards from the vacation of my past." What fascinates the American viewer so, "Lindner's love of secret," tells Europe another story—perhaps the one about Americans' ability to fabricate mythologies out of everyday materials *without*

recourse to secrets, and thus to raise the moment to such an emotional pitch that it freezes to an illusion of eternity—at least until the next moment comes.

Pop-as-culture was the best example for this transformation of products into what Europeans call cultural values, and those conversely into what Europeans consider products. This is something Europeans can scarcely grasp, although they laboriously imitate it. There is in my view no other body of work that so critically demonstrates and utilizes the hiatus between the American and European scenes. And the convergence that Lindner's pictures feign only makes this mutual alienness more troubling. There are two pictures that try to rectify these incompatible currents, and they deserve to be singled out: the European portrait of Proust, of 1950, and the American epitaph for Monroe, *Marilyn Was Here* (1967).

The portrait, and the phantom farewell to an idol; a penetrating inquiry into a man who geared his work to self-experience, and into a Hollywood legend who, forced by her profession to constant physical exposure, denied a personal history, had to remain at the complete disposal of American masculinity even beyond the grave. These are two images that put Lindner in a cold trance, to whose message his work cleaved. The Proust portrait, seen against the oeuvre as a whole, now appears more and more as a key picture. It remains the great initial fiction which, because it had to shatter, first brought about the voracious dialectic between man and woman. What precedes this picture hardly matters. *Proust* ends the successful career of the illustrator, designer, and Sunday painter.

ESCAPE TO NEW YORK Lindner was already fifty at the time. He painted the picture during his first postwar visit of several months to Paris. He had been driven there from Germany by the Nazis in 1933; in 1941 he had fled to New York. It is quite moving to think that the return to Europe, the search for his own ruined world, led to a search for Proust. Such a picture means a lot in a rather sparse production that does not run to more than five or ten pictures a year.

Why Proust? Lindner could not have known him personally. He has had many writers as friends, though, as he likes to say, he has always felt more at ease in their presence than in that of painters. His inimitable ability to formulate recollections and to seize the moment in aphorisms speaks for that. He was among the few to be on good terms with Céline, and to find a humanity in him to others who knew him must seem most unnatural. Lindner also knew Gide, Malraux, Brecht, the Mann brothers ("Heinrich Mann was the more gifted, the other one just spoke better German.") Lindner's answer: "Proust's shameless egoism intrigued me. That can be seen in the result. The image turns inward on itself, is preoccupied with itself. I think the picture does have something shameless about it." Lindner, by reconstructing the encounter, is enabled to spear his vis-a-vis like an insect on a needle, to declare what is immortal long dead. One thinks of Sartre's reason for his *Flaubert*, a work he said was written because Flaubert's world had disappeared, lay there locked away, and could only be traced through documents.

In Sartre as in Lindner there was the same fascinated manipulation of the dead, its final goal being an unsentimental derivation of one's own existence. Both came to autobiography through analysis. Richard Lindner, as he tells it, made lengthy studies for the *Proust:* "What was most difficult for me was to

forget what Proust really looked like. One doesn't, after all, paint the way someone looks but the way he appears." This brings to mind Picasso's work on the portrait of Gertrude Stein. She sat for Picasso over eighty times in the spring of 1906. Finally Picasso said angrily: "I don't see you any more when I look at you." He then left Paris for several months and after his return painted the face, before even seeing his model again.

THE BRAIN: A DEADLY WEAPON Lindner questioned people who had known Proust, showed them his sketches, and compiled, from the advice given him, mainly by a bookdealer at the Palais Royal and by Jean Cocteau, this icon of intense isolation: "Everyone I spoke to hated him. I did not hear one single friendly word." And: "He was a man who only wrote about himself, who only lived for himself. A kind of Picasso. Except without his weaknesses. Picasso is not evil. There was nothing primitive about Proust, or instinctive—everything about him was brain—a deadly weapon." If one compares Lindner's *Proust* with Jacques-Emile Blanche's well-known portrait, that inconsequential, mundane politeness, and confronts it with the testimony of friends and contemporaries, then the physiological and psychological verism becomes apparent. Colette spoke of Proust's ceremonial garments, Léon-Paul Fargue of the complexion of a man who no longer goes out into the fresh air, and Edmond Jaloux wrote: "He seemed constantly to emerge from a nightmare. He could never make up his mind to give up the fashions of his youth: high stiff collar, starched shirt front. It was like facing a child and a very ancient mandarin simultaneously."

The portrait affects one like some apparatus of discontent; and this brings us closer to Lindner's own obsessions, and at the same time to what would from then on determine his style, over and above the theme. The head is armored, the collar garrotes the throat, like a corset that has slipped upward—just as in *Marilyn*, Proust's stiff collar seems to have slid down. Half of the face has a blue tinge. It makes one think of Proust's asphyxiating attacks of asthma. A head as if isolated by a bulwark. Two famous drawings could be cited for comparison, Picasso's *Injured Apollinaire*, and Max Ernst's *Portrait of André Breton*. Bandages interest Lindner; nowhere in the work to come will a free act, unarmed with fetishes, take place.

The search for Proust set a process in motion in Lindner, who took the search as a pretext to liberate his own memory. None of his earlier works foretell this picture, whereas one can maintain without exaggeration that all the paintings done afterwards are simply unthinkable without *Proust*. Corsets, laced boots, riding pants, whips, children whose lymphatic, hamlike bodies seem strangled in their Sunday outfits. A sadistic, garotted, strangulated world takes shape. One thinks of the terracottas of Andrea della Robbia, the *Foundling Children* of the Spitale degli Innocenti in Florence. Corsets, tailor's-dummy upholsteries, sawdust flesh, bloated children seemingly filled with air and surrounded by sharp pointed apparatus and gigantic toys.

This is the lost world that Lindner has bargained for, images of a precarious wish-fulfillment. The sharp toy that threatens the children can make them burst like balloons. The toy world of Nuremberg, where, after all, Lindner spent his childhood, always remained for him a fascinating euphemism for the Iron Maiden, for pillories, executions. ("De Sade is fine literature, not reality. The

Iron Maiden existed.") Kaspar Hauser is naturally also behind this new encounter with his own childhood, the unfulfilled search for an identity. Looked at in this way, doesn't *Proust* become something like a Kaspar Hauser in principle, whom only involuntary memory released from speechlessness? I don't think that the analogy is taken too far, because *Proust* soon became a pretext, a fictitious portrait which immediately was transferred into scenes.

Earlier I spoke about androgynous fascination. The *Proust* with mustache and feminine curls in the corset-collar demonstrates it. Lindner has confirmed this interpretation to me: "In the portrayals of couples, the man is always the weaker. Proust is the exception. He is both man and woman, the total image. An absolute." It is revealing that memories of his own childhood followed the *Proust,* pictures in which the libido, neutralized in the portrait, takes fire over and over again from the play world, especially from the variation of mechanical play. These are sexual pictures. The toy collector Walter Benjamin has brilliantly defined the libidinous value of toys, the connection between toy and fetishism: "Only dolls had the alabaster breast sung by seventeenth century poets, and often enough had to pay for it with their frail lives."

Lindner's studio is filled to bursting with derivatives of "Nuremberg trinkets." Many of them appear again in the pictures. Erotically the images remain more or less speechless. Man and woman meet. There is hardly a touch, a caress—only the accessories finger each other. An eroticism of spare parts, recalling the mechanized Duchamps, or the form-contrasts of Léger which, especially in the 1930s, undoubtedly aimed at staging more than purely formal encounters between objects. Man and woman are surrounded by a lubricated universe. The shining, enamel paints that Lindner added gracefully, deliver the provocative makeup.

The extent to which this parceling of bodies and objects exceeds the by comparison one-dimensional irony of most of the Pop people (excepting the mythological Warhol) is shown precisely by its derivation from the European context. Freud, Wedekind, Strindberg, Stuck, Klimt, rather than continuing to have a subconscious effect, now—ever since Lindner's research for the *Proust* portrait—are handed down as conscious myth. What Lindner has to say about the relationship between the sexes, the inequality which in his pictures is always at the male partner's expense, may well give representatives of the women's movement fits. Here the man is a *manichino*. Shoulders padded, chest padded, he comes on strong only when, having escaped the female's lust, he is allowed to play the pimp. In figures like this, Wedekind is sometimes joined by Dix and Schlichter.

MARILYN WAS HERE The second portrait, that of Marilyn, was done seventeen years after *Proust.* In between there were a Verlaine portrait, a group scene in which a few contemporaries were portrayed, and above all a painting of Ludwig II. *Marilyn Was Here,* like *Proust* was prepared in a series of sketches. The picture was shown for the first time in December 1967, at the Sidney Janis Gallery in New York, together with works by Robert Indiana, Allen Jones, Claes Oldenburg, Dali (*Mao-Marilyn*), Warhol, Jim Rosenquist, and others. Lindner was the only one who accompanied his portrayal with a sort of epitaph in the catalogue. The word combination "public lips" (reminiscent of Eluard's *La Rose*

publique) seems to give the best key to understanding not only Lindner's picture, but also the myth itself. It does, after all, refer to the absolute availability to which cultism had forced the star with the baby voice.

What makes the myth so fascinating may be the very fact that it was fixed by death at just the right moment. One thinks of James Dean, of Jayne Mansfield, of Warhol himself, barely escaping death but living off his myth from the time before the event. What drove Marilyn to her death was this kiss of the whole world, the condition of remaining for all times a changeless, registered trademark, an always freshly opened Campbell can. Lindner: "She was a Hollywood sacrifice. A symbol of its obsession with death and sex. They turned her into a little girl and then kept her in the refrigerator." Only an absolute ban against outgrowing the nation's dollhouse could create this fiction of immortality. Time was not to touch the idol. Lindner: "In America no one admires the legs of an eighty-year-old Mistinguett."

In Lindner's picture she stands, frontally, like a goddess of death, like one of those cardboard enemies the Marines practice shooting on. A target, a kind of mystical national hunting badge, yet one that recalls the Ice Age cave art of Altamira. Seemingly defenseless, a counterimage to *Proust*, this figure remains open to every aggression, every dream. In fact, she tries to attract them. Like the Proust portrait, Marilyn's falls into two parts, a dead, strangled one, and one in which life as remembrance pulsates. The head is immersed in black. Lindner here reaches back to Picabia's *Spanish Night* (1922), a kind of female St. Sebastian persiflage. But a comparison with Lindner's customary fetish attributes shows that he cheats the customer. He has armed his public Marilyn; he has shaped the corset into a terrifying utensil of castration which, like Proust's still collar, tells you to keep your distance. At last liberating her from her passivity, Lindner was the only to present Marilyn as poisoned fruit, as Lulu, as Eve-Pandora.

Paris, 1973

BETWEEN HORROR AND MORALITY *The work of Edward Kienholz*

Kienholz is coming. One did not really know this Californian before this exhibition, because the effect of his scenes is strictly limited to the medium through which they are presented. Birth, death—his picture parables revolve around these themes. These motifs drown out the sociocritical aspect. No one has ever projected horror, reluctance, the grotesque, and the poetry of borderline situations into the aesthetic sphere in so gripping a manner. No artist of our time shows the dance of death so starkly, with so little metaphysical gloss. These are the *memento mori* pictures of our time. The Japanese artist Kudo, who is also being shown—a rather unfortunate coincidence—at the Düsseldorf Kunsthalle, does not come off well in the comparison. The laboratory of fear that he tries to

furnish remains, compared with Kienholz's unforgettable scenes, aesthetically icing on the cake.

Edward Kienholz's art oscillates between horror and morality. But the means which he uses save him from becoming the Frankenstein or Billy Graham of his guild. The cheap effects are lacking. His art always tends toward symbolism, toward composition. That is why the term "tableau", which he himself chose for his works, captures them better than "environment." The best works are the concrete ones: abortion, sex, carfetishism, family. Here he manages the most gripping signs. Wherever he pulls back from this sensuousness, the images become schematic. His *Christmas Nativity Scene*, for instance, is mere artisanship. Art-historical irony does not suit him as well as rage, as scenes reflecting real experiences.

A few years ago a great tableau by Edward Kienholz surfaced for the first time in Europe: *Roxy's*. At the fourth Documenta in Kassel, it intrigued visitors to such an extent that at the end the only thing left of the threadbare Las Vegas bordello was an insurance claim. In its restored version, which recaptures the old dimness, a guard in a chair sees to it that the public's encounter with the environment will remain platonic. *Roxy's* only simulates an environment. Every attempt by a spectator to use this velvet-upholstered private room looks ridiculous. The gestures of participation—leafing through the yellowed magazines, helping themselves to something from the candy dish, sinking into the deep armchairs—appear empty, like grotesque, revelatory substitute acts.

With the exception of *John Doe and Jane Doe*, and *Bunny, Bunny, You're So Funny*, the most important pieces are on show here. In Düsseldorf, Kienholz has followed Claes Oldenburg, the two most convincing American artists now working in sculpture. A greater contrast could scarcely be imagined. Oldenburg poeticizes the unhistorical aspect of our situation, the repetition of the standardized product. His work floats in a sphere of absolute present. Human beings remain outside, turn up as consumers transformed into objects by other objects— the object becomes the projection screen of man. It would be difficult to make the environment more erotic.

With Kienholz we get the art of the American West. To simplify a little, the artists of the Pacific Coast, in contrast to the New York School, have brought into play tactile experiences with materials. They visualize more easily. They underline the self-taught look more. Kienholz always tries, in conversation, to pretend ignorance, to remain aloof from the cultural domain, from artistic speculation. His pride in having read only ten books in ten years, his claim that he had only heard of Duchamp and the antiart attitudes a few years ago—all that describes the man. And yet he seems to have put a little labor into this role. There was a great Duchamp exhibit at the Pasadena Museum in the early sixties. Nor was Kienholz a stranger to the business in other ways. In 1956 he opened one of the first galleries of the area in Los Angeles, and the next year took over the Ferus Gallery in partnership with Walter Hopps. The Ferus Gallery handled, among others, Joseph Cornell, who took the viewer on journeys into magical worlds of objects with his *Boxes*.

Kienholz's first works were done in 1955. They took a strong anti-painting stance, and were assemblages of materials placed roughly into the pictorial space and painted a dark color with a broom. Abstract Expressionism found a concrete

The Birthday, environment. Photo by W. Spies.

expansion in these pieces. The destructive element, the use of "dirty" painting techniques, recall Dubuffet's *Texturologies*. Abstract painting no longer satisfied Kienholz as nonfigurative expression. He gave specific mass to its paint surfaces by using structures that show the same measure of wear, dirt, and use. Fabrics, so important in his work—and mostly given a yellowish glaze—are inserted as relics of Abstract Expressionism. Kienholz is a striking example of the fact that American informal painting of the fifties was in search of a representationalism that could transform this robust, nuance-poor painting style into realism. The same can be said of Rauschenberg and of English Pop. The pictures of a Peter Blake or an R.B. Kitaj vividly show this connection between an expressive graffiti-like style and realistic theme.

The early "combine paintings" which Kienholz made, as he asserts, without knowing Jasper Johns or Rauschenberg, soon gave way to three-dimensional works. Kienholz got his objects in Los Angeles junk shops. The first large piece, *Roxy's*, was made in 1961. It was assembled from diverse compositions originating independently of each other. Up to then, no one had made a composition as extensive or as enterable as this. Three years later Oldenburg's *Bedroom* was included in the *"Four Environments by New Realists,"* shown at the Janis Gallery in New York. Oldenburg had done this work in Los Angeles. The difference between the two artists is startling. Oldenburg chose the phony California chic, the fake leopard skin, the shiny synthetics. Kienholz did not use modern interior kitsch until his latest work (*The Eleventh-Hour Final*).

Kienholz was spurred on by the California scene. Hollywood's mythology gave him the topical spark. It is enough, for the sake of comparison, to have a look at the Universal Studios or Culver City. The rite of sightseeing, cultivated in that town like nowhere else, was transferred by Kienholz to the encounter with his own work. The Düsseldorf exhibition of Kienholz's works could in fact be taken as a digest of the Los Angeles scene. We visit one scene of the crime after another. On the movie lots, millennia lie side by side. Temple, medieval town, Paris street, Twelve Oaks from *Gone With the Wind*, the haunted house from Hitchcock's *Psycho*. This world of total artifice, this synthetic history, do not remain hidden in the wings. All of Los Angeles profits from them. Private foundations and dreams proliferate throughout the city—Grauman's Chinese Theater, with Elizabeth Taylor's, Gary Cooper's, Lana Turner's, Gloria Swanson's hand- and footprints set in cement. Hollywood Cemetery, the Hollywood Wax Museum, J. Paul Getty Museum, Watts Towers, Disneyland, Forest Lawn— all unforgettable as apotheoses of a national and eschatological lie.

One cannot exempt Kienholz from the visualization of private dreams, of religious or moral ideas. These seem to form the basis of the work. But Kienholz varies the local structure. His tableaux appeal first of all to a reflex of the area to pander to the sightseeing mania with ever new fascinations. But Kienholz's works play cat and mouse with the viewer, because they satisfy neither the impulse to kitschy uplift nor the love of eeriness. Kienholz does not restructure—he composes. It is astonishing to see how he subordinates the verism of the material (he creates from a gigantic alexandrine heap of trash) to formal considerations. There are figures, like *Cockeyed Jenny*, that bring to mind the collages of Eduardo Paolozzi (*St. Sebastian*, 1957–59); then there are forms—like in *The Birthday*, or *While Visions of Sugar Plums Danced in Their Heads*—

which, while they make spiritual and physical conditions comprehensible, do endure beyond that as easily remembered plastic formal symbols. Many of the motifs are not new, nor is the principle of the assemblage technique Kienholz uses. Here we re-encounter the psychically haunting object-world of the Surrealists. But what distinguishes *Back Seat Dodge 38* from Dali's *Rain Taxi* is the high degree of transformation of all the elements.

One surprising thing about Kienholz is that no element speaks out independently from the total form. The elements remain in tune with each other. Kienholz does not always use the technically easiest method of synthesizing an assemblage, by attuning the different parts to one another by casting the whole in a neutral material. Picasso often used this method to bring collages of materials with elements as varied as wood, stone, ceramics, plaster, cardboard to the same pitch. Kienholz uses another procedure to harmonize the variety of materials and objects he uses: he covers them with a shiny yellowish resin that works as a patina and that removes the works totally from the sphere of reality into the sphere of a preserved exemplarily eternalized world.

If we look more closely, we discover formal intentions that reach for symbolism and alienation precisely at the point where a theme could become dangerous. Let's take *The Illegal Operation*, the most brutal and oppressive of the works. This is where one can really see how Kienholz proceeds. He starts out from an idyllic reality (the idyll commonly serves him as a foil): floor lamp, nice little rug, a small stool. Against this he sets the apparatus of a ceremony that, in this codelike interpretation, creates an almost unbearable tension. Kienholz gives us the still life of an execution. One is reminded of Warhol's *Electric Chair*. The deed remains poised, as pars pro toto, on this improvised abortion couch—cement-gray, crumbly matter that escapes from a smooth, kidney-shaped growth. This matter and the objects that surround it mutually set the scene for each other. It is on this that Kienholz's principle of assemblage rests: to, literally, put self-designating objects and personal form into relation. The effect arises from this disproportion between the object that was taken over and the addition that was composed. This lends these works their high degree of mystery, which constantly preempts one's thought and one's taste.

Kienholz himself has built in these oppositions. The reason for them is that he chiefly works with material and objects that lie outside of time: Kienholz practices criticism of a present minus thirty years. That is his strength: to have chosen a time interval that is still within the bounds of possible experience. With the help of this time shift, he robs from us the possibility of playing along. If we enter *The Beanery*, modeled after a Los Angeles bar, we become of necessity voyeurs. As with de Chirico, the clock stopped once and for all. It is a Pompeian situation. We go into the bar, and find ourselves in a casket in which the people have petrified in the middle of a gesture. The melancholy of moral breakdown, the melancholy of the situation, are heightened by the very fact that this melancholy itself has become useless. Kienholz robs us of the right to good feelings.

Düsseldorf, 1970

The King and Queen of a Senior Citizens' Dance, New York, 1970.

GRUESOME PHOTOGRAPHY *The posthumous*
pictures of Diane Arbus

One of the most popular New York exhibitions ever was the showing of the photographs of Diane Arbus at the Museum of Modern Art. Sometimes viewers had to wait on line to get in. Arbus committed suicide in 1971. The following summer some of her work was to be seen in the American Pavillion of the Biennale in Venice, no doubt to accommodate the general trend toward the demystification of painting through the photographic eye. At the Museum of Modern Art such expectations played no part. The museum has been collecting and exhibiting photographs since its inception. The Edward Steichen Photography Center on the third floor always has some samples from its collection on exhibit—works by Man Ray, Brassaï, Stieglitz, and others. For the Arbus show, the museum made some rooms available on the ground floor.

The Hyperrealism, the photorealism of American painters (the Americans themselves aren't so sure about the designation) is at the moment still waiting at the museum gates. One sees less of this work than one would have thought. There is no glut; for that, these people paint too slowly. Galerie des 4 Mouvements, in Paris, which managed to sell out its exhibition, "Hyperréalistes américains," noticed this. They have trouble getting enough works to fill orders. American museums and American critics do not seem ready to show the same intellectual respect that the Europeans have managed. "New Realism" in New York means painterly wish fulfillment for the silent majority, an art form which, after playing with the consumer world (Pop), once more became a happy-making consumer world of its own. In contrast to the United States, Europeans have declared this style avant-garde, while the group itself speculates about the abolition of the avant-garde in favor of a pure, immaculate art of entertainment. European aesthetization of Western movies could be taken as a comparison.

The visitors silently wander through the Diane Arbus exhibit. There is no laughter, at most an occasional spasmodic gurgle in self-defense. Unheroic America plods through the photographs like a procession of flagellants. Only seldom, however do settings turn up that are localizably American. Such work with an "imprecise place" is characteristic of Diane Arbus. That is why no well-known scenery or well-known faces turn up in her work. The young man who waits, with his flag and buttons saying "Bomb Hanoi" and "God Bless America," for the start of a pro-Vietnam parade, has the same lost expression as the transvestite. Nothing is dramatized as a mass phenomenon; in isolation the effect is crueler, but such political pictures are rare. Everything else that turns up has something of a timeless anthropology. What is shown leans more toward the horror of the *condition humaine* than the *contrat social:* mostly these are beings which no politics, no resocialization, however benign, could set free. The face dominates—the shell of the person is only brought in where the portrait requires it. There is no search for the picturesque.

If the world of Diane Arbus is compared with that of Brassaï, at first glance the most relaxed, one is first overcome by the lack of atmosphere, the total absence of poetic euphemism, of transfiguration. Here there are no stars of loneliness.

Arbus does not sing the praises of hoboes, she is no Prévert, no Brassaï. Where a dwelling comes into the picture, it is a "horror of a dwelling": to the Russian dwarfs in New York, the living room of the fully grown becomes a trap. Equally unforgettable is the picture of the clean, decent room in The Bronx; there bewildered parents peer up at their gigantic son, ducking to avoid the ceiling, who, as if excusing his otherness in this Kafkaesque "transformation," faces the desire for murder of the normal. Then there are examples in which people try to escape the normal through ritual. The transvestites, the people with tattoos or masks, the nudists belong to this group.

There is no formula for these pictures. A few themes dominate. Arbus looks for the societies within society, the secret fellowships of the outcasts, the sects of organized sham existences. Monstrous beings are irresistible to her: "Legends grow up around monsters. They are the figures from fairytales who bar your way and demand the answer to the puzzle." Within such ghettos the debilitated, the abstruse, too small, too large, too similar, meets itself. Figures of contrast, cheap visual jokes, are missing. Nearly all the photos have something statuelike, they are posed, petrified. Well-known faces, fascination with myth, with beautiful bodies, all that is out. There is no aesthetic doctrine for such pictures, but there is a doctrine of motifs. The style consists of always digging up new anonymous catastrophes, new weirdness. Every photograph thus turns into an exposed visit to the scene of a crime.

Diane Arbus, born in New York in 1923, daughter of the well-to-do owner of a Fifth Avenue store, worked for a long time as a fashion photographer with her husband. Then, in the early sixties, she started studying with the photographer Lisette Model. In 1967 the head of the photography department of the Museum of Modern Art, John Szarkowski, first became aware of her work. Parts of her written notes, found after her death, were included in the monograph that appeared in conjunction with the exhibition. In one note she wrote that she most liked to go to places where she'd never been before.

This nearly ethnological fascination is more powerful than the professional one. The notes she made of her encounters, the short picture captions she often wrote, betray an almost missionary ethic, just as if the camera's lens had succeeded in fooling the evil eye. A list, a sort of curriculum of unusual encounters, hung on the wall of her studio. It enumerated, among others, waiting room, tattoo parlor, recluse, communion, rollerskating, people with insomnia and baby contests.

Some of the strongest impressions are of visits to nudist colonies. The director of one such group assured her that the moral tone was higher there than outside. Arbus's comment on her experience: the reason was that the human body was not as great as it was supposed to be. Once it's looked at, the secret is out.

The photos that she brought back from these troubled Edens offer up life in a depressing way. A random memory makes one think of Edward Kienholz's showcases. On top of the turned-off television sit two photos of nudes, showing a couple in their youth, with the shabby, sleazy, crumpled Eden hovering in between.

Disguises, flight from a situation, private redemption, reflection about identity are all expressed in her photographs. One of the successes at the show is *The King and Queen of a Senior Citizens' Dance, New York, 1970*. This picture was

already shown in Venice. A short caption makes the misery palpable: "Their numbers were pulled out of a hat. They were just chosen King and Queen of the Senior Citizens' Dance Organization. Yetta Granat is 72 years old, Charles Fahrer 79. They have never seen each other before." Dullness, anointed for an hour, a revolting charitable fairy game, understood by Diane Arbus as an end game.

New York, 1972

INFLATION OF THE FLESH *A Visit to Botero's Studio*

For years now Fernando Botero has been dropping his disagreeable fleshy megaliths into the landscape of art. Self-portrait, Mrs. Rubens, Pope Leo X after Raphael, Ecce Homo, Nuncius, official portrait of the minister of war, pair of lovers, passage to the Ecumenical Council, slice of watermelon, kitchen still life—all motifs turn up in the Colombian's pictures, puffy, fluffy, and a bit much.

In conversation, Botero tries to elbow the figures and objects of his pictures into an aesthetic world of their own. "No, I am not a caricaturist. I use deformation like just about every artist. Pictures of nature are distorted to a greater or lesser extent, they're corrected for the benefit of composition." He invariably adds, to lessen the effect of his creatures on the viewer: "I don't paint fat people." And, not avoiding the surprised look, he continues: "My sense of proportion is not out of kilter. Personally, I don't much like stocky people." He tries to isolate the sense of his process of distention. He says he wanted, quite simply, to present scenes of a concentrated, one might say accentuated, corporeality: "The distortion that goes with this is a result of my falling out with painting. The monumental, in my view sensually provoking volumes come from that. I'm really not interested if they seem fat. That means nothing as far as my pictures go. What I'm after is formal fullness. That's something quite different." Not naive art.

This man radiates a high degree of consciousness. He is obviously not a painter who has found his particular wrinkle, who perpetuates an accidental gag because it caught on. Botero constantly refers to historical parallels, he constantly tries, as a European painter, to link himself to history. And here too naive, accidental knowledge—the single encounter with a work that became a model—is absent.

Botero has museums on the brain. Every week he pays a visit to the Louvre—in whose vicinity, across from the Sainte-Chapelle on the Ile de la Cité, he has lived for several years. The study of techniques is important to him. More and more he now uses sanguine, charcoal, pastel. The technically stupendous attempts to revive pastels would be unthinkable without the museums. Such a polished perfection has not been achieved in dry pastel painting since the eighteenth century, since Rosalba Carriera, Quentin de La Tour, Jean-Baptiste Perronneau, and Jean-Etienne Liotard. The painterly *fa presto* for which Manet, Degas, or Toulouse-Lautrec used pastel crayons cannot be found in Botero. His entire work—at least for the past dozen or so years—reacts against the outline,

the draft as an end in itself. The quickly tossed-off sketch doesn't offer him even the advantage of saving labor. He wouldn't save much. A single demonstration makes it quite clear that this man cannot tolerate shortcuts. He always starts out from a free, small pencil drawing. Its broad outlines are transferred to canvas or to a large sheet of paper. The spontaneity of the stroke, the brush that is autonomous in flow, don't concern him. His goal is the perfect, evenly worked surface. That costs him nothing. Whether large canvas or small pastel, he is done with it in three or four days: "I don't understand why a painter has to struggle with his canvas for weeks or months. The execution is the least of it. The slow, problematic method strikes me as a mystification of the avant-garde. Just look at what a Rubens could accomplish in a day."

Fernando Botero in his Paris atelier, 1975. Photo by W. Spies.

EXAMPLES FROM THE OUTSIDERS OF PAINTING Naturally Fernando Botero gets the comparisons that try to legitimize the voluntarism in his own work from outsiders like El Greco—from outsiders in the history of art, not just from the European avant-garde. Just as El Greco's elongated figures do not refer back to real characteristics, neither, in his view, do his own. That's why Botero always points out with relish that critics were blind enough to attribute El Greco's mannerism to the artist's faulty vision. Thus Botero's position within the avant-garde is soon clear: it is a remarkably independent reaction to the art profession. Quite manifestly he does not reach for the liberties that the art of our century has demanded and unreservedly used. The modern, in fact, is largely ignored in the derivation of his work.

How did he come to paint? In Medellin, Colombia, where he spent the first twenty years of his life, he at first met artists who only gave him information about contemporary art. The first works, dating from those years, show traits of an expressive, building-block figuration. They are structures that remain fairly free; nowhere do we find a hint of Botero's later, typically old-master love of detail. But there are clear signs of a predisposition to search for a graphically clear outline of masses.

Nor must the preoccupation with formal models from pre-Conquistador times and with the store of forms that have survived to this day in Central American pottery be overlooked. Pre-Colombian art, folk art, and the altar pieces of the colonial Baroque plainly belong to the early encounters that would later be assimilated and used as a corrective to the European impressions. Another obvious model, that moved all of Central America were the huge narrative frescoes of Rivera and Orozco. Botero considers it extremely important that he comes from a country that has something to put up against Europe. "For me a personality like Rivera was of utmost importance. He showed us that it was possible to practice an art that need not be colonized by Europe. The mestizo attracted me, the mixture of the old-established and the Spanish cultures." And a later thirteen-year stay in New York in no way changed this attitude. Botero always surrounded himself with objects of Colombian and Mexican folk art; even his Paris apartment is decorated with them, and with pictures in his native colonial Baroque.

At first he had in mind a great, official influence à la Rivera. The fresco attracted him, panels not at all. It is no accident that he studied the technique of fresco painting during his first visit to Europe. He came over in 1952, the ship docking in Barcelona. But the museum for modern art in the Parque de la Ciudadela disappointed him profoundly. There, in his first-ever visit to a museum, all the prerequisites for a hefty dose of disillusion were assembled. The works of Nonell, Rusional, Casagemas could hardly live up to great expectations: "I had imagined these European pictures much larger. The easel formats surprised and disappointed me." But a walk in the evening brought, with a shock, a totally new pictorial world before his eyes. In the window of a bookshop he saw an opened book. It showed a picture such as he had never seen before. The following day he bought the book, a monograph on Piero della Francesca. Then Botero settled in Madrid, studied at the San Fernando Academy and copied Goya and Velasquez at the Prado. So thoroughly had he become immersed in that world that a visit to Paris and the Musée National d'Art

Moderne (the first noteworthy museum of modern art he'd seen) left him unimpressed. He didn't even consider wasting any more time in Paris. His goal was Florence. There we find him from 1953 to 1955. That became his real period of study, during which he indifferently avoided the art of the twentieth century.

Along with technical training at the Accademia San Marco, he studied art history. The Florentine trecento and quattrocento, the paintings of central Italy, the Duccios, the Piero della Francescas, occupied him unremittingly. He attended Roberto Longhi's lectures and read Bernard Berenson's writings. An Italian restorer of the Berenson collection introduced Botero at Settignano. Berenson's comments on Giotto made the most enduring impression on the Colombian. The definition of tactile values, the revolutionary difference that a comparison of the two "enthroned Madonnas," Cimabue's and Giotto's, at the Uffizi elucidates, gave Botero practical references. Reading Berenson got to Botero all the more easily since Berenson dealt with the categories of Florentine painting he valued most. ". . . it was the power to stimulate the tactile consciousness—of the essential, as I have ventured to call it, in the art of painting—that Giotto was supreme master. . . ." In another passage, Berenson elucidates the major task of figure painting as ". . . to rouse the tactile sense. . . ."

Later, all of Botero's pictures were to revolve around Giotto's addition of corporeality, of dimension, his superimposition of surfaces, his bundling of figures and introduction of tension in mass through outline drawing. But Botero rather overdoes it. Throats, joints tie up the flesh, bind it like sausages. Fat dogs, small children, swollen fruit were the beginning. But soon the bundling of bodies into plastic packages became the rule. Botero tried to create a type whose ultimate tactile denseness would reach a maximum of aggressiveness. Central American folk art, Giotto, Paolo Uccello—from whose *Battle of San Romano* he acquired the light-dark volumes of the trees, the stretched-out limbs—those are the ingredients of a calculated pictorial world. There can no longer be any question of searching for this "real" shapelessness in reality. A look at the work of the last ten years makes plain that real models, real actuality play a steadily diminishing role. Botero steadfastly practices his "idealism of the compact." He blows everything up.

Most of his themes are taken from existing paintings. The variations after Rubens, Dürer, Bonnard, the narrative Baroque votive tablets of his homeland, make up the thread. Other subjects resemble still lifes of Luis Meléndez, Francisco de Zurbarán, Willem Heda; his statuary group portraits, in which occasional arms and hands, feelingless-asleep, drop on those of a partner, recall the protocoled coldness of Goya's *The Family of Charles IV.* He even shifts back the palpably "contemporary" pictures. In his hands all themes turn to evenly tuned painting. The corpulent, balloony bloat becomes the norm. It rules in every person, in every object—the temptation is to say, without discrimination. Volumes blown up to bursting are the rule. Exaggeration undoes exaggeration's contents, the ceaseless repetition of the principle defuses it. By and by, the viewer manages to control his desire to laugh; he feels bound not to yell caricature too loudly.

WHAT OF THIS IS EVIL, WHAT OPERETTA? Botero's deformation appears continually and thereby becomes, within its circle of pictures and themes,

downright proper. Another kind of presence cannot, after all, be imagined on those panels. This unrelenting deformation should be compared—paradoxical though this may sound—to Giacometti's. There too, constant repetition absorbs the charged representation of the spindle shape, with which we associate, ever since Grandeville's, Daumier's, or Wilhelm Busch's bags of bones, certain very specific social and psychological states. Both—Botero and Giacometti—try by dint of repetition to transform a deviation from the norm into normality. The uniqueness of the effect—and with it the effectiveness of thin or fat—is deflected. Thin or fat are not a means of contrast, but always the outward form of a onesided possibility to which there is no alternative in the pictures themselves.

We enter worlds in which—like with Swift—altered perspectives of the human become the rule. But—unlike Swift—the *contrapposto* of the normal is omitted. That is why it is so difficult to attribute an exact content to the deformation. A reference to existentialism might help a little with Giacometti, but such a literary crutch does not work with Botero. The detail—and these paintings are uncommonly rich in detail—can no longer be evaluated. What in all this is genuinely evil, terrible, bloodthirsty, and what is mere operetta? The identical inflation of flesh is everywhere.

Not even the South American themes par excellence, the military junta, the clerics, bring any real vibration, and this in spite of whatever personal distaste Botero might feel for Latin American conditions. They drown in the soft, flirtatious treatment of the subjects: "You start painting the head of a dictator. You start stroking him, he pleases you, and, touched, you give him a kiss." Basically, this art remains true to the artist's intention; it cannot be qualified: human being, object, nature, young or old, military junta, model in the studio, fat or thin—with Botero, all is fat. Spirit and body are shifted to extremes, lie under a convex mirror. Questions of meaning and content unashamedly step back. The ever mysterious becomes everyday.

Paris, 1975

THE MYTH OF WATER AND DREAM *An*
assessment of the work of David Hockney, Paris, 1974

In 1966 Lawrence Alloway, often called the mentor of the British Pop scene, wrote that David Hockney's program had led him, of necessity, to an art without unity. The erstwhile prodigy of the Royal College of Art had, at the time, already turned his back on London. Hockney's "program" ran something like this: "I paint what I like, when I like, and where I like." What prompts him to paint? Foreign landscapes, human beauty, love and its promotion, and vital events— vital events in his own life, he added by way of elucidation. This subjectivism is contradicted by his becoming part of a school of painters who consciously chose Pop. Alloway's judgment reflects his disappointment with the fact that Hockney had strayed from the recently lauded British version of Pop (by Alloway's calculation the third London attempt at the genre). Obviously it meant little that

in the meantime Hockney had shown himself to be one of the most interesting, stimulating artists to come out of the European Pop generation, one of the very few independent figures to appear since the end of the 1950s.

The year of the group's strongest cohesion seems to be 1964. At that time the first of several parts of an exhibition dedicated to the youngest generation, "The New Generation: 1964," opened at the Whitechapel Gallery with support from the Peter Stuyvesant Foundation. It introduced, in addition to Hockney, Derek Boshier, Patrick Caulfield, Anthony Donaldson, Allen Jones, Peter Phillips, and Patrick Procktor. Their works showed elements of deviation from New York painting that suggested an insular *Zeitgeist* of their own. Still Pop, but with a cool new figuration slipped over a color register derived from Ellsworth Kelly and Barnett Newman. This kind of generalization, however, does not apply to Hockney. The pictures he had at the Whitechapel show—*The Hypnotist, I Saw in Louisiana a Live Oak Growing*—first of all show a knowledge of Francis Picabia and Jean Dubuffet. The sketchy, ragged figures in *The Cha Cha* (1961) or *We Two Boys* (1961) are very close to the graffiti style of Art Brut emulations.

VENICE IN CALIFORNIA The catalogue of the 1964 exhibition remarked about Hockney that he never uses a typical Pop vocabulary. The peek into the museum could still be felt—he certainly found reinforcement in the example of Francis Bacon, who combined stills from Eisenstein's *Potemkin* and Muybridge photos of motion with paintings by Velasquez and van Gogh. Bacon, among the rare artists of substance who—in the face of a general adherence to Abstract Expressionism and Tachism—clung to their own presentation which, independent of Pop's aesthetic of citation, used objects and signs attributively, had a strong influence on Hockney. The existential moment in Bacon's painting, the notation of autobiographical fact—even if not to the extent of expressionistic torment—can be found in Hockney's pictures, etchings, and drawings from the very beginning. The iconography is subordinate to his private Eros, the objects that turn up symbolize his *vie sentimentale*, appear singly, as single examples from a life line; consumer articles, schematized ambiance do not matter to him in their social context, but as requisites of an encounter. Hockney's California period seems typical of this. It began in 1964, with an obvious need to render the topography of a fascination. The vedute that were created there, a transplanting of Venice's libidinal backdrop to the swimming pools of Beverly Hills, quickly attain a fateful individual statement that in *A Bigger Splash* translate Visconti's *Death in Venice* into *Death in Hollywood*.

After the California pictures which dominated the work until the early 1970s, there are a few impressions of Corsica and—as a reference to the trip to Japan—*Japanese Rain on Canvas* and *Mount Fuji*. In 1973 Hockney moved to Paris. Some of the pictures done there round out the 1974 retrospective given at the Palais des Arts Decoratifs with the support of the British Council. It is not a very extensive show—only thirty pictures were assembled, as well as some seventy drawings; the prints are not represented at all.

Three large pictures and a series of portraits of Celia Birtwell—painted in a style reminiscent of Toulouse-Lautrec, behind a borrowed "femme fatale" veil— were done in the few months preceding the retrospective. Two of the pictures were printed on the front and back covers of the catalogue: a view from the

David Hockney, 1975. Photo by Peter Schlesinger.

Louvre of one of its wings and a view of a group of houses from the Louvre. The first confirms Hockney's occasionally voiced admiration for René Magritte, even if, with Hockney, the characteristic unreality in a totally real setting seems closer to Balthus. As with Balthus it is, rather, a typical deviation from attitudes, the representation of a precariously balanced realism, the coupling of separate, inviolate realities into a disparate whole.

In *View from a Window of the Louvre on the Musée des Arts Décoratifs*, the yellowish curtain that partly hides the view seems an allusion to Magritte's easels in interiors that, as picture within picture, maneuver the viewer out of what he expects to see. The transom that turns up under the dimly diaphanous *folie* becomes the stretcher over which the painter's canvas is pulled. It slips, like a filter, between the visitor and the outer world. This has nothing to do with Pop, but it does have ties with Magritte's disoriented realities—Michel Foucault

recently called attention to the linguistic questions they pose. At the time they influenced painters like Louis Cane, Marc Devade, and Daniel Dezeuze, and were given a theoretical foundation in their journal *Peinture*.

I think, however, that the exact autobiographical content of Hockney's picture must be understood. Hockney saw the stay in Paris as a challenge to himself. It is one of his admitted practices to occasionally force a stylistic change by changing his habitat. He set himself the task of painting Paris, and not because he was attracted by Parisian charm or unfamiliarity. He had saved up Paris as his most difficult job, as the place where every exoticism pales, where every detail, every mood has been painted over and over and over again. He was interested in the confrontation with this prodigious mass of fixed images: he found it much harder to paint Paris than Los Angeles. No one, or almost no one, had ever painted Los Angeles.

SPLASH The *Scene from a Window of the Louvre* shows the point of departure. Placing himself inside the Louvre, he paints the section of the Louvre Palace where his exhibition will take place. Everything that he'll put down on this curtain-canvas is the result of a coming to grips with existing pictures. Techniques and style mostly have their rootage in pictures of our century: in Bacon, Dubuffet, Rauschenberg for the allusive mode of omission, which places zones of exact clarification against blurred ones; in Hopper and poster painting for the pictures of the California period; in the Pointillists and the late Bonnard for the two Louvre pictures mentioned here. For the drawings, he went to Juan Gris and Matisse. His encounter with the museum is the source for his frequent motif of a curtain in the picture, of the picture within the picture. And Hockney was demonstrably taken with a fresco of Domenichino's from the Aldobrandini series, acquired by London's National Gallery in 1958.

In 1962 Domenichino's *Apollo Kills the Cyclops* was shown for the first time at an exhibition of the gallery's recent acquisitions. The following year Hockney painted *Play Within a Play*, a picture that, in addition to the motif of the tapestry, presents the scene as picture within picture. It also finds an equivalent for the figure in the foreground, a chained dwarf linked to the illusion of the picture: a man who, in an effort to burst out of the picture, pushes his body against a (real) sheet of plexiglass.

In addition to the Louvre paintings, which in fact can be considered headings for a new chapter in Hockney's work, there is *Gregory Masurovsky and Shirley Goldfarb*, an altogether conventional continuation of the double portraits characterized by Hockney himself as dramas between two people. *Christopher Isherwood and Don Bachardy* (1968) belongs to these; so does *Henry Geldzahler and Christopher Scott* (1969), a dramatic, angry picture of bondage. In *Gregory Masurovsky and Shirley Goldfarb* he picked one of the most picturesque couples in Montparnasse—an omnipresent artistic pair whose breathtaking busyness at vernissages and on cafe terraces symbolizes the final puffs of a particular Ecole de Paris. One cannot avoid seeing in this work (with its open curtain) an Ecce Homo image, a mockery of the Paris School. The cheap little abstract picture in the painting, the small outhouse in the background, turn it into a sad end game in which the artist Hockney, probably ill at ease after his move to Paris, participates.

The Paris exhibition, as an assessment of fifteen years' work, shows several constants. Francis Bacon makes remarkably frequent use of the mirror and of an arenalike stage on which the figures separate and pair up. With David Hockney it's water. He has men under showers, men in the park of the Vichy spa, in Californian swimming pools. And, deriving from the fascination with transparency, there are glass panes (in *Henry Geldzahler and Christopher Scott*, the polish of the glass table and the eyeglasses creates a mood that brings finely honed knives to mind), a glass mountain (in the illustration to Grimm's fairy tale "Oll Rinkrank"). The work to a large degree lives from an imagination and the symbolic use of flow-transparency-sharpness.

One picture, *A Bigger Splash* (1967), illustrates this most strongly: an idyllic California postcard—blue sky, palms, house, in front of it an empty chair, as isolated as Warhol's electric chair. In the foreground there is a blue pool, with a yellow diving board thrust over it. The flawless blue surface is scarred by white splashing water, the aftereffect of a dive. Something distinctive invades the California cliche; a startling disturbance, splashing water, a split-second stand against immobility. This motif—the contrast between tranquility and a transitory "quick" event—can be found as early as 1962 in *Picture Emphasizing Silence*. The aquatic playground is by no means simply a formally pleasing backdrop for Hockney, one which allows him to produce a series of variations on transparency or the ornamental play of broken light beams on the bottom of the pool.

PRIVATE EUPHORIAS Behind these pictures lie, encoded, his private obsessions and euphorias: a downplayed drama, here and there pierced by darts of irony, toys with the myths of water and of dream. The wandering Zarathustra, dishevelled by the storm, corresponds to the swimmer in the open ocean. Gaston Bachelard has pointed to this connection in his *Water and Dreams*. He added that the swimming pool would always lack the fundamental psychological condition that makes swimming a spiritual-intellectual experience. Lautréamont's Maldoror, Swinburne, deal with the poetic struggle with water in the late nineteenth century. Buffeted by the waves, swimming turns into masochism. Swinburne's work lives from such moments.

The Hockney exhibition and Jack Hazan's film, *A Bigger Splash*, which, with the painter's cooperation, tries to explain Hockney's pictures and their background, show the battle against water in chlorinated quiet California pools. Gaily they go into the shower, into the bathtub; alone or in company, the men make their way through the pool. The health club for men is the framework for a cinematic action whose paroxysm seems to be reached whenever a live picture corresponds to a painted one. Hockney, plagued by amorous pain while painting, frees himself before our eyes, reaches for the razor (as also happens in Francis Bacon's pictures), steps under the shower, and lets us share his cathartic aftershave mood, a flashback to the happier time. Henry Geldzahler (former director of the modern art section of the Metropolitan Museum of Art in New York)—not a plausible ephebus—is offered us in a bathtub by the master of masculine half-figures. One ought not to blame Hockney himself for this inept filmed confession. He is in fact a splendid self-portraitist—but the attempt to do for Hockney what John Wilcock did for Andy Warhol in *The Autobiography and Sex Life of Andy Warhol* (New York, 1971) resulted in a truly bad film about art—stretched out to

a hundred minutes by including just about everything that is painted and produced today. Most of the time Hazan tries to reconstruct the paintings with the camera. As for authenticity, for some reason the whole thing has a smell of the filmed novel about it—the extras in Hockney's world are wholly involved in their own little costume piece. A colossal price to pay for turning aesthetics into cosmetics.

Paris, 1974

THE WORD AS REVOLUTIONARY REALITY
Attempt at a phenomenology of the Paris May

On May 1, 1968, the Paris newsstands hung the front page of *Quinzaine Littéraire* between *Playboy, Express* and *Minute*. It was highly visible: "Nathalie Sarraute: We Must Destroy Everything," just that one sentence, in blue and black letters. Amid the everyday supercharged crime and sex it looked insipid, as pacifist as the visuals of consumer advertising that announce A Revolution in Detergents. It was a statement that any passerby who was not acquainted with the systematic aggressiveness of Nathalie Sarraute's books, might easily have taken for a call to introspection, self-assessment. The following days flipped her words upside down. Paris in May turned a subtle, out-of-context figure of speech into the clear cry of a Pasionara. Was this change of meaning necessary? Did comprehending this statement in the context of violence make it more revolutionary or only more chic? You had to ask yourself that question, because most of what was discussed during those few weeks remained untouched by the basic critique of consciousness that advanced French literature had since achieved. Because those who thought this revolution through—or however you wish to call that crisis of consciousness—had failed to marshal their means.

That statement literally jumped at you, it had become a theme—not because like the walls of the Sorbonne or the city's buildings, where every slogan was a battle-cry needing no further interpretation, it had been adopted by the revolt, but on account of its having opposed to the reality of French life the critical, suspicious attitude of one of her most astute minds. What did the weeks that followed this First of May prove? That the meaning of this statement dwindled, having been revoked in historic fact? Or vice-versa that a linguistic metaphor had dissolved, thereby regaining its nominal—one is tempted to say utopian— carefreeness and uselessness? If these questions can be answered, then we would have a key to one particular Parisian spring.

THE AGE OF SUSPICION After all that has happened, one feels like reminding everybody that figurative speech does, after all, cover more ground than literal. At least it is better adapted to our present historic plateau, on which there can be no more talk about calling society, that is *all* of society, into question. The anthropological protest in the work of Nathalie Sarraute, conducted within a

In the backyard of the Sorbonne, May 1968. Photo by Robert Held.

In front of the National Assembly, May 1968. AP Photo.

single social class, goes deeper than selective challenge to society through everyday problems. Sarraute's books are not only the expression of a bourgeois society grown critical of itself; by portraying this situation they reach beyond the sociologically verifiable fact of interpersonal difficulties—they reach, in fact, for the individual himself, they wring the hero's neck. Hers is an incisive description of the levelling of life in the post-Existential period—this displacement of the hero, still a metaphysical and painful process with Kafka and Joyce, is with Sarraute a generous, masochistic giving up of self. Individual rebellion—as feeling, as lie, as confession—succumbs to irony. Nathalie Sarraute is out to smash more than status symbols. She would destroy our faith in the word—by ripping it open, by showing that it is for sale, that we cannot trust the I.O.U. phrases signed by individuals and backed up by individuals. *The Age of Suspicion* is a sketch for a far-reaching cultural revolution, for it gives precedence to the critical aspect, historically right or not, over the system and the human being.

All the patterns of thought developed by contemporary French literature, especially the Nouveau Roman, have so far barely begun to penetrate into French society. These authors are not dealt with in the schools, and at the university study of them is extremely rare; it is after all against university statutes to write a dissertation on an author who is still alive. University reforms will quite likely remove these structural weaknesses and thereby alleviate the schizophrenia of French intellectual life. After university reform, disputes such as the one between Picard and Barthes, in which surviving Lansonism and the New Criticism based on structuralism came to grips with each other, are not likely to sharpen into such authoritarian power squabbles again.

IDEOLOGICAL WAITING PERIOD The absence of the literary people explains in part why the Paris uprising—at least at the university and high school levels—remained so Utopian and speechless. It is nevertheless revealing that in a week of absolute freedom of speech and thought, not one single mind of consequence came to the fore. And yet the way was free to the agitators and ideologues of shock during this waiting period before the bill fell due. A familiarity with the literary works, or rather textual philosophies, would surely have shaped the debate, which is only now starting to be organized. After the withdrawal of the labor unions and the Communist party from campus, totally new possibilities, only now mature historically, have appeared. The events of these past weeks will undoubtedly be examined on the level of language during the coming months. Roland Barthes is already on a commission which has set a "critique of the language of teaching reform" as its task. The catch words, the combative words, the slogans are to be collected and their relationships to action analyzed.

In many cases—and not only in the renunciation of its figurative aspect—language was again equated with reality: the paving stone became a missile, it weighed the newspapers named after that concrete argument, on the sales tables in the Sorbonne yard, and an American poet was arrested because he was carrying one of these stones in his pocket. He had a hard time convincing the police that he didn't intend it to be a weapon, but a souvenir. Where the factions made use of familiar forms and words—French tricolor, *Marseillaise*—interesting fields of interpretation also cropped up: the red flag and the *Internationale*, at

first hurled provocatively at the tricolor and *Marseillaise*, lost their exclusivity as soon as the Gaullists, with tricolor and *Marseillaise*, moved to the Arc de Triomphe. The unions and Communists thereupon themselves adopted the tricolor and *Marseillaise*, along with red flag and *Internationale*, as their own revolutionary emblems. As linguistics was increasingly pushing its way out of departmental isolation to become the prototype, even, of the sciences, it was inevitable that interest in the forms which developed in Paris in May were as strong as those in the facts. The striking imbalance between the various actions very likely resulted from their not being on the right, present-day linguistic plateau. If we stay with the linguistic-literary aspect of the crisis, we must conclude, without denigrating its positive side, that it was all about words.

Language systems, identity or gap between word and content, turned up everywhere. The Sorbonne, itself Alcazar of the word, was overrun—words elbowed their way in from every direction and settled on the walls like a thick film. Everyone wriggled in the ecumenical yard of the Sorbonne, enmeshed in a myriad of words. Outside it was mainly oral speech. People talked as never before. The word spread an almost animal certainty over the squares and streets of the city. Through the word people cuddled up to each other, they celebrated the word. The word, less its content than its spontaneous availability, became the cause of eternal devotion. No matter which group one approached, everywhere the word was extolled, talk meant the unison of familiarity and guarantor of self-worth. The word almost always served the same observation which, half formalistically, half in wonder, would open the conversation: "We're talking to each other again."

THE MONOLOGUE IS FLOGGED TO DEATH As soon as anyone opened his mouth, he was surrounded by others who also wanted to celebrate the miracle of talk. It was a ritual appropriation of the word—and that was the deciding political fact: it was an uprising against the institutionalized monologue of the head of state, the boss, the teacher, the father. The monologue was flogged to death. At the Odeon, in the boudoirs, all over town, people lying on couches talking themselves free—a psychological mass-meeting the likes of which was never seen. The dialogue between workers and students kept circling around a definition of the language: "When I say this and that, I mean thus and so." It was an attempt to seize the world through language, to deal with political and social reality as language. Yet a fear of words also began to set in—words could turn into worthless paper-money (specie) very quickly. No wonder then that at one particular level of the dialogue, where radio and TV statutes had to be decided on, the negotiations collapsed—they collapsed, as was said in *Le Monde*, "out of fear of words."

Slogans and statements were accepted, but as soon as it became a matter of ordering them syntactically—that was the end. Syntax ruins words, it ties them down, makes them dependent. An inadequate syntax prevents joint action. Everyone held fast to *his* word, to *his* argument, carried them like personal property from group to group. This is where the limits of discussion lay. The language and its use remained archeological, wherever they sought ethical and social determination. The arguments of the Commune, of the 19th century anarchists were heard again—word for word. Just as if the point still were, first

and foremost, to evade the threat to the me-ideal from the left and from the right, just as if it were still possible to find meaning for one's own existence at the state's expense.

Within a few days the rhetoric of the revolution had been established—along with that of the counterrevolution. In its last days, when the Sorbonne decided to administer itself an enema, there was a tiny but significant incident on the plateau of language. Through loudspeakers, the Action Committee ordered that the Sorbonne be cleared, and asked for help to throw out a few "radical, incorrigible little groups." That was the same phrase the Minister of the Interior had used when the whole thing began, to describe the masses in the streets. The purge of the Sorbonne started in the name of that authority which a libertarian decentralized society would abolish.

At that moment one became aware of the fact that the days of Paris had already been lost in history. The visual side has vanished in a flash. Skeptically we return and no longer find the corpse—like in *Blowup*, the clue has disintegrated. The coming months will clarify this occurrence: does a missing corpse argue against a murder, or does order against reform? All of this doesn't argue against reality, it merely supports our idealistic determination of that which may be real.

INSTRUCTION FOR A STYLIZED LIFE The fact that the Odeon was cleared, that the Sorbonne voluntarily rid itself of the insignias and excrements of the uprising, is enough for many to regard it all as past. They relied too much on the external, the word, the spectacle. The Odeon and the Sorbonne yard were always only attempts to open the puritan, intellectual revolt to the eyes and ears. From the very beginning the anarchists and Communist dissidents—Trotzkyites, Maoists, Castroists—took over the visual staging. They gave a demonstration of revolution in the age of its aesthetic reproduceability. They made use of a repertoire of forms, half living-theater, half anarchistic *Geste Ravachol*, frighteningly pale and wearing a black vest. The revolution of 1848, the Commune and the scenography of *Potemkin* (closeups of the barricade battles, Eisenstein style, were hung around the Sorbonne yard as instructions for the stylized life) were the points of reference. The actors were satisfied with portraying an abstract unrest.

The yard at the Sorbonne was a three-dimensional diorama of events that did not happen. Slogans and actions that were sold there—"The Revolution Is a Festival," and libertarian sandwiches, and green mint—remained apart. They were savored by the visitor for themselves, in their anachronistic otherness from reality—street disturbances, political strikes. The parents performed this play for the kids. You saw no slogan individually, you bumped against whole walls meant to look like China, the red flag dangled from the facade of the Sorbonne along with socks and underwear. And you waited, as in the anarchistic days of Barcelona, for cars to squeal full speed around the corner—for what is anarchy if it only gets involved with visible authority, if it only pisses on the toilet seat instead of challenging life, the law of gravity, the laws of nature themselves? The reconstruction of anarchic behavior was in part a remake, in historic costume, of the existential postwar years, and replaced lack of activity with mourning and stolid quotations from another time.

A motto for the scenic aspect of these days: "Revolution: movement of something movable which, describing a closed circle, touches all points on it in succession." (Larousse Dictionary). Claude Simon had used that sentence as the epigraph to his novel, *The Palace*, which is set in anarchist Barcelona. For the reader, the revolution and its history dissolve into a thousand single moments in a Baroque cascade of words and objects. Simon seized the revolution by means of an oppositional language that remains in strict present tense, that collects, amasses, and makes a fool out of anyone wanting to grasp history by offering its equivalent. The wish that this moment might more strongly than another tie itself into a historical knot, momentarily gets our historical sense of touch going. To settle down where history plays at being representative, isn't that a chance to escape one's self, one's own fate? Like the bum who, when asked where he lived, escaping into the arms of history, answered: "At the Sorbonne."

Paris, 1968

OVER, OVER, THERE IS A SOFT PLACE IN MY HEART FOR ALL THAT IS OVER....

Samuel Beckett was born in 1906, on Friday April 13—not only a Friday, but Good Friday—in Foxrock, a suburb to the south of Dublin. This distinctive birthday seems—like a mirror image of the Catholic nightmare described by James Joyce in *Portrait of the Artist*—to suit the Protestant Dubliner. Yet Beckett is uncomfortably aware of the distinctiveness. He has no desire to return to Dublin. It remains for him—as it had for Swift—Diaspora.

One pictures him as a man of sorrows, as a walker toward the apocalypse. "His face was bloody, his hands also, and thorns were in his scalp. (His resemblance, at that moment, to the Christ believed by Bosch, then hanging in Trafalgar Square, was so striking that I remarked on it.)" We find this sentence in *Watt*, his second novel, still written in English. Entanglement in guilt, darkened by the sharp Protestant awareness of predestination—shown as a horrible burden in his plays and texts—is everywhere, and so obsessively that one cannot escape the brunt of these questions.

A piece like *Eh Joe*, in which the playful comic gives way to a kind of pronouncement of judgment, cannot be taken as a modern situation that can be psychologically explained and therefore cured, had been symbolized by reversion to some Western well of knowledge. That would reduce Beckett's work to a theological "well-tempered clavier." One thing must be clearly kept in mind— and this in no way imposes a message on Beckett: all Freudian notions of the psyche, and all socio-mechanical resolutions of conflict notwithstanding, Beckett sketches a world view that keeps the imagination open to basic philosophical knowledge. The only strange thing is that one should expect an answer from someone who can make the problems of life so sharply felt—as if it were merely the question, with Beckett, of charades from the good old days.

BEYOND SENTIMENTALITY It is odd, but the postwar world has absorbed weaker, if categorically ideological messages, with delight. How easy it was to accept Camus' definition of the absurd—a good-time doctrine that was sung in every *chanson*. Beckett by contrast has never talked much about his writing. A manifesto titled "Poetry is Vertical" did appear in 1932 in the journal *transition*, bearing the signatures of Hans Arp, Beckett, Carl Einstein, Eugene Jolas, and several others; in a world hypnotized by positivism, it called for a new mythological reality. Beckett assured me however that he signed this simply to be obliging, without even reading it.

Beckett nowhere says—in a positive way—what he intends. But in the late forties he did dedicate a text to his friend Bram van Velde, the painter ("Three Dialogues," *transition*, December 1949); as an indirect manifesto, it seems of primary importance: in it Beckett dissociates himself from the humanism of the postwar era. He gives van Velde's work an astounding definition: that he was "the first to express that there was nothing to express." He calls van Velde a painter without the wish nor the strength for expression who yet felt driven to express himself (a statement, at the time, ideologically closest to a Francis Ponge). Beckett meant that he had discovered something totally new in this behavior—"A work that does not have failure as its theme." I said: "That could also be said of your work. It stands beyond sentimentality." "Yes, I hope so." And he added: "I believe that the concept of the absurd is sentimental. I never accepted that view of the absurd, because it contains a judgment. It requires one to make a judgment. I never could. It's an equation. On the one side, what you can accept, on the other side what you don't want to accept. You add it all up and conclude: that is absurd. I hope there is no judgment of this kind in my work."

What this work—so intensely queried and discussed—does not seem to deliver, is that revealed by Beckett the man? What can the man Beckett add that this incomparably precise oeuvre does not already contain? These questions recur in his presence. Conversation, association with Beckett reveal no sign that merely some mutation of the human, some eccentric-abrasive sensibility, should have found a voice in him. The impression never arises of something isolated, split off from society, unadapted, having lost itself in another world.

Beckett the Wise has long been canonized by a devout following. He remains intensely private, and though one knows of his reluctance to surrender his privacy to his worshippers, one occasionally is tempted to break through that oath of silence that binds his friends as if in some secret clan.

To show the real Beckett, what could that give away? It would be more important to point to his kindness, to his ability to laugh, to his unwavering opposition to all categorical statements, than to keep silent "by order of Beckett," as it were. There are not many anecdotes to tell but there are good reactions. Once I went with him to see Max Ernst: "Sam, I don't have a chair hard enough for you." Beckett: "Max, your softest chair will do."

Rested, talkative, jaunty, and full of plans, Samuel Beckett was spending a few days in Paris. The stay in his little house on the Marne had done him a world of good. He withdraws to Ussy more and more often now. One thinks of Nero Wolfe, Rex Stout's detective—not only because Stout's novels lie all around the cabin: "Images are important in my work, but the view isn't much directed at

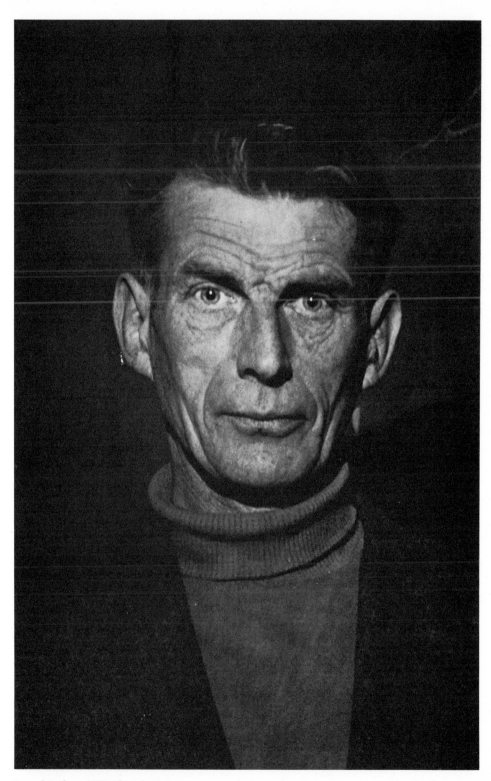

Samuel Beckett, 1967. Photo by Brassai.

the outer world." When one goes to the cabin, the words of Mallarmé come to mind: "I am now impersonal, not Stephane, whom you knew . . . but an aptitude that the spiritual world has created in order to see itself."

Beckett has lightly swept aside his seventieth birthday celebrations. This is a little surprising when one remembers how constantly he plays with numbers, makes additions, sets up series in his work. One need only recall the priceless collective problem of the Lynch family in *Watt:* five generations, twenty-eight souls, nine hundred eighty years. If nothing happens, figures Watt/Beckett, the Lynches will reach a thousand years in eight and a half months.

As part of the celebration, Beckett went to London for the rehearsal of two new pieces, *That Time* and *Footfalls.* Each lasts about twenty minutes. No action theater, but new examples of a form that was announced by *Act Without Words* and actually introduced by *Eh Joe,* the television play. Beckett synchronizes: a sound from the wings encounters mimicry on stage. These are memory pieces. In *That Time,* rivulets of consciousness, whispered by himself, will flow toward the actor from three different sources: stage left, stage right, and the back. The action consists of toleration, of the physiognomic reflection of experience. The situation in *Footfalls* is similar. A woman walks up and down for twenty minutes, her body under the power of a voice.

The extent to which Beckett has for years made use of technical media (in *Embers, Krapp's Last Tape, Film, Eh Joe*) is striking: they allowed him to unravel voice and action, description and deed. Perhaps he recognized in these media a possibility to present one of his fundamental—philosophical—experiences in an objective way. A mere fascination that prompted him to experiment would, in my view, be too slight an explanation. The breaking apart of body and spirit, the clownish Baroque, to which he subordinates his figures in *Murphy, Molloy, Watt,* and *Waiting for Godot,* may have its roots in his early reflection on the Cartesian dualism of body and soul. The joining of these separate entities suggested by the Occasionalism of Arnold Geulincx—God as coordinator of both—would well have been the basis for Beckett's innumerable unpleasant variations on gesticular invalidism in his characters. But along with this there is the fact that Watt or Lucky can also be fitted into a modern optical tradition that reaches from the chronophotography of the nineteenth century through Duchamp's *Nude Descending a Staircase,* Dadaist phantasmagoria of movement, to the Chaplin films, and to Picabia's and René Clair's *Entr'acte.*

As Beckett tells it, he is busy, as he has been for years, with continuous back-and-forth translation, from French into English, from English into French. And he has also worked on the German versions of several plays. One of them was *Rendez-Vous.* It shows a man who waits, listens to music, eavesdrops on a voice that joins in. Music is used as language—as it already was in the radio plays *Words and Music* and *Cascando.* Unlike these two pieces, for which music was written by his cousin, John Beckett, and by Marcel Mihalovici, he will this time use evocative music, like a quotation; he has the Largo of a Beethoven trio in mind.

And with this Beckett reaches again for his carefully measured system of remembrance: in the late work too, ever more severely reduced, seemingly moving away more and more from the concretely descriptive, there is a constant intrusion—like a trace element—of allusions to a far-reaching cultural connec-

tion. A word, an insinuation, rip deep ruts into these metrically balanced, almost computer-like texts. They are moments of reincarnation. Even here Beckett does not relinquish the fascination of the Proustian effect.

THE ECHOLIKE MEMORY The reader of Beckett must draw upon a large inventory of references. In the allusions to Dante, to Caspar David Friedrich, the Luneburg heath, Vico, Leibniz, Theodor Fontane—one must understand these to fully appreciate the texts. Fontane earns a special role through his *Effi Briest:* "A wonderful, appalling book." Maybe this categorical tragedy, dictated by the codex of society, has something of the predestination that grips Beckett's melancholy grotesque figures.

Into the immobility of the present, into the enumeration of a skimpy inventory, come echolike elements now and then to which the tenderness of involuntary memory clings. They spread through the repetitive, twitching texts. In *From an Abandoned Work* we read: "Over, over, there is a soft place in my heart for all that is over, no, for the being over. . . ." From that angle, is it surprising to discover Beckett's first character in the fourth canto of *Purgatory*, in the Florentine lutenist Belacqua, who, full of quietism, allowed the deadline set for him to expire, not only in life but also in purgatory?

Let us take, from the slim volume recently published in New York under the title *Fizzles*, the five pages of the text of *Still*. Beckett has confirmed that this is a self-portrait. The setting can be localized: it is the view through the three windows of his little country house in the "Marne marsh" where he had already written *Endgame*. For economy of means, full use of a limited vocabulary that is controlled and controllable at every point, this breathless text is close to those that have accumulated these ten years, texts of the type of the *residua,* the "abandoned works."

Apparently there is no longer much to interpret. The restlessness of the glance that incessantly switches from window to window and registers the interaction of dusk and dark, is reflected in the syntax, in the short-of-breath sentences that suggest an extinction. The text describes the sunset and—with equally marked objectification—describes the eye, the body lurking in the cabin.

But in the midst of this petrifying objectivity, of this transcript of the senses, there is the hint of a mythical petrification, that of the Memnon Colossus: ". . . that old statue some old god twanged at sunrise and again at sunset." Memnon is not—as in the *Texts for Nothing*—actually named. And the allusion is inaudible. Quite literally inaudible: in the last sentence, as the tense measuring of dusk against dark is swallowed by night, it becomes the bridge from seeing to hearing.

As is clear, a careful reading will show a continuity even in these short works, which tend to be looked on as linguistic exercises without connection to Beckett's rich narrative work. Knowledge of the earlier books enriches these pared-down sentences—associatively everything can be included, from *Dante . . .Bruno. Vico . . . Joyce* (1929), *More Pricks than Kicks* (1934), *Echo's Bones* (1936), *Murphy* (1938), to *Waiting for Godot* (1947-49). After all, can't one recognize, in the sitting figure in *Still,* all those figures who, like Belacqua, like Murphy—who allowed himself to be tied to his rocking chair—like the stump in *The Unnamable,* are in search of ataraxy?

It's a self-portrait of Beckett, this *Still*. Just barely characterized by accessories. Beckett's life too has moved in that direction. The reality of Ussy doesn't add much information: a simple, one-story white house, two rooms, set on a pretty green lawn, no flowers, trees, a lot of gravel, with a white wall encircling part of the grounds.

The period of the eventful travel years is over. It has left him a fund of memories that he is digesting. He likes to talk about this earlier time, about his trips to Germany, to Berlin, Dresden, Will Grohmann's friendly reception, the endless number of paintings he saw, about his reading, being together with Marcel Duchamp, chess, billiards in Paris bistros. He quite readily tells about it all, in great detail. He remembers with a certain pride his reaction on seeing Giorgione's *Venus* at Dresden: the feeling that something was wrong, that there were two different touches, two painters who had gone their separate ways. Grohmann would confirm this: a recent essay by Hans Posse, in the Prussian yearbook, told of an X-ray "separating" the hands of Giorgione and Titian.

Beckett has no small talk. One could examine each word under a magnifying glass, test it for its importance to Beckett. The fascination with Marcel Duchamp also belongs here. Didn't they both, Beckett and Duchamp, provide criticism with its greatest puzzle, didn't they both provoke the most astonishing deliriums of over-interpretation?

He often played chess with Duchamp. I think this is an important piece of information, as is Beckett's statement that he still plays chess, but alone, with the help of his considerable collection of chess books. One remembers that in 1932 Duchamp published, with the chess master Vitaly Halberstadt, a fascinating book, *Opposition and Sister Squares Are Reconciled*. They constructed an "endgame situation." Only the kings and a few pawns remained on the board. But Duchamp and Halberstadt devised a situation in which the pawns were blocked (one remembers Nagg and Nell in their garbage cans). Only the kings could play. In Duchamp's English text the German expression "zugzwang" (a blocked position with a limited number of moves) is used.

LINGUISTIC EXILE A few years ago a certain tension was noticeable in Beckett. In texts such as *Lessness* or *The Lost Ones*, his writing showed a reduction of description and narrative in favor of constructed forms that went even beyond *How It Is*. At the time he wanted to try bigger, longer texts. "Already a failure. I tried, from *Lessness* on, to bring in movement again. But I can't get away from it." He stood, one August day, in a corner of his garden, poked at a small fire with his smoke-blackened stick, and smiled: "I want to get rid of all these incriminating papers."

The texts written since then, including *For to End Yet Again*, show no signs that Beckett is entering a narrative phase. I asked him whether it was conceivable that he would return one day to the rich, detailed slapstick mode of *Watt* and *Godot*. He quite categorically said "no." The humorous-grotesque is no longer part of the picture. He thought that in any case, it could be found on the level of language itself, in repetition, in construction.

This is important to know when one recalls how strongly even the "early" Beckett was possessed by forms of language that drew their effect not only from the narrative mimesis of true comedy but from an independence of rhetorical,

grammatical, and logical concepts. Reflection about expressive potential, the feeling of dizziness that surveying all possibilities caused, interested him very quickly, and not only as a style that drew its effect from the etymological stacking of a clever art language, à la Joyce. On this point he surely takes the position radically opposite Joyce's. It could be called a displacement through Beckett.

At first, in his impassioned advocacy of Joyce in *Dante . . . Bruno. Vico . . . Joyce* (1929), he still agreed totally with Joyce's reflections about language. Dante's going back to the Italian dialects—to overcome the glib Latin of clever literary pedants—is put side by side with Joyce's endeavors, with his attempt to get rid of an English language become impossibly abstract, "sophistic." But to Beckett new linguistic forms are not so important. That's why he reached out to a foreign language, to French. The flight from the mother tongue allowed him, to work so to speak, in an affective linguistic exile.

Paris, 1976

THE OBJECTIVE IMAGE *From Duchamp's readymades to Minimal Art*

Provocation through art, the notion that art has the power to activate conscious-ness and society, is one of the clichés of our time. Provoking aggression of one kind or another even seems to have become the sole purpose of art. Most artists who exhibit their work to us today speculate on a reaction—not a knowledgeable reaction but one of perplexed refusal. In fact the point of the whole art business appears to be the hiatus that lies between the work and one's natural, visual enjoyment of it. The function of this kind of work remains clear so long as the gap between perception and apperception has not been bridged. This is an approach to art that could be defined in terms of polemic against the viewer; yet it is also one that happens to be based on that quality which the viewer's mind most quickly eliminates, namely shock. As soon as the shock has been used up, the viewer's use of the work ceases too. The danger contemporary artists are trying to avoid, of course, is that their work be pre-empted, constantly and seemingly unstoppably, by taste and habit, and they do this by continually shaking our preconceptions and irritating our vision. These are the two basic modes. As far as the first is concerned, the arsenal of the horrible, repulsive and perverse seems to have been exhausted.

To take aggressiveness as a correlate of art and progress in art, a correlate which runs counter to a popular awareness of art that has just, with much effort, been attained—this is a fairly modern phenomenon. The best way to find out what it is all about is to turn back to the second half of the nineteenth century.

The public had soon grown accustomed to the new subjects that Courbet had introduced into art—to a social and political change in iconography. Yet the real battle was not touched off so much by these new themes as by the formal innovations that Edouard Manet made a few years later. What was new in Manet

was not the subject but the artist's retreat, seen here so unconditionally for the first time, into personal legislation of the shape of the visual image.

THE EXAMPLE OF PICASSO At this point, the development of art, its history, began to be written with almost no concern for content. The structure of a painting, in other words, superseded its iconography. Picasso is a prime example of this development, because with him, what was fundamentally new can be seen as a break. While the young French artists of his generation—Matisse, Derain, Braque—were already making matter-of-fact use of that tradition in art which had replaced theme by conception, in which the means of painting had taken on an absolute value in themselves, Picasso was recapitulating this process in his early work, by a kind of phylogenesis. The transition to Cubism was long and arduous, and in the course of it Picasso had to rid his work of innumerable iconographic elements.

Cubism actually began at the point when Picasso, having reduced the importance of content during his pink period, brought a new structural concept into his work: the paraphrase. Here the subject was left intact, being merely taken over, linguistically speaking, as a semantic unit fixed once and for all. Variation, therefore, no longer served to alter this unit or make it more expressive, but worked solely on the level of formulating an identity. There are interesting examples of this in Picasso's pre-Cubist period. He may give us a double image, for instance, where the two female nudes facing each other can no longer be read, in terms of content, as a couple or pair—as lovers, say, or as involved in dialogue—but are simply two statements of the same figure. This is an important early form of something which will continually occupy Picasso in his work to come: tautological portrayal.

The *Demoiselles d'Avignon*, Picasso's painted manifesto, is by far the most superb example of this. Originally Picasso had planned to paint another, typical group scene in which the separate elements were thematically related—a bordello scene with sailors and nude girls. Picasso left the sailors out, however, or rather he changed them as the work proceeded into additional female nudes. This can be traced in the sketches he made at the time. What originally had been a representational, dialectic theme changed into a purely formal process: the portrayal and development of a nude figure seen in profile, *en face*, and in a squatting position. *Les Demoiselles d'Avignon* very clearly if paradoxically defines the end of an iconographic reading of the painted image.

Here for the first time questions about the relation of art to reality arose, questions that over the following decades would be ceaselessly reiterated and varied. The history of twentieth-century art might even be seen predominantly as a demonstration of a reality that inheres solely in works of art. Pictorial space, once fairly comprehensible structurally, a field organized in such a way that the eye could take it in with ease, now became a kind of show window continually re-decorated by artists asking questions about their own medium.

NO INTEREST IN PSYCHOLOGY Before World War One the topic of discussion everywhere was the means of portrayal. What is the nature of the relationship between external reality and pictorial reality? and that between object and art?—those were the questions of the hour. Psychological questions, on the other hand,

had almost completely disappeared from view. This I am sure was due to the fact that in the great art of the period, portrayal of human beings no longer had a central place. Indifference to the psychological aspect of art went hand in hand with a heightened interest in objects—this was the period in which mankind, for the first time in history, had begun to manufacture objects on a large scale. In psychological and social terms, mass-production of objects and the changes these objects brought about in daily life, amounted to a crisis; and the crisis in art— this time in a more positive sense—was likewise brought about by the introduction into painting and sculpture of everyday objects.

Objects entered art in two ways: first, by becoming for a time its sole theme, and secondly, by the attempts of artists to include in their work as many objects, and object-like structures, as possible. Collage, constructions and *objets trouvé* (found objects) are examples of this intrusion into art of things from the outside world. Yet still we are dealing in these images with a kind of conceptual realism, since the objects that entered the image were quotations from reality meant precisely as quotations—they were vehicles of a composition that, transcending the objects used, was to take on a new, autonomous object-character of its own. Only against the backdrop of the widespread fascination with this new brand of representation worked out on the level of pictorial structure, does Marcel Duchamp's laying of hands on a manufactured object make sense. Only against this backdrop did his act take on its unique, unrepeatable, aggressive meaning. His gesture worked because it was a reaction to the a-psychological realism of the paintings just described. And it was revolutionary because it took place within a frame of reference that had been staked out by the art of the time: the displacement of objects into works of art.

The gesture of the Cubists and Futurists, who implanted non-aesthetic fragments in the body of art, Duchamp took as far as it would go—he let it stand in isolation *as a gesture*. Duchamp knew his act could not possibly retain its original indifferent, non-aesthetic meaning. In his final years he realized that the indifference he had meant to show had been exploited, that his gesture had been declared aggressive and capable of repetition, and it was precisely in this constant aggressiveness, in its possibility even, that he did not believe. (His real difficulty was just the opposite, namely to keep a phenomenon out of the realm of aesthetics—a fruitful aporia, as it would turn out.)

It would seem as though Duchamp's gesture, originally a gesture of pure indifference, contained once and for all the anti-aesthetic acts of the twentieth century; and it would appear that this gesture, which we have since accepted as an aesthetic one, has defused the aggressiveness of such acts, thereby demonstrating the impossibility of producing in the field of art, at this particular historical moment, anything but art. I would hold this model of thought and action up to all those who believe that repeated, aggressive demonstrations are possible within the field of reception in which art takes place. Object, shock, aggressiveness exhaust themselves immediately. The aesthetization of every such act is inevitable and, on the present art scene, unavoidable.

VISION AS THEME Examples of this are not scarce. The destruction the Dadaists aimed at, has disappeared from their works. Rauschenberg's first pieces, to which the public reacted as if the city garbage dump had been moved into their living

room, have since come to be seen as arrangements of visual structure that are, almost, beautiful. All this is only meant to show that artistic phenomena based on objects, gestures, actions, or socially activist interventions, cannot lay claim to any calculable, constant effect. These forms of art or non-art, struggling under their load of sociological jargon, are outside painting, outside sculpture; at the very least they narrow down the problem of art by limiting it to precisely that area which, in my view, is the most open to discussion of all—that of the object in modern art.

I would argue that the visualization of the work of art—or better, the fact that since the Impressionists it has been painting technique itself which largely determines composition and iconography of the image—that this visualization is an objective fact. These crucial changes in pictorial structure are not only important stylistically; they have altered the relationship between spectator and work. In the field of Op Art, this relationship has been brought so far into the foreground as to seem the subject of the exercise.

The name Optical Art itself would appear to be a tautology. Vision and visual art go together. To speak of optical art makes sense only if we isolate one aspect of vision from the rest. This aspect I should like to term "thematized vision," a type of vision in which we are made conscious of the act of perception as it takes place. This, of course, limits the range of effects open to Optical art—its practitioners have no choice but to use visual structures that are schematic. Only within a scheme that is recognizable as such, do Op paintings function in the sense just described. As soon as the structure becomes too open, they begin to work like Constructivist compositions.

The sign of a true Op painting is its visual aggressiveness. This is a field in which we are given unchanging facts to look at, a field in which the relationship of viewer to work is determined by laws of perception. The entire apparatus of Op Art, not so much as a style of painting but as a collection of visual models available to its practitioners, is a clever mixture of scientific demonstrations of the laws of perception and corrections of those objective models by the artist. Op Art lives from its limitation to patterns, and these patterns take the place of a comprehensive figure in the sense of Gestalt theory, that would pull the image together into a whole.

Object-related forms are excluded from these works, even to the point that many artists will avoid horizontal lines, since they might be taken as having been derived from landscape. Vision itself is the subject here, and this is precisely what constitutes the great difference between Op and any other style of art which—from its making to its marketing—is based on open, interpretable representation and form.

A further method of transforming image into object is presented by kinetic art, which derives from Op. There it is not only a matter of making the same demand on our perception again and again; in this case the added dimension of movement brings forms into play which the eye attempts to isolate and bring to rest. The impossibility of achieving this, of course, not only tends to put us into an aggressive state, it leads to visual exhaustion. Our eye chases after the moving shapes in the attempt to stop them, fix them. We reach a situation in which we feel ourselves frustrated, since our mental reflex is to counteract the movement and organize the image into a visual whole.

STARE OF THE VOYEUR The description of Op Art sketched above, applies to the more theoretical aspects of such pictorial models as those of Bridget Riley, Morellet, Anuskiewicz, Vardanega, Boto, Demarco, Gerstner, Wilding and Tomasello. Here the first aim is undoubtedly to assault the eye. In his latest film, *La Prisonnière*, Clouzot has attempted to interpret aggressive patterns of this type symbolically. The erotic obsession which is the subject of the film is emphasized by the milieu in which it takes place—the gallery of an art dealer who handles Op and Kinetic Art. The glassy stare of the voyeur corresponds to the demonstration of Op Art objects: psychological compulsion is equated with visual compulsion: and thematic shock answers formal shock, in synchrony. Thus it *is* possible to interpret this kind of work thematically—but not in this particular way. The interpretation Clouzot gives leaves the works themselves unchallenged, it merely uses them as models to demonstrate aggressive, offensive behavior. What is very likely impossible, however, is to transfer the content of the voyeur's obsession to the works, because they cannot be made to function as symbols. And that is probably the crucial difference between Op and the gestures of the Dadaists and Surrealists, or the activities of Pop or Happenings. In these fields every action can be construed symbolically, like configurations into which a content can be read. In the case of Op Art and Clouzot's sexual imprisonment, the relation remains an apposition.

Thus not only representation of the visible world, but also possibilities of symbolic interpretation are sharply reduced in Op and Kinetic Art. These styles waive both thematic aggression and an aggression by association of ideas, by demanding a mode of reception that is stabilized at the level of pure seeing. They demonstrate one aspect of an actual, a-historical human trait—the way the eye functions. This is a fact, not a symbol, and it can be placed beside other objective human drives—hunger, thirst, sex.

MATHEMATICAL FORMS With Minimal Art a new phenomenon enters the scene. Minimal Art is often compared to Constructivist styles, that is, it is understood as an art of pure form. This seems problematic. Minimal Art too can be examined from the point of view of aggressiveness, which in this case lies neither in its intention, as with Duchamp, nor in a demonstration of visual facts, as in Op Art. The provocation here results from a presentation of artistic facts that can no longer be assimilated intellectually. In Minimal Art, form and content are declared identical. The body-mind dichotomy, one of the foundations of European art, of Western thought in general, has disappeared. Perception and apperception are one. The form we see is the same as its content. No surface structure enlivens these works; color, if it appears at all, is strictly monochrome, no hidden nuances. What we are given to discover are the simplest elements on which our perception is based, namely mathematical shapes. Here is the skeleton of perception. The fertile tension between an idea and its execution is missing from these works, our vision completely codified, reduced to point zero. The disturbing and aggressive thing about Minimal Art is that it no longer requires us to distinguish between form and content, since they coincide. This is form unenhanced by passion or idea.

Paris, 1969

THE NEW REALISTS REHEARSE A
COMEBACK *Get-Together and retrospective in Milan*

This is the time of avant-garde harvest festivals: Happenings in Cologne, Zero in Düsseldorf, and Nouveau Réalisme in Milan. Jean Tinguely's surprise coup in front of Milan Cathedral remains (on the part of the artists) the only noteworthy provocation. And, one might add, the only one to strain the concept of reality to any degree. It was frankly a show, requiring an explanation only in the Italian newspapers. In the *Corriere della Sera* there was a mention of the "Greek God of fertility." The contact between assistant and celebrants however did not take place as expected. As Mimmo Rotella was about to get down to the ritual decollage of a prepared poster wall on Via Marco Formentini, he found the spot pre-empted by a political rally. His posters had been covered with counterposters, put up by residents of the soon to be demolished neighborhood to protest their threatened move to some outlying area of greater Milan. One poster stated: "Working people have a right to live downtown." What would have happened if Rotella had gone ahead with his aesthetic demolition act? He decided to express his sympathy and retire.

THE ERROR OF "THE SOCIOLOGICAL" It is not often that one has a chance, within a few short days, of observing the gap between consciousness expansion for invited guests and factual consciousness. What had remained so open-ended during May of 1968 in Paris, what anyone, whatever his special aesthetic predilection, was able to enjoy to the full (Informal, Dada, Pop, Op) fell flat in Milan. There was no selective voyeurism, but there was spontaneous, critical participation. To gloat about that, or even to announce that the political function of art had been proven, occurred only to those who must believe, come hell or high water, that this kind of aesthetic gesture has retained its power. Sorry, it hasn't. What always is possible, however, is to give one's gestures a similitude of virulence by means of an inadequate public. The participation seen here, angry and a result of socially understandable misunderstanding, lay strictly outside aesthetics—it was a collision of a non-public with art forms whose statement remained veiled.

The supporters of the New Realism met in Milan because that was where, ten years earlier, Pierre Restany had published the first manifesto of the group. In Paris this tenth anniversary went virtually unnoticed. The small commemorative exhibition at Mathias Fels's did not measure up to the occasion. Particularly the historic reality of the movement, at this writing the last Paris avant-garde, would have stood out most strongly in Paris. Thus the Milan show at the Rotonda della Besana turned into a score-card of melancholy, the final goodbye to Paris. Only a few of those artists who worked in Paris at the time still live there today. Arman, Christo, Hains, Raysse, Niki de Saint-Phalle, Spoerri, Tinguely would rather be anywhere than in Paris.

Pierre Restany, the spokesman for the group, managed to round them all up one more time. The group no longer exists, and a glance at Restany's manifestoes shows that even ten years ago, this group owed its existence solely to a clever use of the polemics then being hurled against the triumphant Informal Art. How else

could one manage to forge some sort of relationship between the "affichistes" Dufrêne, Hains, Rotella, or Villeglé and Arman, Christo, or Spoerri? In 1960, when Restany gathered these dissimilar artists (among them, or rather on top Yves Klein) under one label, he also introduced the concept of "the sociological." He talks about it incessantly in his manifestoes and catalogue introductions. To Restany this meant using industrial objects and existing urban realities (garbage, torn posters). And he believed that these were being introduced into art for the sake of their factuality.

In retrospect, Restany's group has the appearance of a mutual aid society, drawn together for tactical reasons, in order to take a necessary stand against *Informel*. Restany gathered around himself the artists who rebelled against the self-styled absolutism of the postwar Paris avant-garde. Neither the post-Cubists nor post-Surrealists stood a chance against Informal Art. Anything and everything thematic in pictures had been condemned forever.

DEAD-END PARIS The situation in Paris basically resembled New York, where the Abstract Expressionists had also preempted all the interest. But in the United States the reaction against Abstract Expressionism set in earlier. Robert Rauschenberg and Jasper Johns tried to escape from conformist abstraction by introducing objects and elementary representation. Even before them, Jackson Pollock (in his late work) and Willem de Kooning had already begun to incorporate figurative elements into their pictures. The unrelieved practice of nonrepresentational art had led to stereotypes, in New York as in Paris.

The negated subject had been replaced by codified pictorial signs. The freedom of the nonrepresentational, which related to Dada's point zero (as Restany had correctly recognized), this freedom had in the interim acquired a new meaning: automatic expression had been superseded by a new pictorial alphabet which the theoreticians of this art could, as in a Gestalt theory of poetry decode with no trouble at all. The direct reversion to Dada, to ugly materials and other anti-aesthetic ingredients, was meant to make this literary reading more difficult. And at first it did. For it seems historically proven that the actions of the Dadaists (including the art-indifferent demonstrations of Marcel Duchamp), were put on ice by Surrealism. Duchamp's *Bottle Rack* or *Urinoir* still had, in the 1950s, the same aggressive effect as when they first appeared. That was because Duchamp's actions had, up to then, next to no history of influence. Duchamp's indifference to art was transformed by the Americans (Rauschenberg, Johns, Chamberlain) into anti-art, a collection of recipes making another art impossible.

DUCHAMP MISUNDERSTOOD In the wake of Restany, the New Realists eventually distanced themselves still more from Marcel Duchamp: they aestheticized reality. That seems to be the common denominator for all their different approaches. Their defined world of objects in which the patina of use plays a part (except in the case of Martial Raysse, who seems to be the first to have anticipated European Pop) seemed to emerge directly from Informal painting. Fautrier's, Dubuffet's, or Tapiès's thick applications of paint evoking natural textures and earth, point the way. With the New Realists, however, this fascination with the Informal realism of the world of objects itself, gradually abated. Instead of the skin of things (a skin made of advertisements and political

posters torn off the Paris hoardings by Raymond Hains and Jacques de la Villeglé) these people were increasingly fascinated by the "objectlike." This objectlike quality was something Yves Klein still managed to lend an image— monochrome presentation boards painted with industrial pigments.

Restany's manifestoes, which construe Dada and Duchamp, leave room for a fairly broad construal of the group's new activity: "Each piece of reality contains within itself a possibility of significance." And elsewhere: "To place everyday reality at the disposal of vision, free of rhetoric, free from conceptualization." These statements are based on a far too extensive misinterpretation of Marcel Duchamp. Duchamp's indifference to art is passed off as a fascination with objects. Seen thus, reality as a whole is offered as material that can be aestheticized. As far as the past ten years are concerned, Restany's prediction was certainly correct. The aesthetic plastering of labels on real things certainly has missed nothing. But the fact that Restany was outstripped by his time seems to come from his having been extremely eclectic in the years when *Nouveau Réalisme* was being organized; he was one of the first to speak of misunderstanding, when Sidney Janis used the 1962 "New Realists" exhibition (sponsored by Restany) to play off New York against Paris.

The Milanese exhibition—in the Rotonda, formerly the church of San Michele, a domed chapel on the ground plan of a Greek cross—presents several works by each of the thirteen artists. The presentation (pictures suspended in space from strings) manages to isolate each individual work even further. Here it finally became clear, if it hadn't earlier, what New Realism is today: over and gone, and beautifully caught by a retrospective. Except for César, who is also showing samples from his newer work, everything is from the period when the artists temporarily acted as a group. In retrospect the differences have become even sharper: the poster people are hard to separate from the Informal style of the time, in spite of all the references to the independence of their techniques.

Christo, represented by a few Surreal pieces, appears to us today—since he has rid himself of the psychotic knicknacks—even more as a draftsman who uses string instead of a pencil to draw a line. Yves Klein's gold, blue, and pink canvases as well as his "anthropometric" burial shrouds stand in abstruse contradiction to the term realism in the title.

THE PSYCHOLOGICAL DIMENSION The one who is easiest to tie in with the concept of Nouveau Réalisme is Armand Fernandez Arman—except for the split celli which after ten years, have definitely shown themselves to belong to post-Cubism. The accumulations for which Arman has brought in a flood of objects are among the most successful and fascinating pictorial inventions of our time. They are like wanted posters made of objects, portraits of the age, in the sense of mythologies of everyday life. Arman, and also Daniel Spoerri, whose snare pictures are among the best work produced by the group, sharply contradict Restany's claim of "direct acquisition" of reality. Both Arman and Spoerri require a psychological reading.

Here the reference to time seems strongest, a reference that points to Alain Robbe-Grillet or Nathalie Sarraute. Those two authors also use manipulation of objects, of their sociological accessories, to portray a character, a society, by forgetting, so to speak, to describe them directly. With Spoerri, man is what he

is; with Arman, man is what he leaves behind. One has the feeling that if one were to take a clay impression of Spoerri's tables of leftovers or Arman's cases, The Consumer would fall into one's hand. Tinguely is represented by some of his symbolically functioning machines. In their case it is hardest to speak of realism—everything aims at metamorphosis.

All in all, this was an important demonstration of what had gone on in Paris in the 1960s. It was a look at materials and ideas that fell victim to America's totalitarian hold on innovation. These suggestions no longer interest us as a group problem. We isolate names, personalities, which, had they remained in Europe, would carry still more weight today.

Milan, 1970

YVES KLEIN—THERE AND BACK *French Art of the past decade*

Yves Klein, as can be seen today, was the last Parisian retailer in spectacular avant-garde. In a certain sense, his work formulated less a break with a particular tradition than its breakup. When Klein died in 1962, the period of the great Paris blackout had already been rung in. Klein's death was an attending circumstance, but it seemed to many almost a desertion. Many young painters moved away from Paris in the following years. New York art, not appreciated on the Paris scene nevertheless confused it. The myth of Klein made way for that of Rauschenberg or Warhol. But it is interesting that in a sense Klein's last works, the neo-Classical, blue casts, after his friends Martial Raysse and Arman, make one think of Warhol's portraits, just as the different coloring of one and the same motif in these portraits is already suggested in Klein's red, gold, blue, or pink canvases.

Yet Yves Klein fits fully into the Paris scene. His oeuvre, now being recapitulated in a first-rate selection at the Galerie Flinker, follows (perhaps on account of his striking theoretical concept of "sensibility") like a coda on the sphere of experience of Parisian Informal Art. With Klein, the image opens itself to behavior. Virtually all his works reflect cultic gesticulation. This kind of thing leads to a private mythology, to performing devotionals to self. Paris in the postwar years offers a number of such examples, in which the autobiographical, the subjective claim to pictorial sign was stretched to cover a group.

GROUP EXPERIENCES Publicizing artistic awareness was part of it. Take Georges Mathieu, who liked to have a crowded hall as witness when he painted; or take Alberto Giacometti, whose fanatic search for a human god-image led him to ever sharper reduction of the material, and who so eloquently knew how to place this defeat under the sign of Sartre or Beckett.

These are the borderline points from which the artist rejects painting and sculpture and goes over to action; action which finally, in such as Fluxus and

Yves Klein, 1956. Photo by Jean Michalon.

Happening, appeals to the mimesis of likeminded people, out of the feeling that only a group experience can turn the aleatory gesture of the artist into a binding statement. Ritual also brings a certain assurance: as soon as the tying of the individual to the superindividual group succeeds, one is in a zone that can be declared taboo, like any other sacred community. Abuse of the artist then falls into the category of blasphemy. The "social relevance" which almost every present-day activity of this kind prescribes for itself, is often nothing more than a trick to get out of the responsibility that holding a subjective idea entails.

Yves Klein naturally remained free of such naive pedagogic spoon feeding. His case shows first of all how many of the techniques introduced by the Surrealists could be used in an original, novel way. And the parallel is valid not only in the technical area; the goal too is somehow comparable, the admitted search for an image that aimed, beyond all representation, at trance. This stands for the need for fascination, which even the best of all possible harmonious societies would not be able to replace or invalidate.

Though today we find ourselves increasingly exposed to didactic plays and didactic pictures, this does not prove that anything has changed in our ontological ability to sometimes place fascination above a positivist passionlessness. Surely the strong pull toward history, observable everywhere, can be explained in terms of just this need which the spectator, even in a period that would deny him the image altogether, insists on bringing to it. Rediscovery, rehabilitation, revaluation—particularly of the nineteenth century—have become themes that in many areas have already even superseded the optimistic expectations once placed in avant-gardes. It is not so much history that stands to debate as a fascination, shaped by structural principles, with the possibilities of combining the materials that history offers. Behavioral patterns from the past are being laid bare and, depending on his particular viewpoint, either registered or interpreted by the viewer of today.

The mention of Yves Klein in this connection seems important because recently a book was published in France that has set itself the task of describing and systematizing the very thing the existence of which has steadily been denied in this country over the past ten years, since Klein's death, and that is a new generation of artists.° I should say in advance, however, that neither Klein nor his friends in the New Realism group play much of a part in this book. Klein is mentioned only twice, and one of these mentions is derogatory.

The large exhibition at the Grand Palais in Paris, in summer 1972, which aimed at propagating the art of the dozen preceding years, has provided the illustrations to this book. Jean Clair was one of the show's organizers. Nearly every name in his book was either represented at the Grand Palais or had been invited to participate. What Clair left out however is informative: Kinetic and Op Art. This brushing aside of an art form which surely has had a strong influence on the Paris scene for twenty years now, implies that we are dealing less with a history than a manifesto. Books like Pierre Restany's *Un Manifeste de la nouvelle peinture—les nouveaus réalistes*, seem to have stimulated Clair. The polemical bent of his book, which aims more at constructing than reconstructing

° Jean Clair, *Art en France—une nouvelle génération*, Paris, 1973

a period, leads him to present facts and dates which obviously he thinks we have overlooked. Among these are those works shown in the *Salon de la Jeune Peinture* (1965) which a group of young artists (Arroyo, Aillaud, Parré, Recalcati, Biras, Cueco, Tisserand) put together under the title of "Homage to the Color Green," and the show at the Galerie Creuze (also in 1965), in which Aillaud, Arroyo, and Recalcati presented a joint work titled "To Let Live or Die or The Tragic End of Marcel Duchamp."

Clair sees in the first-named exhibition, which presented a multitude of themes dipped in green paint, a provocative reaction against what French tradition has understood by *peinture*. As far as I can see, it was not much more than an adaptation of New Figuration, of English and American Pop which, however—and here one might agree with the author—at that time were regarded in Paris as a fairly autonomous brutalization of painting. But at the time the show didn't cause all that much of a sensation. Shaking a fist at Duchamp, by contrast, meant a fundamental attack against art and against what had in the meantime become its comfortable dialectic twin, anti-art.

ARTISTIC ACHIEVEMENT Clair starts out with the role taken over by the Americans in the early fifties. He contrasts it to the "arrogant provincialism" of the Paris of that period. Whether all that much has changed in these last years, so positively emphasized by Clair, is a matter for discussion. The contrast seems somewhat exaggerated. Op and Kinetic Art, along with the contribution from the New Realists, did create a climate in Paris that after all seems more independent than what Clair is praising to the skies today. But basically Clair disregards the visual aspects of this art. His text remains geared to a systematization of the materials.

There is no other book that so strikingly illustrates how a mere change in terminology, and a preoccupation with linguistic and ethnological models, can turn a totally international situation (bar a few exceptions) into a Parisian one. It is done, admittedly, in a very clever way. The independent French achievements, whether structuralism as practiced by Barthes, Lévi-Strauss, Foucauld, or Derrida, or the fascinating way of overdefining mental or objective details that Francis Ponge or Robbe-Grillet have perjured, all that is proclaimed as these painters' artistic discovery.

An existing philosophical or literary achievement is turned into their own achievement in painting. Thus it must appear to the reader that this new hermeneutic system not only helps to define their works, but that it is actually borne by them. Virtually everything that happens to the new generation outside the French context is omitted. Unfortunate, that the recent confrontation with the American and international scenes should fall so flat. People like Robert Morris, who immediately comes to mind when looking at the work of the group Support/Surface (a French label for Minimal Art), have simply been left out. That is also true of Joseph Beuys, who is found worthy only of a rather abstruse footnote.

PROUSTIAN REMEMBRANCES Clair divides his new generation into four groups, which impinge and overlap in various ways. The first comprises the painters of the "imaginary." They are juxtaposed to the painters of the "image."

This division is meant to separate pictures containing ties to existing pictorial worlds from those that show independence and absence of relationships. The categories, however, remain muddled: the first group includes, side by side with such expressive artists as Vladimir Velickovic, whose closeness to Francis Bacon leaps to the eye, people who are most easily classified as Hyperrealists. In the second group are painters like Peter Stämpfli, whose cold precision is very similar to the foregoing. A third group, separated from the two painter-groups by matters of principle, is made up of people who have given up the "Painting and Sculpture" grind. They belong, with the "*comportement*" artists (the Fluxus and Happening crowd) to the other wing.

The works available for this terminological demonstration hardly justify the extravagance. Autonomy only rarely sneaks in. The most interesting part of the whole endeavor is the terminological adaptation to the French scene. "Badly painted" is repeatedly used as a qualifying criterion, meant as an ironic stab at the Ecole de Paris. But this sort of thing no longer lurks in today's France, which has become familiar with foreign art through many exhibitions during the past ten years. The most notable attempts have been in the field of Conceptual art, as the French contribution to the last Biennale in Venice has shown.

In that area there are several artists given to a Proustian search for remembrance. Jean Le Gac and Christian Boltanski are most likely to make people sit up. These archivists and trackers down of their own memory remain in a strong cultural tradition. Individualism, frowned upon by the group mentioned at the outset of this piece, reappears here, with the full spectrum of personal coding. These are artists of subjective nostalgia, who hide a cult of the self behind objective research procedures, super adding knowledge of archaeological and ethnological techniques to a fascination with Proust. Certainly, these works take place outside the actual aesthetic realm. Yet their egocentricism seems no smaller than that of an Yves Klein—except he still tried to formulate his fascination as work.

The most important passages of the book concern the art establishment itself. They sketch the basic models of the escape from museum and gallery, or the clash between artists and the institutions they no longer wanted to supply. Clair sees a conduct limited to Paris in this confrontation. Among the people Clair names, a good number did indeed come to grips with various museumlike places—art museums, natural science museums, zoos, museums for arts and crafts. The museum seems to be becoming an extraordinary place. But the predilection for such extraordinary places, against which these young people would have liked to react, has been, ever since Baudelaire, since Aragon's *Paysan de Paris*, since Breton's *Nadja*, part of the attempt to flee city and civilization.

Paris, 1973

DELIGHTS OF THE STRAIGHT AND
NARROW PATH *"Style 1925," alias Art Deco*

What is this thing called "art deco"? It gives off a gamy scent, this dealer and boutique term. And it is precisely this dangerous, dissipated something that draws the collector. He delights in venturing off the straight and narrow path, he scorns function.

Art Deco aspires to becoming a style. In Paris, more and more shops are filling up with decor, objects, furniture of the 1920s, all of them in search of a definition. The French *années folles* offer themselves to the friend of ornamental subjectivism, for countless of the objects which originated at the time, and now so nimbly trip to the antique shop and gallery are one-off pieces. Many have a traceable, unique history. They were withdrawn from use long ago, and since then have lost even the semblance of utility. As stand-ins for pictures and sculptures, they can drive a collector wild who is looking not for samples of an exemplary, thus repeatable, useful design, but is after object-like, isolated uniqueness.

A manifold, formally lush, untamed landscape unfolds before our eyes. What is offered today as Art Deco cannot be accommodated in a metaphor however. We meet again the dialectic of the twenties as we know it from that period's painting and sculpture. The decorative field too is in the grips of contradiction, oscillates between a formal design with a goal, a yen for purism, and a complication of form which cultivates a cleverness conceived by an individual or by a group of likeminded. Much of what appears here can effortlessly be linked to the art—the museum art—of the era. Cubism, Léger, Futurism, Brancusi, Archipenko, Robert and Sonia Delaunay continue to influence. Many other questions that have concerned avant-garde art since the time of the Futurists, of the Cubists' papiers collés, turn up in this decorative-antidecorative circle. The combination of diverse materials, their consciously paradoxical use can be found, since 1910-11, in Picasso and Boccioni; in Klimt even earlier, especially in decoration.

No assessment of Art Deco could hope to compete with an exhibition that aims at demonstrating the sense, value, and consequence of modern design. Nor was there any attempt at competition. The fascination exerted on us by Lalique's pressed glass, Dunaud's black laquer, the erogenous—that is the only word for it—furniture of Groult, the perfection of Ruhlmann—who need not take a back seat to any giant of the ancien régime—this fascination with the rare, the unique, simply tells functionalism, economic arguments and series production, where to get off.

Although a little late, Paris is observing the fiftieth anniversary of one great event of the twenties. The "Exposition Internationale des Arts Décoratifs et Industriels Modernes 1925" was without doubt the most national of all the international shows our century has witnessed. Neither Germany and its Bauhaus nor the representatives of Holland's Neoplasticism were to be seen in Paris on the Esplanade des Invalides or at the Champs-Elysées. The plan to have a show in Paris dedicated to the crafts of the time dated back to before World War I. It is claimed—the French art historian Yvonne Brunhammer has covered this topic

in several publications—that a considerable impetus was given to such a confrontation by the sensational, disquieting appearance of the young German Werkbund at the Salon d'Automne of 1910.

This resolute, well-organized movement for a renewal of craftsmanship made such a strong impression that we find, in the official report, an urgent appeal from the president of the French society of decorators that action be taken against the foreign threat. In the official memorandum we find several of the most important—and at the time revolutionary—points in the Werkbund program. The group around Muthesius, who was for standardization and therefore against expensive, individually handcrafted goods, received particular attention. In the report by the Frenchman Guilleré, we read statements that could only have been based on a knowledge of the questions posed by the Werkbund. Thus Guilleré remarked: "Thanks to an exhibition like this we will succeed in creating inexpensive arts and crafts, truly democratic ones."

At the same time Guilleré took aim at the historical revival styles beloved of French decorators. First came the demand to do away with stylistic imitation: "Will we sink so low that we'll end up merely a nation of copiers?" This is a formulation reminiscent of the texts of the Italian Futurists. They too were searching for a tabula rasa, for a free new start.

The plan for a comprehensive exhibition dedicated to the decorative arts therefore goes back to an extremely precarious historical moment in France. On the one hand there was the desire to get away from national historicism, which was familiar only with the range of French styles; on the other hand it was important to make a contribution which would owe as little as possible to the internationalism of the period. A modern but specifically French decorative style was to be developed. The exhibition had originally been planned for 1913, in Paris, but the war intervened.

The plan could not be implemented until 1925. In the meantime, in 1919, the thoroughly conservative Compagnie des Arts Français had been founded; it tried consciously to oppose the international style with a new created Louis-Philippe style. The 1925 exhibition was quite explicitly meant to serve national prestige. Cynically, all the problems of the postwar period and of the modern social habitat were masked.

The exhibition to which today's term Art Deco refers was an inaccurate mirror of what had been done in the 1920s in the fields of handicraft and design. Nevertheless the attempt is now being made to inflate the Art Deco label to cover an epoch. In the publications that are now coming out in France, the Bauhaus, de Stijl, and Constructivism have quite casually been incorporated into "Le Style 1925."

Eleven years ago in the mid-sixties, the Paris Musée des Arts Décoratifs, which is also presenting today's retrospective, still had managed to keep the controversy going. The "Style 1925," Rateau's hygienic Empire bathroom for Jeanne Lanvin, the martial wrought-iron work of Edgar Brandt, in short everything that was still considered national exoticism in the 1960s, was put up against the comparatively categorical and definitive design of Gropius, Breuer, and Le Corbusier. This endowed that particular retrospective with tension, allowed the viewer to more easily distinguish and define the various tendencies within the French Art Deco scene. The traditionalists—Groult, Iribe, Rateau, Follot, Mère, Ruhlmann—were

faced by a group of decorators like Legrain, Eileen Gray, Coard, Dunand. With Mallet-Stevens and Le Corbusier, innovators turned up who had to be discussed in connection with the functionalist tendencies of the time.

The present edition of the mid-sixties exhibit could not help but be a disappointment in historical terms—all the added material and photo enlargements of the 1925 pavillions notwithstanding. The art trade has played a central role in the selection—as can be gathered from the list of loans. Among these, pieces of furniture by Marcel Breuer and Mies van der Rohe turn up that were not in the 1925 exhibition. With what right no one says. No attempt has been made to show the tendencies of the period or illuminate the origins of modern furniture or interior design. In the sixties neither the means nor perhaps the knowledge for this was at hand.

Today things are different. It was precisely in the sixties that fascination with the Bauhaus arose and triumphed. France, too, temporarily went purist and began scouring its own recent past for any material that seemed faintly in line with the phenotype of Bauhaus furniture and thought. Yet the Bauhaus was seen too strongly in stylistic terms—and it was precisely the establishment of a Bauhaus style that, in retrospect, harmed the innovative spirit in Weimar, Dessau, and Berlin, weakened fundamental Bauhaus positions that were beyond questions of style.

In 1925, Le Corbusier, with his famous Pavillon de l'Esprit Moderne (erected in the face of immense official opposition), was undoubtedly in the front rank; then came Robert Mallet-Stevens, Pierre Chareau, René Herbst, who designed the first tubular steel furniture in France, and Jean Prouvé, who offered furniture for the assembly line. After 1945 these purist, ethical conceptions, linked to the habitat, had a certain chance of succeeding, even with the French middle-class, which in 1925 had fought tooth and nail against Le Corbusier's asceticism. At least by then the stigma of cultural bolshevism was gone.

It is easy to establish the fact that socialist states were in no way permitted to follow the road opened up by Melnikov in 1925 with his Soviet pavillion: dictorial regimes were more comfortable with the symbolic architectures of Pierre Patout, Boileau, Louis Süe, and André Mare. The cool trenchancy of the Bauhaus, Le Corbusier, or Mallet-Stevens offset their intimidating eloquence.

The debate at the 1925 exhibition between the Pavillon de l'Esprit Moderne and the officially sponsored national prestige palaces went far beyond questions of style. The ideology of the avant-garde collided particularly sharply with middle-range taste. A principle came to the fore here; it touched on the meaning of an ornament that attached itself to something useful and therefore, in the definition of those who supported the Modern, turned what was already perfect into an ugly pleonasm. Decor was seen by the purists as a backward step into a condition that was supposed to have been conquered historically and thus anthropologically.

To listen to Le Corbusier brings to mind Bernard of Clairvaux's disputation with the figurative art of the monks in the twelfth century. The aggressive phrases "deformed perfection" and "perfected deformation" could easily have been used by Le Corbusier in his attacks. At the very least a dialectic seems to live on here which can be traced back to earliest time. The social handhold that unnecessary and therefore immoral ornament offers, can also be found in

Bernard: "If one is no longer ashamed of impropriety, why does one not at least shy away from extravagance?"

In the mid-sixties one could still practice exorcism with Bauhaus and de Stijl, could still fight the bombast of memory, the furnished nostalgia. Things are different today, ever since Bauhaus fatigue set in. One can no longer blindly believe in the exclusiveness of any idea of development that would have its last word in purification à la Bauhaus. Without doubt this skepticism toward simplifications and abstractions postulating an unsurpassable final state is the result of the historical moment in which we are mired.

It turns out that simplicity, reduction, are also period phenomena and thus subject to the fluctuations of aesthetic curiosity and aesthetic lethargy. In the 1920s, after Germany's first collapse, the revolutionary forces had weighty reasons to see a rejection of the imperial Wilhelminian decor as an ethical decision. After World War II the necessity arose to make a compromising art disappear. Bauhaus offered itself as an ideologically clean form.

Today's consumer responds to everything the twenties had to offer. Familiarity with Pop Art has, for the first time since the fin de siècle, bred a sensibility for layers of experience that intersect formally determined thought at odd angles. In Andy Warhol's vicinity for instance a feeling for the morbid, for the symbolically magnetized object has surfaced. The circle closes when one visits him today in his New York Factory. Warhol's studio is less a place to work than a place of worship. And the central icon has been, for several years now, French Art Deco, with all the *haut gout* bestowed on it by a clever incapacity for ordinariness and banality that levels the barriers between usefulness and ritual.

Surely we shall, one day, have to let the history of recent art take a different course as we eventually discover the connection, at first so seemingly casual, between the twenties and the fascination with objects of the last ten or twenty years. What role, for instance, has the large Sonnabend collection in New York played in all this? Ileana Sonnabend has for a long time been active as the mother hen of the American Pop generation. Warhol was at home there, as was Roy Lichtenstein, who after an early, as yet art-historical fascination with Léger, has advanced to what ties the whole period to Léger—to the hard, chrome-plated contour and playful snappy planarity.

The name "arts décoratifs" is bland compared to the reception that the items it covers have since received. The short form Art Deco is what brought about the revaluation. It has accomplished what the greats of the Vienna ateliers, Josef Hoffmann and Koloman Moser, called for half a century ago. They wanted the products of craftsmen measured with the same yardstick as the work of painters and sculptors. Well, the cutlery and silverplate of Puiforcat, the book bindings of Legrain, the lamps of Perzel or Edgar Brandt do require, like sculptures and pictures, the privileged individual eye. They do not hide from today's admirer behind a function.

Even whatever filtered from Bauhaus or Esprit Nouveau into the elusive Art Deco had its utility value etched away. Even the plainest simplest forms. The expensive materials needed the cheap ones as antithesis, as a cumbersome and overloaded chest of drawers needed a condensed shorthand chair to set it off. Furnishing and defurnishing, Art Deco is clever enough to contain both. The architect Francis Jourdain had pointed to this highest type of luxury as early as

1925: it was to clear out a room as expensively as possible. The term Art Deco does not really denote a fixed moment in our century—it indicates a momentary situation which beautifully eases our malaise toward the present with a pill from the past.

Paris, 1977

HIPPOPOTAMUS WITH BOOTJACK *The Art of Psychopaths and Modern Art*

The exhibition of Art Brut shown in Paris in 1969 gave a wider audience the chance to see works that have formal parallels with the art of our time, yet mostly lack its artistic intent. These are works that belong—to use Jean Dubuffet's expression—to the "noncultural" sphere, a definition that places them in antithesis to accepted art, (accepted in the sociological sense).

Dubuffet's words hide the claims of an avant-garde, and this statement takes on its full meaning only when the works here presented under the name of Art Brut are compared with Dubuffet's own oeuvre. Then the exhibition turns into an indirect manifesto for Dubuffet himself. A great deal of understandable bewilderment has been created by the term Art Brut, a designation that covers very different phenomena. We can come closest to a clear definition if we start out from the proven pathological cases and put aside the naive or dilettante versions of Art Brut. That seems legitimate since the autistic world of the mentally ill, and particularly schizophrenics, who comprise the largest group, has nothing to do with the basically ambitious artistic intentions of naive and amateur artists. One would have to exclude both the work of Joseph Moindre and the sculptures of Pascal-Désir Maisonneuve. Maisonneuve was a specialist in mosaic work. His masks made of mussels are ingenious, and often ironical. We find no irony however in the psychopathic creations of an Aloise, a Gaston Duf, or a Guillaume: "Irony is wellnigh excluded by their very nature. After all, it refers to a tacitly acknowledged convention, that is, precisely to what the schizophrenic has eliminated from his thought."

In my view the lack of artistic intention or at least its independence of art history would best describe the phenomenon. This definition would be sufficiently broad to cover such influences as illustrated magazines, postcards, memories, works of art on the work of the mentally ill. Since these influences are not of a selective but of an objective kind, they have a function other than consciously received and digested influences. This self-conscious, entirely monistic apprehension of the surrounding world is best reflected in the self-portraits of the schizophrenics. Wölfli for example represents himself at the center of his composition, in a quasi-godlike, hieratic attitude. Phenotypically these works differ very little from the formal boldness of modern art. And the exhibition was probably organized to show not only astounding variety but also to reflect certain qualities of current painting, like automatic writing or gestural impetus.

Dubuffet's formulation avoids the problems that Art Brut poses for psychologists and art historians. Deliberately and polemically he has separated these works from the mainstream of art to proclaim them the true art. That is a paradox, because he has no intention of conceding to these works the one thing that could bring about total integration:° At bottom Dubuffet uses this "noncultural" art to plead the case for his own work. And he succeeds, thanks to the formal relationships that he consciously establishes, in a kind of "cultural" reflex. (Among these perhaps the most important are the elements of agglutination described by Alfred Bader.) Dubuffet in short has made the exhibition too much of his own thing. The visitor's attention was not called to the fact that Art Brut— at least the more exact, psychopathological version—has long been a very fertile area of study, as one can see from the bibliography comprising some six hundred entries that Volmat published in his book, L'Art psychopathologique. Since then innumerable case studies and general works have been added to the literature. Only art criticism and aesthetics have yet paid little attention to this field. This is unfortunate, because methodical study of it, by acquainting one with autistic spheres and ideologies, would certainly contribute to the understanding of modern art.

The history of influence of these works reaches deeply into the field of professional or "cultured" art, yet thus far, the psychologists have been its only Vasaris. A look at the literature is definitely worth while. The analyses by Hans Prinzhorn and Volmat are splendid, isolating numerous elements in a way that suggests these authors' thorough art-historical training. Nevertheless the analyses are of limited value, as the authors themselves admit. Prinzhorn was able to isolate even more elements of relatively pathological character than Volmat. In the meantime, developments in art have absorbed—consciously or not—stylistic elements of this kind. Therefore it is not at all surprising that present-day comparative studies are faced with a dilemma and must conclude that both arts are identical, and that there simply are no pathological elements.

It makes sense to consider the stylistic categories enumerated by Volmat as typical of pathological art if one can distinguish their monomaniacal character as reflecting a compulsion, as opposed to a mere intention, to create. All in all, the newer literature on the subject treads very carefully. But in a number of cases (for instance Leo Navratil), where a normative definition of psychopathological art is given in terms of an art-historical category (Mannerism), we begin to baulk. As long as there are no criteria that allow us to isolate artistic will or intention in pathological art, such comparisons are misleading—primarily because they equate the cultural sphere in which art is created with the autistic sphere in which a patient lives. If, for instance, an iconographic constant could be determined for a particular stylistic period that contains similar information for every artist using it, this would still not hold for the autistic world of the clinical schizophrenic. The works of a Wölfli or an Aloise, two of the most striking cases, have to be considered phenomenologically, that is, their formal qualities or idiosyncrasies must be recognized as an expression of their own personal iconographic and symbolic system. We can do this because the case histories are available. We must, however, keep in mind that Aloise was taught drawing in

° The Compagnie de l'Art Brut collection is not for sale.

school and that Wölfli took his motifs from an illustrated magazine. In addition, the decorative style of these drawings proved to have certain affinities with a type of ceramics made in Heimberg, a village near which Wölfli worked. It is only against this background of individual psychological knowledge that we can describe and comment on the formal, structural problems—development, repetition, stereotype, distortion, *horror vacui*, representation of space and time, anachronisms.

Every important case reflects a personal world. Unities of style can hardly be determined, because style is not handed down in this world. The psychopathic elements contained and repeatedly isolated in these works must therefore—separated from their content—be applied with care. The correspondences to contemporary art are obvious but often superficial. For instance, in the hectic graphism of a Guillaume that recalls André Masson's automatic drawings, one discovers very quickly that there are very precise references to objects. Guillaume reconstructs the patterns of Breton embroideries on which he worked with his mother as a child. Then too, the pathological elements of any of these patients' styles are so difficult to define because there is no "normal" material from before the onset of the illness to which they could be compared. This problem was totally ignored in the Art Brut exhibition. Yet particularly where we see a transition from a socially and historically stable situation to the nonartistic sphere—it is very important. Such cases play a decisive role in the literature devoted to the subject. In some instances, as with Josephson and Hill, one can isolate the pathological factor. Both cases are interesting, for they show how a historically stable and fluent style can be disturbed or even destroyed by illness. One might contrast this with Van Gogh, in whom the onset of illness only intensified a self-acquired historical position.

The integration of Art Brut through Dubuffet has parallels with the integration of negro sculpture by the Cubists and Expressionists. In both cases the integration took place for formal-aesthetic reasons. The historical or, with Art Brut, psychopathological conditions of these forms and their meaning are disregarded. Aesthetic acceptance obscures the innate cultural aspect that is evident in these works much more than would a critical reading based more firmly on their content.

Preoccupation with these problems is, as I've said before, in no way new. With Art Brut it has merely been ideologized in a new way. This is proven by a look at the literature and the history of its influence. A certain growing understanding is revealed by the titles of the books dealing with the subject. The first examinations that linked pathological and contemporary art did so with polemical intent. In 1894 Morelli likened the individualism and symbolism of the art of the mentally ill with the decadent schools of his own time. Later works equated Cubism and Expressionism with the art of schizophrenics. There was not always a polemical intent behind such comparisons, however. If Cesare Lombroso in 1877, spoke of "genius and insanity," it was mainly to point to the diseased element in the work of artists and assign it a high generative role. The discussion of such pathographies—especially those of Van Gogh and Black—at first served the hermeneutics of genius. Eventually, however, the discussion degenerated into an attack on art. Again and again the works of the mentally ill offered criteria for a "scientific" condemnation of current art. Modern art in turn provided evidence for the

"Keller, Wirtshaus, Salon, Stall in Einem". 2.7 1915
"Zigarre weg". v. K

Imagery of the Mentally Disturbed, Case No. 36.

hypotheses of Weygandt, T. B. Hyslop and others who defined the work of various artists by categories of illness. Knowledge of the art of the mentally ill, and formal, accidental parallels to modern art eventually led to the doctrine of "degenerate" art with which National Socialism condemned everything that did not fit into its ideological system.

In his classic *The Artistry of the Mentally Ill*, Hans Prinzhorn introduced the concept of artistry (Bildnerei) not because he wanted to deny aesthetic merit to these works, but because he wanted to replace the technical term art, too dependent on an existing social order, with the more universal notion of creativity. Since then the concept of psychopathological art has generally become accepted. Prinzhorn's preparatory labor pioneered the upgrading and understanding of these works. He was the first to conclude that the theories that considered the art of the insane as a language which translated a pathological content into visual terms were simplifying too much. The psychology textbooks of the time postulated an identity between illness and expression, between the mechanically faithful copying of the epileptic and epilepsy, between the disordered drawing of the maniac and mania, between the ungainly deformation of the paralytic and paralysis.

Prinzhorn, however, determined that the antitheses sick-healthy, art-nonart were in fact blurred by so many interferences overlapping that classification can never be absolutely positive. Even structural psychopathology, so brilliantly described by Volmat, must be adapted from case to case. Archetypal forms can be applied only in conjunction with general diagnosis. Prinzhorn's discovery was important that the primitiveness of most of the drawings reflected nothng pathological in and of itself. The lack of ability shown in these works in no way differs from the lack of ability shown in the doodles of autistically inexperienced normal adults. Nor, on the other hand, does illness give rise to artistic talent. It is at best a trigger.

But the most important conclusion to which Prinzhorn's forty-five years of work led was of an aesthetic nature. It forces us to confront and examine these works: "The separation of our images from the fine arts is today only possible on the basis of outmoded dogma. Seen otherwise, the transitions are smooth." Bader too opposes the emphasis on the psychopathological: "There is no psychopathological art in the true sense, because the phenomenon of art, or rather the creative act, at its core remains uninfluenced by mental illness." That would seem to indicate that the dividing line between cultural and noncultural art is not aesthetic.

Prinzhorn's book (recently reissued) remains the surest introduction to the problem. That, however, is not the only reason why it is worth mentioning. It was of great importance to Surrealism. The exhibition of the Compagnie de l'Art Brut suppressed not only the bibliography but also the prehistory of Art Brut. Max Ernst, who attended lectures on psychology at Bonn University, brought Prinzhorn's book to Paris in 1922. It was a present for Paul Eluard, who had lent Max Ernst his passport for the trip. *The Artistry of the Mentally Ill* influenced not only Max Ernst, but also other members of the Surrealist group. The book became a source whose secret influence is certainly worth investigating. The contents of psychopathological art, enumerated by Prinzhorn in 1922 as an od-

dity, have today—against the background of Surrealism—become decipherable. Prinzhorn wrote: "Why should, in illustration 108, the hair wave not be an eagle's wing as well, why shouldn't Ganymede fly up behind a modern dandy? Poodles play on a sofa that stands on a cliff—a hippopotamus with two heads stands on a bootjack—endless such examples can be collected. . . . No object out there [in the outside world] has a value of its own any longer . . . everything is material for the self-satisfaction of a withdrawn, autistic psyche."

As Dubuffet shows—even the Futurists had already become interested in noncultural art. In 1911, Carlo Carrà and Umberto Boccioni organized an exhibition in Milan in which everyone who had something to say could participate. What this meant was defined by Giovanni Papini. In 1913 he drew up a list of the types of people who possess authenticity: the savage, the child, the criminal, the lunatic, and the genius. The influence of psychopathological art on the art of our time is incontestable, including, to name only one case, Josephson's influence on Picasso. Otto Benesh has examined the influence of Josephson's drawing *Rembrandt and Saskia* on the *Suite Vollard*.

The collection of the Compagnie de l'Art Brut, from which the Paris exhibition was put together, is only one of many. A number of collections were started in the nineteenth century by French psychiatrists. And though at first psychiatric analysis was paramount, soon the aesthetic information of these works began to be emphasized. Prinzhorn's selection for the illustrations of his book takes aesthetic claims into consideration. He was able to draw on the collection of the psychiatric clinic at Heidelberg, which in 1922 contained 5000 works by 450 patients.

The material—repeatedly publicized, reproduced, exhibited—is manysided. It shows a certain anchoring in history, or is at least parahistoric. The extent to which these historical concerns reflect historically conditioned neuroses is an open question, however, as a look at a number of the plates in the Prinzhorn collection, which were recently shown in Paris, show. Those works are quite capable of being dated and localized. In more recent works this trend toward history—or rather topicality—is even stronger. This is probably due to group therapy, which forces many patients to draw or paint, although they'd never have done so before. The studios in the psychiatric institutions in which the groups work create a mutual dependency, out of which a typical style evolves. Similarities arise out of preference for certain techniques—such as finger painting. This becomes particularly clear in psychiatric exhibitions where the material is presented by institution. That complicates the problem further, of course. It means that in examining these works, one has to take the influence of the therapist or other strong personality into account. But these questions ought perhaps to be left to the psychologists.

Modern artists have repeatedly had recourse to elements that stood outside the historic or technical development of their medium, thus enriching it profoundly. It would seem more than appropriate to examine the influence on cultural art of pathological art, as well as that of other noncultural areas. Much work remains to be done in this field.

But the most important problem—and the Art Brut exhibition called attention to it for the first time—is the problem of the valuation of works created within a

delimited pathological autism. In that regard it is necessary to interpret each case individually in terms of its aesthetic system and to describe the work's immanent formal problems.

Paris, 1969

THE BEARD OF THE GARDEN DWARF Kitsch:
An anthology by Gillo Dorfles

Kitsch is something in someone else's living room. What is kitsch? A superstition of art? From the point of view of art, can kitsch still pose any kind of problem? Can it threaten one's own aesthetic position? Art in our century has integrated so many nonaesthetic phenomena that it seems far more interesting—from an aesthetic point of view—to consider the transition of kitsch to art, rather than to establish the normative separation of the two fields. Kitsch is as subject to historical judgment as art is. Whatever lives on historically, lives on less and less as kitsch than as art. Both areas tend to displace each other. In both we must separate actual, effective results from those that leave one indifferent.

That is why the intent of *Kitsch*, by Gillo Dorfles (New York, 1973) to be a kind of catalogue raisonné of prevailing bad taste, seems somewhat formalistic. Kitsch as an absolute does not exist—just about everything, including the "highest" art, can be turned into kitsch given the appropriate stance. By the same token, kitsch is reversible. Let's take the time-worn symbol of kitsch, the garden dwarf. It is kitsch in its appointed context, in its little front garden. But should it be removed from its environs, taken indoors, defamiliarized, it loses its effect. I think that one can do with the dwarf (a kitsch favorite) what Duchamp did with the favorite of fine art, the *Mona Lisa*. If the *Mona Lisa* can have whiskers painted over her smile, then the dwarf's beard can be removed. Kitsch too can be deprived—that is, improved through awareness.

The history of our century contains innumerable examples of art having integrated what could be called—measured on a normative kitsch scale—"bad" art. Collage, Dada, Pop, Funk Art have incorporated masses of elements which, by themselves, would be considered not only outside of art but downright kitschy. Beyond this use of kitsch, there is a view that has, from an aesthetic position, experienced certain manifestations generally considered as belonging to kitsch nonaesthetically—without changing them materially or wanting to integrate them into art. An example of this is the realm defined by Susan Sontag as "camp," phenomena that initially, as taboo manifestations, have an exciting effect. It is the realm of reflection about—where an awareness of aesthetic sinning, of blasphemy, works as a stimulant.

This is a difficult subject, even one forfeited to aporia, as will become clear to anyone who looks around, who sees the extent to which normative certainties have had to be abandoned in our day. The norm of kitsch seems quite as unacceptable as the norm of art. We're dealing more with behavior than with

fact. That is why the concept suggested by Hermann Broch, that of a "kitsch person," seems more acceptable than the systematology of kitsch materials based on formal criteria. Formal criteria or knowledge of forms can be useful in giving opinions about works that irritate aesthetically to a greater or lesser extent. But it would seem extremely difficult to impose such formal criteria on something objectively negative which, through its degree of negativity, flips over into an activating quality—in fact, into a kitsch relevant to consciousness.

Numerous formal reasons cited by Dorfles to establish kitsch cannot be weighed pragmatically; they are mostly of a mythical-cultural order. If, for instance, kitschy reproductions of works of art are discussed, the fact of reproduction itself becomes the kitsch factor for Dorfles. It is revealing that in just about every anthology on kitsch this is given as evidence, and for the reason that the piling up of identical forms is supposed to carry reproduction to the point of absurdity. In that case one could counter that the kitsch effect does not result from the fact of reproduction, but from the relationship that comes about through the stringing together of tautological forms which produce rigidity, ridiculousness. It is the propagation that hurts.

If the situations that give rise to kitsch are examined, it becomes evident that they are pluralistic situations, situations of hybrid nature. The question of the advent of kitsch therefore seems decisive. Kitsch is a fact of our more recent history, of the nineteenth century. The historical revivals allowed incongruity—even raised it to the "styling" of ornament. The synchronic availability of forms that have a diachronic sense created a situation that differed from the preceding periods, which subordinated themselves to constant principles of style. The use of new materials, plus industrial mass products, in whose design—for material reasons, for reasons of the difference between hand craft and machine work—art no longer had a say, all bred the atmosphere of disparity, of mixture, so crucial for kitsch. Aesthetic and social reasons also enter into it: the museum, the cult of preservation, and the concomitant reassuring certainty that throughout the world there are works, in specially erected establishments, worthy of the same emotion. Malraux's ahistorical, psychological manner of considering works of art that were administered by an imaginary museum connecting everything, no doubt was the cornerstone for standardized art and kitsch tourism. The museum, the building to be viewed, the church, to be visited under the leadership of "expert" guides, became mediums in their own right. The mode of information has become so self-sufficient that it hides the multiplicity of what is shown.

These and similar developments have modified the attitude toward the original work. The original work, in its material and historical uniqueness, could not—and there is no point in imagining otherwise—be kept alive in a time of mass media and mass culture, in which the various communication and consumer items are calculated for total consumption. The discussions about the reproducibility of works of art concern the adjustment of aesthetics to the remainder of the information-consumer field. Kitsch and multiples are two antithetical measures of confrontation with a world of accumulation and of private art and capital investment.

One of the good points of the present collection of texts and pictures is that—however much it is concerned with factual proof of kitsch—it does broach

questions which examine provable qualities in kitsch (rigidity, simple, uninter-preted transcription, falsification of scale, prettification, styling) not only in the area where they are evident, even cliche, but also in general human behavior. The reprinting of two important essays by Hermann Broch and of Clement Greenberg's "Avant-garde and Kitsch," as well as Ludwig Gresz's splendid "The Kitsch Person as Tourist," at times move the study from the aesthetic-moral to the anthropological and social sphere.

That goes further than Dorfles's own systematization of the material. He does not proceed phenomenologically, but he seeks to fix categorical differences between art and kitsch, real and unreal, religion and pseudoreligion. Although he does refer to Claude Lévi-Strauss and Roland Barthes, who subjected the shaping of modern myth to excellent analyses, he overlooks the phenomenon itself. The "innumerable Protestant sects" are to him merely pseudoreligions. The interest in decor and clothing "as if these were valuable amulets or miraculous relics" is not explored, but is evaluated as a non-value, that is, kitsch. This opinion can be countered by the view of Hermann Broch, according to whom any value system whose autonomy is interfered with from the outside can be destroyed: "A Christianity whose priests are obliged to bless cannons and tanks, touches on kitsch just as much as poetry which attempts to glorify the beloved ruling house."

Dorfles himself brings in and mixes everything: Beatles, hippies, eroticism, advertising. In all these he detects the workings of kitsch. And yet it is in these fields that an authentic shaping of myth is in progress, out of which a new formal assurance, a style, devolves. In the anthropological sense, kitsch manifests itself most explicitly, where traditional structures live on emptied of meaning. These are the terms in which family kitsch, devotional kitsch, liturgical kitsch, eschatological kitsch—in short, the unproblematic continuity of form—should be inspected. Likewise the argument that pop and entertainment music are suspect too. New music, understood by only a few initiates, supposedly escapes kitsch. This follows a mechanistic cliche that art must first gain acceptance. Yet what of avant-garde ambiguousness, such as that of a Carl Orff or an Alfred Manessier?

Kitsch is not only a private problem, the problem of people who construct a personal high altar out of a record player, travel memorabilia, family photos, flowers, or assortments of cookies. Kitsch is also imposed by urbanists, interior designers, politicians, prejudices against new media, by the cult of private distinctiveness, lamentation over the lost center and the fear of new methods, media and mythologies.

Paris, 1970

TAKE AND DEVOUR *The book as object*

"Asking Questions of the Media" is the theme of Documenta 6 at Kassel, and the organizers have posed one of these questions with their exhibition at the Neue Galerie entitled "Metamorphoses of the Book." In the section of the

catalogue devoted to that show we read: "Artists are beginning to question the medium of the book as an instrument of objective information." According to the authors, this began in the mid 1960s. And in their self-confident jargon they add: "The book as work of art becomes its own subject." Books of this new type were exhibited for the first time in 1972, they say.

No wonder the Kassel people think they're offering something unheard of. Neither do they let us in on the sources of their theme, nor do they provide any background information of a historic nature. They let the motto stand for itself, and if we take it up they should not blame us for finding much of what is presented here adaptive in the extreme. As an example of metamorphosis we need take only those eight books by Zangs, dated 1976, which are out to look paradoxical if it kills them. This is what happens to large parts of the exhibition.

In among the torturedly original pieces we find, here and there, examples of invention that seem truly autonomous and sometimes poetic: the work of Marcel Broodthaers, who dallies intelligently with Baudelaire or Mallarmé; Gotthard Graubner's *Sickerbuch*, an homage to Ungaretti; Laszlo Lakner's *Michelangelo*, which makes effective use of the contrast between encyclopedia and unique symbol; Maurizio Nannucci's *Universum*, and finally Dieter Roth's transformations. Roth's books, which he binds in sausage presses, remind one of Herman Melville's description of a library in *Mardi*, which came out in 1894—a long row of moldy texts in the shape of Bologna sausages, smelling of cheese.

"The paper memory of humanity," as Schopenhauer called it, began crawling out of its cocoon quite a while ago. Ignorance of this fact, it may be, symbolizes once again the approach of an age of illiteracy. Not an inconsiderable body of writings has collected in the meantime on the subject of the Metamorphosis of the Book which Kassel has so naively adopted. Its history is really too interesting and subtle to have been ignored in an exhibition as pretentious as this one is. As recently—or should one say as far back? as 1969, the Paris bookshop Nicaise and Claude Givaudan, the publisher, exhibited more than thirty "object-books," and put out an excellent and detailed catalogue to accompany the show. They introduced to an avid public the production of three houses, "Le Soleil Noir," "Editions Eter—P. A. Gette" and "Givaudan".

WALL OF BOOKS None of these books were shown at Kassel. And yet among them were works that would be widely taken up and varied in the years to come. In 1964, a collaboration between Alberto Giacometti and Marcel Duchamp, *La double vue*, appeared, which included Duchamp's "Clock in Profile," an illustration that juts out of the page like a relief. *La fin et la manière* (End and Manner) by Jean-Pierre Duprey and illustrated by Robert Matta, came out in 1965. When you open the box to this book, a paper-sculpture unfolds like a star through whose openings the color etchings of Matta shimmer. Another book, *Aube à l'antipode* (Dawn at the Antipode) of 1966, illustrated by Magritte, starts to sing when you pick it up. Also worthy of mention are Joyce Mansour's *Carré blanc* (White Square), which is tied by a cord to a plexiglass cylinder into which an etching by Pierre Alechinsky had been cast, and the books of Paul-Armand Gette, which unfold in all directions, spewing objects like fireworks.

One of the most sensational books of all was *Sisiphe Géomètre* by Ghérasim Luca and Piotr Kowalski (1966). The text is printed on five transparent sheets of

plexiglass, each of which is attached to various hollow glass objects filled with gases that light up under the influence of an electric field. The intensity of the light varies with the spectator's movements.

What opportunities have been missed in Kassel. Apparently none of the organizers of the show was acquainted with the Paris catalogue. It was not even quoted. Nor is there a word about the exciting exhibition, *Multiples*, shown at the Berliner Kunstverein in 1974. And yet that exhibition, put together by René Block, depicted and described in detail many of the books that are already classics of the genre.

Or think of all the information contained in the original catalogue devoted to "object-books" at the International Book Fair in Nice: a stack of paper wafers inserted into a plexiglass tube corked at both ends. To read this mobile book, one spreads out the multicolored disks one after the other, turning them over to look at the illustrations and read the text printed front and back. If the exhibitors had done a little research, what might they not have discovered, unavoidably stumbled upon? Maybe even that fabulous collection of object-books which a doctor in Alsace has gathered and around which he had an architect build him a house and "object library."

Aside from that, what is missing in the Kassel survey is a historical point of view, the determination of those moments when fantasy and dream entwined the traditional Western form of the book. Not that it was necessary to illustrate the countless variations of format, function, typography, and illustration books have passed through. But at least some indication of how constantly their shape and look has been jostled, how often their form has also had to transmit content, could have been expected from an exhibition with such high ambitions. But of what earthly use are statements like: "As transmitter of information, the book is a physical stick-in-the-mud."

It isn't only in recent years that the times have found books hard to digest. What a splendid beginning we find in *The Revelation to John*, with passing of the Word:" Take it and eat; it will be bitter to your stomach, but sweet as honey in your mouth." (Rev. 10:8)

There are precedents for much of the eccentricity that has been dreamt up under the slogan "Let's go to Kassel." Take, for instance, the arrangement of books planned by Hubertus Gojowczyk. He is making them into a wall: "There is nothing to read in this wall of books; the books do not turn their back to the person standing before the walled-in door. Only the edges are visible, and a little of the binding." In the sixteenth century it was quite common to have libraries arranged with the book's edge, which bore the title, turned toward the observer. Recall the unique library of the Pillone brothers in Belluno. They had Cesare Vecellio, a nephew of Titian's, decorate the edges of their books with compositions of figures. When arranged, this library must have startlingly distracted from the written word. It is embarrassing when—as in the case of Ugo Carrega—the use of *Leporello* is referred to, without a mention of our century's most famous predecessor of fold-out books, Sonia Delaunay's and Blaise Cendrars's *Prose du Transsiberien* (1913).

The book-as-object has inspired one new invention after another, and not always was it a matter of changing the book's outward shape. Any digging into the history of these inventions will turn up the avowed intention of emphasizing

the "two-facedness" of the book about which Paul Valéry spoke. Changes in the appearance of a book are changes in intellectual communications.

THE "UNLUCKY" READYMADE One need only think of the Sun King's display folios, books that rested on special tables, only their upper, visible cover and spine bound. These were not books to be picked up, but to be opened with awe, as cult objects, in which the battles of the victorious king were described. Or one might recall the unusual shapes that have been appearing for centuries: a Passau book of hours from the thirteenth century, with circular pages; the late fifteenth-century *Chansonnier* of Jean de Montchenu, made in the shape of a heart.

In our century such forms were mainly brought out by the admirers of Alfred Jarry and the Société Pataphysique. There are triangular, octagonal shapes, book-objects that attempt to visually transpose the subject dealt with. And then there is Morel's book about soup, which was produced in the shape of a plate. In the second half of the nineteenth century we find, mainly in France, an astonishing flowering of curious alliances between books and objects. The Goncourt brothers were fascinated by the work of Bauzonnet, a craftsman who knew how to establish a unity between text and binding. Books of erotic stories, for instance, he fitted with bindings of phallic shape. With a little luck, all sorts of curiosities can still be discovered in all book shops, such as, a novel I once found about a prostitute: a pair of slippers, attributes of the profession, had been done in applique on the front and back covers.

Real finds can be made in the twentieth century as well. It is hard to know where to begin. Here too Marcel Duchamp had something to contribute. In 1919, from Buenos Aires, he sent his newlywed sister Suzanne instructions about hanging a geometry book on the balcony and exposing it to wind and rain. As he put it, the wind would leaf through the "unlucky Readymade," rip it apart, and thus turn up ever new mathematical problems. This brings us to an important motif in artists' preoccupation with the book: the demonstration of an endless range of varieties of approach to the written word. Books are no longer to be read singlemindedly front to back; that only limits the possibilities of the text. Variability, chance, brought in by the reader himself, these become ever more important. The text presents itself in constantly new guises.

One thinks of Raymond Queneau's wonderful book, *A Hundred Thousand Billion Poems* (1961). It consists of fourteen series, each with ten paper strips. Each strip has a line of poetry. The system of permutations allows the reader to put together a hundred thousand billion sonnets. Length of reading time: some two hundred million years. In the afterword to the book, the mathematician François Le Lionnais writes that this one book virtually contains more text than everything mankind has written since the invention of writing. Tristan Tzara (*The Rose and the Dog*, illustrated by Picasso, 1958) had his text printed on three concentric circles which can be moved against each other; thus too endless possibilities of variation come about.

For this kind of thing there are also precursors. There was, for instance, the confessional mirror put out by Father Leutbrewer in the seventeenth century: every conceivable sin was printed on a strip of paper; several hundred such strips were held together at the side by two vertical strips. During the reading the penitent lifted out the strip with his particular sin. Leutbrewer: "After confession

everything is returned to its place and mingles with all the other sins . . . without any other person finding out which sins one has confessed."

That we are not dealing here with a random find which deserves attention simply because of today's fascination with the serial motif is shown by the fact that this book, in the Baroque tradition, is always referred to by those who are informed about the book as object. It was, in fact, discussed at a colloquium in Cerisy dedicated to Michel Butor, one of the most original bibliomanes of our time. Butor even wrote about the subject in the late fifties, in an essay, "The Book as Object."

No matter how brief the survey of the object-book, it must not omit references to the Surrealists. The strongest stimulus came from them. (As for everything else that can be referred to as object catalogues in the context of Happening and Fluxus, Duchamp's *Green Box* and the Futuristic and Dadaist *Bits of Paper* must be mentioned.) In a text from the year 1924, André Breton described a dream he had of a book whose spine was made of a wooden dwarf with a long white beard, and whose covers consisted of thick, black wool. He added: "I wanted to bring some objects of this kind into circulation." Breton soon made his first "poem-objects" a reality, and in his circle it was particularly Georges Hugnet who commissioned the most fantastic book sculptures. They go far beyond a book lover's appreciation of good binding. They are examples of the Surrealists' fascination with the odd, the rare, the disparate. In 1936 Ratton, logically, included them in his famous exhibition "*Objets.*" Hugnet had the bookbinders Christy or Mercher execute his ideas. Familiarity with this collection will not only considerably broaden knowledge of the development of the object-book, but that of assemblage and sculpture as a whole. Cork, mirror, cubes, butterflies, flies, cat whiskers, slate, pieces of laundry, garters, an altogether varied arsenal of objects holds dialogues in these books with texts, manuscripts, photos.

The object book in the thirties already belonged strongly to the Surrealist media that were bent on crossing barriers. The exhibition "Fantastic Art, Dada, Surrealism," at the Museum of Modern Art in New York (1936) showed an object book cut from a Sears Roebuck mail order catalogue.

Wherever one looks, one sees attempts to transcend the form, the statement of books. And an overview that is meaningful and makes sparkling intellectual history remains to be done.

Kassel, 1977

ART AND WORDS *How New York displaced Paris— The example of Poliakoff*

On October 12, 1969, Serge Poliakoff died in Paris. With him the last active remnant of the postwar School of Paris disappeared, a man who had managed the leap into the establishment, one of the official artists of the French 1950's. He came from Russia with a guitar, and by the end of his career as a painter, he

owned a stable of racehorses. And a year after his death, the Musée National d'Art Moderne in Paris is giving him a retrospective. Along with Soulages, Hartung, Manessier, Singier, Zao Wouki, Schneider, Vieira da Silva, he was one of the few who stood head and shoulders above the painting Paris legions.

It is difficult today to get a clear image of the fame of these painters. In the fifties they stood as squarely at the center as do the Americans now. The discussions those days were as hooked on words like "informal," and "aesthetics of risk," as they are now on "conceptual," or "socially relevant." The decisive factor may even lie in this change of vocabulary. This change was at least partly caused by the shift in the geographical sphere of influence. The Ecole de Paris could hardly have managed to produce, on its own steam, the predominantly sociological bias of American aesthetics.

Until a few years ago, until the entry of the United States into the art scene, terminological dominance belonged to a poetical-subjective encoding of a work. That can be checked anywhere: even Sartre, Henri Lefébvre, or Garaudy changed their vocabulary when they wrote about art. There was a fullness of ruminations about "gesture," "ductus," "stroke," "peinture." In France discussion about art was primarily a matter of poetic transposition, and rarely a pragmatic one of coming to grips with the structure of a painting. Art criticism remained art contemplation which, like a prose poem, had found its theme in the pictured thing itself ever since Baudelaire. The method was selective, wedded to the object.

In postwar Paris, this trend was radicalized even more by the championship, led by part of the press, of "socialist realism." Surrealism as method seems to have had the greatest influence on the contemplation and criticism of art. That is where a good number of critics got their method, which was not based on historical continuity. Breton's essays on art are, in this sense, prime examples of a preoccupation with the work of art that excludes history, knowledge, or system. But he, like Baudelaire or Apollinaire, nevertheless achieved transpositions that possessed the true characteristics of such works.

"Abstract," geometric, or Informal Art was congenial to this reflection on nongiven subjects. Abstraction seemed to many to have become the definitive reservoir. Only a mastodon like Picasso occassionally managed to break a hole in that dam called The Overcome Object. For the fiction of the abstract artist was perfectly suited to a drive for aesthetic oneness that would have liked to raise that oneness to an anthropological trait of the human being of this century's latter half. As Michel Seuphor wrote in 1957, "Abstract art is so successful that it is about to become the face of our century."

The author of this was a friend of Mondrian's. For him the late Paris turn toward a loosened Mondrianism of peinture and arabesque was a kind of vengeance. The totalitarianism of the abstract was, in addition, a moral principle for a friend of Mondrian's who had witnessed his steady, slow-motion development.

The possibility of an art beyond nonrepresentationalism was virtually excluded from the theoretical discussion of those years. What little non-French art news filtered into Paris—Pollock, Tobey—upheld this conviction. The publications of the time—*l'Aventure de l'art abstrait,* by Michel Ragon (1956), or Sam Hunter's *Modern French Painting* (1956), seconded the conclusion that this definitive

revolution of nonrepresentationalism could only be threatened by a reactionary attitude that would go against artistic evolution. Nonrepresentationalism had become the culmination of art. Everything seemed to agree with this view, even the attitude of the artists, who—like the "painters in the French tradition" (Bazaine, Manessier, Le Moal, Singier)—created out of their early representational themes a nonrepresentational pictorial world that oscillated between *abstraction création* and Tachisme. Nonrepresentationalism became the universal aesthetic, to which virtually everyone bowed down.

It left no room for anything else. Representation in art was eliminated by way of a logically demonstrable development (Cubism to Mondrian, Monet to Kandinsky). Surrealism had lost just about all standing in postwar France. With Surrealism, iconographic and objectlike elements from reality were excluded. Pop Art and New Realism exploded into this world of undefined relations with reality with stunning power. At the beginning it wasn't the special content or the new aesthetic mode of reflection that were provoking. What was irritating was the attack against abstraction, since it was no longer ontologically comprehensible. The nonrepresentational was put up against representation as a secure, historically derived quality. Only a few who at the time took a position against the new representationalism really grasped the total shift that representation as a theme in art had undergone.

When the names of Rauschenberg, Arman, César, or Klein were first mentioned in France, artists and critics attacked a priori a situation which, seen from the telos of aesthetics, seemed restorative to them. Georges Mathieu, the most brilliant theoretician of the *abstraction lyrique,* at the time dismissed the appearance of neo-Dada and New Realism as "temporary invasions." The very choice of both designations seemed traitorous: it demonstrated a relapse into the historical and thus—like with all revivalist movements—a strong involvement with transaesthetic notions and experiences. There, in my opinion, is the basis for the radical crisis that shook the School of Paris in the 1960s: the aesthetic direction that had considered itself part of a historically inevitable development was deflected by a historicizing pull.

The eclectic styles that interpreted Dada's actions led to a renewed infusion of Dada's political and social implications into aesthetics. These implications had been totally ignored by the Ecole de Paris of the postwar years. Reflection on these matters led from aesthetics as consciousness of art to aesthetics as art of consciousness. No wonder that whenever the new content went beyond Dada models, it turned to political-social realities with power and influence—in other words, reality in the true sense of the word: the United States, the Chinese cultural revolution. France and Europe had little to do with those realities. The SDS (the German socialist student organization), the French May revolution were borrowings largely dependent on the American campus situation and the cultural revolution in China, and they only in part came to grips with local problems.

That I think explains why so many of the effects taken over from the American art scene seem like misunderstood booty in Europe and why indigenous American realism (for instance Andy Warhol's superb reflections about the realities of production and consumption) leads in Europe to a romantic exoticism.

These new conditions and a terminologically altered relationship to art going

back a number of years, have also rubbed off on our relationship with the artists who were at the center in the 1950s. The Serge Poliakoff exhibition is an example of that—Poliakoff was a typical representative of the postwar School of Paris.

The works from the late thirties and early forties present compositions—in subdued, broken colors—in which the line still plays an independent role. Eventually line became synonymous with border of a color plane. That is where Poliakoff left it in his succeeding work. He didn't much like change, and held on to his trouvaille to the end of life.

This may have led some exegetes to compare Poliakoff's formal constancy with the codex of the Russian icon painters. Today we see Poliakoff and his faithfulness to his system in a different light. Even the systematic element of this art was hardly given much attention by the interpreters of the fifties. In the meantime there were exhibitions that took as their theme the variations of a more or less constant basic principle ("Systemics," Guggenheim Museum, New York, 1966; or "Serial Imagery," Pasadena Art Museum, California, 1968).

Therefore it is necessary to reclassify an oeuvre like Poliakoff's. The quality that exclusively appealed to the admirers of his art—the pastose coloration, which led interpreters to believe in all sorts of transcendental experiences—has now taken second place to the architectonics of the pictures. With Poliakoff too we now talk about structure; we try to rationalize the lyrical content by downplaying those qualities of the School of Paris that addressed the connoisseur of painting. The comprehensible concept of structure abets that. And so it would seem that this work finally begins its real nonrepresentational career.

Paris, 1970

THE STRATEGIES OF THE NEW ROUSSEAU A
Confrontation: Dubuffet In New York—Chaissac In Paris

Jean Dubuffet is obviously an American favorite. After a retrospective at New York's Museum of Modern Art, after a large show at the Guggenheim Museum, that same institution is presenting a super-retrospective. Frank Lloyd Wright's entire snail was cleared for Dubuffet. How to explain this popularity? No doubt it has some connection with Dubuffet's rejection of cultural art. The Americans have had their hands full, these last decades, with trying to propagate an art of their own, independent of Europe. Dubuffet comes to them a symbol of tabula rasa; after all, he too is trying to get rid of the burdens of history, styles, names, to attain a form of expression free from cultural influences.

Dubuffet's brief in favor of the possibility of such an art suits Americans. From that angle he's their man, their partner in the scenario to bring about a situation that is, if not downright anticultural, at least self-cultural. Dubuffet's arguments, which by and large popularize European cultural pessimism and represent a regression to putative preculture, sound more original in the United States than in Europe.

The Dubuffet paradox remains so self-evident to us Europeans that we are slightly embarrassed to diagnose yet another calculated, quite cunning ploy: the denial of culture, the general raucous rejection of the museum and exhibition establishment have indeed managed to catapult Dubuffet into the museum and—to judge by the series of retrospectives—far more thoroughly than any of his contemporaries. The way Dubuffet's oeuvre is shown these days, the way it sells, exhibits, propagates itself, really needs no better context than, in fact, culture. The dichotomy between action and attitude here has the grotesque traits of a historical mishap. No one rails more vehemently against the state's cultural politics, against museum activities, against art criticism. And no one has acquired, in the process, a cultural apparatus so effective, so made-to-measure.

FUTILE ATTACKS Dubuffet's atelier, with its secretariat, functions exactly like a museum and art society in one. Every opus is most carefully registered, the circumstances of its creation recorded. Twenty-three volumes of such registration already exist. The hatred of museums, Dubuffet's lucrative verbal inconsistency, took a bizarre turn in the late sixties, when the painter presented, with all due pomp, 150 of his works to the Paris Musée des Arts Décoratifs, which occupies a wing of the Louvre. And thus he personally conferred upon himself his rank in museum and cultural hierarchy.

Like so many other artists of this century, Dubuffet exhibits a pattern of behavior before exhibiting his work. In his case it seems to be the least original trait. Influences on him can be traced back through the Surrealists, Dadaists, Duchamp to the Futurists, to arrive at the principal watershed, which divides the confrontation of society against art from the confrontation of art against society. For the Impressionists, the struggle was still with the difficulties of their contemporaries to comprehend their work; but the Futurists and Dadaists pointedly shifted the burden of acceptance and adaptation. Their avant-garde became a struggle against comprehension; they at least tried to slow down empathy—with good reason one of the major words of the period. Strictly speaking, Dubuffet brings nothing but a revival of an attitude that a hostile public expected of its artists a generation ago.

The attempt to put oneself in the position of outsider, to believe that there is a place that is not patronized by state or taste, proved as illusory in Dubuffet's case as it had in Duchamp's or Dada's. The statement (dusted off for the text of the Guggenheim retrospective's catalogue) that Dubuffet remains a thorn in the side of twentieth-century culture, cannot be taken seriously. There is too strong a discrepancy between manifesto and work. One can hardly imagine a hypothetical situation that would not be covered in the encyclopedic scrapbook of our culture. It would in fact be difficult to name situations in the last three decades, during which Dubuffet developed his anticultural stance into oeuvre, that have called forth anything like censure.

I think that the motivation of Dubuffet's attitude, whose genuine evangelism cannot be denied—proven by the writings and letters—might be found in his lack of skill in the scandal-seeking that is part of any cultural activity in our Western postwar world. The system that Dubuffet created for himself polemically is based—in contrast to Duchamp's but devoid of any cynicism—on the belief that even within our totally permissive culture there are still certain reservations

that cancel liberalism in things cultural. That is why Dubuffet's interest was primarily directed toward statements that were on the outer edges of the norm, toward "Art Brut." The concept of "the artistry of the mentally ill," with which Dr. Hans Prinzhorn, in 1922, had launched his attack on Cesare Lombroso's theories, was expanded by Dubuffet to include all forms of cultural activity that are created in solipsistic isolation.

In 1945 Dubuffet started to systematically collect and exhibit—with the short-lived help of André Breton—works by psychopaths, introverts, eccentrics, provincials. He played off this art, supposedly produced in a noncultural environment, against gallery and museum art. The extent to which this was done was new. And Dubuffet's interpretation differed from that which Max Ernst and Paul Klee had given such works as far back as the twenties. For them psychopathological creation, which showed the different sorts of cultural and social regression, was a kind of pattern book from which an art aiming at antiacademicism and spontaneous creation could draw inspiration. Naive and psychopathological creation was transferred to the realm of art.

ARTIST AND WINE DEALER Dubuffet was different. He too admired the work, but instead of trying to bring it into the art of his time, he tried to go over to it himself. He tried a secession beyond museum art. But there is a remarkable parallel with Breton's conviction that poetry could and should be produced by everyone. Dubuffet writes: "I am fully convinced that everyone, without particular knowledge or ability . . . can devote himself to art, with every prospect of success." Yet one must not take this altruistic-sounding position too literally, since in principle he always stayed within the cultural realm with his own work, which he clearly separates from the extolled "Art Brut." What he does achieve is a mimicry of this noncultural art that seems entirely spontaneous. In his way he is a kind of Jean-Jacques Rousseau, also tantalized by the dilemma of an unattainable naturalness, but needing to use the procedures of thoughtful artificiality.

The course of Dubuffet's life shows that the rejection of the official path, a path, that is, through one of the innumerable avant-garde groups of the century, has strong roots in his biography. Dubuffet repeatedly turned to art, but each time returned to his lucrative wine business. When he finally quit the business for good in 1942, this seesaw must have left him with a feeling of estrangement toward the field that he had so often wooed, and a strong reaction against it. Apparently Dubuffet adopted his method of painting from the people whose work he had just then started collecting under the name of Art Brut.

That is why the works of the first years stick to a simple, scribbly figuration. In the beginning he could still paint scenes that smack of the compositional ambition of the Sunday painter. But then those works began to accumulate in which Dubuffet adopted the naive drawing technique of children and particularly of psychopathic artists. A comparison with the plates from Prinzhorn's *The Artistry of the Mentally Ill* (New York: Springer Verlag, 1972) shows how hard Dubuffet tried to simulate a spontaneous autistic condition. The themes remained very simple, mostly figurative, and landscapes were virtually eliminated. Dubuffet concentrated increasingly on the means of painting. In analogy to the materials brought into play by Art Brut, he used coarse techniques, and textures

that accentuate the spontaneous, private character of the activity. The strongly pastose application of the paint, into which a variety of foreign matter has been mixed, gives the picture an objectlike relief.

The influence of Max Ernst and André Masson, with their plaster and sand pictures, must not be overlooked. Nor should the fact that this kind of painting happened to be very much in vogue in the postwar years, and Dubuffet's borrowing from Art Brut may have been fanned by the style of the time. Jean Fautrier, Wols (Wolfgang Schulze), and the many representatives of Informal Art found their language in the tactile values of heavy impasto and lavishly applied color. The "Cobra" group, the Spaniards Antonio Saura and Antonio Tapiès, all fit into this particular system. Dubuffet thus belongs to a precisely definable cultural period.

But Dubuffet was never a nonrepresentational painter. The Informal always turns up in tandem with figuration, no matter how elusive it has become. His *Corps de dames*, those flattened female figures in chalklike flaky colors, panels of dry scabby skin, are directly linked to Fautrier's *Otages* and can be covered by the same interpretation that Ponge, Malraux, and Paulhan gave Fautrier's tormented hostages. Meditation on disintegration and decay, on the crude beauty of weathered, grafitti-riddled walls, belongs to this Parisian postwar time. One might even venture to say that Malraux, while at first also responding to this narcissism, then made it his reason for having Paris, black, bristling with grafitti and weatherbeaten walls, cleaned and neutralized.

By an odd coincidence, at the same time Informal painting, the lyricism of decay, also disappeared. Perhaps some day Malraux's cleanup will be introduced into the history of style. And Dubuffet, who was deeply involved in the variations of materials (*Matériologies*) and who, in his most impressive pictures of the early fifties, came dangerously close to Max Ernst's *Horderbilder*, allowed his interest in textures to abate in the sixties. The *Hourloupe* series—pictures, drawings, sculptures in single small forms that gather together into a great labyrinthian figure—for the time being marks an end. In its standardization of means, a Mondrian-like thrifty restriction to black, red, blue, Dubuffet's new noncultural art no longer differs in the least from what artists like Victor Vasarely, Niki de Saint-Phalle, Roy Lichtenstein, Claes Oldenburg are after.

The *Hourloupe* series evidently owes its existence to the acquaintance with Gaston Chaissac, an odd amateur painter known in France, who since the early 1940s had been a protege of Raymond Queneau, Jean Paulhan, and especially of Dubuffet himself. In 1937 Chaissac lived in Paris for a few months, in the house where Otto Freundlich had his atelier. Obviously Freundlich's interlocking forms had quite an effect on Chaissac. The feature that distinguishes his style, and that particularly lends it originality, the overlapping of elements of similar size— appeared soon thereafter, and he began building his pictures out of these puzzlelike forms. He was soon taken up by Dubuffet and by Benjamin Péret (who discerned a "folk dandy" in his figures, all decked out with caps, scarves, and spats). Chaissac's writings and letters, addressed to everybody and his grandmother, became quite famous in France. Gallimard published *Hippobosque au bocage* as long ago as 1951.

THE INFLUENCE OF ANTIACADEME Does Chaissac belong to Art Brut?

Dubuffet himself did not include him in his collection, and rightly, or so it would seem. Chaissac was obviously exceedingly conscious of his position in relation to cultural art. He, like Dubuffet, willed a separation. In his letters we come across statements like "With my lack of knowledge of drawing" or, stretching not *knowing* to not *wanting*, "I've taken the occasion to stress my awkwardness because it occurred to me that the more awkward my drawing, the less of the rigidity of the art student it would have." These are obviously reflections, conscious reflections about the effect of antiacademicism, statements that parallel similar ones by Dubuffet.

With all this, Chaissac (who died in 1964 without having had a major show, though the Paris Musée d'Art Moderne is giving him a retrospective now) possessed an artistic self-awareness that was firmly based on the inimitability of his style. "I'm astonished that people have tried to plagiarize me. Albert Gleizes did tell me very clearly that my art could not be copied." This could very well apply to Dubuffet himself, who not only quite totally took over Chaissac's characteristic style but also further developed his totemlike sculptures. Dubuffet did, however, free Chaissac's style from its idiosyncracies, from all its disjointed, unrestrained liberties, and transposed it into a clean formalism.

New York–Paris, 1973

FROM DESIGNER TO MESSIAH *Warhol or the* *"Art as Life Movement"*

Gotham Book Mart, the New York book store on West 47th Street, in the 1940s was the meeting place and publisher for the artists, writers and intellectuals who streamed in from Europe. It eventually became, along with Wittenborn and Wye, one of the trading centers where European libraries ended up. Even today there are still volumes with German, Polish, Czech, French book marks on the shelves. And it is possible to find practically complete sets of Ezra Pound's *Little Review*, of *Transition*, or *View* among the 50,000 magazines and journals piled here and there.

The book store made headlines when it put Andy Warhol's early works on display in its second-floor gallery. Its owner, Andreas Brown, assembled material that was known only by hearsay—sketches for commercial illustrations, drawings for private portfolios. Shortly before the exhibition, an old friend of Warhol's, Mario Amaya, said in an interview that he'd love to see some Christmas cards that Warhol drew for a friend in the fifties. The cards were in the "Andy Before Andy" show.

The end of the 1971 season in New York is Andy Warhol's. The great retrospective that started out in California, at the Pasadena Art Museum, in May 1970 and traveled all over Europe, is making the Whitney Museum its last stop. Warhol himself planned the layout, so the show itself is, for the moment, his newest opus. The walls of the large hall on the third floor are covered with Warhol's wallpaper with cow heads. In 1966 he showed *Cow Wallpaper* at the

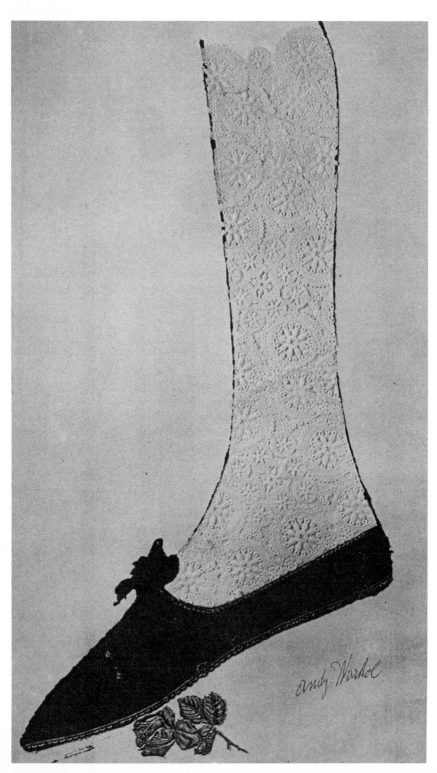

Andy Warhol, *Golden Shoe with Lace Stockings*, 1956.

Castelli gallery. Two years later, in February and March 1968, the Moderna Museet in Stockholm pasted the cow heads all over the façade of the exhibition building. In both cases the wallpaper was presented as a work. This time, however, the rose-tinted herd served as the cantus firmus: against it were displayed portraits, flowers, electric chairs, disasters. The principle, in fact, seems reversible—Warhol could just as well have made a Marilyn or electric chair wallpaper and hung cow heads as pictures. By not presenting his motifs as single pictures, he literally plasters our imagination with them.

INSPIRED BY ADVERTISING Warhol makes use of advertising, the medium in which he first made his name. The richly illustrated catalogue put out by Gotham Book Mart in conjunction with its exhibition shows how Warhol isolated and turned into autonomous units certain stereotypes of advertising technique—especially the iteration of themes and serial repetition. On some sheets a single motif (butterfly, flower, head) is repeated horizontally and vertically over the entire surface. The sheet becomes a display window—it demonstrates abundance, exclusivity. A product announces its totality by entirely filling a space. An identity is produced.

Even the Marilyn displays and the series with the electric chair do not point to variation of motif, but to the fact that consumption and supply are not rationed. Anyone can acquire a standardized feeling from these self-service icons. Therein lies the critical difference between this repetitiveness and its famous precedent, Gertrude Stein's "Rose is a rose is a rose is a rose." Gertrude Stein's was not the repetition of a constant, it was a linguistic perpetual motion that creates variation of meaning underneath the surface monotone from rose to rose. She used repetition to slice the word into the multiple meanings that exist side by side. She therefore did the opposite of Warhol. The "is" with which Gertrude Stein couples her roses is in effect a plus sign.

With Warhol, on the other hand, we're dealing with addition that is not possible on the quality level. His results are always identical. There is only quantitative abundance, and his pictures operate on the principle of infinite quantity. This becomes particularly clear in his pictures of paper money. Nowhere are there bills of different denominations, no bill is worth more than another. This same equivalence holds true of Warhol's repetitive pictures in which the motif (Jackie Kennedy, Ethel Scull) appears to have different psychological qualities (laughter, tears, changing expressions). But there Warhol scoffs at individuation as much as in *Ten Portraits of Artists* or in the Campbell's soup pictures. Thirty-two identical cans with labels promise thirty-two different soups—a promotional ploy in which concoctions tasting more or less alike are touted as offering thirty-two different taste sensations.

WHEN THE WARHOL EFFECT DOESN'T WORK The mechanical multiplication of large amounts (of soup, of death, of fame) has the most startling result when the cliché character of the motif has been previously established (Mona Lisa, Liz Taylor, electric chair, accident). Whenever an image does not have this complete self-evidence, when a new brand or new myth has to be launched, the Warhol effect doesn't work. That becomes quite clear in the commissioned portraits. One of these, *Portrait of Jane Cowles*, shows that Warhol's pull plainly stems from the

meshing of two prerequisites: the technique of reproduction and the theme's mythical fame, created and made available by promotion.

The more banally famous the subject, the more successful the outcome. The sole motif that Warhol successfully launched is his own image, his self-portrait. But the effect is lacking in the portrait of the art dealer Sidney Janis, because there the technical aspect (silk screen print aiming at multiplication and division) is at odds with a motif that has no need for it. On the contrary, it calls for a thinning out, a simplification: this portrait can only be meaningful to the client and to the small group of viewers close to the client. As soon as the uninitiated viewer gets the feeling that, instead of automatic recognition of the theme, a reading, an explanation are required, the fascination drops to zero.

Warhol makes a splendid contribution to figurative art: he pares down the thematic material to visual clichés. If a negative formulation were wanted, one could turn to Sartre's definition of nausea, of excess. Warhol presents the fact of excessive exposure. But at this point he steps in, and comes up with one of the most thorough beautification processes of our time. His aesthetics negate the literally real, that is, the accidental. By and by he abandons confrontation with the exemplary case (*Peach Halves, Water Heater,* or *Dr. Scholl's Corns,* 1960). The aesthetic in these pictures concerned the accidental, capturing the dichotomy between the product as consumed or privately used and the product in its idealized state. The influences of Jasper Johns or Robert Rauschenberg, who tried to wed the perfection of the industrial product with the free, unclean painting technique of lyrical abstraction, began to ebb. In 1962, serial repetition made its first appearance.

Silk screen printing or serigraphy, a commercial process that had been in use for years, allows Warhol to repeat motifs on canvas. In these works Pop (reflection of a consumer culture) and Op meet. Several of the chief characteristics of Optical Art—reiteration, the perception of a stimulating and disquieting repetition of basic patterns—can be traced. The renunciation of an overall form that would meld and tie together these pictorial molecules also plays a part. The heads, cans, dollar bills unite into compositions that are closer to Victor Vasarely's planetary folklore than to Oldenburg, Wesselmann, or Lichtenstein.

This holds true for the use of color as well. The pictures, which mount up forms horizontally and vertically, have virtually nothing in common with Pop coloration. The shrill tones are absent. Warhol harmonizes, seeks veils of color rather than color contrasts.

The exhibition of the early advertising graphics and five-finger exercises at Gotham Book Mart has helped to define the elusive Warhol. The look at his premythical period at least shows that particular stereotypes in his work and in his style can be traced far back into the past. The applies to the semi-automatic methods (he quite early started using a monotype procedure that allowed him to relativize gestural drawings); it also concerns the problem of group work, which cropped up when his mother started collaborating with him. Warhol let his mother sign his work with his own signature and gave her the job of adding legends and texts in a Baroque handwriting. Some of these pieces, in which Warhol's drawings are combined with his mother's handwriting, bring Saul Steinberg's writing-image compositions to mind. The series motif can already be found in these early works as well.

Warhol possesses the means to do anything he wishes, just as he obviously knows every style and effect. Just in time to second this exhibit of the young Warhol, a fascinating book was published in New York. *The Autobiography and Sex Life of Andy Warhol,* edited by John Wilcock (New York, 1971) is without doubt the best book on Warhol next to John Coplan's study. Wilcock interviewed friends, coworkers, and minor figures in Warhol's universe, and the result is a wonderfully informative book. The volume is a striking instance of discipleship gone beyond the bounds of rationality. But whenever the fascination with Warhol abates even slightly we get testimony that thus far has been missing. Charles Henry Ford as well as Henry Geldzahler point to Warhol's ability and facility to absorb and transform the most disparate influences.

A THIN MEMBRANE The creative band that Warhol has organized in his factory guarantees that. It replaces the commissions from which the erstwhile designer and illustrator made his living. Mario Amaya compares Warhol to a thin membrane, a thin piece of cloth through which everything seeps. Geldzahler informs us how Warhol worked out his themes and procedures, how he searched for stimuli. Thus Warhol once asked him what he ought to do next. Geldzahler suggested that he get back to the headline he'd worked on the previous day. Warhol: "Do you think I should do something with it?" Important information comes from Gerard Malanga, his silk screen printer, who answers the question about Warhol's main preoccupations: "Marcel Duchamp, Gertrude Stein, television, films, and John Cage."

In a monograph on Warhol (*Andy Warhol,* Stuttgart, 1970), Rainer Crone demanded that Warhol be freed from the mystification wished on him by art critics and public. That sounds like Andy-prohibitionism. Wilcock's book amply demonstrates how vain and dismal such a wish is. This quite novel history of influence in art, with its messianic imaginative content, could be searched onesidedly for structures—but nothing would be left of it except the neutral, aloof score of an art-and-life-form that has not existed since the heyday of Wagnerism. Theology could contribute quite as much as art criticism to this world of aesthetic flagellation.

New York, 1971

ART ON AMERICAN WEST COAST *Siddharta in* *San Francisco Bay*

The parable of *kannitverstan,* the shortest formula for a journey that domesticizes what is not understood to render it useful, only becomes really clear when one is on the move oneself, on the lookout for *kannitverstan* situations—when, unable to put together a new social and aesthetic stage from details, one turns the details themselves into symbols. What would we bring back from our journeys had there been no Eiffel Tower, no Manneken Pis, no modesty of the Asiatics. The obstinate retention of a fixed idea brings more than absolving a tourist's day and

night shifts. The generalizations to which we cling must be concocted at the beginning of a trip, out of the very freshest impression. Laurence Stern knew at first glance, when he stepped off the boat at Calais, that all French women had red hair. The detail can only assert itself against improbable abstractions.

My journey to the American West had been prepared by friends. From European New York, which, where art, poetry, and protest are concerned, loses itself in increasingly skeptical rituals, one goes out into a land of Mediterranean joy of realization. Richard Lindner had alerted us to the general magnification which this fortunate region brings off; bigger, more scenic scenery; heavier, riper fruit; flowers that grow into trees; instead of hot-dog stands, giant sausages in which hot-dogs are sold. And even what is known about the West Coast School fits the pattern: delight in materials, a natural easy expressivity that seems inherited from the Spanish-Mexican proximity, and in addition meditation, daylong, joyful, self-forgetting gazing at one of the most grandiose spots on earth: the bay of Sausalito, near San Francisco. Since the hippies left Haight-Ashbury in San Francisco—as they did in the East too, leaving New York's East Side for rural Connecticut—this bay in which houseboats bob around like junks amid incense and sitar strains, has become holy water, Siddharta's stream.

An image that suffices to bring to sensibility a short stay in San Francisco, to sum up everything that this city contains in the way of expectation: the ride across the Golden Gate Bridge into the hills, to a wooden house in whose studio collages of sound, text, and image are made. All strongly politically committed, but driven by an intoxication with life that is already beyond any reached or reachable influence. An optimistic evening, significantly different from similar gatherings in New York. The ritual reach for the box in which home-baked hashish cakes are layered to dry, already belongs to the transsubstantiation gospel of the West: the drug seems to consist in the act of taking it. Or a visit to Berkeley, where the police had destroyed a visualization of freedom: a little square, which the students had fitted out as a forum and adorned with plants. In an area that had developed particularly discordant forms of resistance—flower power against clubs—the authority of the state is being forced to compromise itself by fighting against things. Instead of being able to act against power, it is driven to fetishism with reversed signs. It must interpret the nonviolent resistance, and fight nonviolence, for which no form of repression is adapted, with shadow boxing. The garden that serves here as barricade belongs to an extensive pacifist system: to the androgynous disposition, visually no longer acceptable as opponent. One beats no woman, and one beats without shame no being that has conjured away the martial exterior, recognizably the enemy, with curls and undernourished limbs. The fight of the civil rights movement, the protest against the war in Vietnam, everything that lends today's American youth such solidarity, has created a symbolic form for itself on the campus at Berkeley. Because this ridiculous little garden stood for a kind of Eden of Freedom, its destruction became the spur for a vehement, warlike march. *Kannitverstan* here meant: soul, peace, justice. The garden was one of the strongest manifestations of these ideas, as strong as the equation, illustrated by clothing, of the hippies with the people of Tibet or the Shawnee Indians; it was a part of a general aesthetic-political syndrome that had its beginning in the West.

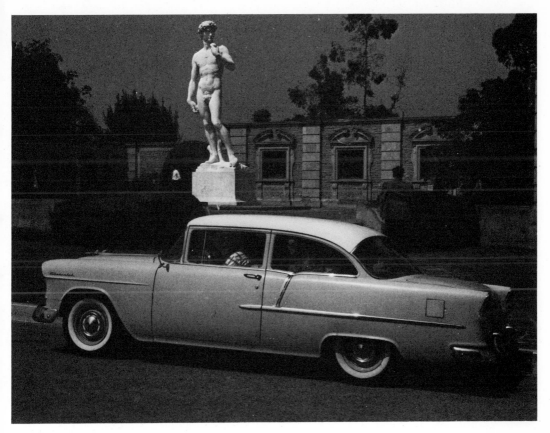

Forest Lawn, Los Angeles. Photo by Alfons Endl.

ANOINTING THE HEART ON SUNSET BOULEVARD The heavenly baritone of Forest Lawn peals every hour on the hour. Up on the hill, where the most grandiose mystification of death in the world emerges into an unimaginable Bellevue, stands the Hall of the Crucifixion, a theater of death in which the cemetery administration performs its ritual, manned flights of resurrection. The cult of death reaches its climax here. We know all about Forest Lawn—which lies in Glendale, the area with the largest percentage of retired people in the country—in a literary way, in any case, ever since Evelyn Waugh's *The Loved One*. The most smiling, most perfumed inferno in the world, dreamstuff of the boldest transcendental artificiality, must surely be the most absurd expression of an entire civilization. It is a place of total care. Death is fought with any means, beginning with what is, in a civilization like California's, the most artificial and absurd of edicts: the ban on artificiality. No artificial flower arrangements are permitted, only real, almost obscenely swollen, enormous flowers. Whatever could have a look of transitoriness, artificial flowers, flowers that turn gray, is kept out: only real flowers are sufficiently artificial in this part of the country. They bloom—and are disposed of. No slow fading, no yellowing. The world's

largest lawn mowers, and the best organized bunch of gardeners in Southern California, march daily over the graves. The square bronze tablets laid flat into the ground are fitted for rational, clean use. Forest Lawn, with its churches, mottoes, stone bibles, ponds, slumber rooms, morgues in Tudor style, its expensive balsam, its lullaby grove for children and babies, became, as was the wish of its founder, the greatest museum in the world. Where can more famous sculptures be seen assembled in one spot? Everywhere, between dark arborvitea and box trees, fresh dead-white marble gleams. It is not for nothing that Carrara gave honorary citizenship to the mass user of its product, Dr. Hubert Eaton, who dreamed up the place.

Pictures, mosaics, everything serves the same gigantic spiritual machinery dedicated to the denial of rot. The large memorial album on a platform gives the visitor support and ideology. The meditations on the flesh, which the institution's artists prepare for an expensive eternity, start with aesthetics. The album's foreword quotes Diderot's remark about Fragonard: "Flesh is hard to portray." In pictures, that is. Flesh is hard to preserve. The colossal, genial death lie at Forest Lawn tries it with an obscenity that borders on the wonderful. It offers the most porno-eschatological service that can be imagined. What lustier wish can the visitor have than to belong to this community of death? The indescribable smile worn by the receptionists in the slumber rooms seconds the advice of the "voice": Protect your family now (by making burial arrangements). . . . It will give you a peace of mind that you cannot achieve in any other way.

Up on the hill, in the sweltering glare, one waits to be let into the Hall of Resurrection. The unbearable tension in this square of bronze, and stone, with a view onto a breathtakingly broad landscape between mountains and sea, mounts from second to second. The mad mixture of Mount Tabor and death-in-makeup becomes highly explosive. A nice young guy, who rode up here with his girlfriend, cracks up. In a rage he chases a lizard sunning itself in front of Resurrection Hall, pulls it apart, and chases the madly laughing girl with the twitching halves. He brings back reality to this place, where death is played off against dying. A brutal sacrilege that besmirches this paradise.

On the hour the bronze door opens. The visitor becomes aware of the cool wide hall across a marble vestibule. Children are not allowed here. During the service they are locked into a soundproofed room. In the half-gloom, Richard Strauss's *Death and Transfiguration* pulsates. It almost seems that this music had been commissioned for this place, where everything looks as if from the hand of great masters. *Twilight of the Gods, Lohengrin,* accompanied by the twitter of birds. And then the biggest painting in the world is unveiled: Jan Styka's *Crucifixion.* It takes minutes for the 200-foot-long and 50-foot-high canvas to be visible in its entirety—a romantic surge of landscape, veduta, and mass scenes, influenced by Fortuny and Fromentin. Then the voice sets in, a soft baritone that anoints the heart. With an incomparable talent for modulation the voice is Evangelist, Moralist, and Redeemer. A little arrow of light roams through Golgotha. The Cross remains empty, Christ stands before it. The curtain closes, and a scene begins that must surely overwhelm even horror show addicts: Christ is nailed to the Cross. The light floods in. The resurrection decor is pulled into place. Dr. Hubert Eaton must have invented the picture himself, because he established in his research that the world's great art had not yet managed to

create a resurrection that was acceptable to Americans as a realistic work. Robert Clark painted it to the specifications of the dreamer Eaton: *This Is the Resurrection Morning*. The *Moonlight* Sonata modulates into the Hallelujah. The texts are chosen to fraternally link Christianity, metaphysics, and commercialism in the marketing of Forest Lawn. The charisma pursues the visitor even into the toilet. The automatic machines that dispense free hand towels assure you, with the panreligiosity of the place, that "God's gift is life eternal."

Forest Lawn has made this gift saleable. The cemetery fits the city. For what it contains is improved art, Michelangelo, Canova, Bourguereau enlarged, brought up to Californian proportions. It is the only place in the world where a copy is spiritually worth more than the original. The style of the copy fits the mythology of Los Angeles, Sunset Boulevard, Hollywood, the mansions in Beverly Hills, to a tee.

THE APOTHEOSIS OF DECAY The artists, museum people, and the few collectors who are located in Los Angeles (Irving Blum, the owner of a good gallery that relies on New York imports, estimates that the buyers who are at all significant number between fifteen and twenty), have to be seen against the background of a total mythological environment, against the background of influential aesthetic, moral, and religious substitutes. Forest Lawn, Disneyland, Beverly Hills, the corner of Hollywood and Vine, where everything connected with films is immortalized on brass stars set in cement, all that elicits a specific reaction. Los Angeles became a wellnigh ideal starting point for an art which takes local givens into account, which is more strongly tied to content, to what is palpable. Today, when there is much talk of a shift of the center of gravity from East to West Coast, Los Angeles has a chance. Thanks to its active museums (County, Pasadena, Newport Harbor art museums), thanks to its galleries (Blum, Butler, Nick Wilder) on La Cienega Boulevard—a curious provisional arrangement that combines the avant-garde of New York's Fifty-seventh Street, the expensive antique boutiques of the Faubourg Saint-Honoré in Paris, an unbelievable mix of junk, masters, and ambulant fur-pelt sellers—thanks to the print shop Gemini, where America's greats, from Albers to Oldenburg to Rauschenberg, have their graphics done, thanks to the experience of being able, as an intellectually priveleged clique in this cosmically expanded cityscape, to lead a rapturously artificial life, Los Angeles has become the counterimage to the terse, sated world of New York. For an ironical lifestyle, for an aggressive exchange of blows with a society which still has an unbroken trusting relationship with its food, its preferences, its prepared death, for an art which already contradicts all the precision, all the showy optimism by its use of disintegrating, decaying materials, this city might be stimulating.

One artist seems to best summarize these local possibilities: Edward Kienholz. He lives in the section of Hollywood Hills from which one has an unobstructed view of the city for miles. At night, in a clarity that is already that of glass, the inflamed, painfully pulsating stretch of light that is Los Angeles lies at one's feet. When Kienholz moved in here a few years ago, there were still goats grazing around the house. He had sought out this observatory because here—at a distance—he belongs to the city which fascinates him, which he admires and hates. He stops the whirl into which the visitor is thrown by this midnight heat,

this upside-down firmament with a calm "Yes, it's okay." Kienholz has created a work that has only limited ties with Pop. It's rather closer to Dada. It is interesting that the most important representatives of a polished, clean Pop in New York are at home in a city in which basically the elements addressed by Pop are lost. Advertising, consumerism, autofetishism are still really phenomena in New York; they do not make up the city itself, as in Los Angeles. Even in New York, America is the West. Only there can one find with such reflective matter-of-factness the lifestyle that Pop glosses. The West is not filled with history, but nevertheless Los Angeles carries its short history with a seriousness that would become a thousand-year culture.

The reaction of a Kienholz to a city which contains everything that Pop makes its theme (can make its theme from a distance) without restraint, has to be effected with different means. If the Pop artists of the East Coast, European spirits like Oldenburg, make use of the West Coast's alphabet, its junk, its gigantic discharge of ugliness and formal madness, then Kienholz uses the property of the East: the plush of New England, the import of the material of memories carried by an immigrant. Kienholz demonstrates in his assemblages (*John Doe and Jane Doe, The State Hospital, Bunny, Bunny, You're So Funny, Untitled American President, The Illegal Operation, The Birthday, While Visions of Sugar Plums Danced in Their Heads, Roxy's*) the disintegration, the death that no prudery can hide from view. The bodies burst apart obtrusively in his nearly religious memento mori environments. The bedrooms, bars, bordellos, hospital rooms into which he leads us use the pieces of scenery that were the fashionable and fresh present in films with Gloria Swanson or Garbo. Kienholz defends himself with delapidated lace, screaming radios, evergreens. He wants his activity understood as aggression, as a categorical art that throws slow, ugly death against acceptable death in aspic, as a reaction against an evaporated presence that sets itself down at the swimming pool and twenty years later, just goes away.

Kienholz is an artist who strongly stimulates and determines the American scene. He had suggested early, personal answers before the great momentary excitement about Conceptual art had begun. These answers concern, almost exclusively, ways of selling and reselling art. He can draw here on his own experience: in the 1950s he and Walter Hopps ran a gallery in Los Angeles. In the meantime he only sells his work under an agreement that the buyer will share with him any profit that accrues from a resale. Now he has cut back the work (in an exhibition shown by Eugenia Butler in Los Angeles) to the sales mechanism proper. He has laid bare the skeleton of what is negotiated: assets. These are inscribed on small cards with gouache. The artist sells directly, at present-day market value. The cards carry the price of the picture or the names of materials or goods for which Kienholz is willing to barter his work. The art market has happily met this challenge. The list of objects received in barter in this way sounds scurrilous, like a patched-up poem. In reality the list reflects exactly the need of this energetic hunter, collector, and user, who must have plenty of everything in his house. In his gun room there are more than thirty rifles, and in his bathroom eleven showers work simultaneously. Here is a list of the things he got in return for his works, a list that is as good as an autobiography: ten screwdrivers, one saw, one blowtorch, an electric clock, a Jackson drawing,

an old Chevrolet, a medical examination, a new suit, some Warhol graphics, a dental treatment, legal consultation, forty dozen farmfresh eggs (they are delivered, a dozen at a time, in a Rolls Royce), two sleeping bags, an adding machine, five years of free tax service, two good horses for the mountains, a tree saw, a work by Paolozzi, four new car tires, an icebox. The buyer delivers the goods and the artist makes over the title of the work to him.

An interesting adjustment to the system, nothing more. Masochism of the collector, who hands the artist the whip. An example which at most shows that Kienholz, even when he is wrangling with the newest trend, never loses sight of his goal: not to be forrmalistic, but to unmask.

California, 1969

THE EMBALMED EVERYDAY *The march of the New Realists in America*

Is this still the New York art scene? This very latest cry which the clever Sidney Janis is at present whispering to his happily buying clients in his Fifty-seventh Street gallery? A few weeks ago Ellsworth Kelly was still there: a simple colorfield picture, an attempt to make the action of the color appear as a modification of pictorial form. Two-part, geometrically clearly delineated canvases did a balance act in two colors. The one color tried to push the other off the tightrope. Sensible problems of quantity to which an ever-shrinking school of Postpainterly Abstraction has trained receptive visitors. The narrower the visual limit became, the stronger grew—an indispensable correlate—an aesthetic-philosophic talent for interpretation.

Now the reflex of gallery visiting has brought me once more, on a Saturday, to Janis's overcrowded gallery. At first I just stood next to some people, without any knowledge of what was being shown. For me, the change in the art scene came in a moment of shock. Next to me, on a chair, sat a man. What made me finally discover the art work in this was the embarrassing inability to imagine an individual of such a type being admitted into this distinguished haven. Down to the very last wrinkle, enlarged pore, smudge of dirt, this was an absolute facsimile of the unwanted, unimaginable gallery goer. The puerile, morbid American delight with optical illusion is so great that nearly every mid-sized town has its waxworks. It is a delight that brings billions to the American-way-of-death business every year. For this hyperrealism is never more strongly and greedily experienced than in the moment when the dearly departed is disemboweled, embalmed, rubbed down, and made up in the California cult of death, then is put into the slumber room for his last appearance. With the greatest financial extravagance, his best smile is kneaded in for the last time. Like no one else, Edward Kienholz has revealed this aesthetic death lie. If there is an obscene art, then it's that being offered for sale by the newest avant-garde. Not because one can, as with the dallying maiden of Andreas, count every pubic hair, but

because this puffed-up naturalism knows how to bring in, servilely and insidiously, the concept of *skill*. How this all adds up can quickly be gleaned from Sidney Janis. All the pieces are sold. The buyers snatch from the prospering Pygmalion his standard-production Galathea, like sailors their inflatable little woman, for aesthetic tranquilization at home.

It must be said that Sidney Janis has such flourishing stylistic turnabouts well in hand. He knows when a bored group of collectors requires a fresh diversion. As long ago as the sixties, when one or the other future Pop artist got himself talked about in various smaller galleries, Janis quickly decided to turn it into a trend. The group show "New Realists" consecrated a group out of a few independent people. If it was called New Realism then, it was renamed "Sharp-Focus Realism" ten years later. The concept at least seems better chosen this time, since it includes the idea of the photographic, exact portrayal. There are not to be subjective, deliberately blurred, under-or over-exposed pictures, none that present "soft-focus" versions of reality. They wiggle their way in between realism and Surrealism, just in case there should, somewhere, still be some room.

One is reminded of Man Ray's irritated reaction to the question whether photography was art, which he liked to counter with another question—whether art was photography. There are intellectual overtones in the concept of Sharp-Focus Realism, especially in this gallery, which repeatedly showed Albers, Anuszkiewicz, and Vasarely: this inclusion of conceptuality allows the interpreter so disposed to maintain a closeness to Optical Art. An avant-gardish double meaning is cleverly established. One only waits for a theoretician to dig up for this flat boredom what Kahnweiler transmitted about Picasso: after Cubism, during the First World War, Picasso suddenly started drawing in an obviously Classical style. He presented the result to his friends with the comment that one could nevertheless see that Cubism had happened. All that's really missing is that such an internal dialectic, made possible by Picasso's work as a whole, be compared to the cynical academic craftsmen at the Janis gallery.

There is no phenomenon that does not elicit its own interpretation: it is advertised. If in New York there is at first a superficial (and justifiable) reference to America's own art history, which always enjoys making the perfect copy of reality, then one has to fear that the next Documenta might legitimize the trend. And within the total concept, a section will be given over to the contemporary realism of the Western world.

Naturally not all works at the Janis Gallery copy what has already been done. Here too one can distinguish individual gestures, personal viewpoints. But there is no lack of examples of imitative art. Duane Hanson's "businessman," referred to earlier, might well be a loan from the Musée Grevin. For Philip Pearlstein there is material for comparison in Vallotton and in painters of the Neue Sachlichkeit. He certainly fits least into this group. Bravo's *Untitled* stumps no one who ever took note of the Flemish precision painting which influenced the entire American nineteenth century in the work of Charles Bird King, Raphaelle Peale, William Michael Harnett, John Frederick Peto, or John Haberle. That goes for Paul Sarkisian or Stephen Posen as well.

The great exhibition at New York's Metropolitan Museum in 1970, "Nineteenth-Century America," seems to have pushed this tradition back into consciousness with startling speed. Just about every historian of the American scene

points to the barely controllable American desire not to allow its own concept of reality to be stolen by estranging portrayals. Abstraction, the conceptually revised image, has so far remained more consciously and provokingly modern in the United States than in Europe. It is certainly a fact that American artists had a hard time to detach themselves from European academicism, by which American society was evidently fascinated. Only quite late, at the very end of the nineteenth century, did the Ashcan School organize around Robert Henri. And in 1915, Theodore Dreiser's *The Genius* finally presented, in Eugene Witla, a fictional character showing the artist as an independent, rebellious spirit.

America—where else is there a phenomenon like Norman Rockwell? He satisfied the need for art of four million readers with his *Saturday Evening Post* covers from 1916 until the magazine folded. A luxury edition containing the works of this painter (compared in all seriousness to Rembrandt by some quite respectable people) was published by Harry N. Abrams and within two years was one of the great successes in the art book field: 400,000 copies of the expensive book have been sold. Nowhere has the American dream been better portrayed than there. Phobias and predilections are absent or present in the right measure. Looking through the collection of 318 *Saturday Evening Post* covers, one appears to be in a happy, tolerant, at most intermittently carping land. There was no Korea, no Vietnam, no Depression, no prohibition. A land that here and there allowed its white boys to play with black ones, and where the great event was the alighting of a gigantic Thanksgiving turkey on the family table.

Thomas S. Buecher, head of the Brooklyn Museum, who commented on this harmonious parade, could truthfully write that Rockwell was America's most famous artist. He is certainly, next to Alfred Stieglitz, the most important American art figure of the century. From 1905 on, Stieglitz committed himself to new art in his Photo Secession Gallery in New York. He had understood that the schism between art and society brought about in Europe by the antiacademic forces must be imported to the United States. Combating the public need of salon painting seemed to him a great moral task. The soothing art of a Rockwell, which never offered the viewer anything but yet another Sunday concert request program, not only had a strongly conservative effect, but became, with its magazine publication, a constant condemnation of modernism.

For his huge circle of consumers, Rockwell has all the qualities that are so obviously left out of modern art. Rubens, Greuze, Hogarth, Wright of Derby, Spitzweg, Leibl, all this turns up in his work with a changeability that swings between brio and exact photographic imitation. Such perfectionist painting never existed in this degree before Rockwell. One can imagine the effect of a Rockwell cover in which a reverently nonplussed, perfectly painted higher-type gentleman stands staring at a Pollock-style picture, with "Connoisseur" printed underneath. Four million people had a sample of "degenerate art" delivered to their homes on the same day.

What are the people at the Sidney Janis Gallery compared to Rockwell? Or those one has been seeing for the past two or three years at the downtown galleries, or those who present such well-painted canvases every year at the Whitney Museum? Whoever gets ecstatic about the precision of Estes, Salt, Blackwell, Mahaffey, McLean, Leslie, or Chuck Close, might just as well turn to Rockwell right away. He is certainly not only in his own way a genial

perfectionist, but he has profited as much as the new names from the mediums that have influenced the newest realism: color photography, enlargement, screen printing, technically indifferent color television which prefers its luminous picture overprecise. And Rockwell too plays with optical effects which we first saw a few years ago in the color photos of the moon landing program. His *Astronauts on the Moon* (1967) or *Apollo II Space Team* (1969) thus belong to Sharp-Focus Realism as much as does Going's *Rosebowl Parade*.

As for the themes of Sharp-Focus Realism, it can be said that they are found everywhere. In Edward Hopper as well as in the Pop artists. The exclusive racing cars built by Salvatore Scarpitta in his ivory garage don't seem to have lost any of their fascination even today. The gleam on wings and shock absorbers replaces Monet's misty color on the cathedral. Urban landscape, world of advertising, a little junk art, cleanly painted Christo packages, all this enters the pictures: these often only appear so wonderfully technical because Wesselmann, Rosenquist, Warhol, Lichtenstein reduced this academic precision of technology to a beautiful level by bringing calculated breaks, irony, collage effects, into the picture. Barbara Rose, a strong champion of the second generation of American abstract painters (Frank Stella, Jules Olitski, Ellsworth Kelly, Al Held, Larry Poons), forsees that the fusion of word and thought, "painterly knowledge = avant-garde," practiced at Janis's will lead to a reconciliation between Rockwell aesthetics and collectors who have become reluctant to buy.

One has to know Rockwell and take him seriously in order to grasp this amazing reactionary rejection of all experiment and theorization—especially because in the United States, as is always emphasized, the European distinction between pure raw and applied art has remained unclear. Preoccupation with the comic strip belongs to this view. But it never turned up in fact, only in arrangements in the galleries, just like the Pop people, mostly hailing from the fields of decoration, advertising, or stage design, knew how to conceal their backgrounds. It could be said that this enormous academic potential, which has now painted itself free in one stroke, was previously handed down in para-artistic areas. Hollywood, Disney Studios, interior decorating, commercial and poster art, magazine illustrations, have cultivated and developed a technically sophisticated knowhow that the art schools and the art market tried, over decades, to do away with or bypass.

Thus the strange situation could arise that a long tradition, always regarded as external to art, has now again snuck into aesthetic competition. This phenomenon can be explained like any other. Abstinence from the real is revenged by (takes its revenge in) the presentation of formless reality. But analysis must not immediately be equated with an establishment of values. Otherwise everything that can be described, because it is a phenomenon different from some other existing ones, would be worthy of its own museum. Even Pop and Nouvelle Figuration obviously did not suffice to satisfy this new demand for depiction. They did once again bring in themes, but the trend is evidently toward noninterpretable functionless facsimile. The visible world and motifs are not represented but accepted. All this has nothing to do with Courbet, with the Ashcan School of the turn of the century, with Neue Sachlichkeit. But it does

with a technologically fostered blindness to blood and soil (*Blut und Boden*).

New York, 1972

AVANT-GARDE TIGHTROPE ACT, OR *Whatever happened to Pop Art?*

Pop Art—no other movement has ever brought the American art scene so forcibly to Europe's attention. One would think that its renown might have raised awareness of the American scene itself, which had been rendered harmless in such a hedonistic-corroborative way.

According to John Sloan, the American artist has always been regarded as an unwanted cockroach in the kitchen of a pioneer society. This seems to have been invalidated by the Pop artists. No style has more cleverly drawn on the nonartistic general sector, the area of life that is transposed into a functional sign language. Playing with popular culture, adjusting to its appearance, Pop has reached about as far downward as Socialist Realism has upward, toward the heroic commonplace.

THE ART OF CITATION But Pop, the movement that for Europeans stakes out exactly, like a wish-fulfillment, the terrain of Americana, had a harder time at home than its broad history of influence would have led one to expect. The leap between culture in the traditional sense and the autonomy of the media had, to a large degree, an exotic appeal in Europe, because even if much of what Warhol or Lichtenstein presents seems to characterize its own milieu, the total impact of the world that is structured in these images is lost. Pop Art is simply not the objectively newest representationalism in Europe.

Surprisingly, Pop did not appear first in America, but in England—as a half ironical, half lethargic fascination with another lifestyle that needled with its otherness. The point of departure for English Pop, which at first rather showed signs of being a new edition of futuristic cultural fatigue, was, if we can believe the reports of the participants in its birth, less a real experience than an encounter with illustrations, with the plates in such books as *Mechanization Takes Command*, by Siegfried Giedion, or Moholy-Nagy's *Vision in Motion*. That is why Pop's typical set piece appears at most as a quotation in English Pop, not in the inevitable hieratic capitals we find in American Pop. Basically, what the English are doing is much closer to the 20th century tradition of urban painting, a structuring of the discrepancy between the ego (self) and the environment, which can be experienced as a greater or lesser sentimental stimulus. Such characteristics are absent from Oldenburg or Lichtenstein.

In New York, Pop remained, by and large, gallery art. This observation is not a value judgment, but a comment that in spite of an apparent global stylistic accord, there exist instructive discrepancies in judgment and experience. Not one

of the great American museums was prepared to hang these pictures, to us so American in the ethnological sense, side by side with Newman, Pollock, or Still. For many intellectuals who wanted to see a liberation from the European standard through Abstract Expressionism, Postpainterly Abstraction, and finally Minimal Art, Pop expressed in an almost obscene way the frightening and painful existential garroting of the intellect. I think that the often passionate loathing of Pop in New York cannot be separated from a newfound postwar self-confidence in the venture of basing an autochthonous, non-iconographic painting on American conditions.

The texts and manifestoes published at the time show clearly that the America which was amalgamated into a theme by Pop could initially form the premise for a new nonrepresentational painting. Just because a city like New York was not stylized, was not subjected to a historical design, there was a perceived possibility of attaining a concrete nonrepresentational art out of other than iconoclastic motives. Harold Rosenberg wrote in 1947 about New York's anonymity, about the possibility of destroying an aesthetic past that could only be expected from a new form of life. Naturally this new wave of nonrepresentationalism belongs to the logical illusions of the postwar era. Abstraction turns up as the Utopia of a life freed from social and ethnic conflicts.

Hardly any of the works of Pop artists found their way into public collections. Only in recent years has a meaningful attempt been made to correct this. Apparently Pop, even if it is itself history by now, is still a sign of an unmastered present. It is no accident that nonchauvinistic arguments keep cropping up in discussions in the United States. Whereas European influence on Abstract Expressionism is claimed to be minimal, if it isn't denied altogether, the autonomy of Pop is downgraded. There a European background is sought and eagerly found in Ozenfant or Léger, as well as in the American Cubists and purists of the early twenties.

THE LIST OF BRITON The Whitney Museum of American Art, certainly not the most prestigious institution among New York museums, put on a show that made museum people hop around like cats on a hot stove. Significantly, the Whitney turned to the Englishman Lawrence Alloway for assistance. Alloway and friends in the "Independent Group" had put on the first Pop Art show—and voiced the concept of the genre—in London in the 1950s. In exhibition as well as catalogue, Alloway avoided references to Hamilton, Paolozzi, Peter Blake, or Richard Smith. The question of Pop's internationality wasn't brought up, but in order to give Pop in New York a formal ancestry, Alloway referred to that part of the New York School that concretized the Abstract Expressionism of the early postwar years (Robert Rauschenberg) or objectified it into cool color-field painting.

Since then Pop has of necessity undergone a growing contraction as a concept. The more questions of quality came into play, the more drastically and clearly pictures, sculptures, environments were separated from a scene that was suddenly recognized as basically a synthesis. For Lucy R. Lippard, the label is limited to five artists: Warhol, Lichtenstein, Tom Wesselmann, Claes Oldenburg, and James Rosenquist. What once appeared as a movement, a broad movement, is being bundled into monographs. There is something to be said for Lippard's limitation: a recognizable purism of portrayal can be claimed for all five artists

named. Whatever slides into formlessness, especially the Happening—which does not set limits on Pop but which experiments with it as the total style of an epoch—is excluded. There is no place in this definition for Rauschenberg and Jasper Johns, who are mainly mentioned as precursors. The lack of relationship with Abstract Expressionism helps to achieve autonomy. Such a limitation denies any influence by the first New York school and its search for the individual mark on every picture. What the paintings of Pollock and Kline bring forward so strongly, a symbolism interpretable only in reference to a private world, is eliminated by the five Pop people; they reject, on the level of their representationalism, precisely the patinated object personalized by use.

Alloway's list—and thus his exhibition—puts the problem differently. He stretches the concept of predecessors to Johns, Rauschenberg, and Larry Rivers, adds people like Richard Artschwager, Robert Indiana, Allan d'Arcangelo, Jim Dine, Joe Goode, Mel Ramos, and Ed Ruscha and—while not a panoptic presentation of the figurative as such, but promising a new definition—leaves Kienholz, Marisol, and Segal at the door. As a consequence, Pop Art is not supposed to indicate a generally new representationalism in the United States. In the catalogue—a book that at least tries to make up with lavish illustration for the seemingly accidental, often irrelevant loans in the show—popular culture (as distinct from folk art, that is, the directly comprehensible notations used by all the media) remains the common concept to which Pop Art reacts. This presupposes that the themes and means of presentation used by Pop derive as much as possible from the available visualized world.

Naturally, in such a definition, internal artistic or avant-garde questions can only be subordinate because, as soon as they become primary, they disturb the mechanics of spontaneous seeing. Popular culture serves as material and not (this should be remembered) as the goal of this art. A return of what was fashioned into the basic material would, after all, negate Pop Art as a specific manifestation. From that point of view, work such as that of Jasper Johns obviously acquires a definite meaning. Not formally, because formally Johns's art, like that of Rauschenberg and Rivers, still belongs to "dirty" abstraction: it lacks the mechanized, perfect smoothness. Ellsworth Kelly or Robert Indiana would be closer, especially Indiana, with his catchy heraldic aesthetic that can be traced back, as a visual commonplace, to the commercial signs of the nineteenth century.

THE NEW WINCKELMANN What is discernible in Johns is reflection about reality and its portrayal in the form of a reality. His double play with the American flag, which belongs to the few questions left open by Marcel Duchamp, surely has a crucial meaning for Pop, not least because it happens to an object that has become a Pop motif like no other. After-effects of this discussion can be detected in nearly all the Pop people: Lichtenstein operates on the waferthin line, known only to the expert, between real comics and those altered to counterfeit for the sake of art. But fundamentally Pop does not manage to have a recognizable group style: what is recognizably shared is the personal fascination with visual and consumer cliches. One possibility comes to mind: that Pop is a permissive indulgence in reaction. But as in every art—as it had been earlier with Dada or Surrealism—in which digging into the existing largely replaces

dependence on normative style, the personal nature of the choice becomes paramount. This is where a Warhol seems to rise above all the others. The more casual, the better. Perhaps that's why the works of Wesselmann seem as devastatingly artistic as a newly minted Modigliani or Matisse. Too much remembrance is dragged in. As a gag about civilization this might be all right, but it is still simply Play Bach for the expert.

Pop Art seems to us the fascinatingly precarious tightrope act of the avant-garde: between the belief in progress and in development, which lowers style after style from the flies, and the nostalgic glance backwards which nowadays turns the dead, the overlooked, into a resonating sound box, Pop juggles an art completely in the present. Pop gives no more and no less than the clarification of the supremacy of a way of seeing in art that is no longer articulated by culture. When these pictures started to turn up at the end of the fifties, it was not so much a matter of a new representational art—and defined as such, Pop was at first opposed, branded a regressive return to formula painting—but an art that commented on the requirements of a new, already stylized representationalism which was conveyed through the media.

Marshall McLuhan, basically carrying La Mettrie's *L'Homme Machine* further, appears as the virtual Winckelmann of the decade. Without McLuhan's upgrading of things that must have seemed disasters to even warmly receptive minds, Pop would not have been able to keep free of the despair-of-civilization feelings caused by the avalanche of goods and media. That is the reason for the astonishing epicurianism in these pictures, for the very prompt embarcation to a consumer and media Cythera.

New York, 1974

A GIANT HAND THAT MOVES THE EARTH
Land art, a modern phenomenon of escape from cities

What kind of people are they, those officiants of a Land Art who are fanning out into the countryside? They are not out to depict the landscape, but to express themselves within it—to move the earth with a giant hand, to combine situationlessness with situation. Michael Heizer, Richard Long, Robert Morris, Robert Smithson, and Walter De Maria come to mind; their huge projects, cautiously groping at the edge of Utopia, ensure that art makes the headlines.

A series of exhibitions has tried to provide information about Land Art and to interpret these "sculptures" that incorporate earth, landscape, the horizon, as part of their material. One of the earliest shows was "The Art of the Real: U.S.A. 1948–1968," organized by the Museum of Modern Art in New York in 1969. Then followed the survey "Earth Art," which sharpened and narrowed the focus of the theme; it took place in 1969 at Cornell University in Ithaca, New York. The exhibition "When Attitudes Become Form," put on by Harald Szeemann at the Kunsthalle Bern in 1970, was memorable. It introduced Heizer, Long, De

Maria and Dennis Oppenheim to Europe. Later there followed "Earth, Air, Fire, Water: Elements of Art," at the Museum of Fine Arts in Boston (1971), and "Interventions in Landscape" at the Hayden Gallery, Massachusetts Institute of Technology, Boston (1974).

At present there is a survey being shown at Washington's Hirschhorn Museum, which specializes in sculpture. This is another effort—this time with the help of ten artists—to give an interpretation of the art form. Under the title of "Probing the Earth," sketches and layouts are on show. There is photographic material reporting on excursions to distant—mostly American—horizons. What legitimizes the notion of probing the earth is something all these works share—a projection of romantic, ecological moods into nature.

These works do not depict landscape, earth, elements, they engage them. The exhibition only includes works that were conceived for specific places and aimed at a permanent presence, thus excluding concepts or realizations that incorporated transcience from the outset. That left out John Beardsley, who organized the show, and also Christo, whose *Valley Curtain* and *Running Fence* are among the most lavish and impressive works to come out of the confrontation of landscape, society, and art. But it seems, if one looks for a definition which covers all the examples in the Washington show, that the participation of the public, so important to Christo, is largely absent here.

Withdrawal from the public eye is a decisive factor in these works; they aim—as all programs and manifestoes show—at the transposition of physical experience into meditation. Christo's receptivity to actual construction procedures and materials could hardly be made to fit in with the works gathered at the Hirshhorn Museum. They all display a certain regression: they stage a recollection of archaeological, prehistoric makers and signs.

The question of the provenance of this art is only touched upon. There are references to the prehistoric Nasca culture of Peru, to Herbert Bayer's *Earth Mound* (1955) in Aspen, Colorado, and to Isamu Noguchi's *Pyramidal Memorial to Man, As seen from Mars* (1947). In most of the examples at the exhibition, a link to Minimal Art can be observed. This is true of Heizer's *Double Negative*, an excavation some thirty feet wide and forty feet deep, that he is planning for a mesa at the edge of an erosion field east of Overton, Nevada, as it was for the observatory being erected by Robert Morris in Osterlijk Flevoland, northeast of Amsterdam.

What is behind this escapism that builds its refuges on lakes or in deserts? Without a doubt there is more to this trend than simply a continuation of Minimal Art. If one can start from the premise that the reduction of content with which Minimal Art struggled against the themes of Pop and civilization is of importance to Land Art, then one could conclude: the calculated and almost hygienically necessary zero point was immediately transposed into a symbol for infinity and primordiality.

The formal kinship with Minimal Art however remains superficial. For in these works, which take into account the orbit of the earth, solstices and equinocts (Nancy Holt, Charles Ross), references are sought which Minimal Art—as the latest and most radical phase of a concrete art that tried to do away with metaphor and meaning—rejected for itself. The literal reading of simple forms that presuppose a rejection of complicated, assembled structures and that, with

Donald Judd, Tony Smith, or Robert Morris (as long as he kept his work within gallery walls), aimed at elementary signs without symbolic overtones, all this does not affect those artists who broke out of Manhattan into the country. After all, they don't only transport their simple forms into the distance, they announce, with their soundings, measurings, and restructurings, confessions that are full of allusion and that cry out for commentary. Any proximity of their work to the semantic reduction and rejection of meaning in Minimal Art, is more likely caused by the fact that large plastic works erected in and with the landscape, self-evidently require a simplification of means. And this elementariness intensifies the effect of the escape from the city. Thanks to the limitation to simple forms, the pressures that nature exerts on large sculpture is lessened.

This effect is shown by the more impressive examples of the Land Art genre— Michael Heizer's *Complex One*, Robert Morris's *Grand Rapids Project*, Robert Smithson's *Spiral Jetty*. In situations where the eye, in a planetary sweep, no longer experiences the humanly wrought change in an environment devoid of human intervention—whether the Nevada desert, that Barbizon of land artists, or on the shores of Great Salt Lake—as an actual work, none recently made, or in fact made at all, that is when the effects are strongest and when works meet the definition as Land Art most rigorously. At the same time the barrier between it and the innumerable examples of monumental sculpture, horizontal sculpture, architectonic articulation of landscape becomes clear.

Michael Heizer's *Complex One*, 1972-76

But here the exhibition and the summing up, attempted in Washington, show their weaknesses. An eccentric like Harvey Fite (1903–76) who for thirty-five years was building a mass of walls, hollows, and embankments on a property in Saugerties, in New York State, belongs more to the field of landscape architecture. And Charles Simond's Liliput sandbox urbanism, which combines models of past ways of living with sociocritical intentions in the shadow of New York's skyscrapers, remains a sociological reflection tied to a sentimental love of ruins.

The total renunciation of architectural and urbanist questions that Heizer, De Maria, or Smithson evince, the hubris they oppose to social determinism, have nothing to do with the foregoing. Walter De Maria's work is not in the exhibition, but he is mentioned in the text of the catalogue.

The more orthodox members of the guild erect cult places that withdraw from the profane ubiquity of gallery art. This flight out of the art business is frequently talked about—and artists who believe that no more objects should be added to a world already obstructed by them, second this in their commentaries. These works affect us like a fata morgana of nonpossession, of ungraspability. The isolation that is sought, the fascination with the remote place that can be reached only with great difficulty or at great expense, all that belongs to the rites of initiation required by Heizer, Smithson, or Richard Long. The mimesis of primitive forms of surveying, copied from pre-Columbian sites, is obvious.

One might also refer to the tradition of American landscape painting of the nineteenth century, which culminated in the Hudson River School. To a large extent these pictures expressed the clash of untamed, unuseable nature and civilizing intervention—the panoramic landscapes with their cosmic stage effects of Thomas Cole come to mind. There is also an echo of the heroic landscapes of Poussin, Claude Lorrain, Salvator Rosa.

Comparisons could go into detail. The combination of transitoriness and the relativity of history and human achievement found expression in Thomas Cole's unforgettable *Titan's Goblet* (1833): a fleeting world in the universe that will be extinguished in the next moment, when the titan brings his goblet to his lips. One is tempted to see Smithson's *Spiral Jetty* as a transposition of Cole's painting.

When Robert Smithson made his sculpture, *Gyrostasis*, in 1968, he accompanied it with a commentary that maintains this intertwining of simple form with cosmic allusion. *Spiral Jetty*, on the northeast shore of Great Salt Lake, becomes the symbol of a humanly organized intrusion into a landscape that, by Smithson's own description, contains within itself all the signs of eeriness, wildness, and hostility to life. Only in combination with this primeval landscape, with the myths that tell how the red water, saturated to leaden heaviness with minerals, is in subterranean contact with the ocean, does this succinct intrusion of Smithson's gain the urgency of the Hudson River School painters.

Smithson does not simply start out from the "phenomenological evidence" of this impressive, desolate piece of land. The mythological depth of the area rouses him. He discovers, under the leaden water, an immobile cyclone, a sleeping earthquake, and out of this recognition came the concept of the *Spiral Jetty*.

In this remote places of initiation, stillness rules. And these productions are— if we stay in the area of American art—basically in search of the same thing that Mark Rothko and Barnett Newman strove for in their pictures; a magical

conjuration of the sublime. One cannot deny the fact that the meeting with the exiled Surrealists in the 1940s had a crucial influence on Rothko and Newman. A look at the journals published at the time in New York by the Surrealists suffices. There we find proof of the fascination with the American landscape and a mass of struggles with ethnological questions, that predicted this very flight from city and civilization.

The visions that Max Ernst had set down in the pictures of the cycle *The Whole City,* in which the city is devoured by the land, came true in his encounter with the real landscapes of Arizona. In this connection André Breton's *Prolegomena to a Third Surrealist Manifesto* must be mentioned. In it, and this time against the background of his American experience, he again attacked the anthropocentric image of the world. Surely the opening sentence, in which he says that he is too much under the influence of the North to ever become part of a system, refers to the mystical search for an insight and revelation that refers—in art—to the central "byway" that leads from Blake, Caspar David Friedrich, through Turner, Munch, Kandinsky, Klee, Surrealism, to Rothko and—why not?—on to Land Art.

Washington, 1978

FROM FELT TO FAT TO THE SUNNY STATE
Joseph Beuys at the Guggenheim Museum

Joseph Beuys is now an official export. Can he be the favorite son of the German cultural politics? He represented West Germany at the Biennale in Venice, and again in Sao Paolo. And now the Guggenheim, thanks to German support, is giving him his first comprehensive retrospective. With good reason—a *Newsweek* magazine correspondent commented that not the least interesting aspect of this Beuys show was its financing. *Soho News* also picked this up, and remarked that while Beuys is known in Europe as a political artist, one wonders how effective his politics really are, once the good intentions are discounted; the paper then expressed the suspicion that Beuys is being given this support by Germany to show the world how liberal it is.

What does this mean? Has Beuys metamorphosed himself into a respectable three- or—with all due respect—four-dimensional representative for alternative cultural work? The opening at least made clear to Americans the extent to which Beuys has become a German object. Whole groups of fans came streaming in, from cultural department heads to notables in dinner jackets. A travel agency had solicited possible target groups, offering a package deal to the extraordinary world event which even includes a final glass of dark German beer in downtown Manhattan. Therefore the sentence most often heard on opening night was: "Did you come over especially for this, too?"

At the Guggenheim, Beuys leads us through his works in twenty-four stations, twenty-four stations that may be taken as a symbol for his day-and nighttimes,

around the clock; there is an echo in this of the hegemonous demand for twenty-four-hour action "and in us . . . under us . . . land beneath" (Galerie Parnass, Wuppertal, 1965). A dream is on show. It reaches from the *Bathtub* over a line of display cases from the Stroher Collection in Darmstadt, the dismounted *Honey Pump* from the 1977 Kassel Documenta, the Fireplaces from Basel, to the twenty-ton *Tallow* that rests downstairs in the museum like a mass of ice in C. O. Friedrich's *Stranded Hope.*

HIS CLAIM The man who everyone says has thrown every current artistic concept by the boards, who will have nothing to do with our traditional view of art, now roosts in the museum like any other artist. Doesn't Beuys claim that even Dada, Marcel Duchamp, or Surrealism are not points of reference for him? He has stressed this need for autonomy in many conversations. And even those who don't take everything he says as gospel are in this context uncritical and impressed. "One cannot measure with equipment beholden to a system intrinsic to art, a work that claims to and actually does have nothing more to do, nor will have, with our inherited view of art."

Joseph Beuys, *Tramcar Stop.* Venice Biennal 1976. Photo by Barbara Klemm.

In fact, no one quite dares tackle Beuys's claim. The difference in the voluntarist Beuys may seem artificial, but once we have a look around, things really do seem different. The history of art of the last seventy years is the history of constantly new forced breaks and contradictions. The Dadaists, to name only them, surely put into question the concept of the art of a period in a much more fundamental and far-reaching way; they also possessed the critical intelligence not to turn an exemplary, historically anchored, necessary act of liberation into a prim institution which would deliver small liberations to order.

Beuys is, in fact, participating in a powerful Copernican change that began in the early part of our century. Oddly, nowhere is a comparison drawn between Beuys's marginal attitude, so highly appreciated by the media, and the behavior of the Dadaists. If no other, Johannes Baader, self-styled "Oberdada," should at least be mentioned. Within the context of the political, elucidating work of destruction of the Berlin Dada group, he announced his world-encompassing doctrine of salvation, and he preferred theatrical attitudes and activities to work.

IN THE MUSEUM From Baader's pen we find descriptions of actions and assemblages, in which he himself participated; had the Weimar Republic had a television program at its disposal, it would no doubt have telecast them: "The figure of History, whose decapitated head of real Bavarian bees' wax hangs in front of the remains of a Royal Prussian Rex canning machine, will never allow that so musical a paradox as a world war become a reality." It should also not be a secret that Beuys was not the only one to make cemetery crosses and memorials; Johannes Baader too started as a gravestone cutter, with the so-called last things.

The essence of Beuys is his immense need for autonomy. That is no doubt why he resisted a museum retrospective for so long: it would, whether he wanted it or not, put him in touch with art originating parallel to his own work. This monologuist inventor of social-plastic art insists on freedom for himself. His is a communicative group endeavor for which the social contract is apparently lacking. It is astonishing that nowhere in the comprehensive Guggenheim show is there even a brief suggestion of what Beuys would after all most like to be— the educator of humanity, the teacher. That's why American visitors to the exhibition keep wondering where the examples of the famous intersubjective activities might be. For in the museum, in the sun, Joseph Beuys stands all alone.

Is it possible to accept uncritically the special christological position in which the artist Beuys has established himself? Hardly ever has such a syncretic construction of atavism, regressive ritual, and forced preaching of salvation preoccupied minds to such a degree in the aesthetic area. This although the argumentation rejects any kind of discursive intelligence or any analysis which recognizes our reality as a historically derivable process, not one reversible at will, and draws conclusions from this.

Certainly, this appellative chaos delivered by Beuys could still be accepted; the fact is that these days such mystical-shamanistic figures are having their hour in the limelight. Dada too had asserted chaos, and Dadaist destruction has shown itself in retrospect to have been one of the most magnificent positive moments for art and thought. But Dada belongs to a longer history of European enlightenment.

What is hard to accept is the dearth of reflection that marks (with few

exceptions) the literature around Beuys. Even the latest publication, the book for the exhibition by Caroline Tisdall, is nothing more than another splendidly illustrated example of descriptive literature which is timidly intent on explaining Beuys with Beuys. One misses any sort of historical confrontation in this study.

Undoubtedly the universalism on which Beuys's influence largely rests is again fostered in this way. The transcendental, unique gift is emphasized which denies every historical link—and for the artist this includes the history of form as well. The interpreters participate in the attempt to break out of the age, an attempt that at first certainly had a deep existential significance for Beuys. We find similar situations wherever an extra social-Utopian value is to be infused into art.

Beuys's diction of hope, which no doubt goes back to a dramatic, tragic experience, does not in fact differ much on this point from a Mondrian or Kandinsky; in their writings they used associative language to hide the fact that their absolute forms, cleansed of all contingency, derived from a stepwise reduction of trees in bloom or Russian broadsheets—that is, from deeply felt early sense experiences and accidental inspiration.

There is in Beuys a deep layer of experience that not even the barbs of his opponents can destroy: there is a plastic intelligence, an ability to create optic and psychic irritations that seem to express the terror, the wounds of an epoch. A parallel with George Grosz, Otto Dix, Rudolf Schlichter, imposes itself on the mind. With the difference that the protest of Dada, after the lost First World War, after the failed revolution, could still place itself within a context of real situations.

But in the formal regressions of a Beuys to psychotic-gloomy materials, to blood color, bones, decay, to everything that points to the bandage of Amfortas's unhealable wound, to metals that enervate the viewer as would oppressive, low-frequency power plants—here the anonymity of another time can be felt, the unconcreteness that can no longer be played upon by the ingenious Dadaist reversals and paradoxes of technology. And there—if one wants to stay within the symbolism—the gestures of healing, of protection, acquire humanity.

The degree to which Beuys expresses the terror of a period can be shown by a comparison with Wols or the hostages of Jean Fautrier. Thus one is inclined to interpret these works instinctively and sensually. But Beuys has largely eradicated horror and well-being, as his commentaries show. Even in a work such as *Auschwitz,* the blocks of fat aren't supposed to refer to what everyone would naturally think of; it becomes much more a homeopathic healing aid of a *similia similibus curantur.* Beuys originated the remark, "Marcel Duchamp's silence is overrated." And yet it happens to be openness that makes Duchamp's work so fascinating. The silence brings about a swirl of interpretation. But that is eliminated by the self-reviewing Beuys for his own case. With Beuys there is the exhausted evidence of a plastic statement. And that is what criticism must deal with.

Nowadays anyone who dares utter even a few skeptical words about Joseph Beuys must take care. His nonderivativeness is supposed to make any criticism of his charismatic being seem a little out of place from the very outset. Criticism is in fact equated with profanation. And this may very well be the alarming point. One should, after all, have the possibility of making distinctions between the visual evidence and the program—a program that only had a temporary

instrumental meaning even for Mondrian and Kandinsky.

The philosophy of life delivered with the work is irritating. According to that philosophy, it is an accepted fact that our well-being can be attained through a return to ethnomedicine and household remedies, and that a whole happy army of uncommitted people will suddenly materialize just when we bid goodbye to the positivist concept of science of which Beuys disapproves. Which concepts are we concerned with here? With those of the leader who confronts parliamentary democracy with his charisma. With anthroposophic oracles, with aesthetic thoughts of deliverance which had already been fashioned—albeit under different circumstances—by Lagarde and Langbehn from a claim of superiority of the spirit.

FROM HEAD TO HEART Our more recent history certainly does not lack for movements to reform life. All such total solutions look toward the past. Beuys's views too contain a good number of these restorative traits, and these need to be right at a time when Ayatollahs conducting politics according to religious tenets are on the move. It is necessary to make sure that thinking does not deteriorate into slop. Isn't it disconcerting, therefore, to see the American reviews of the Beuys exhibition speak of "nordic" and "national"? One cannot entirely get away from the impression that this favors the kind of ideology of art, with its regressive, burdensome attributes, that other countries like to ascribe to Germany. The Germans have, after all, commonly been masters at equating cultural criticism with complaints about civilization. And it is this very note of opposition to civilization that is found in the writings and interviews concerned with Beuys. The eye glides toward the Eurasian no-man's land offered as the new Atlantis to a community of billions, beset to the bursting point with problems.

In addition—and here too Beuys's worshipers are silent—Beuys simply coarsens one of Surrealism's favorite ideas, in which petty nationalist principles were challenged with a map on which Western "civilized" Europe was almost totally melded with Asia. One of the Surrealists' most lasting and passionate mental games was always to widen the boundaries of European experience—that is why they collected non-European art, why they tried to do away with traditional aesthetics through a systematic passion for the remote, the subcultural. All this is used quite radically and literally by Beuys. What he offers people—and for him the bee colony is not a symbol, but a model—is a conflictless community in which state and economic system would disappear in favor of libertarian salvation. Genetic manipulation may some day help us into such a paradise in any case.

One can also read that the exhibition gives ammunition to those who hate him as well as to those who value him. That is not correct. One point is ignored. One could speak of Beuys's exorcism and banalization. His notoriety rests on the fact that he knows how to put stories across, from one Sermon on the Mount to the next. But the show of the work no longer brings out just what made him one of the most successful mystagogues of our time. Rather it forces us to look at drawings, objects, relics of actions. And here one might venture to say that perhaps Beuys's talk was overrated.

Looked at from this point of view, the exhibit is an event: Beuys relinquished the very thing that made him the darling of the media. There are no actions.

And the show makes another thing plain: the production of Beuys without the presence of the dramaturge Beuys to a large degree forfeits its function of irritation. Thus the New York critics are helpless.

What it boils down to is an art exhibition which, no matter how many baffling elements it offers, can be taken in stride by a New York public that, for the past twenty years, has rolled from one enthusiasm and eagerness to learn to another. The superlatives served up by the critics in advance in any case insisted only that Beuys was the most important *European* artist of the postwar period.

New York, 1979

DEMOLITION OF A COUNTERPERFORMANCE *Realisms between revolution and reaction*

One has become used to the fact that art historians and museum staff gradually explore the aspect of modernism that is out of the avant-garde's limelight. How much terrain still remains to be explored there? With which finds is the existing museum still to be qualified? The exhibition "Les Réalismes entre révolution et réaction 1919/1939" at the Centre Georges Pompidou certainly does not see its theme merely dithyrambically.

The show was put together by Jean Clair, one of France's most brilliant art historians, with the invaluable cooperation of Günter Metken. Not only the visual arts but also architecture, design, and literature are presented in this multifaceted examination of realism. All sections of the center were enlisted in this venture. An elaborate catalogue assembled essays and source material in support of this controversial exhibition. There are some dazzling analyses—especially in the unfamiliar Italian area, thus decisively enriching the heretofore stereotypical representation of the Italian situation, whether Valori Plastici or novecento.

What becomes particularly clear is that it was the overpowering past, barely qualified by the avant-garde, which controlled that country, intent like no other on surmounting the (French) avant-garde. It may very well have been Picasso's own dialectical revision of the avant-gardist position that gave the Italians the courage for Italianatà. Thus, at the very least questions are raised by the exhibit that had not been asked before; to these questions belongs the one about the role of models, about a possible coupling of tradition and a precise recognition of the prevailing historical moment.

PARIS OR MUNICH Can this exhibition prevent the replacement of the disdained onesidedness of *one* avant-garde by another onesidedness? Surely there is more at stake here than the upgrading of a few hitherto obscure figurative painters who will benefit by being linked with the great names in the show. Can one take this show as an art exhibition, visit it and—in compliance with the subtitle—let the fullness of the show wash over one, half yielding, half rejecting? Is it simply

a matter of broadening our knowledge, of shifting the threshold of our tolerance and our experience?

But the fundamental question is why there need be, in our time, what might be called a second figurative drive. For the reception of a part of the exhibited works very obviously depends on the restorative needs of our time. To express it differently: will this exhibition have consequences, or is it already the consequence of a steadily alleged fatigue with experiment?

Such an exhibition and such a discussion would not have been possible ten years ago. At that time the veristic, politically leftist wing of Neue Sachlichkeit achieved its first notoriety. With unproblematic idyllists à la Kanoldt or Schrimpf it would hardly have been possible to go international. How the landscape can change! How strongly France may feel this radical change in its own body will become clear in the next few months. The series of great balance sheets that the Centre Pompidou has offered ("Paris-New York," "Paris-Moscow," "Paris-Berlin") is to end in the self-ward "Paris-Paris" show. And this when, of necessity, a period ·(1937–57) is to be presented during which Informal Art triumphed in France, a period in which there was very little room for representationalism, if one considers the figures who determined market and conversation.

Could one therefore speak of a direction in art which left Paris either on the left or on the right? Rash critics are already offering the contemptible catchword of an Italian-German Axis. At least the French section presents nothing in this exhibition—if one excepts Picasso—that can be put side by side with the pictures and drawings of a Grosz, Dix, Hubbuch, Schad, Schlichter, and especially of a Beckmann, all of whom are represented supremely well.

New Objectivity and Surrealism have common roots in de Chirico. Since de Chirico is in a certain sense presented as the father figure of the exhibition, Surrealism—which after all did not want to be unrealism, but a life movement that butted against the insignificance of reality—should not have been left out. One thing, however, cannot be denied: German and Italian art are having their big moment in France. To characterize what is emerging at this time, one could reverse a well-known statement of Walter Benjamin's: "Spiritual currents can reach a gradient sharp enough for the critic to set up his power station on them. Such a gradient is created for Surrealism by the different level of France and Germany."

This time the French seem to be standing in the valley and estimating the sharpness of the gradient. This time the French grant an astonishing importance to figurative painting, thematically often exotic, which was developed outside the Ecole de Paris. The exhibition's catalogue contains surprising statements, like the one that Munich was more important than Paris in the development of Europe's twentieth-century art. Such a judgment, no doubt deliberately couched in these provocative terms, bases itself to a large degree on the momentous encounter of de Chirico with Munich, in a way the immensely melancholy antithesis to the—by definition—positive and optimistic avant-gardes of the first decade.

Our period no longer presents manifestoes; when it does try, they are swept away by a torrent of meanings. But there is one exception, which can be related to this exhibition. When, a few weeks ago, no less a luminary than Claude Lévi-Strauss intoned a paean of praise for trompe-l'oeil painting, the haphazard

occasion for it almost led one to look on it as unimportant eyewash, of the type found in polite forewords. But then Lévi-Strauss, in conversation with Jean-Marie Benoist (printed in the first number of the Centre Georges Pompidou's *CNAC Magazine*), gave a quite unequivocal reason for what must be called an ethnocratic (rather than culture-critical) attack on abstract art.

The rejection of experimental art can easily be traced in Lévi-Strauss. In *La Pensée Sauvage*, there is a quite explicit negative judgment on artistic concepts that do not inform about an outer world which can be experienced. This verdict from the original and influential intellectual is bound to have consequences. Lévi-Strauss sets what he regards as supreme in art, the disegno of Flemish painting, the inviolable order of things, against the subjective aberrations of a humanism that has lost the measure of richness of appearance. In his praise of the trompe l'oeil, Lévi-Strauss unites praise for the *bello mestiere*, skill, and learning.

If I understand him correctly, he thus turns—as an ethnologist who sees destruction and hubris in the historically self-conscious course of history—to an art in which the eye must subordinate itself to nature, and the subject to the object. And with an intuition for that which most strongly determined the most recent history of art as well as the psychology of artistic impatience, he brings in Picasso, as an example of an artist who put different models of uncommitted subjectivity between himself and reality. Lévi-Strauss's text is totally hostile to everything in twentieth-century aesthetics that could and had to arise out of the contingency of the subject.

This kind of facsimile naturalism, whose aim is to oppose a conservatory of binding skills to what is obviously dismissed as mere daubing, can certainly not have the blessing of the Parisian exhibition. Its title is in the plural, and it deals with realisms. Openness toward the various tendencies of the apprehension of reality, that reaches from criticism of a "return to order" to the engagement of artists, determined the selection. The figurative work presents, in its different variants, the filling material that can be juxtaposed with the exponents of a historical construction determined by the avant-garde. The intellectual risk of such a counterreformation lies in one's hand.

Whoever walks through the rooms feels that essential positions are being relativized. Where is the concept of freedom, the subjectivity, which seemed particularly to symbolize the avant-garde of our century with its own, self-surmounting dynamics? Did avant-garde not stand, rightly, against norm and permanence as totalitarianism of right and left tried to introduce them, in the name of comprehensibility and popularity? In the long postwar period it was therefore unthinkable that art could turn to figurative painting. In a certain way, individualism fed off the norm, equated with crime, of government control.

There were several examples of the official taste of the Third Reich at the exhibition. In them the relationship to time is denied—time as the frenetic experience of the individual, with his claim to and hope of uniqueness. The concept of development that the avant-garde brought forth and constantly intensified surely stood, even more than its content, in the way of totalitarian art. Nothing could provoke a government as strongly as an absolute denial of permanence.

And thus we come to the dividing line that runs through the exhibit. It is an

aesthetic barrier that these realisms cut through. What touches us at all out of these critical or melancholy quotations from reality? The exhibition shows that the art of our time only turned to the standard, the model, Classicism, where it had to operate to any extent out of the melancholy of an irreparable loss. This in itself comments on the meaning of coming to grips with history: it can be experienced aesthetically there where it does not appear as a repetition of a past, but as a break that embodies a time limit.

On this point there is no appreciable difference with the mechanisms of the avant-garde. What de Chirico, Carrà, Grosz, Picasso, Hopper start with as an outwardly classical model lives on its very distance from that model. The past does not appear unbroken in the work, only as a quotation. The past can only touch us today in the form of a collage. The collage, which patches together, presents the disparate; it is the most meaningful symbolic form produced by the art of our century.

It isn't by chance that the opposition to the positive avant-garde which—like Cubism, Expressionism, Futurism—found legitimacy alternately in transcendental certainties, a break with civilization, or the glorification of the moment, sets in not with the identification but with the distance from a Classical model. It was Giorgio de Chirico in Munich who experienced the greatness of his own origins—in the German yearningifor Italy, in the nostalgia of Nietzsche, Klinger, Böcklin—as an exoticism. He was one of the first who experienced this exile in time, who could no longer manage a repetition of the past.

De Chirico started with one of the most momentous and poetical critiques of historicism, of the binding nature of his own origins. This Italian gave the confrontation an intellectual frame which parried all the mendacious, opportunistic national renaissances. He opposed the literalness of past greatness. And yet he did not negate history. He suffered from its excess. Not until the 1920s did he preach a return to the commitment of classicism—and his own tragedy says more about this aesthetic stillbirth than all the pictures of the Nazi painters and sculptors, which are so awful that they cannot even be used as the counterargument of a normative art.

De Chirico demanded, from the very beginning, an art that would, unlike the developmental trend of modernity, reduce subjectivity. He needed concreteness to escape the banal concept of reality. He put together quotations from reality. His pictures became rebellions against explicability. With him this flight out of positivism, which pits knowledge against metaphysics, availability against mystery of the world, became tinged with the critical melancholy which later also drove the Surrealists to their desperate stand against the blunted grasp of reality. This is the crux of the need to constantly roil the causality of the world of appearances, and thus, thanks to profane inspirations and epiphanies, to see reality with new eyes.

Figuration—with de Chirico, as with those influenced by his system of mixing reality, always remains a critical figuration. The break between an art of the past which always had its self-evident, natural anchor, and a relevance that could no longer back up art with clear models, was the focal point at first. Not until the twenties did he return, as prodigal son, to the plaster, timeless arms of his fathers. At this moment the tension let up—de Chirico, Carrà, Casorati, Sironi, Cagnaccio di San Pietro, Virgilio Guidi, all drew back to an Italianatà that

alternately addressed Giotto, Bronzino, Piero della Franscesca. More and more, a binding concept of a model became clarified; it was finally expressed in 1933, in a manifesto signed by Sironi, Funi, Campigli, and Carrà: "Fascist art rejects research and experiment. . . . The style of fascist painting has to orientate itself on antiquity."

WHERE IS THE LIMIT? And with this collective conviction, the grief, the isolation of man and thing which San Pietro, Sironi, or Guidi at first had still allowed to show through, in the spirit of the time, and in spite of their search for a binding concreteness, disappeared from their work. Instead, a spurious optimism, that could interchangeably serve the various regimes, put in its appearance. The dialectical freedom from commitment and history as fascination, which de Chirico had existentially experienced as a break, disappeared. In the meantime art had escaped from metaphysical shock into heroic servility.

The Parisian exhibition is a splendid teaching tool; for what is somewhat rashly—and certainly with calculated provocation—billed as a parallel to the art history of our century, is in fact revealed (where we can agree with it) as a rehabilitation of content art. And this has long been negated in France, as has been shown by examples from Scandinavian countries and Belgium. It turns out that the limits for the general expansion remain narrowly drawn. Art under fascism, the multiplicity of works assignable to the novecento, socialist realism (which was not, unfortunately, considered in this show as a variant of reactionary representationalism), are not acceptable because our century has an aesthetic position and it is not possible to retrocede behind it.

Realism, Representationalism, need for Classicism and a norm, these are concepts that do in fact continue to exist in our century—although the avant-garde has often self-confidently tried to do away with them—but they remain concepts that can now only be experienced as breaks. That is why the clear "winners" of this exhibition, besides de Chirico, are the painters of the veristic wing of the New Objectivity, because their Realism or Classicism has remained dialectically tied to the present. German art, because it so often emerged at the edge of political and social disaster, could find its hour here.

Paris, 1981

These articles first appeared in the newspaper the *Frankfurter Allgemeine Zeitung* in Frankfurt, Germany. The exception is the article "Nilpferd mit Stiefelknecht" (Hippopotamus with Bootjack—The art of psychopaths and modern art) which appeared in the *Stuttgarter Zeitung* in Stuttgart, Germany.